T0393280

Palgrave Studies in Creativity and Culture

Series Editors
Vlad Petre Glăveanu, Department of Psychology and Counselling, Centre for the Science of Learning and Technology, Webster University Geneva and University of Bergen, Geneva, Switzerland
Brady Wagoner, Communication and Psychology, Aalborg University, Aalborg, Denmark

Both creativity and culture are areas that have experienced a rapid growth in interest in recent years. Moreover, there is a growing interest today in understanding creativity as a socio-cultural phenomenon and culture as a transformative, dynamic process. Creativity has traditionally been considered an exceptional quality that only a few people (truly) possess, a cognitive or personality trait 'residing' inside the mind of the creative individual. Conversely, culture has often been seen as 'outside' the person and described as a set of 'things' such as norms, beliefs, values, objects, and so on. The current literature shows a trend towards a different understanding, which recognises the psycho-socio-cultural nature of creative expression and the creative quality of appropriating and participating in culture. Our new, interdisciplinary series Palgrave Studies in Creativity and Culture intends to advance our knowledge of both creativity and cultural studies from the forefront of theory and research within the emerging cultural psychology of creativity, and the intersection between psychology, anthropology, sociology, education, business, and cultural studies. Palgrave Studies in Creativity and Culture is accepting proposals for monographs, Palgrave Pivots and edited collections that bring together creativity and culture. The series has a broader focus than simply the cultural approach to creativity, and is unified by a basic set of premises about creativity and cultural phenomena.

More information about this series at
https://link.springer.com/bookseries/14640

Wendy Ross · Samantha Copeland
Editors

The Art
of Serendipity

Editors
Wendy Ross
Department of Psychology
London Metropolitan University
London, UK

Samantha Copeland
Technology, Policy and Management
Delft University of Technology
Delft, Zuid-Holland, The Netherlands

Palgrave Studies in Creativity and Culture
ISBN 978-3-030-84477-6 ISBN 978-3-030-84478-3 (eBook)
https://doi.org/10.1007/978-3-030-84478-3

Cover illustration: Yuval Helfman/Alamy Stock Photo

This Palgrave Macmillan imprint is published by the registered company Springer Nature Switzerland AG

The registered company address is: Gewerbestrasse 11, 6330 Cham, Switzerland

The editors would like to thank all the contributors for their interesting and thoughtful reflections. We hope that this is the start of conversation about the role of chance in creativity. Special consideration must also go to the members of the Serendipity Society who have provided many moments of reflection since its foundation in 2016. Wendy also thanks Max, Sam, Sophie and Will for their never ending patience as well as Vlad Glăveanu, and Frédéric Vallée-Tourangeau for all their support. Samantha extends similar thanks to Neil and Becca for their loving support, her Woodill neighbours and many colleagues for their insights along the way.

Praise for *The Art of Serendipity*

"Serendipity is at the core of human existence. It can bring us joy, love, and connection. It is about potentiality, about what *could* be. Cutting-edge serendipity researchers Wendy Ross and Samantha Copeland have brought together an array of inspiring serendipity researchers and practitioners to reflect on how serendipity unfolds and what we can learn from it. Whether you unexpectedly stumbled over this book or had it on your radar already, you will find it a beautiful gift that will trigger and embrace your curiosity, imagination—and creativity. Good luck!"

—Prof. Dr. Christian Busch, *Bestselling author*, The Serendipity Mindset: The Art & Science of Creating Good Luck; *Program Director, CGA Global Economy Program, New York University*

"For anyone looking to increase their chances for the kind of surprises in life that lead to meaningful breakthroughs, this book is for you. Ross and Copeland's work shows how to position one's self for chance encounters and how to begin managing one's own "luck." The research in this book helps us understand serendipity, and offers thought-provoking

conclusions that suggest we have more control over the happy accidents we experience than we might imagine. The overall concepts they propose—the importance of knowing how to recognize an opportunity and how our we use our trained skills to help us make something of that recognition—is uplifting, reassuring, and extremely hopeful."

—Steven Fischer, *Two-time Emmy Award nominated Writer/Producer*

"Chess play horses can jump, even aside. The Art of Serendipity is this talent. As the Sofists knew, you can't look for the unknown, because then you don't know where to look for. But you can stumble on the unknown, by doing a surprising observation, that you explain correctly. It can lead to unsought findings: a serendipitous discovery (in science), invention (in technique) or creation (in art). Serendipity, like stupidity, is an intrinsic aspect of human behavior and a crucial, universal, funny phenomenon. It is 'l'imagination au pouvoir' (Paris, 1968) for everybody, in its most democratic form. Behaviorist B.F. Skinner advised: "When you run into something interesting, drop everything else and study it!" More precise: When you stumble on an enigma, an anomaly or a novelty, explain it, and test your hypothesis. Planning is a must, but plans are not holy. Choose your own track. Hamlet said: 'Readiness is all.'"

—Pek Van Andel, *Serendiptologist*

Contents

Notes on Contributors

Samantha Copeland is an Assistant Professor in Ethics and Philosophy of Technology, at Delft University of Technology, and founding Co-Chair of the Serendipity Society. She works on ethical issues in transformative contexts, such as resilience planning and engineering, the development and application of emerging medical technologies, and transdisciplinary research.

Ken Gilhooly graduated in psychology from one of Scotland's four ancient universities (Edinburgh) in 1967 and went on to take a Masters in mathematical psychology and a Ph.D. in experimental psychology at one of Scotland's newest universities (Stirling). From 1970 to 1999 he worked at Aberdeen University before taking up a Chair at Brunel University London and later at the University of Hertfordshire where he is now an Emeritus Professor (since 2011). He also held a part-time Chair in Gerontology at Brunel University London and a visiting Professorship at Regent's University London, 2012–2018.

His research has focused on higher mental processes such as concept learning, problem solving, reasoning, decision making, expertise effects, ageing effects, insight problem solving, creativity and incubation. He

has a long-term interest in specifying thinking processes in information processing terms and in understanding the role of working memory in a range of thinking domains. His work has attracted regular support from UK Research Councils, the European Union and from leading charities funding research and has led to numerous publications in the form of journal articles, book chapters, textbooks and monographs. His most recent monograph (with Mary Gilhooly) is *Aging and Creativity*, due out with Academic Press early in 2022.

Currently he is focusing on (1) attempting to clarify basic concepts in the area of thinking, problem solving and creativity and (2) beginning historical work on the huge impacts of Henri Poincare and Graham Wallas early in the last century on the subsequent research on thinking, problem solving and creativity

Vlad P. Glăveanu is Associate Professor and Head of the Department of Psychology and Counselling at Webster University Geneva, Associate Professor II at the Centre for the Science of Learning and Technology (SLATE), University of Bergen, Norway, Director of the Webster Center for Creativity and Innovation (WCCI) and founder of the Possibility Studies Network (PSN). He edited the *Palgrave Handbook of Creativity and Culture* (2016) and the Oxford *Creativity Reader* (2018), co-edited the *Cambridge Handbook of Creativity Across Domains* (2017) and the Oxford *Handbook of Imagination and Culture* (2017), authored *The Possible: A Sociocultural Theory* (Oxford University Press, 2020), *Creativity: A Very Short Introduction* (Oxford University Press, 2021) and *Wonder: The Extraordinary Power of an Ordinary Experience* (Bloomsbury, 2020), and (co)authored more than 200 articles and chapters in these areas. Dr. Glăveanu co-edits the book series Palgrave Studies in Creativity and Culture for Palgrave. He is Editor of *Europe's Journal of Psychology* (EJOP), an open-access peer-reviewed journal published by PsychOpen (Germany). In 2018, he received the Berlyne Award from the APA Div 10 for outstanding early career contributions to aesthetics, creativity and the arts.

Hayley Kasperczyk holds a B.A. (Hons) in Theatre Studies and Art (Lancaster University), and an M.A. in Performance Practices and Research (Royal Central School of Speech and Drama). After carrying

out research focused on the situationist movement, Hayley worked as a space hunter with some of the UK's leading site-based performance companies including Pundrunk, 1929, and Coney, as well as for TV and film productions such as *Downton Abbey*. Hayley has also produced site-based audio artwork in London and Belgrade with Jeremis Iron Arts Collective and for Waltham Forest Council as part of their *Borough of Culture* 2020. She now works in art and set decoration for TV and film with recent credits including BBC's *I May Destroy You* and *Silent Witness*, ITV'S *Unforgotten*and an upcoming Disney Film.

Bem Le Hunte is a Professor at the University of Technology Sydney (UTS). She is the Author of several short stories and four novels. Her first two novels, *The Seduction of Silence* and *There, Where the Pepper Grows*, have become number one bestsellers and have been published internationally to critical acclaim. Her latest novel, launched in 2020, is *Elephants with Headlights*. At UTS, Bem is the founding Course Director of the Bachelor of Creative Intelligence and Innovation, a multi-award-winning, transdisciplinary, future-facing degree that teaches creativity across 25 different disciplines. Before that she had a career spanning three decades in the creative industries. She is also the Director of Teaching and Learning at the TD (Transdisciplinary) School, where she has a research interest in transformative creative learning. Bem has a B.A. and M.A. in Social Anthropology from Cambridge University and a Creative Doctorate from the University of Sydney. Writing has always been her elemental passion, and the gift of this calling has allowed her to flourish in many ways and worlds—well beyond the written word.

Gerhard Lock is a German-born Musicologist (Estonian Academy of Music and Theatre, EAMT, Estonian state 1st price for M.A. thesis 2004, EMTA Ph.D. candidate since 2008), Composer (member of Estonian Composers Union since 2005), Improviser and Musician. He was researcher 2006–2008, since 2009 lecturer at Tallinn University Baltic Film, Media and Arts School. He is co-organiser of international conferences (since 2005 in collaboration with EAMT and Estonian Arnold Schoenberg Society; since 2009 the TLU CFMAE series), editor of journals, books and websites. Since 2009 he is CFMAE: The Changing Face of Music and Art Education peer-reviewed international research

journal co-founder and managing editor. His research fields (including the Ph.D. thesis in progress) are musical tension, cognitive analysis and modelling. Other fields are interdisciplinarity (music and arts, dance, audiovisual, etc.), creativity and improvisation research as well as music history, education and digitalisation topics. He is Member of the Estonian Arnold Schoenberg Society, the European Association for Music in Schools (EAS) and the Serendipity Society.

Paul L. March initially trained and worked as a Clinical Psychologist in the UK, specialising in brain injury rehabilitation. In 2000 he moved to Geneva, Switzerland and went to art school. Initially working in various mediums, since 2009 he has focused almost exclusively on clay and has regular exhibitions in Switzerland, France and the UK. In 2016 he began a D.Phil. in archaeology at the University of Oxford, supervised by Lambros Malafouris. Paul uses sculpture, informed by Material Engagement Theory to map the way materials and human movement collaborate to create the mind—a process of investigation he calls clayful phenomenology.

Ana Piñeyro is an independent Designer and Researcher, working at the intersection of programmable, responsive materials and experimental textile design. She holds a Ph.D. in Textiles from the Royal College of Art, London, and an M.Sc. in Cognitive Systems and Interactive Media from Pompeu Fabra University, Barcelona. Ana's practice seeks to enrich the aesthetic and functional vocabulary of materials by revealing their inherent latent capacities through experimental processes of manipulation and transformation, employing craft-based methods for embodied engagement with materials and tools. Ana has previously worked on research and innovation in electronic textiles and textile-based responsive technologies at CETEMMSA Technology Centre (now EURECAT), Barcelona; in the development of colour and material innovations for automotive interiors at Johnson Controls GmbH (now Adient), Burscheid; and has undertaken research on the effects of colour on emotional states in mixed-reality environments at SPECS Research Group, Pompeu Fabra University, Barcelona. She has lectured in areas of textile design and smart materials & textiles at universities across Europe. Her work has been awarded prizes by the Miquel Mas Molas Foundation

and the Institute for Catalan Studies, Barcelona; a development grant from FAD incubator (Fostering Arts and Design), Barcelona; and has been funded by Marie Skłodowska-Curie Actions (EU Horizon 2020) and the Uruguayan research and innovation agency (ANII) and BID Lab. Ana is currently exploring the morphing capacities of conventional materials such as wool and paper.

Wendy Ross is a Senior Lecturer in psychology at London Metropolitan University. Her main topic of research is the role of material serendipity in higher cognitive processes such as insight problem solving and creativity. Her work is interdisciplinary, and she moves from in-laboratory experimental studies to focused cognitive ethnographies to explore her main research interest of the role of things in cognition. Her interests in serendipity lie in challenging the notion that discovery and creativity can be traced back to a moment in the head but are rather better seen as moments which arise through action and are necessarily distributed. She is currently working on a model of serendipitous cognition, seeking to understand how the interaction with accidents can increase our understanding of how thinking is distributed across people and objects.

Jaak Sikk (Ph.D.) is a Researcher, Writer, Improviser and a Pianist. He teaches contemporary improvisation at the Estonian Academy of Music and Theater and music College of Tartu named after Heino Eller. His doctoral thesis (Ph.D. obtained in 2020) "The Influence of Stimulus Induced Imagery on the Quality of Improvising Freely" researched the possibilities of using imagery in the process of improvising. In his teaching methodology, performances and research, Jaak aims to combine philosophical concepts, neuroscience and human psychology with practical actions and artistic experimentation. Jaak is an active performer in Estonia and abroad as an improviser. He participates in the artistic research project RAPP lab, which unites several artistic research centres of Europe. He is currently working on a handbook of free improvisation directed to music teachers.

Dean Keith Simonton is Distinguished Professor Emeritus of Psychology at the University of California, Davis, having earned his

Ph.D. in Social Psychology from Harvard University. His research programme spans various questions associated with genius, creativity, leadership, talent and aesthetics. Simonton's curriculum vita lists more than 550 publications, including 14 books: *Genius, Creativity, and Leadership*; *Why Presidents Succeed*; *Scientific Genius*; *Psychology, Science, and History*; *Greatness*; *Genius and Creativity*; *Origins of Genius*; *Great Psychologists and Their Times*; *Creativity in Science*; *Genius 101*; *Great Flicks*; *Social Science of Cinema*; *The Wiley Handbook of Genius*; and, most recently, *The Genius Checklist*. Although most of his empirical research uses historiometric methods, he has also published laboratory experiments, mathematical models, computer simulations, meta-analyses, psychometric investigations, secondary data analyses, single-case studies and interviews. Simonton received the William James Book Award, Sir Francis Galton Award for Outstanding Contributions to the Study of Creativity, the Rudolf Arnheim Award for Outstanding Achievement in Psychology and the Arts, the Henry A. Murray Award for "distinguished contributions to the study of individual lives and whole persons", the Joseph B. Gittler Award for "the most scholarly contribution to the philosophical foundation of psychological knowledge", the Distinguished Scientific Contributions to Media Psychology Award, the Theoretical Innovation Prize in Personality and Social Psychology, the George A. Miller Outstanding Article Award, the E. Paul Torrance Award from the National Association for Gifted Children, three Mensa Awards for Excellence in Research, and the Mensa Lifetime Achievement Award "for contributions to the field of human intelligence".

Andrew Sneddon is a Scottish Artist who lives and works in the UK. He is a Lecturer on the postgraduate Fine Art course at the University of Edinburgh/Edinburgh College of Art and senior lecturer in Fine Art at Sheffield Hallam University. He studied at Glasgow School of Art and at the British School at Rome. He completed his doctorate from the University of Edinburgh entitled "*Confusions of meaning in the concept of place: An investigation into the role place occupies in influencing the production and reception of the artwork*". He has exhibited internationally and nationally. Andrew's practice and research focuses on exploring our complex engagement with place. He makes site-responsive artworks

that explore the relationship between people and place with particular attention paid to traces of cultural memory. He is interested in the habitat and signatures of place and how they are encoded within the material forms of the commonplace. Andrew has written on a variety of subjects concerning Fine Art practice and theory. In 2014, he published with *Études critiques en improvisation*, an academic journal on improvisation, community and social practice housed at the University of Guelph, Canada. His essay, *The Act of Improvisation within the work of Tacita Dean,* considered how acts of improvisation are used as a framing device through which the decision-making process of the artist is revealed in relation to failure, serendipity and sagacity.

Rose Turner is a Cognitive Psychologist interested in the processes involved in arts engagement, particularly those related to empathy. She holds a B.A. (Hons) in Theatre Studies (Lancaster University), an M.A. in Performance Practices and Research (Royal Central School of Speech and Drama) and a Ph.D. in Psychology (Kingston University), which examined the effects of engaging with fictional narratives on empathic abilities. She has worked for several years as an actor in theatre and film and applied arts practitioner taking creative arts interventions and arts-based training programmes into education, criminal justice, health and social care settings. She is now a Lecturer in psychology in the Science Programme at London College of Fashion, University of the Arts London.

Frédéric Vallée-Tourangeau obtained his Ph.D. from McGill University. His research has explored causal and Bayesian reasoning. More recently, he has been working on problem solving from a distributed cognition perspective, seeking to better understand how new ideas are constructed through the transformation of objects.

List of Figures

Briefing for a Systemic Dissolution of Serendipity

Accident and Serendipity in Music Composition, Improvisation and Performance Art

The Anableps Guide to Serendipity: Intentional Serendipity as Creative Encounter—A Decolonised, Literary Perspective

The Pleasure of Not Knowing and the Importance of Serendipity in Contemporary Art Practice

Problem Solving, Incubation and Serendipity

On Creativity and Serendipity

Wendy Ross and Samantha Copeland

The current collection gathers the perspectives of academics and creative practitioners to discuss the role of serendipity in domains as varied as creative problem solving, sculpture, writing, theatre and design. The chapters in this volume address issues such as the nature of the prepared mind, the role of accidents, serendipity as a skill or way of engaging with the world, and indeed, whether serendipity as a concept is even possible within the coupled, dynamic system which so often marks creative engagement with the world.

W. Ross (✉)
Department of Psychology, London Metropolitan University, London, UK
e-mail: w.ross@londonmet.ac.uk

S. Copeland
Technology, Policy and Management,
Delft University of Technology, Delft, Zuid-Holland, The Netherlands
e-mail: s.m.copeland@tudelft.nl

W. Ross and S. Copeland (eds.), *The Art of Serendipity*, Palgrave Studies in Creativity and Culture, https://doi.org/10.1007/978-3-030-84478-3_1

Serendipity and creativity are both concepts that cover a broad range of phenomena. At first glance, the creative domains in this book are spread widely and perhaps too widely to be contained within a single discipline: problem solving, scientific discovery, music, art, theatre, sculpture, textile design and writing. Creativity is a heterogeneous field, loosely held together by the bipartite, "standard" definition—as something which requires novelty, and either meaningfulness or usefulness (Runco & Jaeger, 2012). This definition of creativity has led to many arguments about what actually *counts* as creativity, and there is a risk of conceptual dissipation, to the point where so much falls into the category that the definition fails to define (see Ross, Simonton, this volume). However, these fields are united by the investigation of how novelty is generated and taken up and, alongside this, how progress is made. In short, people have an urge to avoid stasis and to explore unknown territory. Creativity studies are concerned with the processes that underlie this exploration of the unknown.

Serendipity is perhaps even more contentiously defined. The word "serendipity" was famously coined by Horace Walpole in 1754 in a letter to Horace Mann, in which he described the *sortes Walpolianae* thus:

> This discovery I made by a talisman, which Mr Chutes calls the *sortes Walpolianae,* by which I find everything I want, *a pointe nommée,* wherever I dip for it. This discovery, indeed, is almost of that kind which I call serendipity, a very expressive word, which as I have nothing better to tell you: you will understand it better by the derivation than the definition. I once read a silly fairy tale, called the three Princes of Serendip: as their Highnesses travelled, they were always making discoveries, by accidents and sagacity, of things which they were not in quest of: for instance, one of them discovered that a mule blind of the right eye had travelled the same road lately, because the grass was eaten only on the left side, where it was no worse than on the right – now do you understand Serendipity? One of the most remarkable instances of this accidental sagacity (for you must observe that no discovery of a thing you are looking for comes under this description) was of my Lord Shaftsbury, who happening to dine at Lord Chancellor Clarendon's, found out the marriage of the Duke of York and Mrs Hyde, by the respect by which her mother treated her at table.

These few lines raise most of the key questions which have made serendipity a "slippery concept" (Makri & Blandford, 2012). First, there is the nature of the "sagacity" or personal wisdom required to make the most of what is stumbled across in the course of everyday life. Second, the nature of the accident and third, the role of what constitutes the quest in the line, "a thing which they were not in quest of". This slipperiness licences multiple interpretations of the core text. In their overview of the word and concept, Merton and Barber (2004) suggest that the notion of "serendipity" has come to function as a cipher, allowing writers the chance to rewrite definitions that reflect their own preconceptions. Napolitano (2013, p. 293) makes a similar observation, suggesting that there is a recurring pattern of "serendipity's meaning being 'refracted' by the behaviors and experiences of its users". The collection of chapters in this volume lend further evidence to this claim, leaving these three core aspects still inconsistently defined.

However, the longevity of the word and its attractiveness as a category suggests that it captures an important aspect of human experience. Indeed, while Walpole invented the word, the concept it describes clearly existed prior to this definition and has been described in different ways by different writers (Alcock, 2010; Silver, 2015). We suggest that we can focus on the core notion, that is, the interaction between human agency and environmental contingency which marks so much ongoing experience. From Walpole to Louis Pasteur's "le hazard ne favorise que les esprits prepares" (Pasteur, 1854), writers on serendipity emphasise this dual nature with varying degrees of poeticism. Shulman suggests it is "a process hovering ambiguously between the [...] incisive mind and the wheel of fortune" (Merton & Barber, 2004, p xiv) and Copeland describes it as being "at the intersection of chance and wisdom" (Copeland, 2019, p. 2385).

So, despite the at times frustrating ambiguities inherent in the definition above, we believe that Walpole has leant researchers a useful hook on which to hang thoughts of how the combination of chance and skill play out in different domains. More modern scholarship on serendipity (such as those examined in these chapters) has moved from a detailed examination of the ambiguities inherent in Walpole's letter to thinking about how serendipity can be used to support our understanding of the process of

human engagement with environmental uncertainty and to support the investigation of how we interact with events in a non-linear manner. This lends support to a model of human thought and behaviour which reflects much less rational planning than traditionally allowed. This model is, in turn, intrinsically linked to novelty and therefore, creativity. As Austin (1979, p. 61) writes, "to be fully creative, you must respond positively to the risk and challenge of exploring new frontiers". Thus, creativity and engagement with uncertainty are seen as intertwined. Indeed, one of us argues (Ross & Arfini, forthcoming) that open and dynamic systems are the only way for true novelty to emerge—a point Simonton also considers in his chapter in this volume.

The role of luck in the creative process has been documented in several places. Notably, Csikszentmihalyi's collection of interviews with ninety-one eminent creative professionals across all domains led him to write (Csikszentmihalyi, 1996, p. 46):

> When we asked creative persons what explains their success, one of the most frequent answers – perhaps the most frequent one – was that they were lucky. Being in the right place at the right time is an almost universal explanation.

However, a closer examination of one such case study in luck described by Csikszentmihalyi reveals that it is rather an instance of serendipity, that vexingly contingent mix of skill, luck and timing. Early on in the book, he discusses the work of Vera Rubin who discovered that stars belonging to a galaxy do not all rotate in the same direction. Although the moment that precipitated that realisation was triggered by an "accidental observation" (p.2) of two pictures taken almost a year apart, the resulting story illustrates that "she could use this luck only because she had been, for years deeply involved with the small details of the movements of the stars". It is clear that while the trigger was external, to exploit and explain the phenomenon required internal actions. Such an accident would be useless to a neuroscientist who would not know how to interpret them, just as Rubin would have been unable to interpret the output of an fMRI scan. Luck therefore is recognisably necessary, but it is not sufficient to fully explain creative success.

There is perhaps even more discomfort about allowing accidental moments into the artistic creative trajectory (see Lock & Sikk, Piñeyro, Ross, this volume). Weisberg (2006, p. 60, emphasis added) summarises the problems with accidental creativity thus:

> Let us say that I am a painter, and one day I accidentally spill paint on a canvas, which leaves a stain on my partially finished work, making it unusable. Let us further assume that I am visited by the director of a museum, who sees my stained canvas, loves it, and purchases it for display in the museum. The painting is then discussed in art books, and other artists use my spilled work as the basis for innovations of their own. My piece of junk has thus become part of the world of art. Was I creative in producing that painting? *No* (…).

As Piñeyro (this volume) shows we can move beyond this somewhat disingenuous thought experiment to consider the work of those such as Bruce Nauman who specifically create situations and allow those situations to unfold out of control and to do the creating for them—in Nauman's case, mice in his workshop. Here the locus on artistic intentionality shifts and the "doing" happens beyond the artists' direct control. Of course, in this case we can more easily recognise that the creativity here lies not in the traces of paint (nor the routes the mice take in the case of Nauman) but in creating the situation and in the reaction to these events and their framing (see Copeland, this volume).

This instinct, that creativity requires clear intentionality (otherwise described as needing to be meaningful or purposeful), underlies anxieties about the kind of creativity generated by non-intentional algorithms and puts accidentally created work of great beauty outside of the bounds of creativity research. Elsewhere (Ross & Vallée-Tourangeau, 2020), one of us has argued that this is in part because the role of chance in creativity undermines the notion of creativity as an epistemic virtue; it is hard to reconcile the idea of a creative genius with the idea of contingency. It also belies the very real nature of the work that is required for any form of artistic creativity. As the chapter from March and Vallée-Tourangeau (this volume) demonstrates, a work of art requires significant effort, attention and time to come to fruition. We suggest that the acknowledgement of

the role of a certain level of skill in dealing with chance when it comes to creativity is an important way to reconcile the underlying instinct that a simple response to luck is not "true" creativity (see Simonton, this volume). For this reason, we suggest serendipity is a better framework than pure luck or accident.

Furthermore, recent research in creativity is moving away from the "I" paradigm (Glăveanu, 2010), that all creativity comes from the view of a creative genius. That is, there is a move to view creativity as more systemic (Csikszentmihalyi, 2014; Montuori & Purser, 1995), which creates a space for the role of distributed creative agency and invites us to use serendipity as a lens to explore how that distribution happens. We suggest that the dual nature of serendipity, the requirement for there to be an input from both inside and outside the system, allows us to grant space to socio-material agency while still acknowledging the importance of the human. As Csikszentmihalyi (1996) argues, accepting that some things are beyond our control does not undermine the role of creative and artistic talent in creativity but acknowledges that the whole creative trajectory from idea to absorption lies in a social context and is fraught with contingency. All the writers in this volume stress that this distributed agency should not be considered a sharp division, but that rather serendipity is a relational concept that unfolds through doing and action—blending and destabilising traditional notions of cause and effect. A form of knowing-through-doing both generates and is generated by accidental encounters with people, things and events (see Copeland, this volume). This leads to the delightful yet vexing contingency of creative processes. Part of understanding the characteristics of contingency involves engaging directly with serendipity. We argue that it is likely a serendipity-based approach will enrich our understanding of the whole creative process (although see March & Vallée-Tourangeau, this volume, for a position more critical of this research programme). We further suggest that being comfortable with a process which is inherently contingent may be important as creativity researchers grapple with the complexity of their own research area.

This complexity, of a concept which requires subjectivity to be understood—as one of us has argued, a person must experience an event as serendipitous for it to be serendipity (Copeland, 2019)—and which

is yet also dependent upon something beyond personal experience, is reflected in the ways that the writers of the following chapters discuss the notion. At the extremes we find the work from Simonton and the work of Le Hunte, who approach serendipity from entirely different directions—Simonton suggests that we can submit serendipity to a formal analysis, Le Hunte uses her own expertise as a novelist to reflect on the role of serendipity in her creative process. We see similar tensions within the chapter from March and Vallée-Tourangeau, in which the writers are forced to take on positions that they find uncomfortable and aim to convey an in-the-moment perspective in retrospect. The position of the serendipity "narrator", whether the writer of the chapter or the person identifying and experiencing serendipity, is incredibly important when we consider its relational nature. As Ross and Glăveanu's chapters make clear, the surprise necessary for serendipity is an inherently relational one; we must take into account the position of the person experiencing the surprise as well as the event that generates the surprise. When Gilhooly writes that serendipity does not have to be noticed by the person experiencing it in the case of subliminal hints given to problem solvers, the definition of serendipity shifts and rests with the researcher. This complexity of approaches and perspectives invites a pluralistic understanding.

The Role of the Agent: Sagacity

Consider the various ways that the phenomenon of the prepared mind is described and interrogated in the chapters of this book. Pasteur's famous (mis)quoted phrase, "chance favours the prepared mind" has accompanied accounts of serendipity and sagacity from the time of Walpole. Whereas in science, however, serendipity is often about *finding* something that wasn't looked for, in the creative arts serendipity results in the *production* of something that wasn't part of the original plan for the work. This is a stark difference between artistic discovery and scientific discovery. Whereas scientific progress is seemingly inevitable, artistic creativity tends to be far less teleological (although see Martindale, 1990). For what, then, must the creative mind be prepared,

for serendipity to happen? As Glăveanu (this volume) suggests, the mind cannot be constantly prepared, and the open-endedness of creativity together with the element of chance means that we cannot know for what, exactly, one ought to prepare. In response, Glăveanu suggests that rather than being fully prepared in the classic sense of having all the right things in place before the event, we should conceive of the prepared mind in terms of curiosity and wonder.

In the chapter by Piñeyro, the prepared mind is more about being ready to engage: one must be prepared to be flexible, to receive the nuance of the material with which one is working, and to respond in kind. The prepared mind is a forward-looking mind, "ready for anything" that may come its way, but within the constraints of the creative project and the materials that will constitute it. March and Vallée-Tourangeau convey preparedness as more of a process, a making-oneself-ready for new ideas about how to work with a material by working with the material itself: as one plays and thinks and goes on through time, the relationship one has with the material grows more complex and intimate, and one's mind becomes more prepared for the creative turn. Le Hunte draws our attention to this idea of preparedness as a relational term with her depiction of serendipity as the muse's sister, someone she can get to know and yet a relationship that will require time and attention (and empathy) to develop. Gilhooly emphasises the role of an incubation period in his chapter, how serendipity occurs often after one has reached the state of impasse and has put the problem aside. To return to Glăveanu's chapter, we see there that the prepared mind is better thought of not as a "depository" but rather as a "network of relations and entanglements with objects, ideas, people, places, institutions, and cultural practices". Copeland does something similar in her approach to serendipity through metis, the "cunning wisdom" of an individual who is fortified by their own past and expertise to contribute something unexpected and novel to a changing situation. Thus, the prepared mind, in light of the work contained here, is more about being in a state of readiness, more so than having the right tools and expertise to hand when chance arises.

The role of expertise has been addressed—although the issue has not been resolved—in the serendipity literature, particularly in respect to

serendipity in science. Some have suggested that the novice is more likely to be serendipitous, because their expertise does not lead them to throw away potentially valuable accidents as presumed mistakes (e.g. see Myers's 2011 collection of tales from medical history). However, as Merton (1948) notes, those who are "steeped in theory" are more likely to recognise the value of an unexpected observation than the naïve. One's own expertise is also in relation to the context in which one finds oneself, however, as several of the chapters in this volume discuss: with Ross, we take a close look at the interplay between an individual's ability to notice something potentially serendipitous, and the willingness of the world around them to accept it as a discovery. Copeland notes specifically the role that context can play in constraining or enhancing the individual's ability to notice and follow up on accidents that may be serendipitous. Even Simonton, who offers a more internalist perspective on the prepared mind than other, more relational accounts in this volume, suggests that some of the expertise that historical figures demonstrate in serendipity lies in their ability to assess the context they are in: he notes specifically Galileo's insight into the extra value that discovering moons around Jupiter added to his own patronage by the Medicis, for whom he could name those celestial bodies.

Turner and Kasperczyk externalise the prepared mind, in a way, in their exploration of immersive theatre. In this context, the actors and directors construct a stage for serendipity: they place the minds of the audience into a prepared context; the minds of the audience are prepared, having bought tickets and being led through a constructed, immersive environment, to experience something unexpected and new as they step into the stage. They note that the serendipity is up to this relation, however: not every audience member will experience it, and not every attempt to cultivate it by the actors and directors will be successful. Further, the serendipity experienced by the audience during and in reflecting upon the theatrical event will be personal, and so may happen in ways beyond the predicted scope of the play's intentions. But this is the very nature of immersive theatre, argue the authors: to be open-ended in its effects. Similarly, Lock and Sikk, in their chapter, discuss how serendipity represents an interruption incorporated into the flow of a musical piece—an interruption or flaw is not a failure when taken

up by the performer into an improvised piece, and a true improvisation can have no failures, only change. These approaches seem to suggest the prepared mind can be better seen as a conditional and contextual cognitive state than an innate, stable and personality trait.

The prepared mind also needs to be surprised. This notion of surprise is perhaps more complex than it at first appears. As noted already, it seems to require both naïveté and a deep theoretical embeddedness. As Arfini et al. (2018) memorably write:

> This is to say that an unexpected serendipitous event is never a non-sequitur: it sparks an "aha!" reaction, not a "How is that even possible?!". Fleming's "Oh!" reaction was when he managed to frame and understand the antibiotic effect of a mold. He did not enter his laboratory to find a moldy culture singing the chorus of Mamma mia!: that would have sparked another kind of reaction.

A serendipitous surprise requires that the person experiencing it knows and understands what is usual so that the unusual can be recognised and reasons for it postulated. And yet, as Piñeyro notes, knowing too much about what is usual can hinder one's openness to the unusual: in her chapter, her own ignorance about the materials with which she was working allowed her to make the mistake—to generate the accident and to be open to it as an opportunity for further exploration—that led to a new creative trajectory. The treatment of the phenomenology of surprise in the following chapters is linked to the place they assign for serendipity in creativity: when the accidental becomes expected, such as in the creative process experienced by March in his chapter with Vallée-Tourangeau, or in true improvisation as described by Lock and Sikk, surprise is diminished as the creator adopts the appropriate attitude, one that expects and accepts the accidental inherently as opportunities for taking new paths and a new possible outcome for the creative process itself. As accidents become expected and no longer generate true surprise, suggest these authors, creators are no longer experiencing serendipity, and thus their explorations further elucidate the importance of the accident to our understanding of serendipity in creativity.

The Role of the Environment: Accident

Of the two parts of serendipity, the accident is perhaps the most controversial, underexplored and yet most essential. A focus on the accident moves serendipity from a "capability" (de Rond, 2014) to an event. It also challenges human centric forms of understanding and switches the normal order of events from one where a human agent imposes their will on an inert matter (a form of hylomorphism such as described in Ingold, 2010) to one where there is accident followed by sagacity. This inversion of traditional human cause effecting a material change is destabilising and also evokes anxiety around creative agency, as we suggested above.

As we see throughout the chapters in this volume and in the following sections, such a stark binary becomes hard to sustain. Indeed, as Ross points out, the "pure" accident with no prior human action rarely occurs and a naïve understanding of accident in this way would needlessly restrict what we consider serendipitous. March and Vallée-Tourangeau (this volume) suggest that there can be no accident within a system and use this to argue for the dissolution of serendipity. We agree with the perspective that an accident has to be something that disrupts the flow of the system and therefore comes from outside, so assuming a continuously extending system excludes accidents from consideration. It is for this reason we are unclear to what extent the internal serendipity discussed by Gilhooly and Simonton in this volume is really possible (as both also question). We have sympathy with Gilhooly's description of the complexity and contingency of a network approach to this internal serendipity, but would suggest that the concept of serendipity is easier to sustain when thought of as sparked by external stimuli (whether that initial spark is material or social).

In other words, given our own work and the work in this volume, our vision of serendipity takes it to be more than a simple combination of existing factors. As Boden (1994) suggests, new combinations could lead to improbable moments, but true creativity includes not only that which is improbable but also that which is impossible. Therefore, in our view, while serendipity requires a systemic approach, we also query the notion that a system should be extended indefinitely without reflection: a view from wholly within is problematic, just as a view from nowhere

would be. Rather, the accidents in the creative processes described in this volume tend to illuminate the boundaries of the system at hand, and the authors draw attention to these boundaries even as they demonstrate how interference by accidents, and sometimes serendipity, tend to extend them outward. Systemic boundaries are expanded, that is, both by pushing outward and by things outside of it breaking in.

What defines an accident is, as referenced by Piñeyro, that it is unanticipated and unplanned. It must also be experienced as that. As Ross writes, the notion of an accident is relational on both a personal and broader scale. Two chapters in the current collection, Lock and Sikk and March and Vallée-Tourangeau, question whether the conscious experience of an accident is possible when the artist and their material (whether clay or improvised music) are in flow. Indeed, Lock and Sikk's chapter suggests that serendipity may be a temporary stage in the development of musical virtuosity, one where accidents are viewed as problematic, and then become incorporated so that the pinnacle of musical development would be that point when accidents happen but are no longer perceived as such. March and Vallée-Tourangeau suggest that accidents are impossible if we see intentionality as being extended into the system. These chapters thus suggest a complexity around the relationship between artistic flow and serendipity. Perhaps a certain naïveté and distance from the material is required (as suggested by Turner and Kasperczyk) for serendipity to become manifest, or perhaps the accident may trigger that distance and disrupt flow when it is recognised. Phenomenological approaches to creativity are underrepresented in the literature and we suggest further research of this nature would be useful to understand both the creative experience and the experience of serendipity.

Just as we have seen above with the reflections on the nature of sagacity, these reflections on accidents also indicate a complexity which belies their seeming simplicity. The accident is as relational as the prepared mind. The contingency of serendipity calls for further reflection on the complex dynamics involved in each aspect of these parts; we see it as an indication that we need to look beyond a simplistic reductionist model to model serendipity (and creativity) instead as emergent phenomena.

The Entangling of Agency: The Role of Emergence

As March and Vallée-Tourangeau argue, it is impossible to truly understand serendipity as a bipartite phenomenon. If it were, then designing for serendipity would be an easy case of generating more random moments and watching skilled human agents exploit them. Such a plan is tantalisingly attractive but rarely survives sustained examination (Olma, 2016).

So, while cultivating serendipity outside of creativity is often seen as maximising chance opportunities in terms of quantity, here, as in the serendipity literature, we see that the quality of an encounter has more influence on its productivity than the number of encounters. This is not to say that creating opportunities for accident and chance is not desirable—chance has long been used by creatives as a method, as we see in several of the chapters here (particularly those by Sneddon and Piñeyro, but also see Simonton, Copeland, Turner & Kasperczyk). However, as we have seen above, this is not the same as simple randomness: the fact that an encounter happens by chance is not sufficient for it to be deemed creative.

However, research from Makri et al. (2014) shows us that an artistic sensibility may seek spaces where accidents may be more likely to happen. And indeed, Piñeyro's own chapter demonstrates how accident can become sedimented into a coherent structure. Piñeyro (borrowing from Iverson) describes two methods, the retrospective harnessing of the accident and the intentional generation of accident to spark a creative moment. But by incorporating such methods into our process, the binary of intention and accident becomes harder to sustain. Turner and Kasperczyk take this to be less of a problem than a potential fruitfulness: by taking serendipity to be the purpose of immersive theatre, the creative impact of the theatre experience extends into its influence on life in general, such as when audience members take their experience into their own lives to have serendipitous moments generated after as well as during the performance. Directors of such theatre cannot intend to have these effects, but they can intend to create opportunities for unintended effects through serendipity. Copeland discusses the indirect cultivation

of serendipity through providing the means to cultivate the related skills and the (supportive) space in which to practice those skills. Thus, more than the generation of more chances by introducing randomness is needed; rather, because serendipity emerges from the stream of human interaction with the uncertain and dynamic surroundings, the generation of such experiences and their results must take that environment to be complex, systemic and emergent.

Conclusion

Serendipity is a complex term. Like, creativity, it remains unclear to what extent writers and researchers on serendipity are considering the same phenomenon, and its positioning as an event, an experience and also a skill invites a pluralistic and fluid approach. Yet, it is repeatedly cited as a key component of the artistic process and human experience. This is perhaps because serendipity is concerned with understanding how people navigate uncertain and incredibly complex environments. These environments are necessarily filled with unanticipated moments and interactions which may become more salient in moments of progress and discovery as material uncertainty transforms into human knowledge and understanding.

An Overview of the Chapters in This Book

Vlad Glăveanu: What's 'Inside' the Prepared Mind? Not Things, but Relations

Creativity theorist Vlad Glăveanu takes up the problem of the prepared mind in serendipity theory; in creativity theory, the assumption that mind-meets-world has the effect of creating an impossible dichotomy, in contrast to recent work on the inter- and iterative relationship between our inner and outer worlds. Rather, he suggests, we can work with the concepts of curiosity and wonder to understand how accidents motivate us toward creativity. Surprise in this account is distinctly relational,

an experience that moves us between the known and the unknown, the familiar and the unfamiliar, and back again; to understand this movement, we must look beyond the individual and her intra-psychic processes, to the context in which the experience of serendipity can be seen as a system of relations.

Samantha Copeland: Metis and the Art of Serendipity

Through the lenses of different forms of rationality taken from the ancient Greeks—episteme, techne and metis—philosopher Samantha Copeland takes us through various ways of seeing sagacity as an 'art of serendipity'. She focuses in the end on the promise of using metis, or "cunning wisdom" as a frame for both describing and instructing others in this art, that combines the generation, recognition and follow-up of accidents as opportunities. Due to the embodied, contextual and personal nature of the expertise that metis captures as a mode of reasoning in a dynamic, uncertain world, Copeland suggests that the art of serendipity must be practiced with each other as well as in our material engagements and in our minds.

Wendy Ross: Heteroscalar Serendipity and the Importance of Accidents

Cognitive psychologist Wendy Ross describes in this chapter a foundational problem we will have to tackle, if we are to study the phenomenon in creativity: accidents and sagacity come together at various levels, from the socio-historical to the personal, to the micro- scale, which presents a shifting sense of serendipity that can be difficult to grasp. Focusing on microserendipity in this chapter, Ross highlights that sagacity may be ubiquitous in creativity, but the accident marks out serendipity (retrospectively, at least) as distinct. In light of this, serendipity can be narrowed down, at the micro-level, to the experience of a break in one's flow state, when the accidental forces us to reassess artistic intent.

Rose Turner and Hayley Kasperczyk: Space for the Unexpected, Serendipity in Immersive Theatre

In this chapter, psychologist Rose Turner and practictioner Hayley Kasperczyk describe and look closely at the nature of immersive theatre, performances where the spectator becomes spect-actor, brought into the theatre as participants rather than audience. Through cultivation of a space meant to generate serendipity, directors and actors in immersive theatre approach their art as open-ended and contextual; each spect-actor will have a unique experience, one that may carry on past the bounds of the play itself. Serendipity is thus the bread and butter of immersive theatre, marking the success of an interaction between cultivated space and theatrical intentions of the director and actors, and the personal, experiential perspective of the audience member.

Ana Piñeyro: Fostering Creative Opportunities by Embracing the Accidental Within Practices of Making

In this chapter, textile and materials design researcher Ana Piñeyro uses a personal experience with an accidental turn in her work to explore the meaning of serendipity in art practice. She unpacks the practice of allowing the accidental to permeate one's work as an artist or manipulator of materials: in the narrative she shares, her own lack of expectations about how the material she is working with will respond allows her to experience an accidental reaction to the heat she applies, and thus opens up a realm of new possibilities. As a theoretical approach, Piñeyro proposes that serendipity is a method for creative interaction with one's materials, requiring an openness to both the process and the outcome that one may attain through working with them.

Paul L. March and Frederic Vallée-Tourangeau: Briefing for a Systemic Dissolution of Serendipity

Sculptor, Paul March and experimental cognitive psychologist, Frédéric Vallée-Tourangeau provide similar perspectives, from their different positions; each describing how serendipity becomes so integrated into the processes of creative making or laboratory-based problem solving that it appears to disappear. By focusing on Walpole's, less often cited description of serendipity as 'accidental sagacity', the authors draw attention to the idiosyncratic nature of the creative moment. Instead of looking at serendipity retrospectively and viewing accidents as things that interfere with well-laid plans, they concentrate on a microanalysis of the moment, first in the artist's workshop and second in the psychologist's lab. Their granular accounts of each environment demonstrate how the concept of the accidental dissolves into the present experience of creative manipulation.

Gerhard Lock and Jaak Sikk: Accident and Serendipity in Music Composition, Improvisation and Performance Art

With a focus on composition, improvisation and performance art in the realm of music, Gerhard Lock and Jaak Sikk closely examine the relationship between error or fault and serendipity in creative performances. With a particular focus on the perspective of the performer, the authors call attention to the vanishing point of serendipity: when true improvisation happens, the performer integrates all accidents into their creative process, and just as the concepts of error and fault no longer belong in such a context, serendipity too evaporates. Comparisons with the role of accident from the audience's perspective and from the perspective of composers and performance artists woven through the discussion serve to further elucidate the interaction between serendipity, fault and the accidental in the creation of music.

Bem Le Hunte: The Anableps Guide to Serendipity: Intentional Serendipity as Creative Encounter—A Decolonized, Literary Perspective

Novelist Bem Le Hunte offers in her chapter the 'Anableps Guide to Serendipity', exploring the concept and role of serendipity in her art through a semi-fictional narrative about her encounter with it, as an intriguing and mysterious creature and as a kind of muse, the Queen of Serendipity. The insider perspective she thus offers in this chapter gives insight into the fluidity of the artist's relationship with serendipity, as the experience moves back and forth from interior to exterior perspectives toward sense-making. Through this journey we see various aspects of serendipity highlighted: the role of connections, trust, bias and choice, as well as the importance of encounters with our heroes to mark our journey by.

Andrew Sneddon: The Pleasure of not Knowing and the Importance of Serendipity in Contemporary Art Practice

Artist and researcher, Andrew Sneddon opens his chapter with a reflection on how a chance encounter while on an artistic placement helped him to break the feeling of 'not knowing'. From this he moves to a comprehensive review of the role of chance in modern art practice, making the argument that the Cybernetic Serendipity exhibition was more an example of randomness than the use of a skilled engagement with chance. He then reviews work from the Artist's Placement Group and discusses the risks and benefits associated with allowing chance rather than a plan to direct artistic activity before taking a close look at the way accident and sagacity plays out in the work of contemporary artists, Jeremy Millar and Adam Chodzko.

Ken Gilhooly: Problem Solving, Incubation and Serendipity

Cognitive psychologist Ken Gilhooly reviews in his chapter the various ways that incubation can lead to the solving of seemingly intractable problems. In particular, he suggests, 'Mertonian' serendipity (following Yaqub's categories), the kind that occurs when we find a solution to a problem we are keen on solving, but in a surprising place or way. Incubation can create opportunities for serendipity via environmental cues from unexpected observations, or endogenously, as ideas combine in interesting ways while our mind wanders or we dream while asleep.

Dean Keith Simonton: Serendipity and Creativity in the Arts and Sciences: A Combinatorial Analysis

Dean Keith Simonton has examined serendipity at several points in his career as a creativity theorist, and this chapter closes our collection by consolidating those reflections and takes a closer look at the unique character of serendipitous creativity. Serendipitous creativity is an example of combinatorial creativity: like other creative combinations, serendipitous ones are three-factored; this chapter describes how the factors combining in serendipity are similar or different than other creative and non-creative combinations. Further, Simonton details in this chapter the particular nature of personal serendipity in creativity: for it to count as creativity, the accidental must lead to something of personal value, a creative product that is valued by its discoverer.

References

Alcock, S. (2010). The stratiogpraphy of serendipity. In M. de Rond & I. Morley (Eds.), *Fortune and the prepared mind* (pp. 11–22). Cambridge University Press.

Arfini, S., Bertolotti, T., & Magnani, L. (2018). The antinomies of serendipity: How to cognitively frame serendipity for scientific discoveries. *Topoi*. https://doi.org/10.1007/s11245-018-9571-3

Austin, J. H. (1979). The varieties of chance in scientific research. *Medical Hypotheses, 5*(7), 737–741. https://doi.org/10.1016/0306-9877(79)90035-5

Boden, M. A. (1994). Précis of The creative mind: Myths and mechanisms. *Behavioral and Brain Sciences, 17*(3), 519–531. https://doi.org/10.1017/S0140525X0003569X

Copeland, S. M. (2019). On serendipity in science: Discovery at the intersection of chance and wisdom. *Synthese, 196*, 2385–2406. https://doi.org/10.1007/s11229-017-1544-3

Csikszentmihalyi, M. (1996). *Creativity: The psychology of disovery and invention*. HarperCollins.

Csikszentmihalyi, M. (2014). Society, culture, and person: A systems view of creativity. In *The Systems Model of Creativity* (pp. 47–61). Springer.

de Rond, M. (2014). The structure of serendipity. *Culture and Organization, 20*(5), 342–358. https://doi.org/10.1080/14759551.2014.967451

Glăveanu, V. P. (2010). Paradigms in the study of creativity: Introducing the perspective of cultural psychology. *New Ideas in Psychology, 28*(1), 79–93. https://doi.org/10.1016/j.newideapsych.2009.07.007

Ingold, T. (2010). The textility of making. *Cambridge Journal of Economics, 34*(1), 91–102. https://doi.org/10.1093/cje/bep042

Makri, S., & Blandford, A. (2012). Coming across information serendipitously—Part 1: A process model. *Journal of Documentation, 68*, 684–705. https://doi.org/10.1108/00220411211256030

Makri, S., Blandford, A., Woods, M., Sharples, S., & Maxwell, D. (2014). "Making my own luck": Serendipity strategies and how to support them in digital information environments: Strategies for "seeking" serendipity and how to support them in digital information environments. *Journal of the Association for Information Science and Technology, 65*(11), 2179–2194. https://doi.org/10.1002/asi.23200

Martindale, C. (1990). *The clockwork muse: The predictability of artistic change*. BasicBooks.

Merton, R. (1948). The bearing of empirical research upon the development of social theory. *American Sociological Review, 13*(5), 505–515.

Merton, R., & Barber, E. (2004). *The travels and adventures of rerendipity: A study in sociological semantics and the sociology of science*. Princeton University Press.

Meyers, M. (2011). *Happy accidents—Serendipity in major medical breakthroughs in the twentieth century*. Arcade.

Montuori, A., & Purser, R. E. (1995). Deconstructing the lone genius myth: Toward a contextual view of creativity. *Journal of Humanistic Psychology, 35*, 69–112. http://journals.sagepub.com/doi/10.1177/00221678950353005

Napolitano, C. M. (2013). More than just a simple twist of fate: Serendipitous relations in developmental science. *Human Development, 56,* 291–318. https://doi.org/10.1159/000355022

Olma, S. (2016). *In defence of serendipity*. Repeater.

Pasteur, L. (1854). *Oeuvres de Pasteur/réunies par Pasteur Vallery-Radot*. https://upload.wikimedia.org/wikipedia/commons/6/62/Louis_Pasteur_Universit%C3%A9_de_Lille_18541857_dans_les_champs_de_l%27observation_le_hasard_ne_favorise_que_les_esprits_pr%C3%A9par%C3%A9s.pdf

Ross, W., & Arfini, S. (forthcoming). Serendipity and creative cognition. In L. J. Ball & F. Vallée-Tourangeau (Eds.), *Routledge handbook of creative cognition*.

Ross, W., & Vallée-Tourangeau, F. (2020). Microserendipity in the creative process. *Journal of Creative Behavior, 55*(3), 661–672.

Runco, M. A., & Jaeger, G. J. (2012). The standard definition of creativity. *Creativity Research Journal, 24*, 92–96. https://doi.org/10.1080/10400419.2012.650092

Silver, S. (2015). The prehistory of serendipity, from Bacon to Walpole. *Isis, 106*(2), 235–256.

Weisberg, R. W. (2006). Expertise and reason in creative thinking: Evidence from case studies and the laboratory. In J. C. Kaufman & J. Baer (Eds.), *Creativity and reason in cognitive development* (pp. 7–42). Cambridge University Press. https://doi.org/10.1017/CBO9780511606915.003

What's 'Inside' the Prepared Mind? Not Things, but Relations

Vlad P. Glāveanu

'Chance favours the prepared mind' is a well-known phrase attributed to nineteenth-century bacteriologist Louis Pasteur. It captures a more general understanding that people who are knowledgeable and pay attention to chance events have a greater likelihood of making the most of them, including creatively. Given that chance, by definition, refers to the unexpected, the 'prepared mind' needs to be constantly alert, which is close to impossible. Beyond receptivity, this mind also has to know a lot and be able to quickly analyse what is happening, select what is relevant from it, and make the necessary connections with current needs, requirements and preferences (see also Copeland, this volume).

V. P. Glăveanu (✉)
Webster University Geneva, Bellevue, Switzerland
e-mail: glaveanu@webster.ch

University of Bergen, Bergen, Norway

W. Ross and S. Copeland (eds.), *The Art of Serendipity*,
Palgrave Studies in Creativity and Culture,
https://doi.org/10.1007/978-3-030-84478-3_2

It is easy and tempting, therefore, to place all these processes—analysis, selection, association, etc.—within the individual mind and to consider them largely invisible to an outside observer (see Simonton, this volume). This is how the inside–outside divide became an organising theme within serendipity research and, more broadly, creativity studies (e.g. Boden, 2004; Corneli et al., 2014). Chance events and the environment are readily observable but mental processes have to be inferred, most often post factum. This leaves researchers with basically two options: a) to study supposed processes and traits in abstract terms, as a hovering potential that is expected to become manifest later on; or b) to consider the creative outcome and 'decide' on what constituted (or not) serendipity in a retrospective manner (see also Ross, this volume). Only recently have new methodological proposals emerged based on the micro-genetic analysis of creative action as it unfolds (Ross & Vallee-Tourangeau, 2020).

A key challenge faced even by these more recent studies goes back to the dichotomy mentioned before and the difficulty of connecting cognition, affect and motivation (internal) to behaviour (external), either post factum or in vivo. What is problematic here is the logic of connecting. Instead of considering the 'elements' above as interdependent, a lot of serendipity and creativity research is based on the—frequently implicit—assumption that cognition and behaviour, person and environment, the prepared mind and chance events are two interrelated yet distinct entities (for a critique of this epistemological approach, see Marková, 2003; see also March & Vallée-Tourangeau, this volume). This all makes it normal, then, to ask causal questions such as how thoughts and emotions shape behaviour or how chance events impact the mind.

In this chapter, I will try to overcome this deep Cartesian-like split (Jovchelovitch, 2019) by discussing the 'prepared mind' as a system of relations that cut across person and world and, in doing so, recognise the basic fact that the person and, by implication, the mind are already part of the world in its material, social and cultural constitution. As such, instead of placing more things—traits and/or processes—inside the creator's mind, it makes more sense to distribute them within the in-between space of on-going person–world encounters (for more details about this conceptual attempt see Glăveanu, 2014, 2020a). This is not

to deny the fact that individual minds do exist, ontologically, as well as a world of chance events, accidental happenings and, more generally, of people, things and symbols whose existence is independent of said mind. However, trying to make clear-cut distinctions between the 'inside' and 'outside' is futile here, especially for a phenomenon like serendipity premised precisely on active encounters, not mere connections (see also Le Hunte, Ross, March & Vallée-Tourangeau, this volume).

There are ways of discussing the 'prepared mind' that recognise individual psychological activity without separating it from everything beyond the border of the skin or of one's skull. We just need to follow other analytical distinctions that are more fruitful. The ones I will be building on here have to do with expectation and the unexpected, the familiar and the unfamiliar, knowing and not knowing, certainty and uncertainty. These states are decisively not internal to the person. Getting to know, forming expectations, dwelling in the unfamiliar or experiencing uncertainty are all processes that require the world as much as they require the self. And, I propose as well, they are all essential for understanding serendipity. In particular, I will examine and largely contrast the dynamic of curiosity and that of wonder as ways of 'moving' in-between familiarity and unfamiliarity and, ultimately, recognising their union.

The prepared mind of serendipity and creativity research can be one of internal 'things' like conceptual combinations, imagined scenes, private insights and divergent ideas. But this is an impoverished view of it. Instead, let's consider curious and wondering minds existing in and through relationships. Minds constituted by the movement between knowing and not knowing, familiarising and defamiliarising, minds that both anticipate and are surprised by the world they're already part of.

The Experience of Surprise

Jerome Bruner (1979) noted that creativity results in effective surprises (see also Ross, Simonton, this volume). This was his way of reappropriating the more widely used criteria of novelty and effectiveness (Runco & Jaeger, 2012) and relating them back to the person of the creator and his

or her audience. Indeed, there would be little creativity to talk about if its processes or outcome didn't surprise anybody, if they were not—at least initially—unfamiliar and strange (see also Turner & Kasperczyk, this volume). It is a strangeness that gets to be 'tamed' through meaning-making and the socialisation of the new within the old or what already exists (Glăveanu, 2011). And yet, creativity (and serendipity) don't just end in but originate from surprise.

On the one hand, the effective surprise caused by the creative outcome can inspire further insights and creative processes in the creator him/herself. This is why, for example, artists make several prototypes before the final work or produce multiple versions of it. Each one makes them aware of some unexpected quality they are looking to cultivate. And this is why it is often very hard to decide when the artwork is done (Glăveanu et al., 2013), when it has no more surprises to offer that could help take it further. On the other hand, unexpected or surprising events can lead to new ideas and fuel creative action. Still, this is not always the case given that the novelty of surprise can be either ignored or speedily made sense of and familiarised, losing its potency and capacity to stimulate further thought.

Surprise is often studied in psychology as an emotion. More than this, it is assumed to be a basic emotion, together with happiness, sadness, anger, fear and disgust (Darwin, 1998). This means that reacting to unexpected stimuli with surprise is a natural, unlearnt reaction. What we make of this surprise though, and how and when we allow ourselves to express it, remains highly cultural. Another important observation for our discussion here has to do with the locus of surprise as an experience. It's easy to assume that being surprised is a purely individual matter. In the end, the facial expressions of surprise, studied by Darwin, clearly belong to distinct individuals. There are also other studies focusing on the qualities that make a stimulus surprising and on how surprise is cognitively processed (Lorini & Castelfranchi, 2007) given that specific stimuli quasi universally trigger this emotion.

In an attempt to extend the 'prepared mind', I want to propose that surprise is, already, a distributed phenomenon. That it is the specific relation between person and stimulus, within a wider socio-material and cultural context, that's the basis for surprise as an experience (and any

creative or aesthetic experience, for this matter, see Dewey, 1934; and for abductive processes, Grinnell, 2019, see also Ross, this volume). This is not solely because one needs both a surprising stimulus and a mind ready to be surprised by it. It is because, ultimately, the experience of surprise builds on a wider dynamic between familiarity and unfamiliarity, the known and the unknown. The latter trigger surprise, especially whenever they 'irrupt' from within the familiar or the known. How do we know something is familiar or unfamiliar for us? There must be a much longer history of actions and interactions at play, helping us determine which one is which (see also Arfini et al., 2018). The acquisition of knowledge never takes place in the isolation of 'private' minds but requires the active manipulation of objects (Piaget, 1952) and mediating social relations (Vygotsky, 1980). What is known and unknown cannot be, therefore, explained by focusing on the person alone. These categories require us to explore the wider ecology of 'person within his or her context'.

And so, to properly understand what it means to be surprised, one has to recover the holistic relations between person, stimuli and context. In this sense, the experience of surprise points both ways, towards person and world, and it is fundamentally grounded in the temporal inter-linkage of the two. It is only when considering things systemically and developmentally that we get to comprehend the continuous movement between familiarity and unfamiliarity, the manner in which the unfamiliar becomes familiar through exploration and appropriation and, at times, it emerges from within the familiar and helps us consider it anew (Heidegger, 2010). Equally, the unknown is gradually turned into the known and yet, each known opens up the possibility of grappling with ever more complex unknowns (see Plato, 1903).

In what ways is, then, the 'prepared mind' surprised? It does not become so through an internal processing of knowns and unknowns but through the continuous relating of old and new experiences. These experiences either took or are taking place in-between person and world and intimately reflect their temporal co-evolution. For serendipity, surprise remains an essential first step (even if it can occur throughout; see also Makri & Blandford, 2012). Without surprise there would be no awareness of what is new, unfamiliar and unknown. And, as I argued before,

this awareness would be impossible, in turn, without references to the old, the familiar, the known. The key question is how exactly novelty is handled once detected. Ignoring it takes us outside the realm of serendipity and creativity. Acting on surprise is what describes curiosity and wonder, two interrelated yet contrasting processes I go to focus on next.

The Experience of Curiosity

Curiosity is often seen as a prerequisite of serendipity (Åkerström, 2013) and, as such, as one of the key markers of the 'prepared mind'. This is how, for example, curiosity has been consistently studied, as a trait or state (Naylor, 1981), directing all our attention towards the individual and his or her mental properties. Whether associated with emotion and personality (through its proximity to interest; see Kashdan & Silvia, 2009) or with cognition (especially under the guise of epistemic curiosity, Berlyne, 1962), this phenomenon shared, in psychology at least, the same individualising fate as surprise, with which it stands related (Fisher, 1998).

It is the case that, most often, curiosity is born out of encountering novelty, unfamiliarity, and the unexpected. It is also the case that, as a process, it primarily directs us from not knowing towards knowing and from the unfamiliar to the familiar through a series of symbolic and embodied actions such as raising questions, tinkering, reflecting, formulating hypotheses and testing their feasibility, etc. (see also Turner & Kasperczyk, this volume). But what is essential about all these actions— and the experience of curiosity itself—is that they are by nature much more distributed than we usually consider them to be.

Starting from the definition, we can see that the dictionary tends to refer to curiosity as an eagerness or wish to learn about something rare or unusual. This reflects well the 'internalisation' of curiosity as a need or wish, even if its trigger often lays outside the curious mind. However, a quick look at the etymology dictionary shows that this meaning emerged from the seventeenth century onwards. In the late fourteenth century, the notion brought to mind a 'careful attention to

detail', 'skilled workmanship' and the 'desire to know or learn or inquisitiveness'. In Latin, curiositatem (nominative curiositas) meant 'desire of knowledge, inquisitiveness', while curiosus meant 'careful, diligent, inquiring eagerly, meddlesome', from cura 'care'. A different picture thus emerges, one in which the curious individual is not only epistemically motivated but engaged, a personal way of relating to the world akin to caring (see also Copeland, this volume). Reducing the scope of curiosity to 'wanting to know' opened it up to severe criticisms across time.

For instance, Edmund Burke in the eighteenth century labelled it as the first and simplest emotion we discover in the mind, describing whatever desire we have for, or pleasure we derive from, experiencing novelty (Burke, 1958). The restlessness of the curious mind was perceived in particular by Burke as a sign of giddiness and superficiality, of always changing one's interest and of being easily satisfied with whatever knowledge comes to replace the initial surprise (Lloyd, 2018). A similar critique was formulated by Heidegger, closer to our time, when he noted that curiosity, at least when contrasted with wonder, ensures that we know just for the sake of knowing. It is also unstable given that, as soon as it obtains sight of something, it almost immediately looks away at what comes next (Heidegger, 2010).

It is not my aim here to assess the 'giddiness' of curiosity. Like any other experience relating us to the world, it can be passing or enduring. What is more interesting for my purpose here is the 'direction' taken by curious minds—from unfamiliarity to familiarity. In other words, from not knowing to knowledge as the end point at which one's curiosity can be said to be 'satisfied'. Sometimes knowledge is easily obtained, for instance by asking others and getting a suitable answer, other times it can be difficult to come about, involving months or even years of passionate research (fuelling sometimes long-term projects that define one's life purpose; see Wallace & Gruber, 1989). In each case, the curious mind doesn't exist within itself but extends into the world through information seeking and exploratory behaviours. That is why the classic image of a curious child, for example, is not one of solitary mental pondering but of actively doing things—asking, reading, manipulating objects, trying out—until a solution is in sight. This is also the reason why curiosity

relates so closely to creativity (Hagtvedt et al., 2019) as an open and explorative process taking place in-between self, others and world.

Given curiosity's propensity to know and discover, how does it contribute to serendipity? As a direct way of following up surprising ideas or events and striving to understand them more fully, it can be argued that curiosity is an essential movement for the prepared-mind-in-action. This movement takes the person from an initial state of unfamiliarity and not knowing to one in which the novelty has been properly digested and becomes, all of the sudden, 'normal', even anticipated (in retrospect). The danger for serendipity—and creativity for this manner—is whether the end point of curiosity doesn't take the person back towards the safer ground of what is already known and familiar. If this is the case, then the initial novelty and surprise become incorporated, without much change, within past experience. But this doesn't have to always be the case. Curious explorations of novelty can help us discover new ground and, as such, transform our sense of the unfamiliar and the familiar (see also Turner & Kasperczyk, this volume). This is because productive, more enduring forms of curiosity make us question not only the unfamiliar but also what we initially assumed to be familiar and known. In this way, the curious mind becomes a wondering one as well, and this changes the nature of our experience altogether, including our relation to the world and to knowledge itself.

The Experience of Wonder

The movement of wonder is different to that of curiosity as it takes the mind from the familiar to the unfamiliar or, better said, it helps it discover the unfamiliar within the familiar. More than this, it has a more symbiotic relationship with the unknown. Instead of searching for its replacement with knowledge, a wondering mind dwells within the unknown, to use a Heideggerian term (see Heidegger, 2010), and it finds this experience transformative. It is, after all, the old Socratic basis for inquiry. For Socrates (Plato, 1903), philosophy was born in wonder in the sense that it emerged from a systematic practice of doubting and questioning what is taken for granted in society. This is certainly a useful

habit for creators who are looking for moments of serendipity in their practice but, in order to truly experience wonder (and not moments of wondering within an otherwise curious search for knowledge) they need to accept not knowing and to patiently learn from this very experience.

This is not as easy a goal as it sounds. Not knowing can easily lead to anxiety and even to anger, whenever the possibility of attaining certain and final knowledge is refused. This is why, after all, Socrates was condemned by the Athenians to death for seemingly perverting the minds of the young, making them doubt everything and, in doing so, making them incapable of decisive action (Lloyd, 2018). And yet, there are clear benefits associating with engaging in wonder, key among them being the capacity to defamiliarise the world and, in this manner, discover completely new perspectives on it. This is why wonder has a close connection to creativity (see Glăveanu, 2019), closer perhaps than curiosity. It places the mind in a meta-position from which multiple ways of relating to one's reality become possible. Wondering is an essential part of becoming aware of and starting to explore an expanded range of possibilities, a central part of any creative process.

And, just like surprise and curiosity, wondering cannot be reduced to intra-psychological processes alone, even if there is a great temptation to do so (see Simonton, this volume). For instance, Carlsen and Sandelands (2014) identified four key 'moments' of wonder including arousal (the moment of surprise and appreciation of something as new, strange or beautiful), expansion (the moment of questioning and seeking new forms of understanding), immersion (the moment of empathic resonance with the world) and explanation (the moment in which a new understanding is reached through a sense of beauty, harmony or truth). Not only do these stages assume an 'end point' to wonder which, as mentioned above, goes against the Socratic-Heideggerian tradition of thinking about it, but they also place wondering firmly within the head. In contrast, recent accounts (Glăveanu, 2020b) connect this phenomenon with the encounter between self, others and world and recognise the importance of embodied action—from playing to tinkering—for wondrous explorations of the unknown (see also Sneddon, Turner & Kasperczyk, this volume).

Reducing wonder to its psychological dimension or to its behavioural facet is equally limiting. What defines this process is precisely the articulation between activity and passivity, immersion and detachment, and between what has been identified as wondering at and wondering about:

> The first, a receptive and inward type in which the feeling of surprise or excitement is dominant and the signifying element more or less disappears; the second, an active and outward type which brings to the fore a creative, signifying interest and subordinates the receptive element. The expressive 'wonderful' and the 'ah!' of pure excited joy illustrate the first type of wonder experience, whereas 'wondering' in the active voice indicates the formative, intentional force that aims at putting into meaningful form the relative disorder of the emotional experience. (Parsons, 1969, p. 93)

The kind of relations that constitute a 'prepared mind' that wonders are those between being receptive to a surprising world and, almost simultaneously, acting on this world in order to grasp the nature of the surprise it presents. The goal is here understanding (process), not having understood once and for all (outcome). Wondering therefore marks a specific way of relating to oneself and one's environment in which both the wonderer and the wondrous become open, indeterminate and, as such, are placed firmly in the realm of the possible. This is the reason why wonder is an ever-present companion of creative processes. Creativity can take flight from wonder (Rothenberg, 2014) and return to it every time uncertainty and open-endedness become dominant features of the experience. Creative outcomes themselves are triggers of wonder both in the creator and his or her audience. When the latter get to wonder, the work itself starts to become re-interpreted, re-discovered and, in symbolic or physical ways, created anew (see the notion of user innovation, von Hippel, 2005; also the 'open work' of Eco, 1989).

The Experience of Serendipity

The history of the word serendipity is as interesting as the phenomenon it came to represent and, intriguingly, it is reflective of it. Serendip was the Arabic name for Ceylon, today the island of Sri Lanka. An old Persian fairy tale, The Three Princes of Serendip, depicted the adventures of three travelling heroes who made several discoveries by accident and sagacity. Translated in the sixteenth century from Persian to Italian, then from Italian to French, it was read by Horace Walpole who, in a letter to his friend, Horace Mann, coined the English term serendipity (Ban, 2006). A term invented by chance—the fortuitous reading of an old story translated into multiple languages—came to capture the essence of chance in our lives. But chance and accidents are only one side of the serendipity coin. Sagacity, or the general capacity of the 'prepared mind' to make something out of chance events, is the other.

To fully understand the experience of serendipity as a system of relations, and not as a reified set of intra-psychological processes, we need therefore to recover the interdependencies between events and mind and to grasp the broader context of both (see also Ross, this volume). For instance, we need to consider what the person who experiences serendipity had been doing before (and after) encountering the chance event. Also, how his or her relations to the world—reflected in needs, wants, thoughts and actions—had come to ideally position this person *vis à vis* the potential of chance. We need, in other words, to understand what prepares the 'prepared mind' and this understanding should take into account a long, personal and sociocultural history of entanglements (Ingold, 2010; Latour, 2005) between self and other, mind and world.

The fortuitous discoveries discussed by both serendipity and creativity research require us to look both ways, as it were, and, more importantly, to integrate chance and mind within a broader ecology. Even the individual or psychological facet of this phenomenon—sagacity—cannot be constructed as a quality of the isolated mind (for social and cultural discussions of wisdom see Sternberg, 2003). And there is yet another important detail to take into account. The three princes of the old tale were making discoveries they were not in search of. This means, naturally, that they were animated at the time by other goals and other forms

of engagement with the world (in this case, the world within the fairy tale). What accidents 'did' was to trouble these settled engagements and relationships. Accidents led to surprise and surprise, as argued here, was responded to with curiosity or wonder and sometimes with both (see also Piñeyro, this volume).

Serendipity is therefore much more than the interrelating of 'external' events and 'internal' minds, of accidents and sagacity; it is, first and foremost, a way of interrelating the new and the old, the familiar and the unfamiliar, the known and the unknown. What we often find in moments of serendipity is that the unfamiliar and the unknown irrupt within the familiar and the known and trouble it, disturbing the course of one's initial action and intent. Of course, we call this serendipity when the outcome of this disruption is unexpected yet positive, useful, creative in some way; the label is thus always applied retrospectively (Copeland, 2019). But if we were to approach a forward way of looking at serendipitous acts (see Ross & Vallee-Tourangeau, 2020), we would discover that the familiar and the unfamiliar are defined in relation to each other in a dynamic, recursive manner. What we start off with as familiar is contrasted with the unfamiliarity of chance happenings (i.e. we notice the difference between what we intended and what emerged or what else happened). This helps us defamiliarise the familiar itself (i.e. we get to understand more about our initial doing) or start familiarising the unfamiliar (i.e. we try to align the new with the old, to see if it can be used to achieve an existing, overarching game) or, most often, do both (i.e., engage in a quick back and forth movement between the two).

The 'paths' of curiosity and wonder largely map onto the dynamic discussed above—from unfamiliar to familiar and from familiar to unfamiliar—but it is the movement between them and the ultimate integration of familiarity and unfamiliarity that give serendipity its unique creative potency. Unfortunately, the process of serendipity is rarely discussed in the literature in these terms. The 'serendipity pattern' is often reduced to the fortuitous discovery of by-products (Merton, 1968) or classified with the help of historical illustrations (e.g. Columbian, Archimedean and Galilean serendipity; Friedel, 2001). In such accounts, the chance event and the 'prepared mind', although connected through by-products and revolutionary insights, remain largely separate from

each other. What the mind 'does' with or 'makes' of chance is cast internal to it. How can we think about it differently?

Concluding Thoughts

In this chapter, I argued that we should envision the 'prepared mind' less as a depository of different things (such as cognitive mechanisms, affective reactions and motivational orientations) and more as a network of relations and entanglements with objects, ideas, people, places, institutions, and cultural practices. In other words, the 'prepared mind' expands well beyond the border of the skull or skin and becomes transformed through this. The study of serendipity makes the perfect case for distributed cognition and creativity (Glăveanu, 2014). It invites us to consider the inter-relation between the world's chance and accidents, on the one hand, and the mind's sagacity and receptivity on the other. But, for as long as these two 'terms' are kept separate and the focus placed largely on how the individual mind is capable of serendipitous insights, we will fall short of this phenomenon's epistemic promise.

What I proposed further is to go beyond reinterpreting the 'prepared mind' as a relational entity and consider more specifically what is being related to what. My conclusion is that it is not events or ideas that get connected as much as experiences of knowing and not knowing, discovering the familiar and the unfamiliar, encountering the unexpected within an otherwise mundane set of results. These categories should not be defined in dry or mechanistic intra-psychological terms. What we need is an account of how unfamiliarity is positioned *vis à vis* the familiar and how serendipity allows us to dwell in newly created spaces between the known and the unknown. Ultimately, the relations that constitute the 'prepared mind' can be best understood as general movements from one type of experience to another. And the three phenomena I found essential for serendipity and, more broadly, for serendipitous forms of creativity, are surprise, curiosity and wonder.

If surprise as an emotion is a natural response to the detection of novelty, then the experience of surprise reflects the entire history of relations between person and world, individual minds and culture.

Something is new or surprising only in contrast with what is already known and what is anticipated to happen. And these grow out of actions and interaction in and on one's environment, both individually across the life-span (ontogenesis) and collectively across the evolution of society (sociogenesis). As such, the 'prepared mind' being surprised is, from the start, a distributed state.

What we make of this initial surprise marks, however, the existence (or not) of a serendipitous encounter with the world. Overcoming the tendency to either ignore the new or immediately 'tame' the unexpected with the help of easy and automatic explanations, the person can initiate the gradual transformation of the unfamiliar into the (newly made) familiar—the path or movement of curiosity—or he or she can, conversely, start from the familiar and, using the sense of surprise, change it into something even more unfamiliar—the movement specific for wondering. The first builds up knowledge, the second one questions all forms of knowing.

In the end, choosing to portray the sagacious 'prepared mind' as a mobile system of relating the familiar and the unfamiliar through a close interplay between experiences of surprise, curiosity and wonder, can have long reaching consequences. First, it helps us go beyond questions about serendipity and creativity that start from the premise of mind–world separation (and connection) and of pre-defined spaces 'inside' and 'outside' these interacting yet distinct 'entities'. Second, and related to the above, this approach encourages us to develop, theoretically and methodologically, tools that help us make better sense of entanglements, distributed action and eminently human forms of experience. Even if surprise is widely present in the animal world, and many animals also display more or less complex types of curious behaviour (Kaufman & Kaufman, 2015), wonder remains the defining feature of thinking beings (della Mirandolla, 1994). Surprise, curiosity and wonder are seen here as eminently human because they capture a specific kind of movement that results in widening our horizon of possibility (Glăveanu, 2020c). Finally, the question emerges as to how we can conceptualise and study a 'prepared mind' that restlessly tries to surpass its own limits, that travels freely between the known and the unknown. How do we describe a mind

that, especially in the context of serendipity, reveals itself not as having things but as being in movement, existing in and through relationships? Last but not least, if all the premises above hold, what movements and relationships help the 'mind' not to prepare for but to simply be creative?

References

Åkerström, M. (2013). Curiosity and serendipity in qualitative research. *Qualitative Sociology Review, 9*(2), 10–18.

Arfini, S., Bertolotti, T., & Magnani, L. (2018). The antinomies of serendipity how to cognitively frame serendipity for scientific discoveries. *Topoi, 39,* 939–948.

Ban, T. A. (2006). The role of serendipity in drug discovery. *Dialogues in Clinical Neuroscience, 8*(3), 335–344.

Berlyne, D. E. (1962). Uncertainty and epistemic curiosity. *British Journal of Psychology, 53*(1), 27–34.

Boden, M. A. (2004). *The creative mind: Myths and mechanisms.* Psychology Press.

Bruner, J. S. (1979). *On knowing: Essays for the left hand.* Harvard University Press.

Burke, E. (1958). *A philosophical enquiry into the origin of our ideas of the sublime and beautiful.* Routledge & Kegan Paul.

Carlsen, A., & Sandelands, L. (2014). First passion: Wonder in organizational inquiry. *Management Learning, 46*(4), 373–390.

Copeland, S. (2019). On serendipity in science: Discovery at the intersection of chance and wisdom. *Synthese, 196*(6), 2385–2406.

Corneli, J., Jordanous, A., Guckelsberger, C., Pease, A., & Colton, S. (2014). *Modelling serendipity in a computational context.* arXiv preprint: arXiv:1411. 0440

Darwin, C. (1998). *The expression of the emotions in man and animals* (P. Ekman, Ed.). Fontana Press. (Original work published 1872)

della Mirandolla, P. G. (1994). *De hominis dignitate* [On human dignity] (E. Garin, Trans.). Studio de Tresi. (Originally published in 1486)

Dewey, J. (1934). *Art as experience.* Capricorn Books.

Eco, U. (1989). *The open work.* Harvard University Press.

Fisher, P. (1998). *Wonder, the rainbow, and the aesthetics of rare experiences.* Harvard University Press.

Friedel, R. (2001). Serendipity is no accident. *The Kenyon Review, 23*(2), 36–47.

Glăveanu, V. P. (2011). Creativity as cultural participation. *Journal for the Theory of Social Behaviour, 41*(1), 48–67.

Glăveanu, V. P. (2014). *Distributed creativity: Thinking outside the box of the creative individual.* Springer.

Glăveanu, V. P. (2019). Creativity and wonder. *Journal of Creative Behavior, 53*(2), 171–177.

Glăveanu, V. P. (2020a). A sociocultural theory of creativity: Bridging the social, the material, and the psychological. *Review of General Psychology, 24*(4), 335–354.

Glăveanu, V. P. (2020b). *Wonder: The extraordinary power of an ordinary experience.* Bloomsbury Press.

Glăveanu, V. P. (2020c). *Mobilities and human possibility.* Palgrave.

Glăveanu, V. P., Lubart, T., Bonnardel, N., Botella, M., de Biaisi, M.-P., Desainte-Catherine, M., Georgsdottir, A., Guillou, K., Kurtag, G., Mouchiroud, C., Storme, M., Wojtczuk, A., & Zenasni, F. (2013). Creativity as action: Findings from five creative domains. *Frontiers in Educational Psychology, 4*, 1–14.

Grinnell, F. (2019). Abduction in the everyday practice of science: The logic of unintended experiments. *Transactions of the Charles S. Peirce Society, 55*(3), 215–227.

Hagtvedt, L. P., Dossinger, K., Harrison, S. H., & Huang, L. (2019). Curiosity made the cat more creative: Specific curiosity as a driver of creativity. *Organizational Behavior and Human Decision Processes, 150*, 1–13.

Heidegger, M. (2010). *Being and time* (J. Stambaugh, Trans., revised by D. J. Schmidt). State University of New York Press. (Originally published in 1927)

Ingold, T. (2010). Bringing things to life: Creative entanglements in a world of materials. *World, 44*, 1–25.

Jovchelovitch, S. (2019). *Knowledge in context: Representations, community and culture.* Routledge.

Kashdan, T. B., & Silvia, P. (2009). Curiosity and interest: The benefits of thriving on novelty and challenge. In S. J. Lopez & C. R. Snyder (Eds.), *Oxford handbook of positive psychology* (2nd ed., pp. 367–374). Oxford University Press.

Kaufman, A. B., & Kaufman, J. C. (Eds.). (2015). *Animal creativity and innovation*. Academic Press.

Latour, B. (2005). *Reassembling the social*. Oxford University Press.

Lorini, E., & Castelfranchi, C. (2007). The cognitive structure of surprise: Looking for basic principles. *Topoi, 26*(1), 133–149.

Lloyd, G. (2018). *Reclaiming wonder after the sublime*. Edinburgh University Press.

Makri, S., & Blandford, A. (2012). Coming across information serendipitously: Part 1—A process model. *Journal of Documentation, 68*(5), 684–705.

Marková, I. (2003). *Dialogicality and social representations: The dynamics of mind*. Cambridge University Press.

Merton, R. (1968). *Social theory and social structure*. The Free Press.

Naylor, F. D. (1981). A state-trait curiosity inventory. *Australian Psychologist, 16*(2), 172–183.

Parsons, H. L. (1969). A philosophy of wonder. *Philosophy and Phenomenological Research, 30*(1), 84–101.

Piaget, J. (1952). *The origins of intelligence in children*. International University Press.

Plato. (1903). Theaetetus. In J. Burnet (Ed.), *Platonis opera*. Oxford University Press. Perseus Digital Library.

Rothenberg, A. (2014). *Flight from wonder: An investigation of scientific creativity*. Oxford University Press.

Ross, W., & Vallee-Tourangeau, F. (2020). Microserendipity in the creative process. *Journal of Creative Behaviour, 55*(3), 661–672.

Runco, M. A., & Jaeger, G. J. (2012). The standard definition of creativity. *Creativity Research Journal, 24*(1), 92–96.

Sternberg, R. J. (2003). *Wisdom, intelligence, and creativity synthesized*. Cambridge University Press.

von Hippel, E. (2005). *Democratizing innovation*. MIT Press.

Vygotsky, L. S. (1980). *Mind in society: The development of higher psychological processes*. Harvard University Press.

Wallace, D. B., & Gruber, H. E. (Eds.). (1989). *Creative people at work: Twelve cognitive case studies*. Oxford University Press.

Metis and the Art of Serendipity

Samantha Copeland

There are many ways to talk about serendipity. Often, it is closely associated with the subjective sensations we express by exclamations of surprise and discovery: "Aha!" or "Eureka!" (Ross & Arfini, forthcoming). Objectively speaking, we might say that it is "an emergent property of discovery, describing an oblique relationship between the outcome of a discovery process and the intentions that drive it forward" (Copeland, 2019). All that really means is that it comes out of an otherwise linear process at a bit of an angle—the outcome is not what we set out to attain, but it's valued nonetheless. As Lennart Björneborn (2017, 2020) has pointed out, this "bit of an angle" can also be called the "adjacent possible": it is accessible from where we are, but we didn't

S. Copeland (✉)
Ethics and Philosophy of Technology Section, Faculty of Technology, Policy and Management, Delft University of Technology, Delft, The Netherlands
e-mail: s.m.copeland@tudelft.nl

© The Author(s), under exclusive license to Springer Nature Switzerland AG 2022
W. Ross and S. Copeland (eds.), *The Art of Serendipity*,
Palgrave Studies in Creativity and Culture,
https://doi.org/10.1007/978-3-030-84478-3_3

know beforehand it would be there. This is not to say it is only a small thing; serendipity is often used as a rhetorical notation to highlight a particularly significant chance discovery, a way to emphasise that we didn't just learn something new, our very expectations about how we might learn new things, or what kinds of things there are to learn, have been expanded or changed. Serendipity generally has a decidedly positive valence, given by the way we use the category. Thus it labels many of the most well-known discoveries in our history: medical advances such as penicillin and the small-pox vaccine, inventions like Velcro and the Post-It Note. Finally, if it is serendipity, then there is sagacity (perceptive wisdom) involved, and this sagacity is the element that separates serendipity from mere good luck.

Indeed, we find ourselves increasingly referring to serendipity *rather than* luck: the rhetorical purpose of serendipity, I have argued (Copeland, 2018, 2019), is to call out the role of agency in a chance discovery. More than mere luck, serendipity, as the term's inventor Horace Walpole declared, denotes a discovery of "accident *and sagacity*". What is this sagacity, then? Some kind of perceptual wisdom, it seems, an ability to sniff out the value in those accidental results or unexpected observations that others might mistakenly label a mistake, or dismiss out of hand, for their out-of-the-ordinariness or appearance by chance rather than skilful intention. Associated with not only the expressions of surprise, serendipity seems to entail surprise, or at least the application of the category requires that the discovery in mind be accidental, unintentional and unexpected. This mark of the unintentional is such an important part of serendipity as generally conceived that several have gone so far as to hive off, as dubious examples, those incidents deemed to have the appearance of serendipity but nonetheless a whiff of intentionality about them. The category of "pseudo-serendipity" invented by Royston Roberts (1989) and perpetuated by others takes up this divide and marks those discoveries that happen by accidents and sagacity yet fail to fall conclusively under "the unsought" (van Andel, 1994; see also Simonton, Gilhooly this volume). Sagacity, then, is a special wisdom associated with seeing the value in chance events, a value that others would have missed, and

is specifically associated with being surprised. So how can one, we might ask, be both wise and surprised? (see Glăveanu, this volume).

Archimedean apocryphy might give us the classic example, which tells of his surprise at finding the solution to his puzzling problem by observing his own bathwater in action—"Eureka!". However, the recent research that I will discuss in this chapter indicates something more than a confluence of problem, persona and events in a unique moment of discovery, but rather possibly a general skill, exercised by those who seem to encounter serendipity purposefully and often in their lives, research, art or craft. It is this idea of the *art of serendipity* that I will examine closely here—an understanding of sagacity, I will argue, that can include creativity but also other forms of expertise. Sagacity must be a skill or capability best exercised in response to surprise; it cannot be captured, that is, by the sense of skill that can be learned by rote and practice, towards improving the chances of a predictable outcome, it rather suggests a skill that is learned through interaction with others and the world, in a necessarily dynamic space. In this chapter, I unpack the concept of sagacity by exploring three ways we might understand the art of serendipity, through the lenses of three categories of reasoning drawn from the traditions of ancient Greece: episteme, techne, and metis. I propose that contemporary understandings of metis may provide us with the best way to capture the essence of sagacity in serendipitous discovery and invention.

In the first section, I consider types of reasoning associated with serendipity that might fit under the category of "episteme", a word often translated from the Greek as "knowledge". The focus here is on theoretical knowledge and the creation of new ideas. Episteme is about knowledge for its own sake; serendipitous discoveries from this perspective are surprising and valued because of the new perspective they offer, the idea and the moment of personal intuition or genius that made them happen. Through the lens of episteme, then, the art of serendipity is seen as a set of cognitive skills.

Techne is a more complicated concept to work with, due to its many uses, a pluralism that has existed from its early days in our theories about

ways of knowing.[1] It is not fully distinct from, so much as complementary to episteme. Theoretical knowledge is part of techne, as it is through techne that such knowledge can be applied. Where episteme is knowledge for its own sake, techne is knowledge towards the production of something, knowledge for the sake of that production. It has instrumental, rather than intrinsic value. Through this lens, I turn in the second section to another way of talking about the art of serendipity in the literature, as a craft or the application of strategy and skills to generate unintentional serendipity, through indirect intent and yet with a goal in mind.

The explorations and analyses offered by looking through the lenses of episteme and techne will demonstrate that something is still missing from such accounts of the art of serendipity, and so I further apply recent work on skills related to metis, or "cunning wisdom". I argue that this maligned and oft-forgotten account of reasoning from the ancient Greeks, a grounding part of their democracy and an underlying theme in many of their mythological tales, displayed by heroes and goddesses alike, has much to contribute to our understanding of the art of serendipity as it can be practised today. As I will show, metis not only captures important aspects of sagacity that a focus on episteme and techne tend to elide or to which they give short shrift, it enables us to see sagacity as a skill developed in community, along with others, and through active engagement with chance, ourselves, each other and the world. This perspective affords an inclusive and forward-looking approach to serendipity that gives us direction as to how to direct changes in direction in response to uncertainty toward serendipitous, positive outcomes.

[1] In fact, as Serafina Cuomo (2007) describes it in *Technology and Culture in Greek and Roman Antiquity*, the task of defining techne as it was used in ancient Greece and Rome is both "arduous" and idealistic, given the variety of definitions and understandings at play, as well as their normative content. Mark Thomas Young (2017) similarly describes the complex entanglement of meanings and values used to distinguish between craft skills and local knowledge, both forms of techne, in early modern discourse about scientific practice.

Episteme

One of the more dominant tropes in serendipity literature is that a "prepared mind" is a necessary condition for serendipity. Mark de Rond, for instance, follows Arthur Koestler in highlighting the importance of what they call "bisociation"—a new connection between ideas that are already in one's head. For de Rond, sagacity lies in the ability of someone to see meaningful relations between "matching pairs" of events or observations; as he describes it, sagacity is a capability (2014). First, note that this notion does not only present in de Rond's approach. De Rond redescribes the generation of his matching pairs as "combinatorial play", a concept named by Einstein, and explained most thoroughly by Paul Thagard in his work on reasoning in scientific discovery (see also Simonton, this volume).

Thagard tackles the role of serendipity in discovery through his approach to scientific reasoning as utilising combinatorial play—the generation of combinations of representations in our mind, that lead to questions, hypotheses and discovery. Serendipity is what generates surprise, in Thagard's view: for example, in the discovery process of *h. Pylori* bacteria, Robin Warren's "initial *noticing* of the spiral gastric bacteria can best be described as serendipitous" (Thagard, 1998 p. 114, emphasis mine). What Thagard emphasises is that Warren "just happened" upon the bacteria whilst looking for something else; it is not the outcome but rather the originating factor that demarcates serendipity here, as either a type or an initiator of scientific discoveries. What makes it a discovery—or what makes it *creative*—however, is the novelty and productivity of the combination of representations that this trigger of surprise generates in the head of the one surprised (e.g. Thagard & Stewart, 2011). In other words, Thagard separates out the surprise as a trigger for a discovery, preceding and enabling the discovery, whereas the discovery itself is constituted by the results of that surprise, in terms of new ideas about the relationships between representations. In the case of *h. Pylori*, the discovery does not happen in the moment when they found this bacteria in such a surprising place, the discovery takes place only when that observation has an effect on what Warren (and Barry Marshall) *thought* they already knew about the stomach, bacteria and

ulcers. Mere surprise does not amount to a discovery unless it generates such a novel and important combination of representations in one's mind; serendipity is the result of these combinations, so not properly captured by a focus on surprise or, even, on what has caused the surprise.

Thus, the focus here is not on the cause of the surprise, the external event or interruption, but rather on what happens in the mind. The conditions for discovery are not external but internal; even when surprised, one must also have the right representations in one's mind to combine, in order to profit off the trigger with discovery.[2] If sagacity is a matter of having the right ideas in one's head to combine when chance interferes, then it may indeed be captured by episteme and thus requires the exercise of cognitive skills over ideas.

Episteme is the category of knowledge in which abstract theory resides, where ideas and the relations between them are the focus. While Thagard emphasises that creativity is caused by the recombination of representations, those representations do have social and external origins. But the value of serendipity is in its contribution to what happens in the head, to those representations. Dean Simonton likewise emphasises that the essence of creativity exists in the cognitive processes that may be stimulated by the outside world, and lead to the production of objects in that world—but it is the cognitive processes that make it creativity (this volume, see also Gilhooly, this volume). The real work, that is, occurs at the level of ideas and imagination. Sagacity, then, is an intellectual capability, having to do with one's ability to bring ideas together in new combinations.

Indeed, it is true that serendipity sometimes does occur inside one's mind: an unexpected encounter or chance event may trigger a change in one's expectations or perception of the world around them, for example,

[2] Such a focus on what is in the mind at the moment of a chance encounter has several implications, many of which I explore in more depth elsewhere (Copeland, 2018, 2019). Some of those are implications for our understanding of discovery: by emphasising the innate or accumulated wisdom needed to see the value in an unexpected observation, one upholds the single-moment and genius-generated model of scientific discovery. But it is also well-known among sociologists, historians and philosophers of science that such discoveries occur most often in a process, and always within a context, and even extend socially through networks (particularly in modern, collaborative science) as well as over time. Here I would like to focus on the implications of the internalist approach for understanding sagacity.

even having a significant impact on how one looks at life. As this perceptual shift is experienced by the serendipitous person herself, and insofar as it is not public until or unless she makes it so, then it clearly can exist internally. Such private serendipities, however, are not paradigmatic but rather the exceptions that prove the rule: indeed, we only know about them because they *are* shared, as stories of serendipity or as contributions to a field of knowledge.[3] And when they are shared, they describe the origins of a process of discovery, invention or personal growth and change; the new ideas that these unthought-of-before combinations generate lead to actions and changes in behaviour, to new theory formation and debate; they have an effect on the social and material world. In other words, even if we think that the discovery itself is an internal event, consisting only in the combination of internal, cognitive representations of what we observe and know, both the trigger of surprise that initiates that discovery and the positive outcome that deems it serendipitous are external, happening beyond one's mind and having an impact beyond one's ideas and perspectives.

This is not to say that the cognitive aspects of the "aha" moments are not important: these do play a key role in our serendipity stories, and are important to our understanding of that phenomenon, but more so, they represent one of serendipity's more interesting contributions to our personal and shared histories—its tendency to disrupt our expectations (see Ross, this volume). Serendipity, indeed, is a moment in which we encounter the world differently than usual; we look for things where we expect to find them, we find serendipity where we wouldn't have thought to look. This can lead to a shift in expectations, and thereby to how the world is perceived—and this is how Thagard puts it in respect to Fleming's shift in perceptions upon witnessing the reaction in his petri dish. While Fleming's response to that reaction was more than to merely observe, his observations (and the resulting, new conceptual combination) did lead to a shift in what he thought was possible to observe thenceforth:

[3] Examples of this personal level of serendipity leading to changes in one's worldview can be found in the autobiography of ecologist James Estes (2020), for example, and in the 2008 Darwin College Lectures, the Serendipity series, particularly the last, given by author Simon Winchester (in de Rond & Morley, 2008).

...the serendipitous discovery of penicillin might be erroneously construed as simply a matter of perception, but what made Fleming's discovery novel, surprising, and important was his more complex recognition that mold was killing bacteria, producing the key conceptual combination *bacteria-killing mold*. (Thagard, 2012)

But, as I have argued elsewhere (e.g. Copeland, 2018) the *significance* of this shift is not that Fleming had a new idea, it lies in the wider effect this conceptual shift had on how we practice medicine and investigate the properties of biological substances for therapeutic potential. Even when it does lead to only personal development, recognising meaningful connections does not lead to such development unless they are seized upon as opportunities and acted upon (Napolitano, 2013, 2018). Indeed, recognition may occur but action prevented or simply not taken, and thereby serendipity lost instead of gained.

Episteme, therefore, cannot give us the whole story. Too much of what is essential to serendipity—what triggers it, and what gives it its positive valence—happens outside the head; some factors that encourage or constrain it may be cognitive, but are also environmental and even social, and any practitioner of the art of serendipity must thus take this variety into account.

Techne

If this is the case, then perhaps we should turn to techne, rather than episteme, for our understanding of how one might be prepared in the right way for the unexpected. Techne is the art or craft of skilled work, generally with materials and often creative, but always productive; looking at the art of serendipity through this lens will draw out how serendipitous discoveries emerge from and also influence the way we interact with the world.

Indeed, skilled encounters with the world is the focus many approaches to serendipity take up in respect to the problem of sagacity. There are three ways to understand the art of serendipity as the exercise of this kind of interactive or applicative skill. First, there are those

with sagacity in the sense of having an ability to generate more opportunities through their intentional or unintentional behaviour and actions. Second, there are those who are better able to perceive opportunities as such, than others may be. And third, there are those who display sagacity in the sense of being more able to take up opportunities when they do arise and are perceived.

Those who focus on increasing chance encounters that may lead to more serendipity often do so physically: the "water-cooler" approach to building design, for instance, that we see in the corporate offices of serendipity-savvy companies like Facebook and Apple, focusses on moving people in ways that encourage chance encounters that wouldn't happen otherwise. From bathroom relocation to strategic placing of cafeteria lines, or in the case of the Francis Crick Institute,[4] enforcing shared laboratory space, restructuring the spaces people walk through and work in generates new connections between them—and, hopefully, between their ideas and expertise.

James Austin points to a category of serendipity, the art of which boils down to "moving about more", what he calls the "Kettering principle" (Austin, 2003, p. 76). "General exploratory behaviour" is likely to generate more chance opportunities, especially when accompanied by curiosity and a willingness to explore and experiment with things (see Glăvenu, Turner and Kasperczyk, this volume). He contrasts, this, however, with sagacity,[5] and I agree that this sense of generating chance is not what we are looking for here: it seems not an "art" but rather just a fact of the matter that when we move about more, things are more likely to bump into each other unexpectedly. Merely generating more opportunities does not seem to be enough, these efforts must also be

[4] See David Matthews, *Times Higher Education*, 'The Francis Crick Institute: Science and serendipity', November 26, 2015; https://www.timeshighereducation.com/features/the-francis-crick-institute-science-and-serendipity.

[5] Austin defines this sagacity as operating by the "Pasteur Principle"—as one can guess, this is equivalent to the prepared mind, with the "added level of chance" I note elsewhere in this chapter also noted by Austin (2003): "Some special receptivity born from past experience permits you to discern a new fact, or to perceive ideas in a new relationship, and go on to comprehend their significance", as he describes it (p. 76). Since this approach to sagacity is remarkably passive and chance-laden, I do not use it in the paper, for reasons that should be obvious to the reader by the concluding paragraphs at latest.

accompanied by follow up; Google and Facebook cannot profit from spaces created intentionally to generate chance, if their employees are not supported in following up on their new, potentially risky, ideas about where to take the company next.

So, the art of generating more opportunities will be more than just generating chances, just as it has to be more than just making a connection. Rachel McKinnon (2014) suggests that "staying in the game" is the skill related to making one's own luck in this way: the skills that allow you to stay in the context where chances might be generated (literally, in her article, *staying in the* badminton or poker *game* that she describes as examples) are those that increase your luck by increasing your exposure to chances for being lucky. Thus, the relevant skills are *indirectly* relevant, related to the skilled manipulation of the *context* rather than generating lucky opportunities in themselves. But those skills will not be specific to generating serendipity per se through chances, rather they are skills appropriate to whatever context serendipity happens to arise within— badminton skills, scientific expertise,[6] etc. Thus, they do not necessarily differentiate those who exhibit sagacity (the specific wisdom associated with serendipity) from those who are very good at doing whatever it is they are doing: this particular approach through techne, that is, does not pick out what is special about serendipity.

If it is not about generating chance, then perhaps we can follow the sense of sagacity as a kind of perception and see the art of serendipity as an art of perceiving opportunities that arise by chance as such, as opportunities to pursue and not just random events or errors. This is the notion that tends to elevate the serendipitous discoverers to the level of genius in our narratives: they perceive something in a chance event that no one else could have perceived, and for this reason they are awarded Nobel Prizes and accolades for their genius. As James McAllister (2016) points out, this kind of genius associated with chance discovery is part

[6] As Fleming noted in his banquet speech upon accepting the Nobel Prize in 1945, his skills as a bacteriologist are what allowed him to perceive and pursue the value he saw in the mold's effects within the petri dish (and, as he notably also remarks, his lack of skills in the clinic and in chemistry prevented his own discovery of the truly remarkable properties of this substance until Florey and Chain's team was able to). https://www.nobelprize.org/prizes/medicine/1945/fleming/speech/.

of what he calls the "rhetoric of effortlessness": the idealistic depiction of a scientist who is prepared with the right knowledge and insight to see the world as it truly is, they receive the observations offered up by chance from the world and are skilled and clever enough to perceive the scientific value in those observations without hardly trying. This is the serendipity captured in Archimedes' cry of "Eureka" and in Fleming's near-miss when he resisted discarding the famous petri dish.

However, the passivity of this approach to sagacity does not reflect an "art of serendipity" so much as the idea of the prepared mind, mentioned already above. Following the famous quotation from Pasteur, approaches to discoveries by chance often emphasise the need for a "prepared mind"—when chance arrives, one must already be prepared to recognise its value. Which raises the question, how might one prepare for something unpredicted? Indeed, the only knowledge we have of what counts as good or sufficient preparation comes after the fact; so long as the observation or event occurs truly by chance, we cannot predict it, and thus the nature of serendipity itself belies an art, craft or set of skills that would require full preparation beforehand to be successful. Indeed, this only adds further layers of chance to serendipity: now we need the right person, who happens to be prepared in the right way, to make the right observations or to be in the right place at the right time, for serendipity to happen. But such a story will tell us only about that one instance of serendipity, with a focus on the confluence of contingencies surrounding it, and not about the art employed by those who might make serendipity happen, generally speaking. While the first approach was too broad, giving us an idea of sagacity as vaguely "skilful", this approach is too narrow, giving us a particularist account of sagacity that we cannot generalise.

We could, then, broaden our scope and allow that it may be possible to train ourselves to more readily identify chance opportunities, as we train other senses. Perhaps we can be more attuned to opportunities through practice and attention; like with tasting wine and learning about *terroir*, perhaps we can become more attuned to the subtleties of chance. Or, like the philosopher who can see a bad argument a mile away, we might train our cognitive abilities to pick out potentially valuable accidents. Sanda Erdelez, for example, found in her research (1999) a group of

people she calls "super-encounterers" of incidental information; they rely on a mostly indescribable "method" that they find reliable for encountering useful information by chance—they "count on" serendipity to be a regular part of their research strategies[7] (p. 26). Regular "encounterers" and "super-encounterers" differ in that the former perceives that they frequently experience serendipity in their lives, but the latter recognise a connection between how they conduct themselves as information seekers and the serendipitous experiences they have had. This idea that we can intentionally behave in ways conducive to perceiving the value in chance opportunities is picked up by approaches to sagacity that treat it as a way of life. Christian Busch picks up this theme in his book *The Serendipity Mindset* (2020), for example, where he recommends strategies for creating more opportunities through chance in one's life, but also for perceiving the value of opportunities when they come your way. He does not stop there, however: it is equally important to take up the same opportunities and allow them to shape your life.

That is, even if we have the skills honed to pick out chances for serendipity better, this would not suffice, failing in similar fashion to the prepared mind, as I described above. Research into the nature of serendipity has noted the role of filters, pressures, and other distractions that interfere with the ability of even a prepared mind to perceive opportunities for chance discovery and/or to follow up on them. As Jannica Heinström points out, in the case of coming across incidental information, "without basic topical knowledge, there is no capacity to interpret and receive the message, without motivation there would be no interest to pick it up, and in emotionally stressed moods thought processes may be blocked against divergent thinking" (Heinström, 2006, p. 580). Factors beyond the information itself, and the preparedness of the mind to comprehend the information, may interfere with the success of a potentially serendipitous, chance encounter. Environmental differences play a more clear role influencing the likelihood of serendipity than individual differences (McCay-Peet et al., 2015). Abigail McBirnie (2008) points to what she calls "serendipity filters", the kinds of pressures

[7] Notably, Erdelez notes that they mention not only regularly encountering more information useful to their own purposes, but also information that is relevant to other people they know (1999, p. 26).

on time, attention and on our ability to alter our direction of inquiry and action that ultimately lead to serendipity being lost, despite the chance moment and the (otherwise) prepared mind. Bernard Barber and Renee C. Fox wrote about this exactly in their article, "The Case of the Floppy-Eared Rabbits: An Instance of Serendipity Gained and Serendipity Lost" (1958): two scientists experience the same confluence of prepared mind and chance observation, but due to a variety of other factors, only one made the serendipitous discovery about rabbit ear cartilage in the end. Thus, the threat of interference from internal and external factors means that the art of serendipity is not captured by the perception of chance, nor even of its value, alone. One must also be able to navigate the relevant contingencies in order to see the discovery through.

Perhaps, then, the art of serendipity is (also) about taking up opportunities when they do arise. Serendipity requires real "human effort", suggests Busch: in a key example, an entrepreneur notices that a number of great speakers have been stranded in the same place due to a flight-stopping volcanic eruption, which presents an opportunity by chance, and uses his connections to create a TEDx talk series, taking advantage of the extended London layover (p. 15ff). Recognition of the opportunity was a necessary feature of this event, and the entrepreneur in question was likely uniquely prepared to take it up, but it was the taking up of the opportunity that made it a moment of serendipity with a positive outcome. So, even this "mindset" extends beyond preparedness and noticing; one must also learn how to "leverage" the unexpected, to act upon it in ways that bring advantages to oneself.[8]

To this end, it seems that learning to take up opportunities is a way of seeing the art of serendipity in strategic terms: when chance arises, one must recognise it but also know what to do with it in order to make it into serendipity. If the goal is serendipity, then one must know how to strategically manipulate the environment and context in order to generate chance and also the pathways to act upon those chances. That is, one puts strategies in place to overcome the kinds of interference I mention above: filters, pressures and time constraints that hinder

[8] Above I referenced Christopher Napolitano's work on serendipity in personal development, to similar effect (Napolitano, 2013, 2018).

serendipity can be mitigated through a strategic approach to tackling them or heading them off. Not only entrepreneurs,[9] but also researchers, scientists, engineers and others have looked at how to do this, in a number of contexts. The techne of serendipity, in this sense, is a set of skills that enable us to manipulate the context in which serendipity may occur, in order to maximise the potential for its success when it does.

Material manipulation in particular brings out discussions of how to generate serendipity through strategies in context (Piñeyro, Ross, this volume). That is, in art, engineering, architecture and design, serendipity occurs through and also influences one's skilled interaction with one's material world. The art of serendipity in these examples is a strategic approach to the best methods for eliciting and allowing for such influences to happen, when the opportunity arises. For instance, Synne Frydenberg et al. (2019) tested methods for explicitly allowing serendipity to influence their research in positive ways, while working on how to improve bridge designs on arctic ships. To facilitate serendipity, they took an open mixed methods approach, having a number of options ready to deal with whatever may arise, and employed methods in innovative ways to solve problems as they came up.

This kind of approach more or less follows the sense of serendipity captured by Robert Merton (1948) in his description of the "serendipity pattern" in sociological research, which occurs when an "unanticipated, anomalous and strategic datum exerts a pressure for initiating theory" (p. 507). By strategic, Merton means to highlight the role of the observer, both in determining the value of the unexpected datum and in taking the initiative to use that datum to extend theory or take a new direction with their research. The art of serendipity, then, requires knowledge of the field as well as the insight to know how new information might change that field. I want to note something else in this pattern described by Merton: the datum "exerts a pressure", it "confronts" the researcher, intriguing them and leading them down a new path. Thus, the agency is not all in the observer, even if the value of the observation is determined by them (or, if you prefer, recognised by they who are "steeped

[9] As Nicholas Dew argues, for instance, serendipity can ground particular strategies in entrepreneurship, such as the effectual reasoning approach described and developed by Dew and Sarah Sarasvathy (see Dew, 2009 for an introduction to this connection).

in theory", Merton 1948, p. 507). Serendipity patterns arise when facts about the world reveal themselves in chance encounters. The sociologist depicted by Merton must know how to take their observations forward, but they do so in the form of an active (and strategic) response to an observation made by chance.

Seeing the art of serendipity as a strategic art in this way highlights on the one hand the interaction, through manipulation and response, between the agent and the world, and thus how seeing sagacity through the lens of techne allows us to acknowledge the roles of trigger and outcome in the process of serendipity, unlike episteme. On the other hand, strategy implies a clear intentionality, even if one keeps one's options open: the desired end to a strategy is clear, and so how one might choose a method for responding to the unexpected is constrained by the valuable outcome one wishes to achieve. In the case of the arctic ship engineers in Frydenberg et al. (2019), for example, their mix of available methods and willingness to alter pathways in response to chance events were constrained by the fact that all roads led to the building of a bridge, the criterion of success for their endeavours. If this is the art of serendipity, then, it is the art of gaining a strategic advantage over chance on the way to achieving one's intended goal.

Consequently, while techne provides a way to understand the points of interaction in serendipity that happen outside of one's head, it remains limited in its ability to account for the open-endedness of serendipity; this, I will show, can be made more clear when we look at the nature of those points of interaction more closely through the lens of techne. I argue, that is, that accounts of the art of serendipity that see it in the context of techne—as strategy or craft—bring to the fore the fact that such an art would be inherently responsive.

The encounter or confrontation of a chance observation with an observer has been a focus of researchers who see serendipity in terms of affordances, for example. Björneborn (2017) describes an affordance as, "a usage potential when environmental and personal factors correspond with each other". It is a way of seeing something as useful to you in some way; serendipity as affordance emerges from the relationship between a person and the world. Selene Arfini describes affordance as an embodied form of awareness, "about the adaptive value of the object or the event

she is observing or manipulating" (Arfini, 2019, p. 82). Affordances are about what the world offers up to interact with or use, but they are perceived by humans who have needs and desires that shape those affordances: as a chair affords a human the opportunity to sit down,[10] so chance affords those with sagacity an opportunity for serendipity. Note that in these approaches the mode is active engagement, not passive observation of what the chair, or the chance, has to offer. Whether consciously or not, the person comes together with the object or event in an embodied perception of that object or event as a certain kind of thing: in a perception of a chance observation or encounter, as an opportunity, new idea or new way of thinking about the world. Thus, the engagement is mutual, the features of the person and of the world together create the affordance; serendipity, in this light, emerges *in response*.

Likewise, the strategies described by Frydenberg et al. (2019) represent an attempt at least to be less goal-oriented and more responsive. The art of serendipity, as they describe it, includes four elements (which they take from Rivoal and Salazar (2013), and expand upon). Sufficient background knowledge, the first criterion, reminds one of the prepared mind; under their anthropological approach, however, this becomes reflexive interpretation, or the ability to foreground one's own knowledge in a situation in order to acknowledge its limitations. Likewise, the criterion of an inquisitive mind is not about the freedom to be curious, but rather the ability to "build serendipitous outcomes with sagacity rather than happening upon them" (Frydenberg et al., 2019, p. 1902). Thus the focus is on relationships rather than events and process over outcome. The third criterion, creative thinking, takes up the need to allow data to "develop naturally" rather than by force, by acknowledging the human aspects of rich data collection. And finally, good timing is not about being in the right place at the right time so much as it is about attending to the opportunities for relationship building that will ultimately lead to the serendipitous sharing of different perspectives and collaborative problem solving. Thus, rather than design for serendipity itself, the group approached serendipitous design innovations as something that emerges

[10] For a cat, in contrast, the chair may afford a landing pad for a complicated series of jumps to the kitchen counter. Humans and cats, and others with varying needs, abilities, or experiences, will see different affordances in the objects they encounter.

from the context when we focus on inclusion and iteration, and attend to the limitations of our own understanding and imagination. The techne here is a craft of reshaping one's strategies and methods in response to what happens along the way to one's goals; setting out the criteria above, the research team is attempting to formulate a set of guidance or heuristics meant to ensure the right kinds of response.

A similar approach can be seen in the work of Ana Piñeyro (2019; this volume) when she writes of serendipity in relation to textile design. Hands-on engagement with different materials can lead to unforeseen results, insofar as the materials themselves have agency within these inter-actions: they move, react, respond and change as we work with them, and in ways we might not predict if we constrain their properties first through design (March & Vallée-Tourangeau, this volume). Serendipi-tous moments illustrate this fact about materials, encouraging designers to seek first to explore, rather than manipulate or control, the material properties of textiles. The experience opened up new possible outcomes, and so it was, as she calls it, a "generative mistake": not the accident itself, but how it affected the process and thus what came about as a result was what made this serendipitous (i.e. what was *generated* by the mistake). Likewise, the process model favoured by many information scientists (e.g. Makri & Blandford, 2012) includes not only the recognition of an opportunity but its exploitation as well. As I noted in my early work on serendipity, the valuable outcome is a necessary feature of serendipity, and this requires taking some kind of action in response to chance (see also Townsend & Mikkonen, 2019, p. 1856).

As Wendy Ross has pointed out in her work, luck must be enacted (Ross & Vallée-Tourangeau, 2021; Ross, forthcoming). In experiments with interactivity, for instance, where participants were asked to move tiles (or not) in order to create words from an anagram set, the same circumstances (an accidental shifting of the tiles into a legitimate word) could produce different results. The results, that is, depended entirely on whether the participant *noticed* the potentially valuable combination of tiles as such and *responded* in turn by calling the experimenter's attention to the word. Unless an individual "capitalises" on the lucky chance presented, that is, there is no serendipity (Ross & Vallée-Tourangeau, 2021, p. 852).

Techne, as an art or a craft, however, is often understood as the skilled application of theory to the world. So, strategies, rules, heuristics and methods for manipulating our world indeed could fall under techne. What I will argue in the next section that such accounts of sagacity as techne miss, however, is the reciprocal and reflective nature of the inter-activity between the chance and the person: it is not a prepared mind within which chance may take seed in the form of a novel combination of ideas, directed from outward in, nor is it directed from inward out, as in the application of rules or skills to a particular kind of situation or to produce a particular result. Rather, it requires an active engagement in the form of responding to a changing environment, in which one's predictions about what will happen have proven unreliable. For these reasons, I now propose that metis, rather than episteme or techne, is the better lens through which to understand the art of serendipity.

Metis

I begin with an exploration of what kind of reasoning metis represents.[11] While episteme and techne have enjoyed long and fruitful traditions in philosophy, metis has been virtually lost to discussions of reasoning until fairly recent work in classics and organisational theory, which aims to recover its potential as a useful category, both descriptive and prescriptive. In general, metis can be summarised as "cunning wisdom" (Detienne & Vernant, 1978). The goddess of that name, Metis, was the first wife of Zeus and the mother of Athena;

> Metis….intervenes at moments when the divine world seems to be still in movement or when the balance of the powers which operate within it appears to be momentarily upset…The cunning of Metis constitutes a threat to any established order; her intelligence operates in the realm of

[11] I owe the idea for this exploration of Metis in the context of serendipity specifically to a memorable dinner conversation with Mark Thomas Young. Errors made here in the use and interpretation of concepts such as episteme, techne and metis are all my own, and I happily refer the reader to work by Young for a more complete and nuanced investigation (e.g. Young, 2017, 2019).

what is shifting and unexpected in order the better to reverse situations and overturn hierarchies which appear unassailable. (Detienne & Vernant, 1978, p. 108)

A shape-shifter, she embodied cunning wisdom as she avoided the attacks of her husband until he tricked her into assuming the shape of something small and swallowed her. Already pregnant (the source of Zeus' anger, feeling threatened), she took this opportunity to manufacture the armour Athena was notoriously wearing when she burst forth in birth from Zeus' head (or thigh), thereby protecting her daughter in way she had not herself been protected from the king of the gods (Detienne & Vernant, 1978, p. 182).

Odysseus is probably the most well-known Greek paradigm of metis; he was "frequently praised for having metis in abundance and for using it to outwit his enemies and make his way home [in the Odyssey]" (Scott, 1998, p. 313). In his recent book, W. D. Holford (2020) provides a more contemporary example of metis, or cunning wisdom. In January of 2009, pilots Captain "Sully" Sullenberger and Jeffrey Skiles successfully (without loss of life and few injuries) ditched an airbus on the Hudson River after losing their engines. Holford points out that the landing "involved improvisation in the face of ambiguous information involving complex technological systems" (p. 10). He goes on to say that "Such improvisation was deemed successful in that the operators were able to 'dynamically match' themselves to the system's new and sudden non-routine operations" (p. 10)—note here the role of adaptation and response to a changing situation with new terms, while still applying the expertise the pilots had already. They were not prepared for this situation, but they were prepared to respond well to this kind of situation, *which they found out in the process of responding*.

Metis is all about responsiveness: one must be prepared, yes, but not only in the sense of having the right expertise or body of knowledge at one's command. And it requires more than having ideas or representations that can combine in novel ways. One must be prepared to interact with the changing situation in which one finds oneself, whether that be an epistemic situation (thus requiring knowledge-based preparedness) or engine failure in the plane one is flying (requiring an embodied

response). Metis thus incorporates the theory of episteme, and the application of techne, but in situations where we cannot make assumptions or predictions about what might happen next.[12] Thus, it is rather perfect for the art of serendipity.

One thing that needs to be noted is the rhetorical valence of words like "cunning": it calls to mind associated words, like cheating or manipulating; "the despised weapons of women and cowards" in our historical rhetoric and narratives (Detienne & Vernant, 1978, p. 13).[13] It is the word used to describe the cleverness of the Greeks when they took Troy by Trojan horse (Young, 2019, p. 17). Sean Silver (2015) points out that this idea of metis, because it includes "tricks and stratagems", is distinct from the kind of techne that is grounded in episteme—such "oblique" methods of discovery contrast with direct application of theory. Recent work has made the idea of metis more robust and pointed to the suppression of its status as a legitimate form of reasoning by Platonic and Aristotelian ideals of systematic knowledge, garnered by experts and attainable by only the contemplative few (Detienne & Vernant, 1978). As Holford points out, metis is inherently *human* knowledge, and as such, discoveries made by metis emerge from our human, embodied and lived experience, and are thus not captured well by the rational

[12] Readers familiar with Greek modes of reasoning may wonder why I do not speak of phronesis here, rather than metis. Briefly, phronesis is a mode of reasoning we employ when we have to consider the particularities of a situation in order to know the right thing to do. But it is not so much a reflexive, responsive mode of reasoning, as metis is. Work on phronesis, in contrast to the work on metis I use here, does not emphasise the role of chance and ambiguity, nor parallel the recent work on serendipity, so the strong parallels I draw here between episteme, techne and metis do not hold for phronesis. While I have touched in other work on the moral aspects of phronesis (Copeland, 2020), I also leave open for now the question of whether there are virtues associated with metis, as there are with phronesis. Exploring such overlaps and distinctions between them is a matter for another paper.

[13] As James Scott points out in respect to how Odysseus' metis is described in myth, "The emphasis is both on Odysseus's ability to adapt successfully to a constantly shifting situation and on his capacity to understand, and hence outwit, his human and divine adversaries" (Scott, 1998, p. 313). But when we are talking serendipity, we turn this on its head: rather than escaping from a situation, serendipity is about taking up an opportunity for increased value (as I noted in the introduction, it has a distinctly positive valence in our rhetoric). There is thus more to explore about the relationship between metis as "cunning", its negative valence, and who has been said to have metis in our narratives, as well as who gets the credit for being serendipitous in science (e.g. see Copeland, 2018) but that also lies outside the scope of this particular chapter.

reconstructions of our scientific methods that we publish in journals and abstract into theory (Holford, 2020, pp. 5–6).

There is a line of thought in the literature on serendipity that allows us to understand the responsiveness and manipulative aspects of metis without the negative valence associated with cunning, and that is the framing of serendipity as play. Most recently, Björneborn has worked with the idea of haiku as a method for researching serendipity: as he puts it in a presentation of the experiment, "using haiku as a reflection tool in my research, in itself provided an unplanned value – a serendipitous experience".[14] Playing with the concepts by trying to fit them into the constraints of haiku poetry revealed new truths through the experience—this required more than combining representations in new ways, it included a manipulation of the ideas as material things in order to reveal novel "matching pairs". Pek van Andel mentions play as one of the patterns of serendipity he identifies in the literature and through story (van Andel, 1994); he also mentions practical jokes and a sense of humour as precursors to serendipitous discoveries. Turning everyday ways of doing things on their head through humour and play can create the kinds of combinations that we found in the section on episteme through active engagement not only with ideas, but with each other and the world.

A similar trope can be found in the work of Umberto Eco, who draws a comparison between lunacy and serendipity: serendipity happens when things turn out to be quite different than they seem, where stupid beliefs turn out to be more correct than the prevailing wisdom, or where mistakes and errors become victories over chance. Eco's *Serendipities: Language & Lunacy* (see the 1998 translation by William Weaver) offers a series of essays from this perspective. This theme is also identified in Bacon's approach to chance discovery in his depictions of scientific discovery as a kind of hunting-like craft: "There is, in Bacon's words, a kind of "madness" here" (Silver, 2015, p. 249). Again the negative valence shows through in a way, as these metaphors of lunacy and

[14] From a blog post about that poster presentation, retrieved from here (March 2021): https://theserendipitysociety.wordpress.com/2020/01/27/haiku-reflections-in-research-on-serendipity/.

madness imply an overturning of reasonable methodology (the application of theory) in favour of metis (the embodied response). In neither of these cases, however, does madness imply an unreasonable outcome: the madness lies in the recognition that the usual, "more reasonable" methods would have missed out on the discovery made. So it is unreasonable in the sense of not being episteme or techne; it is, however, a reasonable response to a surprising world.

As *human* reasoning, metis is not merely rational when successful, but practical, taking in social, contextual and temporal factors. Further, it is an explicitly embodied form of reasoning (Holford, 2020, p. 19). James Scott (1998) suggests it requires the "art of locality": "The subtleties of application are important precisely because metis is most valuable in settings that are mutable, indeterminant (some facts are unknown), and particular" (p. 316). Holford follows Scott and others to suggest the following methods for cultivating the skills of metis:

> (i) the internalization of formalized abstract knowledge (techne/episteme); (ii) the internalization of formalized situational knowledge (as formalizations of past collective experience), (iii) social practice and dialogue/deliberation, and (iv) repetitive individual practice of technical knowledge within real situational contexts involving indwelling. (Holford, 2020, pp. 8–9)

While heuristics are employed in metis, these are not hard and fast rules but rather encapsulate adaptive capabilities that responsive reasoners can shape to fit the circumstances. Thus, rather than applying rules, knowledge gained from theory and experience may be formalised but must also be internalised. Holford thus draws parallels with the pragmatic approach to knowledge-as-practice found in theorists such as Dewey or Haack (Holford, 2020, p. 13), or the tacit knowledge that Polanyi theorised.

In Holford's list of methods for cultivating metis quoted above, "indwelling" is emphasised as a technique. In the article by Frydenberg et al. (2019), we see a similar emphasis on indwelling as a method for cultivating serendipity: in the example they describe as a "contextual wake-up call", the serendipitous exchange occurred because the designers

were there, on the boat, when certain conditions prevailed, and could experience for themselves the effects of those conditions on the usability of their design (p. 1907). Adopting the perspective of the boat crew by putting themselves in the same situation allowed the designers in this case to put their expertise to use to respond to a situation they hadn't imagined before they had encountered it. To gain that perspective, they needed to dwell within it: this is not so much a strategy applied to a situation, as it is a way of understanding the situation and continuously re-formulating a strategy from within. Further, in response to that situation, one brings to bear one's own expertise and perspective on the problems and opportunities that arise.

To reinforce this idea that there is something about the unique perspective, gained from lived experiences of responding to uncertainty and not necessarily from an acquiring of a particular set of skills or facts to have at the ready, I turn to Miriam Solomon's argument for understanding creativity through the lens of standpoint theory. Solomon (2006) points out that even where the creative product is a novel combination of cognitive resources, more than this combination is required: creative individuals are seen as having an additional "intrapersonal intelligence" that allows them to sort the worthy from the unworthy combinations to pursue (here she follows Gardner, 1994, on p. 230 of Solomon, 2006), *and* they need to have a diversity of resources, a social context that provides the (conceptual and environmental) materials needed for the cultivation of creativity through practice (Solomon, 2006, p. 231). Standpoint theory highlights the fact that individuals have an epistemic advantage, due to their unique perspective in the intersectional and social environment they have dwelled within (Solomon, 2006, p. 232ff). Standpoints are "epistemically fruitful" and reflexive (Solomon, 2006, p. 233): they are expressed in an attitude towards one's own perspective, as a productive contribution to the knowledge and understanding of the group. Like the "cunning" of metis, expressing oneself creatively from one's standpoint is not a way to be "nice" (Solomon, 2006, p. 234), it is a response to the world and an assertion of one's own expertise in response to new situations.

Similarly, Scott (1998) draws on the example of "traditional cultivators" of the land, when it comes to making changes to our agricultural

techniques. Scientists and inventors may generate ideas and equipment, but when the cultivator himself applies a solution, the effects on his own livelihood are intimate and immediate. Further, while he may lack the theoretical knowledge that could explain why some solutions work and others don't, he has knowledge that a scientist would lack: dwelling within the context means he notices details about the land, the seasons and the interactions within the system that is his farm, that an outsider could not witness (Scott, 1998, p. 324). Traditional cultivators developed complex techniques not through the application of theory, but through responsiveness to the contingencies that influenced the success of their practices. What Scott labels metis among the cultivators, recalls Solomon's points about what standpoint perspectives can bring to the table.

To bring this discussion back to the art of serendipity, our understanding of the responsiveness that I argued is required for serendipity is now made more robust by recognising that, rather than an application of set heuristics or technique, as in techne, such responsiveness comes from one's reflexive awareness about one's own expertise in response to an uncertain or dynamic situation, as with metis.

In the serendipitous incidents examined by Riika Townsend and Jussi Mikkonen (2019), we see this in the description they offer of the kinds of research behaviours they observed: "In all cases we emphasized researcher reactions, facing unforeseen incidents and unexpected outcomes as potentials rather than failure, and actively cross-pollinating knowledge" (p. 1867). At the level of organisations, we see this in the attitude of "generative doubt" that Miguel Pina e Cunha et al. (2015) have recommended for companies that wish to encourage serendipity: as a combination of preparedness and openness, conceiving of doubt as a legitimate attitude for an organisation to take allows that organisation to respond better to dynamic situations. Strategies such as these will oscillate as the situation changes, as what counts as preparedness is reassessed. And importantly: "The cultivation of doubt as a legitimate organizational state plays a critical role in the process of making serendipitous work acceptable" (Pina e Cunha et al., 2015, p. 14). Adopting an attitude of generative doubt, that is, creates a space in which the art of serendipity can be practised.

Practitioners of the Art

Given what I have said about the relationship between metis, serendipity and standpoint above, one might wonder whether the art of serendipity is an art at all, whether it can be mastered, or if it is, after all, a denotation of mysterious and innate "genius" tendencies that the serendipitous naturally have. That is, if sagacity is truly a *unique property* of an individual, then it might be that no term of apprenticeship can hope to transfer such a skill, and our analysis of the art of serendipity would be moot. But this would be a misreading of the evidence given thus far. In this section, thus, I want to highlight the interaction between the individual with metis and the context in which the art of serendipity can be practised and learned. Indeed, I want to suggest that the art of serendipity, when practised, leads to the cultivation of metis, a way of reasoning in the world and, indeed, vice versa: that metis is a way of reasoning that can be practised and refined, and doing so generates serendipity in turn.

First note that the skills involved are contextual. If we want to create more chances, then we need to cultivate the skills of the game, recall, to keep ourselves "in play" longer so that we have the chance to take up those chances as opportunities in the first place. Further, the role of indwelling and tacit knowledge highlight that the art of serendipity will be particular to the local context, rather than a universalisable set of learned rules or methods. While metis is depicted in mythology as the saving grace of a goddess or hero in a dire situation, such extreme conditions are not needed for metis to be a useful way of reasoning. Every day we experience uncertainty at multiple levels, and we are called to act in response to changing situations when we are parents, chefs, drivers, pilots or engineers, even when we are solving anagram puzzles for our psychology professor. Not all responsive reasoning is metis, and not all metis is "cunning" or in response to an adversary or tricky situation. Metis does come into play whenever the environment itself is changing, when our skills and experience are being called upon to respond differently to the world than they have before, and we are called upon to recognise our own expertise and to apply it strategically, despite this uncertainty.

The art of serendipity is to use metis in the context one is in, to acknowledge one's own standpoint within that context and use one's expertise to notice and utilise what others may miss. Thus the responsiveness of metis translates into an art of understanding how to act and observe, and to bring one's own unique expertise to bear, within a given situation. Such situations begin with surprise, but also or rather with discomfort and unease, when the situation is risky or one's response is also a responsibility. Or it can be taken up as a more generally positive attitude or approach, so that we find ourselves living in a surprising world (see Glăveanu, this volume). When we look at serendipity through the lens of metis, that is, we can also look at metis through the lens of serendipity: while metis captures the way we respond defensively to risk and uncertainty, it can also capture the way we respond positively through wonder and curiosity.

The cultivation of metis as sagacity towards serendipity in individuals will need external support; it needs to take place in an environment conducive to and even encouraging of serendipity. As tacit, embodied knowledge, learning how to reason with metis must be done experientially, through interaction with others and with the world. Thus, individuals must be given the space to explore, respond and interact in order to practice those skills. As Cunha et al. (2015) suggest, the attitude of an organisation that sees doubt as a legitimate practice towards their own goals and strategies encourages serendipity because it encourages the people within those organisations to see the unexpected as opportunities for enacting change (p. 16). Stephann Makri et al. (2014) suggest several ways that computer interfaces can not only create more chances for serendipity in their users but also may support the cultivation of serendipity related skills: for instance, if technology highlights potential patterns for us that we may not have noticed on our own, we in turn may become more likely to notice such patterns when they arise without the technology's help (p. 2191). The art of serendipity is not the art of generating that particular pattern in that case, but rather the art of knowing patterns may arise, and identifying them, even when we do not create them ourselves. Creating spaces, whether organisations, institutions or computer dashboards, in which we can practice the skills of metis—is how metis might be taught.

The situation in which we find ourselves exercising metis is seldom an interaction between oneself and only the world; generally speaking, these kinds of situations are also social. With Odysseus and his antagonists, or Metis and Zeus, the response is in direct response to someone; the dynamic nature of the system is due to the dynamic nature of this conflict between foes. Again, however, there does not have to be conflict (and certainly not on the grand scale of the Theogony or Odyssey) for there to be dynamism: as Holford points out, metis is the reasoning that grounds democracy and other agonistic human enterprises. The pragmatic approach taken by those who employ metis is, "a naturalistic approach that view[s] knowledge as arising from an active adaptation of the human organism to its environment" (p. 13). Democracy is about the integration of diverse standpoints, "in acts of free self-determination and self-governance" (Holford, 2020, p. 14); reasoning in democracy is learned through practice, by autonomously exercising one's reason in a public forum; metis is accessible to all who learn to reason in such an environment. As Gary Fine and James Deegan (1996) point out in relation to serendipity in ethnographic research, when it comes to being fortunate in building the right relationships to gain access to the context of study, "Research can be conducted with many good contacts, rather than with a unique, heroic one. The question is not about establishing relations with only the right person, but rather whether the researcher can make use of the relationships" (Fine & Deegan, 1996, p. 441). That is, more important than the unique confluence of contingencies that lead one to meet the right person is the response one has to that person when they meet: relationships are built on how we respond to one another, not by merely bumping into one another by chance. Martin Sand and Karin Jongsma (2020) discovered in their research with practising scientists who experience luck in their careers and practice, that while they see scientific practice as an area over which they exercise some control, the social connections that build their careers in that practice are susceptible—not always in a problematic, but in an essential way— to serendipity (p. 580). Making serendipity happen, like metis, has as much to do with how we respond to each other as with how we respond to chance itself.

Indeed, when we respond together to serendipity, it is possible to simultaneously create a space in which serendipity can happen by supporting each other. The art of serendipity is not necessarily a solo art, it can be practised by groups; this kind of trans-disciplinary experience is described by Townsend and Mikkonen (2019, p. 1864). In the first case they describe, researchers were validated in their uncertainty in a way that enabled them to follow up on a serendipitous opportunity with confidence. In another case, an unexpected result led first to conflict and then to researchers contributing their diverse expertise towards a novel solution. Shifts in the roles that individuals played within teams, as a consequence of an unexpected need for different expertise, "created an open-minded research space within the design team allowing to be more flexible in other explorations" (p. 1866). Thus, responding as a group to serendipity made the group as a whole more able to respond well to chance in other instances as well. Recall the third method of cultivating metis described by Holford (2020): "social practice and dialogue/deliberation". The indwelling that is required for the responsiveness of metis is more than just being in the right place; it is engagement with that environment and with the people who dwell there too.

So, one who practices the art of serendipity has to do so in an environment that supports this practice, and the art itself is the practice of bringing one's own expertise to bear in response to the unexpected. This includes both social and embodied awareness of both one's own role within that environment and the capabilities one has to contribute in the situation that are unique to oneself. Indwelling in this context is an active engagement; the practice of engaging is how we develop the art of responding well, and responses can be described as the unique confluence of individual expertise and the unexpected. This is the art of serendipity, and the reasoning involved is captured best through the lens of metis.

Conclusion

I have argued in this chapter that metis best captures the art of serendipity; cunning intelligence is a way to describe how we encounter the unexpected, as individuals who are uniquely prepared (or not) within the situation they find themselves to respond well to changing circumstances, ambiguity and uncertainty. This art is an exploratory art, and it is grounded in the general expertise that individuals have in respect to navigating their own particular circumstances. That is, those who practice the art of serendipity leverage their individual capabilities in novel ways when chance events offer the opportunity to do so. It is not a feature of the chance itself, but rather of the response that generates serendipity, at the level of the individual, the group or the organisation. Thus, the art of serendipity is a responsive art, as metis is a responsive reasoning.

What understanding the art of serendipity through metis brings to light is the embodied, relational and responsive nature of serendipity itself. The cultivation of sagacity, as a consequence, requires the cultivation of individual agency: individuals must be given the support and encouragement to bring their perspectives to bear when they might enable fruitful responses to unpredicted results. Dialogue and deliberation are part of the process; while serendipity may happen sometimes in the head, it happens more often out in the world, in the space between people as they sort out whether they are faced with a mistake or an opportunity, and rework what looks at first like madness into discovery. Most importantly, when we practise this art of serendipity, it can shape the possible outcomes of our research processes and practices, expand the potential of our methods, and generate new spaces for exploration and transdisciplinarity that form when we respond together to the unexpected.

References

Arfini, S. (2019). *Ignorant cognition—A philosophical investigation of the cognitive features of not-knowing*. Springer Sapere.

Austin, J. H. (2003). *Chase, chance, and creativity—The lucky art of novelty*. MIT Press.

Barber, B., & Fox, R. (1958). The case of the floppy-eared rabbits: An instance of serendipity gained and serendipity lost. *American Journal of Sociology, 64*(2), 128–136.

Björneborn, L. (2017). Three key affordances for serendipity: Toward a framework connecting environmental and personal factors in serendipitous encounters. *Journal of Documentation, 73*(5), 1053–1081. https://doi.org/10.1108/JD-07-2016-0097

Björneborn, L. (2020). Adjacent possible. In *The Palgrave encyclopedia of the possible* (pp. 1–12). Springer International Publishing. https://doi.org/10.1007/978-3-319-98390-5_100-1

Busch, C. (2020). *The serendipity mindset—The art and science of creating good luck*. Penguin Books.

Copeland, S. (2019). On serendipity in science: Discovery at the intersection of chance and wisdom. *Synthese, 196*(6). https://doi.org/10.1007/s11229-017-1544-3

Copeland, S. (2018). "Fleming leapt on the unusual like a weasel on a vole": Challenging the paradigms of discovery in science. *Perspectives on Science, 26*(6). https://doi.org/10.1162/posc_a_00294

Copeland, S. (2020). Moving past phronesis: Clinical reasoning in person-centered. *European Journal for Person Centered Healthcare, 8*(3), 315–322.

Cuomo, S. (2007). Technology and culture in Greek and Roman antiquity. *Cambridge University Press*. https://doi.org/10.1080/00033790902898359

de Rond, M. (2014). The structure of serendipity. *Culture and Organization, 20*(5), 342-358. https://doi.org/10.1080/14759551.2014.967451

de Rond, M., & Morley, I. (Eds.). (2008). *Serendipity: Fortune and the prepared mind*. Cambridge University Press.

Detienne, M., & Vernant, J.-P. (1978). *Cunning intelligence in Greek culture and society* (J. Lloyd, Trans.). Harvester Press.

Dew, N. (2009). Serendipity in entrepreneurship. *Organization Studies, 30*(7), 735–753. https://doi.org/10.1177/0170840609104815

Eco, U. (1998). *Serendipities: Language and lunacy* (W. Weaver, Trans.). Columbia University Press.

Erdelez, S. (1999). Information encountering: It's more than just bumping into information. *Bulleting of the American Society for Information Science, 25*(3), 26–29.

Estes, J. A. (2020). *Serendipity: An ecologist's quest to understand nature*. University of California Press.

Fine, G. A., & Deegan, J. G. (1996). Three principles of serendip: Insight, chance, and discovery in qualitative research. *Qualitatives Studies in Education, 9*(4), 434–447.

Frydenberg, S., Eikenes, J. O., & Nordby, K. (2019). Serendipity in the field: Facilitating serendipity in design-driven field studies on ship bridges. *Design Journal, 22*(Suppl. 1), 1899–1912. https://doi.org/10.1080/146 06925.2019.1594948

Gardner, H. (1994). The creator's patterns. In M. Boden (Ed.), *Dimensions of creativity* (pp. 143–158). MIT Press.

Heinström, J. (2006). Psychological factors behind incidental information acquisition. *Library and Information Science Research, 28*(4), 579–594. https://doi.org/10.1016/j.lisr.2006.03.022

Holford, W. D. (2020). *Managing knowledge in organizations—A critical pragmatic perspective*. Palgrave Macmillan.

Makri, S., & Blandford, A. (2012). Coming across information serendipitously—Part 1: A process model. *Journal of Documentation, 68*(5), 684–705. https://doi.org/10.1108/00220411211256030

Makri, S., Blandford, A., Woods, M., Sharples, S., & Maxwell, D. (2014). "Making my own luck": Serendipity strategies and how to support them in digital information environments. *Journal of the Association for Information Science and Technology, 65*(11), 2179–2194. https://doi.org/10.1002/128. 23200

Mcallister, J. W. (2016). Rhetoric of Effortlessness in Science. *Perspectives on Science, 24*(2), 145–166. https://doi.org/10.1162/POSC

Mcbirnie, A. (2008). Seeking serendipity: The paradox of control. *Aslib Proceedings, 60*(6), 600–618. https://doi.org/10.1108/00012530810924294

McCay-Peet, L., Toms, E. G., & Kelloway, E. K. (2015). Examination of relationships among serendipity, the environment, and individual differences. *Information Processing and Management, 51*(4), 391–412. https://doi.org/10. 1016/j.ipm.2015.02.004

McKinnon, R. (2014). You make your own luck. *Metaphilosophy, 45*(4–5), 558–577. https://doi.org/10.1111/meta.12107

Merton, R. (1948). The bearing of empirical research upon the development of social theory. *American Sociological Review, 13*(5), 505–515.

Napolitano, C. M. (2013). More than just a simple twist of fate: Serendipitous relations in developmental science. *Human Development, 56*, 291–318. https://doi.org/10.1159/000355022

Napolitano, C. M. (2018). Serendipity as an example for a new four-tiered model of the study of intentional self-regulation. *Research in Human Development, 00*(00), 1–15. https://doi.org/10.1080/15427609.2018.1489097

Pina e Cunha, M., Rego, A., Clegg, S., & Lindsay, G. (2015). The dialectics of serendipity. *European Management Journal, 33*(1), 9–18. https://doi.org/10.1016/j.emj.2014.11.001

Piñeyro, A. (2019). Kinetic morphologies: Revealing Opportunity from mistake. *Design Journal, 22*(Suppl. 1), 1871–1882. https://doi.org/10.1080/14606925.2019.1595027

Rivoal, I., & Salazar, N. B. (2013). Contemporary ethnographic practice and the value of serendipity. *Social Anthropology, 21*(2), 178–185. https://doi.org/10.1111/1469-8676.12026

Roberts, R. (1989). *Serendipity—Accidental discoveries in science*. Wiley.

Ross, W., & Vallée-Tourangeau, F. (2021). Catch that word: Interactivity, serendipity and verbal fluency in a word production task. *Psychological Research Psychologische Forschung, 85*(2), 842–856. https://doi.org/10.1007/s00426-019-01279-y

Sand, M., & Jongsma, K. (2020). Scientists' views on (moral) luck. *Journal of Responsible Innovation, 7*(S2), S64–S85. https://doi.org/10.1080/23299460.2020.1799623

Scott, J. C. (1998). *Seeing like a state—How certain schemes to improve the human condition have failed*. Yale University Press.

Silver, S. (2015). The prehistory of serendipity, from Bacon to Walpole. *Isis, 106*(2), 235–256. https://doi.org/10.1086/681977

Solomon, M. (2006). Standpoint and creativity. *Hypatia: A Journal of Feminist Philosophy, 3*, 226–237.

Thagard, P. (1998). Ulcers and bacteria I: Discovery and acceptance. *Elsevier Studies in History and Philosophy of Science Part C: Studies in History and Philosophy of Biological and Biomedical Sciences, 29*(1), 107–136.

Thagard, P. (2012). Creative combination of representations: Scientific discovery and technological invention. In R. W. Proctor & E. J. Capaldi (Eds.), *Psychology of science: Implicit and explicit processes*. Oxford Scholarship Online. https://doi.org/10.1093/acprof:oso/9780199753628.003.0016

Thagard, P., & Stewart, T. C. (2011). The AHA! experience: Creativity through emergent binding in neural networks. *Cognitive Science, 35*(1), 1–33. https://doi.org/10.1111/j.1551-6709.2010.01142.x

Townsend, R., & Mikkonen, J. (2019). Serendipity as a catalyst: Knowledge Generation in Interdisciplinary Research. *Design Journal, 22*(Suppl. 1), 1853–1869. https://doi.org/10.1080/14606925.2019.1595038

van Andel, P. (1994). Anatomy of the unsought finding. Serendipity: Orgin, history, domains, traditions, appearances, patterns and programmability. *British Journal for the Philosophy of Science, 45*(2), 631–648. https://doi.org/10.1093/bjps/45.2.631

Young, M. T. (2019). Chapter 4, Mechanics as cunning knowledge: The engines of metis and ingenium. In *Technology and practice in seventeenth century English experimentalism* (PhD dissertation). University of Bergen.

Young, M. T. (2017). Manual labor and 'mean mechanicks': Bacon's mechanical history and the deprecation of craft skills in early modern science. *Perspectives on Science, 25*(4), 521–550. https://doi.org/10.1162/POSC_a_00252

Heteroscalar Serendipity and the Importance of Accidents

Wendy Ross

Luck is problematic when it comes to moral or epistemic virtues such as creativity. Interviews with creative people (Csikszentmihalyi, 1996; Sawyer, 2018) point to its undoubted importance to both career trajectories and creative moments. Indeed, Csikszentmihalyi writes (p. 46).

> When we asked creative persons what explains their success, one of the most frequent answers—perhaps the most frequent one—was that they were lucky. Being in the right place at the right time is an almost universal explanation.

We value creativity and so displaying it is a socially desirable act. The role of luck in creativity undermines the notion that creativity is a character virtue; character virtues require the agent to know what she is doing, to

W. Ross (✉)
Department of Psychology, London Metropolitan University, London, UK
e-mail: w.ross@londonmet.ac.uk

© The Author(s), under exclusive license to Springer Nature
Switzerland AG 2022
W. Ross and S. Copeland (eds.), *The Art of Serendipity*,
Palgrave Studies in Creativity and Culture,
https://doi.org/10.1007/978-3-030-84478-3_4

make an active choice and for this to stem from her fixed disposition (Kieran, 2017). In the case of creative success generated by luck, these criteria cannot be met. However, as argued by Gaut and Kieran (2018), creative success also seems to be more reliant on luck than other forms of success.

So, the question becomes how to reconcile the seeming contingent nature of creative success with its personal and scientific import. In the past we have invoked the muses or other supernatural explanatory factors (see Le Hunte, this volume) to explain this or allowed it to rest on the shoulders of great creative geniuses who rise above the flux of chance (Montuori & Purser, 1997). I have argued elsewhere that the answer to this is to move from considering the relationship with chance as one of luck and rather to consider it as a manifestation of serendipity; that is, as *enacted luck* (Ross & Vallée-Tourangeau, 2021c). Serendipity is the combination of accident and sagacity—it requires both luck (in the form of accident) and, crucially, the exploitation of that luck by a skilled agent (Merton & Barber, 2004). In this respect, serendipity allows us to negotiate the narrow path between uncontrolled accident and agential intent and attribute a form of distributed epistemic credit across agent and environment.

There is a danger in equating serendipity with creativity. Definitions of both creativity and serendipity are volatile. Both tend to centre on two characteristics—novelty and value in the case of creativity; accident and sagacity in the case of serendipity—and then seek further stability with a variety of additions which suit the situation (see Simonton, this volume). In a way, this definitional instability is inevitable—both concepts suffer from the same problems of contingency, unpredictability, and a conceptual spread that includes both the mundane and the extraordinary. For both, the list of necessary conditions gets ever longer without looking like reaching sufficiency; a list which threatens to engulf all human action. After all, a broad enough definition of novelty can include almost any act (Martindale, 1990) and all human activity takes place against a background of environmental flux or chance. A definition which is broad enough to cover every eventuality that could be labelled either serendipity or creativity is weak and meaningless, yet threshold definitions are also vexingly unsatisfactory.

In addition, definitions of creativity which have tried to cast the interdisciplinary concept as something worthy of academic study have struggled with the tension between the mundane and the mysterious implied by the idea of "bringing into existence" at the heart of what it means to be creative. On the one hand, "to bring into existence" is an everyday act—moving through life, each experience is novel; on the other hand, generating something from nothing is conceptually and practically problematic. To counter this and avoid crediting the "schizophrenic word salad" (Weisberg, 2010, p. 237) by attributing it the label of "creative", most definitions agree that creativity has to have some level of value whether that is personal or social value. This value further complicates the concept of creativity, given that "creative" status can be awarded and taken away with an alarming level of arbitrariness (see also Simonton, this volume). In the same way, serendipity as well only occurs in retrospective sense making (Solomon, 2016) and can also be changed depending on the standpoint of the observer. So, for both, the definitions require taking into account the extended network (Copeland, 2019; Csikszentmihalyi, 1998, 2014). These extended networks decide whether an act is either creative or serendipitous, or both, and the collective can also change its mind. It is because of these vexing complexities, I wish to move away from a conceptual definition to a focus on descriptions of process.

This conceptual dissipation in the case of serendipitous creativity is particularly a risk if we argue—as I have elsewhere (Ross & Arfini, forthcoming; Ross & Vallée-Tourangeau, 2021c)—for a materially engaged form of creativity which requires an open system to generate novelty. Novel existence presupposes a tangible form and so a full study of creativity cannot limit itself to the study of sequestered psychological functions. It is impossible to be creative in abstract. The notion that a mental blueprint is drawn up and imposed on inert matter—so called hylomorphism (Ingold, 2010)—is not upheld by any observational or qualitative data of which I am aware and so reflects creativity as we wish it were rather than as it actually is. Rather, it seems creativity unfolds incrementally and recursively along multiple timescales and in coordination with the material (Glăveanu, 2020; Glăveanu et al., 2013). The nature of the form changes with the nature of the creative action but

similarly the nature of the creative action changes with the nature of the form.

Creativity in this view consists of actions on objects and this material engagement (Malafouris, 2013) is part of a constant interaction with things beyond the closeted agent. Creative action requires a dissipation of agency and familiarity with an uncomfortable uncertainty (Beghetto, 2020; Glăveanu et al., 2013; March, 2019). If this is the case, then at first glance the relational nature of serendipity seems to permeate all aspects of the creative process. Environmental flux and material affordances shape and direct the flow of creativity and what emerges is not reducible to either artist or material, process or final product. However, I will argue that serendipity goes beyond a simple connection between agent and chance. Such a binary definition of serendipity dissipates it to such an extent that all creativity—and perhaps even all human activity—can be seen as serendipitous. This is unhelpful.

This chapter will explore a way of understanding serendipity which casts it as more disruptive in nature than this. I will suggest that serendipity requires a break in a flow state, and it forces a reassessment of the artistic intent. We can trace this by three things: first, an accident stemming from unintentional action or an external source, second, the noticing of the accident (indicated by surprise) and third, a change in creative action. These are similar to the elements picked out by Arfini et al. (2018) who identify both the accidental and "game changing" nature of serendipity. Where I depart from them is by not attributing a value to the accident; the aim of the analysis outlined here is to assess the accident without the post-event value judgement. This means that the accident becomes ontologically unstable with regards to serendipity, but I suggest these three stabilising characteristics outlined above (and in more detail later) will go some way to mitigate this. Furthermore, the arbitrariness of social judgements mean that serendipitous events are necessarily *always* ontologically unstable, as that label can be removed as easily as bestowed.

However, it is important to begin by situating the argument for serendipity as a single surprising event in more extended understandings of serendipity. I agree with the wider literature (e.g., Copeland, 2019)

that it is these broader understandings—personal and socio-cultural—which shape whether or not an event is understood as serendipitous. This retrospective coronation is the very thing which makes serendipity "slippery" (Makri & Blandford, 2012). In this respect serendipity closely resembles creativity in terms of its heteroscalar composition. The argument laid out here with regards to serendipity draws on similar discussions around value attribution and definition in the creativity literature, which is also rooted in the tension between the moment of "insight" and the broader structural causes of creative products. However, I also agree with Baumeister et al. (2010) that it is only the accident that differentiates a serendipitous from a non-serendipitous discovery because "sagacity" is required for all discovery. Therefore, a theory of serendipitous discovery which does not pay serious attention to the accident risks blurring the line between the two. I therefore suggest that becoming comfortable with the ontological instability may be necessary.

Heteroscalar Serendipity

What follows is a necessarily brief description of how the different temporal levels of serendipity interact when it comes to creativity and discovery. This is captured by the notion of heteroscalarity, that is the importance of taking account of the simultaneous different time scales over which a phenomenon can occur to fully understand it (this is similar to multiscalar approaches as described in Steffensen & Vallée-Tourangeau, 2018). I do not intend this as an exhaustive account of how serendipity plays out in the generation of a creative product. As I have already indicated, an exhaustive account of serendipity or creativity is perhaps unobtainable or at least useless when obtained. Rather, I offer an illustrative one to situate the argument I shall make for the understanding of the accidental event to generate a clearer view of what serendipity means and how it can help us understand creativity.

The narrative scale of serendipity has been highlighted by others (see for example Solomon, 2016). Yaqub (2018, p. 176) calls this the "window of analysis" and points to the difficulty of pinpointing temporal start and end points for a serendipitous incident, suggesting rather that

we speak of a serendipitous "phase". As well as start and end points, I also suggest that we have a problem of heteroscalarity—that is that serendipity can take place across multiple time scales each with an attached level of granularity. Take the story of the discovery of penicillin: Fleming's discovery was serendipitous in different ways yet each necessary in the overall story. It was serendipitous that Fleming was in a time when the scientific networks existed to cement his initial observation, as well as being serendipitous that he personally was equipped with a mind prepared to understand the implications of what he saw and finally it was a serendipitous accident that generated the triggering observation. The final discovery emerges from all three and is irreducible to any one of them.

Figure 1 describes the complex nature of the temporal rhythm when it relates to both creativity and serendipity. Understanding this requires

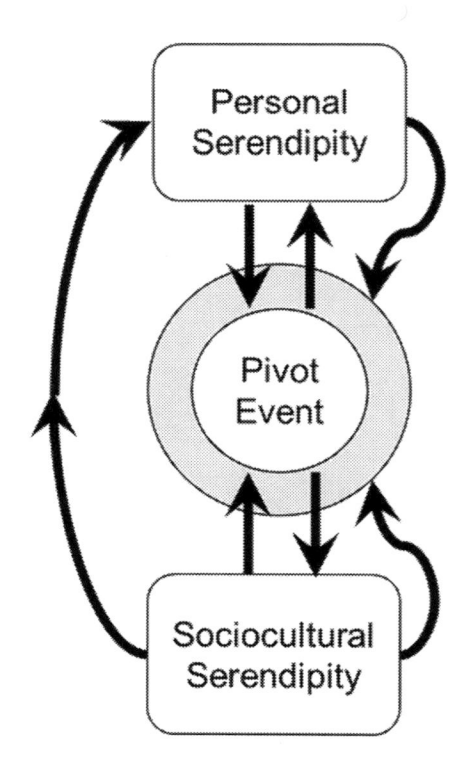

Fig. 1 The Heteroscalar model of serendipity

a comfort with plurality and the contradiction occasioned by different yet interconnected levels of analysis. The event shapes the surrounding personal and socio-historic environments, which then also shape and change the event as well as both interacting with each other, leading to a form of backwards causation (Latour, 1999). However, what lies beneath these shifting time scales is necessarily the exploitation of an accident. This accident is the pivot event, a threshold moment when something changes which is reflected in a change in the creative trajectory. Whilst the accident is not serendipitous in itself, it is a prerequisite for distinguishing specifically serendipitous discoveries.

A creative act is nested within a person and that person is nested within a wider social and cultural context. Each of these shapes and constrains the other dynamically. Serendipity can intervene at any level: The "place" and "time" in "being in the right place at the right time" are multiple and connected. Let us start with the broadest level: Socio-historic serendipity. This is the historical backdrop which both generates and constrains the nascent creative act (Ross et al., 2020). There is a thread of inevitability to this form of historically situated serendipity. Simonton (2004, p. 10) argues that it (in the form of zeitgeist) is "strikingly incompatible" with the chance perspective. He suggests that viewing cultural ages in this way makes creativity inevitable. I concur and I view the idea of a golden age of multiple discoveries (Lamb & Easton, 1984) as clear evidence for the inevitability of social change and discovery, thus categorising characteristics of wider socio-historic background as serendipitous needs to be done with care.

However, I also suggest that, for some forms of serendipitous discovery, the socio-historic background can be better understood as an extended prepared mind (in the tradition of the prepared mind, Clark & Chalmers, 1998) which provides the ground which is fertile enough for creativity and innovation to take hold from incidental observations (a similar argument is made by Muthukrishna & Henrich, 2016). In the simplest form, discoveries require the correct tools to exploit and sediment the discovery. Some inventions such as Leonardo's helicopter have survived but it is likely that many others have been lost. If the right time is almost guaranteed to generate a certain idea, an idea out of time

is almost guaranteed to not be followed up. On a very basic level, the exploitation of an accident is constrained, not by the sagacity of the individual agent, but by the abilities and resources of wider society and social networks.

The idea of an extended prepared mind is further embedded in the systems model of creativity introduced by Csikszentmihalyi (1998, 2014). He argues that the creative actions are only creative once publically recognised as such, even if that public recognition is as mundane as the scoring of judges on a consensual assessment task. In this model creativity is seen as "a phenomenon that is constructed through an *interaction* between producer and audience" (Csikszentmihalyi, 1998, p. 314, emphasis in the original). Creativity requires transmission and sedimentation from a broader domain, which in turn requires selection and acceptance by a field that can be surprisingly narrow. Thus, there is an inherent paradox at the heart of creativity (which I discuss further below in relation to the notion of the adjacent possible). An idea must be novel but not so novel that it is rejected by the field. The field must be prepared to accept it. As we shall see, this tension is repeated on a microscale when we come to the role of the accident. Both creativity and accident require rupture and diversion, but if too extreme then they are disregarded or the skills necessary to exploit them are not available. Thus, they walk an uncomfortable tightrope between disruption and continuity which is constrained by the surrounding socio-historic environment. This is something Glăveanu (2019) describes as immersed detachment.

There are many tales of a scientific discovery that lay unexploited because it was not recognised by the field until much later. Take Boris Pavlovich Belousov's discovery of the foundations of the Belousov-Zhabotinsky Oscillator (Winfree, 1984). A surprising observation was followed up by the scientist but lay unpublished because it was not at that time considered possible—it failed to find sympathetic reviewers and so languished for many years. The occasional and regular rediscovery of past discoveries suggests that there cannot be a strict inevitability to a particular scientific discovery being exploited by an extended prepared mind even if certain features of a society make a scientific discovery inevitable. Survivorship bias means that we are aware of those things which are eventually accepted by a field, but we should be very wary of assuming that

this process picks up all great discoveries simply because we could never know if recognition did not happen.

Therefore, for an accidental observation to take hold and change long-term trajectories then socio-historic serendipity is required to intervene in two ways. First when the accident happens, the broader extended societal mind needs to possess adequate resources to exploit and cement this and second, broader social judgements are required to coronate the person, product or thought (Copeland, 2018). That the accident takes place in a time and culture which possesses these two qualities is serendipitous. Furthermore, a momentous enough event will change the surrounding socio-cultural environment which will then produce a narrative which supports the event and yet this impact can also only be understood in relation to that environment. It is important to note that the *same* event can be therefore either serendipitous or not serendipitous depending on what happens after.

Personal serendipity refers to the next level, one that is often reported by those who have assessed the long-term careers of creative people (Csikszentmihalyi, 1996; Getzels & Csikszentmihalyi, 1976; Sawyer, 2018) and is also that referred to by Gaut and Kieran above. It describes the idea of contingency in a personal life trajectory. The role of chance in this case takes on a more finely grained aspect than in socio-historic serendipity where it is often smoothed out of the narrative, and so the role of an accident comes into a sharper relief, although viewed through the eyes of the person who experiences it and so already understood in retrospect. The inevitability which seems apparent in the longer timescales is less so when the necessary skills for the exploitation of an accident fall more contingently—a discovery may be driven by zeitgeist but that it falls to the particular person to add the final piece often seems a tale of improbable connections.

The third scale on which serendipity can happen is the focus of the rest of this chapter. That is the momentary "accident" which is the trigger for a change in creative or innovative trajectory. I argue that it is at this moment that serendipity occurs as an *event* and accident meets sagacity; later in the narrative arc of serendipity it becomes an *experience*, which is how it is more commonly understood. The accident is experienced by a person and is often reported and understood as an experience, but I

argue that it can also be seen as a single event which can be observed in detail. This is important to develop an empirical research programme examining precipitating causes and the best actions to take. It in important to recognise that in itself this event is not serendipity but is rather ontologically unstable until after it is complete and has been enacted. At this stage when there is a clear outcome it is classed as either valuable or not. This means it is intimately reliant on both socio-cultural and personal serendipity both at the moment it is recognised and afterwards. The shifting ontological status of the event poses a challenge for a systemic examination which is why it requries isolation.

Microserendipity

Socio-historical and personal serendipity are structuring causes. They are necessary for the enactment of serendipity, but they are not triggering causes (Dretske, 2010). All discovery, innovation and creativity take place in networks and they are secured by individuals who have certain skills and talents. This is a trivial observation. What sets serendipity apart is that the triggering cause is an accident which arises from outside the system. This is a radical understanding of serendipity which constrains the conceptual dissipation outlined above but which may end up overly reducing the number of events we label as serendipitous. It does not deny the importance of other temporal levels but rather suggests that these are important for *all* elements of creativity. What makes the accident important is that it is not inevitable. This is why not all discovery and creativity are serendipitous. Serendipity on this time scale I call microserendipity to emphasise its narrower focus. Microserendipity aims to move away from the wider timescales (Ross, forthcoming; Ross & Vallée-Tourangeau, 2021c, 2021a) to focus on a single event.

Elements of socio-historical serendipity and personal serendipity have been explored in the literature, but the moment of accident is perhaps under explored. This is not surprising. The accident can only be recognised as serendipitous after it has occurred, indeed only becomes serendipitous after it has occurred. This is then problematic; short of recording and following people who we suspect of having the potential

for a creative act (and a researcher would have to be lucky even then) by the time that accident is identified as serendipitous we no longer have access to that moment to observe it. Furthermore, it is necessarily filtered through the levels of socio-cultural and personal retelling identified above to be identified as important. However, research on serendipity deals with complexity and contingency as a matter of course so it needs to embrace this most contingent of elements.

It is also problematic because it points towards a reductionist view of a phenomenon which is intrinsically emergent. A focus on the accident as the primary driver in serendipitous discovery threatens to undermine the arguments laid out above for serendipity's heteroscalar nature. After all, serendipity requires recognition and a retrospective coronation, and so an accident cannot be either serendipitous or not serendipitous without this. However, I suggest that a focus on the nature and characteristics of the accident is as important as the focus on individual sagacity in respect to serendipity as a skill which is already sustained (de Rond, 2014); indeed, often even those who focus on this skill also include the triggering moment (Makri & Blandford, 2012; McCay-Peet et al., 2015). Emergent phenomena require plurality of analysis to understand their complexity. Multiple levels of analysis can co-exist and indeed do (Giere, 2006).

I therefore suggest there are three characteristics of the serendipitous accident which can help us understand how that accident occurs and how it can further lead to novel thoughts or things. First, the accident arises from either object-actions (that is pure "accident" in the folk understanding) or non-directed actions on and with objects. Second, while unintended, the results of the actions are both noticed and generate surprise. Third, it represents a change in the creative trajectory and occasions the forming of a novel creative system with a different intention. A serendipitous accident is necessarily contextualised which prevents the focus becoming too severely reductionist; a serendipitous accident is also a situated accident. It cannot be understood without a reference to the state of the broader surrounding system before it occurred, and it is only serendipitous if it is later enacted. This means we keep the sequential nature of human action whilst still maintaining that some aspects are

unexpected and unpredictable. Paradoxically, a focus on the accident as an event may help underline the importance of the surrounding system.

I argue that an accident characterised in these ways will not only support us to identify serendipity outside of an experiential narrative account but also stop the spread of serendipity as a description suitable for any and all human action. A serendipitous accident is not a sufficient condition for serendipity to arise, the subsequent retrospective coronation that has been picked out above is also necessary. Consequently, I offer these three characteristics as a starting point to build a theory of serendipitous accidents.

Non-Directed Action

Serendipity and creativity require action: Creative thoughts become manifest through action (Glăveanu & Beghetto, 2020). It is this that separates creativity from imagination. In taking on a form whether that is subvocal murmuring, a written score or the premier of a full orchestral piece, the creative thought shifts and moulds the underlying nature of that form while also being shifted and moulded by it (Malafouris, 2020). The practical implementation of the imagined plan cannot be detached from that plan and so plan and creative objects are co-created. Thought and form are collapsed. Intention arises in action and is created by soft assembled creative systems at the centre of which are the artist and the material, but around which are many different things both proximal and distal which sediment the process until finally something is created. In short, creativity is a dynamic process which resists static analysis. Serendipity is similar in structure. The agent responds to an event in the environment and that response shifts and shapes the event, turning it from something which the person could just have passed by to something "serendipitous". At the centre of the soft assembled system is the event and the agent's response to it but that event is anchored and tailored by networks which sustain and support it.

Initially, it seems that a difference between serendipitous and non-serendipitous creativity is the point in the creative timeline the action takes place. In non-serendipitous creativity, the action and the creative

things co- create and there is no easily identifiable trigger event (March & Vallée-Tourangeau, this volume), whereas in serendipity, the creative action is a response to an event which is outside of the agent's control. Post-event action is required to enact and generate that which stems from the event, but it is not a generative action in itself. This aspect of serendipity leads to profiling of environmental affordances that can maximise these forms of actions. I call these object-actions to empha-sise the lack of direct human agency. These object-actions are what are commonly considered to be pure "accidents", that is they are movements in the world which are not generated in any way by the human agent that they affect. These, however, are perhaps the rarest forms of actions leading to serendipity and also those for which there is the least evidence beyond the anecdotal.

However, at other times, actions with and through objects generate these accidents so the divide between action and accident is less clear and attribution of intential agency murky. This is something that Austin (1979) has labelled the Kettering principle (see also Copeland, this volume), that serendipity and discovery are more likely to arise from something which is in motion. Actions on objects like this are more common in the serendipity literature. These serendipitous actions can be divided into those which occur prior to the pivotal event and are a trig-gering cause and those which occur afterwards and have a sedimenting effect. Sometimes the preparatory actions leading up the event lead the event to be labelled as pseudoserendipity (Roberts, 1989) but the divide between the serendipity and pseudoserendipity is hard to sustain and has been frequently challenged (Arfini et al., 2018; see also Simonton, this volume). However, by allowing accident generated by intentional actions into the class of serendipitous triggers, we return to the problem of conceptual elision, where all human actions are seen as serendipitous so I suggest that the idea of accidents generated by human action needs further refinement.

Rather than categorising the action by where it occurs in the creative trajectory, I suggest that this division should not be a temporal one but rather one of intention. Post-event action is marked by an intention to build on the effects of the accident, pre-event actions (whether object-actions or actions on objects) which generate the accident should be

marked by a lack of planning and the unexpectedness of the result. That is, the results of the actions were unanticipated. This is at the heart of the notion of an "unsought finding" (van Andel, 1994).

Intentional action has a representative and an attitudinal aspect. Intention in this respect requires a plan (the representational aspect) and a belief that that plan can be carried out and will yield results. It is for this reason that an action with the plan of generating random events will not be serendipitous. If I believe that by scrambling letters, I can generate a moment of randomness that will trigger a creative moment then I am carrying out an intentional action and whilst the results may be unplanned in their detail, they are not unplanned in their overall structure. To be an accident, the trigger action must generate something different to the initial representative aspects. Equally, while the intention can be to solve a problem, some serendipitous tales demonstrate unintentional action where the plan has been carried out without a concomitant attitudinal aspect. That is, actions can be carried out ostensibly with the intention of solving a problem but with no belief that those actions will be successful. Such quasi-desperate actions only become serendipitous through attitudinal change.

Whilst environmental and personal triggers have been investigated, there has been less attention paid to the types of actions that might generate serendipity. Kirsh and Maglio (1994) introduced two different motivations for action: Epistemic and pragmatic. Whilst a pragmatic action has as its intention progression towards a concrete goal, an epistemic action is one which does not advance or change the practical landscape but does yield more information about the situation. Epistemic actions are those which aim at manipulating information bearing structures to reveal the information and increase understanding (Rowlands, 2018). For example, an epistemic action would be to turn a jigsaw puzzle piece so it was clear where it would fit in the overall picture, a pragmatic action would place it there. Neither of these actions are useful to our understanding of action and serendipity because they reflect both a representational and an attitudinal aspect. This indicates intentionality from the agent (see also March and Vallée-Tourangeau, this volume, for a discussion on extended intentionality).

On this view, serendipity is generated by unintentional actions. Such forms of action I suggest can be labelled exaptative actions (Ross & Vallée-Tourangeau, 2021b). The notion of exaptation is borrowed from innovation (Andriani et al., 2017) to signal something which is repurposed. Exaptative actions start with one representational aspect but expose information contained in the object of interest unrelated to that initial plan. I call these actions exaptative to emphasis the change of direction that occurs once their initial results are observed. These actions may be skilled and intentional, but they do not have within their representational or attitudinal aspect the plan or the belief that they will generate the knowledge that they end up generating. When the epistemic state of the system is shifted through these unintentional actions, they then change recursively to secure the knowledge revealed. Their purpose becomes different and pre-serendipitous actions become post-serendipitous actions.

Exaptative actions are important to understand serendipity. Not only are they often reported in anecdotal tales, but they allow serendipity to resist falling into an unhelpful binary of agent on one side and accident on another. The important aspect of an exaptative action is that it generates an unintentional change in the epistemic state of the system which in turn updates the representational aspect of the action. It is not that the change is not generated by the agent but rather that is does not map onto the change intended by the initial action. However, systems are always changing and intentionality is sometimes hard to infer or recall. In which case, we risk returning to the dissipated nature of serendipity where all actions over objects are in some way considered serendipitous. For this reason, we need to add another aspect to the notion of a serendipitous accident: the element of surprise.

The Element of Surprise

The etymological roots of accident imply something entering from outside the system. It comes from the latin *accidere* meaning "to fall down, impinge on, be heard, happen" (Merriam-Webster) and serendipity is firmly tied to the "act of noticing" (Rubin et al., 2011). At

the heart then of the notion of a serendipitous accident is that it comes from outside the system, involves a disruption and is noticed. These aspects can be collapsed into one: A serendipitous accident is surprising (see Glăveanu, Simonton, this volume). I suggest that the element of surprise is key to resisting the conceptual dissipation outlined above. In this case, a bland definition of serendipity that threatens to engulf all encounters with environmental chance ignores the disruptive nature of the phenomenon (see Copeland, this volume). For serendipity to have the effect with which it is credited then it is necessarily disruptive because it forces a change in epistemic field and (as we shall see) requires a change in action. This disruption is marked by surprise.

Surprise connects both creativity and serendipity. Whilst it is not part of the core bipartite definition for either, it is regularly attached to creativity. Boden (2004, p. 4) defines creativity as "the ability to come up with ideas or artefacts that are new, surprising and valuable" and Simonton includes it in his calculation for creativity (see Simonton, this volume). However, surprise is also situated and relational; something is surprising for someone and something which may be surprising in one situation passes unnoticed in another (Ross & Webb, forthcoming). It is an epistemic judgement related to prior expectations and the likelihood of an event. It has both affective and cognitive dimensions which make it hard to classify (Celle et al., 2017).

What marks a difference in the theoretical analysis of creative surprise and serendipitous surprise is the proposed origin of the surprise. Current cognitive research on creativity focuses on the moment of "insight" as a key factor. Historically, this derives from a combination of Gestaltist psychology (Köhler, 1925) and Wallas's (1926) four stage theory of creativity. This affective and cognitive mechanism is regularly linked to creative inspiration and is examined by presenting participants with initially intractable problems. It is theorised to consist in the alleviation of a feeling of being stuck, a feeling of certainty in the proposed solution, a feeling that this solution came suddenly, a feeling of "aha" and, importantly, a feeling of surprise in the answer. Thus, it is marked by a similar lack of agency to serendipitous surprise but differs in two fundamental ways. First, insight is theorised to be an internal mechanism which comes

from a (disputed) mental process whereas serendipity is necessarily occasioned by something which comes from outside the system. Insight theorises a novel representation of existing information whereas serendipitous surprise is more radical—it is not surprise at discovering what you already knew framed differently, but surprise at new knowledge.

For new knowledge to be recognised and incorporated into the system, a particular state of the system is required. This state relates to a prepared mind state, reminding us that surprise is a situated emotion. As Arfini and colleagues (2018, p. 5) write:

> Fleming's "Oh!" reaction was when he managed to frame and understand the antibiotic effect of a mold. He did not enter his laboratory to find a moldy culture singing the chorus of Mamma mia!: that would have sparked another kind of reaction.

In other words, serendipitous surprise relies on the adjacent possible (Björneborn, 2020)—the event has to be close enough to what the system views as possible even if the knowledge is not there before, and the boundaries of the system have to be flexible and dynamic in order to assimilate this new knowledge. This is a quasi-liminal knowledge state which requires both expertise (to recognise and assimilate) and ignorance (to experience surprise). In this way, we are redirected to a relational and contingent phenomenon because the boundaries of the adjacent possible are necessarily dynamic. This is why surprise and noticing do not necessarily follow directly after the event but can occur far further along the narrative arc of the event when the adjacent possible changes in such a way to create understanding and the space for the knowledge to be recognised.

This aspect of the adjacent possible echoes the argument that Yaqub (2018) makes of the relationship between theoretical expectations and serendipity. The accident forces a deviation from theoretical expectations, but this presupposes that these expectations already exist. Surprise requires an existing backdrop. An observation can only be incongruent if the relevant theoretical knowledge is there to offer a contrast. Many stories of scientific innovation surrounding serendipity describe a change

in a theoretical field which is impossible to enact unless you are intimately aware of that theoretical field. It is in this way that the prepared mind is situated. If Fleming's culture could sing and dance it would not be serendipitously surprising because it would not require a disruption of theoretical expectations so much as an entire set of new ones; there is a level of continuity in the experience of serendipitous disruption.

As discussed above, this is also true of creativity. Creativity requires rupture but that rupture cannot be too severe or else it is not creative because it is not able to be fully valued by the field. There has to be both continuity and rupture. So, both serendipity and creativity sit in a liminal space, the in-between both disrupting and simultaneously relying on and supporting the status quo (see also Le Hunte, this volume). This is where the complexity of situated value clouds even processual accounts. It is not yet clear how to disentangle this.

The second difference between insightful surprise and serendipitous surprise is that insight is theorised to be an end state. The problem is solved and epistemic closure is attained. This is marked by the emphasis on high certainty in the answer. Serendipitous surprise is rather the start of knowledge exploration and ignorance reduction. Rather than epistemic closure, it represents an epistemic opening and thus is linked to curiosity rather than certainty. The new knowledge is not sedimented until it is enacted and explored. The re-representation and reframing of the theoretical situation requires verification. The importance of assimilation and exploration of the novel epistemic landscape is discussed in the next section.

The Importance of Enactment and Change

It is not enough that the accident happens nor is it enough to generate a feeling of surprise, the accident must also lead to further action. Indeed, serendipity can be most properly located not in the person nor the accident but rather in the actions that combine both. This time this action takes an intentional form which is marked by a change in the system. If the accident is discarded by the agent and does not generate a change

in cognitive or creative trajectory then it is not relevant to an understanding of that process. For example, Barber and Fox (1958) tell the story of two scientists who both made the same surprising observation (that rabbits ears droop when injected with palpain) and for one this led to a change in actions and a discovery whereas for the other this was an interesting but dropped diversion. The moment of accident and noticing and surprise was the same in both, the changes were not. For an accident to be a serendipitous one it must also be reified through action. A prepared mind must not only be prepared to notice but also be prepared to enact the accident and its implications. This is the true value of pinpointing exaptative actions. The action surrounds the event, generating and securing it. The idea of exaptation relies on the idea of change and the change is marked by a change in intention sparked by the noticing of an opportunity.

This change may be delayed along with the act of noticing but noticing must lead to action; the novel information yielded by the accident must be reified in further action otherwise the accident remains inert. Indeed, the accident often triggers the formation of a new creative system in which the accident forms a part. This is supported by the argument made by Arfini et al. (2018) that discovery through environmental change is ubiquitous in science so to demarcate serendipitous discovery requires a game changing perspectival shift which takes place at the level of the system. The same is true of materially engaged creativity. It is not enough to be surprised by an unintended act, the surprise must lead to action and change in the creative system. As Glăveanu et al. (2013, p. 5) note, material undergoing is marked by accidents and objects which "change the original plan".

This change from unintentional to intentional action requires either a change in the representational aspect of the action—it now proceeds according to a novel plan—or also a change in attitudinal aspects—the increased likelihood of success marks a change in the attitudinal aspect of the intentionality. Unplanned success sparks the feeling that success is inevitable and so attitudinal intentionality sets in even if the way ahead is unclear (see also Lock et al., this volume).

The Benefits of a Focus on Accident

I have been careful to hedge my claims for the importance of the single event as I lay out the preliminary basis for a theory of serendipitous accidents in creativity and discovery. It is important to resist a reductionist approach for something inherently emergent but I also hold accident is a necessary condition of serendipity to avoid a bland conceptual dissipation which is equally important to resist. The accident exists alongside and within a focus on social, cultural or personal aspects which are important for all creative action; it is the accident which makes it a serendipitous action. However, the accident is not a fixed point, rather it can only be understood as part of a liminal space. Its ontological instability is a necessary discomforting and this discomfort is one which sits with researchers in both creativity and serendipity.

I suggest that there are three interlinked benefits to a focus on accidents which can help advance our understanding of serendipity. First, it forces the recognition that the existence of serendipity requires moments of failure; that is, when it is a poor choice to follow up the information yielded by the accident and while all the pieces were in place, serendipity nonetheless did not occur. A fuller understanding of this will support practical efforts to increase serendipity. Second, that this acknowledgement of failure from the same initial trigger will paradoxically strengthen the argument for both the arbitrary nature of the accident and the necessary nature of serendipitous networks and post-event sedimentation. Additionally, removing the human generated notion of post-event value from the accident and accepting its ontological instability allows us to move towards a systematic investigation of serendipity as a feature of extended cognitive systems (for a longer discussion of this aspect see Ross, forthcoming).

A complex human phenomenon such as serendipity which is at once an event, an experience and a rhetorical device, and which spans multiple time scales, requires a complexity of analysis and plurality of focus. The danger of a concentration on the wider aspects of the system is that this can lead to a conceptual dissipation as the skills necessary for chance discovery to be enacted are the same as the skills necessary for any

discovery to be enacted. Focusing on accidents requires being comfortable with a dynamic situation and an unstable event but, I suggest, it will restrict conceptual spread and allow us to make clearer inferences about the relative importance of that moment.

Acknowledgement I thank Vlad Glăveanu, Frédéric Vallée-Tourangeau, Thomas Ormerod, Franklin Jacoby, Maxwell Vincze and Samantha Copeland for helpful comments on a previous draft.

References

Andriani, P., Ali, A., & Mastrogiorgio, M. (2017). Measuring exaptation and its impact on innovation, search, and problem solving. *Organization Science, 28*(2), 320–338. https://doi.org/10.1287/orsc.2017.1116

Arfini, S., Bertolotti, T., & Magnani, L. (2018). The antinomies of serendipity: How to cognitively frame serendipity for scientific discoveries. *Topoi, 39*(4), 939–948. https://doi.org/10.1007/s11245-018-9571-3

Austin, J. H. (1979). The varieties of chance in scientific research. *Medical Hypotheses, 5*(7), 737–741. https://doi.org/10.1016/0306-9877(79)90035-5

Barber, B., & Fox, R. C. (1958). The case of the floppy-eared rabbits: An instance of serendipity gained and serendipity lost. *American Journal of Sociology, 64*(2), 128–136. https://doi.org/10.1086/222420

Baumeister, A. A., Hawkins, M. F., & López-Muñoz, F. (2010). Toward standardized usage of the word serendipity in the historiography of psychopharmacology. *Journal of the History of the Neurosciences, 19*(3), 253–270. https://doi.org/10.1080/09647040903188205

Beghetto, R. A. (2020). Uncertainty. In V. P. Glăveanu (Ed.), *The Palgrave encylopedia of the possible*. Palgrave MacMillan.

Björneborn, L. (2020). Adjacent possible. In V.P. Glăveanu (Ed.), *The Palgrave encyclopedia of the possible* (pp. 1–12). Springer International Publishing. https://doi.org/10.1007/978-3-319-98390-5_100-1

Boden, M. A. (2004). *The creative mind: Myths and mechanisms* (2nd ed.). Routledge.

Celle, A., Jugnet, A., Lansari, L., & L'Hôte, E. (2017). Expressing and describing surprise. In A. Celle & L. Lansari (Eds.), *Benjamins current topics* (pp. 215–244). John Benjamins Publishing Company.

Clark, A., & Chalmers, D. (1998). The extended mind. *Analysis, 58*(1), 7–19. https://doi.org/10.1093/analys/58.1.7

Copeland, S. M. (2018). "Fleming leapt on the unusual like a weasel on a vole": Challenging the paradigms of discovery in science. *Perspectives on Science, 26*(6), 694–721. https://doi.org/10.1162/posc_a_00294

Copeland, S. M. (2019). On serendipity in science: Discovery at the intersection of chance and wisdom. *Synthese, 196*, 2385–2406. https://doi.org/10.1007/s11229-017-1544-3

Csikszentmihalyi, M. (1996). *Creativity: The psychology of discovery and invention.* Harper Collins.

Csikszentmihalyi, M. (1998). Implications of a systems perspective for the study of creativity. In R. J. Sternberg (Ed.), *Handbook of creativity* (pp. 313–336). Cambridge University Press. https://www.cambridge.org/core/product/identifier/CBO9780511807916A027/type/book_part

Csikszentmihalyi, M. (2014). Society, culture, and person: A systems view of creativity. In *The systems model of creativity* (pp. 47–61). Springer.

de Rond, M. (2014). The structure of serendipity. *Culture and Organization, 20*(5), 342–358. https://doi.org/10.1080/14759551.2014.967451

Dretske, F. (2010). Triggering and structuring causes. In T. O'Connor & C. Sandis (Eds.), *A companion to the philosophy of action* (pp. 139–144). Wiley-Blackwell. https://doi.org/10.1002/9781444323528.ch18

Gaut, B. N., & Kieran, M. (2018). Philosophising about creativity. In B. N. Gaut & M. Kieran (Eds.), *Creativity and philosophy* (pp. 1–23). Routledge.

Getzels, J. W., & Csikszentmihalyi, M. (1976). *The creative vision: A longitudinal study of problem finding in art.* Wiley.

Giere, R. (2006). Perspectival pluralism. In S. H. Kellert, H. E. Longino, & C. K. Waters (Eds.), *Scientific pluralism* (pp. 26–42). University of Minnesota Press.

Glăveanu, V. P. (2019). Epilogue: Creativity as immersed detachment. *The Journal of Creative Behavior, 53*(2), 189–192. https://doi.org/10.1002/jocb.242

Glăveanu, V. P. (2020). A sociocultural theory of creativity: Bridging the social, the material, and the psychological. *Review of General Psychology.* https://doi.org/10.1177/1089268020961763

Glăveanu, V. P., & Beghetto, R. A. (2020). Creative experience: A non-standard definition of creativity. *Creativity Research Journal*, 1–6. https://doi.org/10. 1080/10400419.2020.1827606

Glăveanu, V. P., Lubart, T., Bonnardel, N., Botella, M., Biaisi, P.-M. de, Desainte-Catherine, M., Georgsdottir, A., Guillou, K., Kurtag, G., Mouchiroud, C., Storme, M., Wojtczuk, A., & Zenasni, F. (2013). Creativity as action: Findings from five creative domains. *Frontiers in Psychology, 4*, 176. https://doi.org/10.3389/fpsyg.2013.00176

Ingold, T. (2010). The textility of making. *Cambridge Journal of Economics, 34*(1), 91–102. https://doi.org/10.1093/cje/bep042

Kieran, M. (2017). Creativity as virtue of character. In E. S. Paul & S. B. Kaufman (Eds.), *The philosophy of creativity: New essays* (pp. 125–144). Oxford University Press.

Kirsh, D., & Maglio, P. (1994). On distinguishing epistemic from pragmatic action. *Cognitive Science, 18*(4), 513–549. https://doi.org/10.1207/s15516 709cog1804_1

Köhler, W. (1925). *The mentality of apes*. Liveright.

Lamb, D., & Easton, S. M. (1984). *Multiple discovery: The pattern of scientific progress*. Avebury.

Latour, B. (1999). *Pandora's hope: Essays on the reality of science studies*. Harvard University Press.

Makri, S., & Blandford, A. (2012). Coming across information serendipitously—Part 1: A process model. *Journal of Documentation, 68*, 684–705. https://doi.org/10.1108/00220411211256030

Malafouris, L. (2013). *How things shape the mind: A theory of material engagement*. MIT Press.

Malafouris, L. (2020). Thinking as "thinging": Psychology with things. *Current Directions in Psychological Science, 29*(1), 3–8. https://doi.org/10.1177/096 3721419873349

March, P. L. (2019). Playing with clay and the uncertainty of agency. A material engagement theory perspective. *Phenomenology and the Cognitive Sciences, 18*(1), 133–151. https://doi.org/10.1007/s11097-017-9552-9

Martindale, C. (1990). *The clockwork muse: The predictability of artistic change*. BasicBooks.

McCay-Peet, L., Toms, E. G., & Kelloway, E. K. (2015). Examination of relationships among serendipity, the environment, and individual differences. *Information Processing & Management, 51*(4), 391–412. https://doi.org/10. 1016/j.ipm.2015.02.004

Merton, R., & Barber, E. (2004). *The travels and adventures of serendipity: A study in sociological semantics and the sociology of science.* Princeton University press.

Montuori, A., & Purser, R. (1997). Social creativity: The challenge of complexity. *Le Dimensioni Sociali Della Creatività. Pluriverso, 1,* 78–88.

Muthukrishna, M., & Henrich, J. (2016). Innovation in the collective brain. *Philosophical Transactions of the Royal Society b: Biological Sciences, 371,* 20150192. https://doi.org/10.1098/rstb.2015.0192

Roberts, R. M. (1989). *Serendipity.* John WIley & Sons.

Ross, W. (forthcoming). Serendipity and creative cognition: Towards a systematic consideration of the serendipitous genesis of a new idea. In S. M. Copeland, M. Sand, & W. Ross (Eds.), *Serendipity science.* Springer.

Ross, W., & Arfini, S. (forthcoming). Serendipity and creative cognition. In L. J. Ball & F. Vallée-Tourangeau (Eds.), *Routledge handbook of creative cognition.*

Ross, W., Smith, S., & Vistic, J. E. (2020). Collaborative Creativity. In V. P. Glăveanu (Ed.), *The Palgrave encyclopedia of the possible.*

Ross, W., & Vallée-Tourangeau, F. (2021a). Catch that word: Interactivity, serendipity and verbal fluency in a word production task. *Psychological Research Psychologische Forschung, 85*(2), 842–856. https://doi.org/10.1007/s00426-019-01279-y

Ross, W., & Vallée-Tourangeau, F. (2021b). Rewilding cognition: Complex dynamics in open experimental systems. *Journal of Trial and Error.*

Ross, W., & Vallée-Tourangeau, F. (2021c). Microserendipity in the creative process. *Journal of Creative Behavior.*

Ross, W., & Webb, M. E. (forthcoming). Surprise. In V. P. Glăveanu (Ed.), *The Palgrave encyclopedia of the possible.*

Rowlands, M. (2018). Disclosing the world: Intentionality and 4E cognition. In A. Newen, L. De Bruin, & S. Gallagher (Eds.), *The Oxford handbook of 4E cognition* (pp. 334–352). Oxford University Press. https://doi.org/10.1093/oxfordhb/9780198735410.013.17

Rubin, V. L., Burkell, J., & Quan-Haase, A. (2011). Facets of serendipity in everyday chance encounters: A grounded theory approach to blog analysis. *Information Research, 16.* https://doi.org/

Sawyer, R. K. (2018). How artists create: An empirical study of MFA painting students. *The Journal of Creative Behavior, 52,* 127–141. https://doi.org/10.1002/jocb.136

Simonton, D. K. (2004). *Creativity in science: Chance, logic, genius, and zeitgeist.* Cambridge University Press.

Solomon, Y. (2016). Temporal aspects of info-serendipity. *Temporalités*, 24. https://doi.org/10.4000/temporalites.3523.

Steffensen, S. V., & Vallée-Tourangeau, F. (2018). An ecological perspective on insight problem solving. In F. Vallée-Tourangeau (Ed.), *Insight: On the origins of new ideas* (pp. 169–190). Routledge.

Van Andel, P. (1994). Anatomy of the unsought finding. *The British Journal for the Philosophy of Science*, 45, 631–648. http://www.jstor.org/stable/687687

Wallas, G. (1926). *The art of thought*. Jonathan Cape.

Weisberg, R. (2010). The study of creativity: From genius to cognitive science. *International Journal of Cultural Policy, 16* (3), 235–253. https://doi.org/10.1080/10286630903111639

Winfree, A. T. (1984). The prehistory of the Belousov-Zhabotinsky oscillator. *Journal of Chemical Education, 61*(8), 661. https://doi.org/10.1021/ed061p661

Yaqub, O. (2018). Serendipity: Towards a taxonomy and a theory. *Research Policy, 47*, 169–179. https://doi.org/10.1016/j.respol.2017.10.007

Space for the Unexpected: Serendipity in Immersive Theatre

Rose Turner and Hayley Kasperczyk

Theatregoing is a key feature of contemporary culture. Mainstream theatre encompasses a wide range of styles, including "serious" plays (e.g., drawing room dramas and the works of Shakespeare) and populist pantomime, musical theatre and farce (Bull, 2004). Productions at either end of this spectrum typically take place in conventional proscenium arch theatre spaces. The proscenium arch (which may or may not be arched in shape) is the architectural frame surrounding the stage. It creates a fairly unified view of the performance with the audience making up the "fourth wall"—the imagined wall which separates stage from spectators—of the play's setting. In Shakespeare's *Macbeth*, for example,

R. Turner (✉)
University of the Arts London, London, UK
e-mail: r.turner@fashion.arts.ac.uk

H. Kasperczyk
Independent Practictioner, London, UK

© The Author(s), under exclusive license to Springer Nature
Switzerland AG 2022
W. Ross and S. Copeland (eds.), *The Art of Serendipity*,
Palgrave Studies in Creativity and Culture,
https://doi.org/10.1007/978-3-030-84478-3_5

audiences observe King Duncan's murder and Lady Macbeth's descent into madness from the edge of the king's chamber and the walls of the castle. This set-up positions the audience as voyeurs, or passive witnesses of the action.

In the 1970s, alternative theatre spaces started to appear in Europe and North America, including smaller studios attached to established theatres, and these programmed experimental works that were not being seen on the main stages. Today, these versatile spaces continue to enable a range of staging modes (e.g., the audience positioned around [in-the-round] or either side of the stage [traverse], or moving between scenes [promenade]), which break the fourth wall and facilitate multiple perspectives on the action. During the 1970s, the number of performance art, physical, community and educational theatre groups in the UK grew from around forty to well over 200 (Bull, 2004). These companies utilised studio spaces as well as a range of non-theatre venues; their "rich, ideologically contradictory, theatrical turbulence" (Bull, 2004, p. 362) reflected the volatility of the social and political context (rioting and strike action had destabilised both the private and public sectors). It would be another four decades, however, before these more radical approaches to theatrical staging began to move into the mainstream (White, 2012).

In 2011, at an abandoned club in Chelsea, New York, *Punchdrunk* staged a reimagining of "Macbeth" entitled "Sleep No More" (Barrett & Doyle, 2011; developed from their 2003 London version). In this incarnation, instead of making up the fourth wall, theatregoers were encouraged to wander between rooms across five floors, follow performers through the space and explore scenes and props. They were instructed to maintain physical distance with the characters but encouraged to make eye contact with them, which could lead to private interactions. As a result of this individually guided method, scenes could be viewed in various sequences, and plot segments could be emphasised or missed out, with each audience member experiencing a uniquely fragmented version of the story. This approach was credited with the rapid development of the so-called modern "immersive" theatre movement in New York (e.g., Mandell, 2016) and London (following the premiere of *Punchdrunk's*

"The Masque of the Red Death", a retelling of Edgar Allen Poe's tales staged in a repurposed Victorian town hall; Barrett & Doyle, 2007).

Following commercial success of the newly popular immersive mode, "theatre's new buzzword" (Gardner, 2012) began to be applied to a range of productions that involved some level of audience interaction, were interdisciplinary, or were staged in unusual spaces (e.g., Machon, 2016; White, 2012).[1] Indeed, the modern immersive theatre established by *Punchdrunk* shares key characteristics with other avant-garde practices (see Lock & Sikk, Sneddon, this volume). Like immersive theatre, "postdramatic" theatre (Lehmann, 2006) moves away from linear narrative and emphasises the experiences of spectators, often incorporating live interactions between performers and audiences. Performance art[2] differs from immersive theatre in that it tends towards testing boundaries and pushing performers to physical and psychological extremes, rather than emulating life through narrative. However, it too aims to generate experiences for audiences (rather than simply transmitting a narrative) and relies on the engagement of individual audience members in order to realise the meaning of the work. The treatment of the audience as individuals rather than a unified mass distances these forms from mainstream proscenium arch theatre. Furthermore, performance art and immersive theatre both incorporate "real" elements as opposed to the artificial and metaphorical elements of mainstream theatre (e.g., fake blood, acted emotions, representational backdrops).[3] However, the central tenet of immersive productions is the careful selection and curation of (often non-theatre) space. This is especially true of *Punchdrunk*, whose elaborate, large-scale interiors have proven particularly appealing to theatregoers (White, 2012). In mainstream theatre, as well as in other contemporary practices, the location of the performance space is unimportant and usually unrelated to the production's content, hence the

[1] The precise origin of the term "immersive theatre" is unknown. It appears in Kershaw's (1999; 2007) description of the highly sensory and poignant experience of being in the dramatist Vargas's audience.

[2] This term came into use in the 1970s and refers to a range of live art practices developed from the visual arts and including happenings, guerrilla events and body art.

[3] Marina Abramović, the grande dame of performance art, distances performance art from theatre, which she denotes as "fake" (A Sky Filled with Shooting Stars, 2010).

production may tour a range of theatre venues. In immersive theatre, the space may be a repurposed site or an existing theatre venue which has been transformed to imitate the world of the narrative.

Thus, despite elements in common with other theatre practices, it is the concomitance of three dimensions which characterises immersive theatre (Biggin, 2017; Mandell, 2016): First, the audience is invited into a carefully selected, curated and often scenographically detailed space, which functions both as performance venue and as museum or installation. Detailed design elements define the space as inherently theatrical and facilitate emotional responses (Barrett & Machon, 2007). This exploratory environment (White, 2012) affords multisensory engagement: like mainstream, community and interactive theatre, the environment stimulates sight and sound but, unlike those forms, also touch, smell and even taste. Second, narrative is conveyed through performers and props (e.g., letters or newspaper cuttings) and this may be multi-layered, non-linear and episodic. Third, audience subjectivity is integral to the piece, which moves away from mainstream theatre's treatment of the audience as a mass entity. Audience experiences can be both personal and social (involving participation in small groups, for example), and can include dialogue with performers, interactions with props and guiding oneself around the venue. By combining these elements, immersive theatre provides a unique context for audiences to take ownership of literary narratives and imbue them with new and personally resonant meanings.

Serendipity

The context created by this combination of elements gives rise to serendipity, wherein fortuitous accidents emerge from the interplay between people and environmental elements (e.g., McCay-Peet & Toms, 2015). In immersive theatre, the environment (the venue, scenography and props), is curated by people (the creative team). This provides a space for personal and unexpected encounters to shape other people's (the audience's) individual interpretations and understandings of the narrative. Whilst it is not possible to orchestrate or predict an agent's serendipitous

encounters (Björneborn, 2017), in this setting, environmental elements can potentiate serendipity, allowing for the emergence of truly serendipitous experiences (as opposed to hyper-personalised or "sensational" serendipities geared towards specific individuals; Reviglio, 2019). This chapter explores the emergence of serendipity in the context of immersive theatre. We move away from more generalised applications of the term "immersive theatre" (Machon, 2016) and recognise it as constituted through serendipitous interactions that arise from the interplay between audience, performers and narrative elements within the bounds of a curated environment. We draw on complementary approaches to understanding spectatorship and performative spaces to illustrate this interplay, and consider how environments designed to initiate playfulness are central in preparing the mind to identify, appreciate and utilise the unexpected.[4]

From Spectator to Spect-Actor

> All things are ready if our minds be so.
> —Shakespeare, *Henry V, Act IV*

Theatre requires an audience; without one, it is merely a rehearsal. Boal (1974/2000, p. xx) used the term "spect-actors" to describe attendees of forum theatre[5] who were able to direct the course of events; for example, by suggesting actions that a character facing a problem should try next. Whilst spectators passively observe, spect-actors participate and disrupt;

[4] Whilst this chapter focuses on live (real-time) theatre, meanings of film and literature are also realised in the space between the creatives' intentions (e.g., author, director, performers) and audience's interpretations (see, for example, Frampton, 2006). A key difference, however, is that immersive theatre narratives provide a framework for the action but are not predetermined and so are actively shaped by the audience.

[5] Forum theatre is a form of community theatre pioneered by Augusto Boal. Scenes usually demonstrate a character or characters experiencing oppression, and audience members are invited to take a directorial role, stopping and altering the course of events. This affords the exploration of a range of scenarios which may be applicable to real-life social issues.

they are "dynamic creators of significance" rather than "simple receptors of textual meaning" (Barker, 2004, p. 1). Boal viewed mainstream theatre as perpetuating elitist versions of the world that functioned to pacify audiences. His approach foregrounded the role of the audience in order to imbue them with power over the narrative and to democratise theatrical storytelling.

In immersive theatre, too, the audience is invited to take ownership of the narrative and to explore it in depth. Whilst forum theatre allows a limited number of individuals from the audience to "trespass" (Boal, 1974/2000, p. xxi) into the fictional (stage) space in order to steer the action, this in itself does not constitute an immersive event. Due to the tendency for experimental productions to manifest in unusual, repurposed and sometimes public spaces, individuals may pass by parts of a performance without knowing. If I encounter a street production blocking my route but do not recognise it as a rehearsed piece, I have not experienced a performance but an inconvenience, hence the importance of a curated environment. In immersive theatre, the audience does not trespass but is *invited* into the performance space where they become an inhabitant of the fictional world. To have experienced an immersive theatre production I must not only be aware of its existence, but of how my encounters and actions have created that experience as uniquely my own. I must not only bear witness to it, but also take control of and be able to reflect on my role in the unfolding of drama.[6] Crucially, the spect-actor must be prompted to engage with the production in a self-guided and reflective way.

Making the Familiar Strange

The spect-actor can be prompted towards this self-guided and reflective mode via "defamiliarization", a technique in which familiar things are presented to audiences in strange ways (Shklovsky, 2015). This strange-making jolts the individual into a heightened state of awareness, which prompts active, reflective and intellectual engagement with the content

[6] This mirrors the nature of serendipity itself, which requires recognition by the agent (Copeland, 2019; McCay-Peet et al., 2015).

of the work. Whilst defamiliarization is not specific to theatre (or any artistic medium; film and other narrative modes too can defamiliarize audiences), theatre offers a range of techniques that can serve to make the familiar strange. In the satirical plays of Brecht, for example, defamiliarization techniques such as breaking the fourth wall by directly addressing the audience, third-person narration, or a sparse aesthetic combined with the use of placards to signify locations and character identities were used to highlight political and social issues such as poverty, corruption and fascism (e.g., the ascent of the Nazi Party in pre-war Germany, portrayed in the guise of "The Resistible Rise of Arturo Ui"; Brecht, 1941/1993).

Rather than providing entertainment to be absorbed, enjoyed and emoted with, Brecht (in line with Boal) encouraged intellectual engagement with social and political ideologies. However, whilst drawing audiences in intellectually, Brecht kept them physically separate from the staged action. By contrast, the immersive theatre audience's own presence within the fictional space juxtaposes with the authentic set and costume elements that situate the fictional world. This both highlights and disintegrates the boundary between two coexisting realities: that of the audience (the "real" world) and that of the characters (the fictional world): "[the spect-actor] exists in the scene and outside of it, in a dual reality… not just in the fiction, but also in his social reality" (Boal, 1974/2000, p. xxi).

Spect-Actors as Co-Creators

Defamiliarization in this context prepares the mind for serendipitous encounters to occur (see Pasteur's notion of the prepared mind in van Andel, 1994 see also Glăveanu, Le Hunte, this volume): it functions to "stimulate the imagination of the spectator, to provoke questioning and to embrace her in an interpretive and critical process" (Pearson & Shanks, 2001, p. 119). It prompts audience members to be actively "present" and, to this end, moves them from a mode of *seeing* to a mode of *doing* (Seegert, 2009). Thus, their presence becomes performative and they transform into a co-creator of the production (see Papaioannou, 2014):

> Not content with watching, I wanted to feel [the performance's] force, its warmth, its wetness. That desire to experience more fully is at the heart of immersive theatre, which can place us in situations that we are unlikely to encounter in our everyday lives, rather than merely placing them before us. (Trueman, 2010, paras 1–2)

In immersive theatre, a full experience is an interactive one; however, spectators do not automatically become spect-actors when opportunities for "doing" (acting on and interacting with production elements) present themselves. First, opportunities for, and expectations of, audience participation vary between tacit and overt (Keefe, 2015). These can range from simple (e.g., the ability to self-guide around the space but with no interactions with characters), to more complex (e.g., taking on a character and taking on dialogue). In some performances, audiences may be invited, but not required, to interact: they can "go with the flow" (Papaioannou, 2014, p. 161) and get involved to the extent that they wish. In others, audiences may be expected to take on roles, such as in *You Me Bum Bum Train's* eponymous production (Bond & Lloyd, 2012), which transported audience members into narrative episodes where they were directly treated as each episode's protagonist (Howson-Griffiths, 2019). Second, audience members will have different perceptions of "theatricality", evolved from experience with both mainstream and unconventional theatre stagings (Papaioannou, 2014). Prior experience of mainstream theatre may restrict interactions and reduce inquisitiveness (e.g., via "mental set", a form of fixed thinking in which creativity is constrained by prior experience with the situation, object or problem being engaged with; Schultz & Searleman, 2002) as audiences may perceive themselves as onlookers rather than as participants. Conversely, experienced theatregoers may feel comfortable in the performance space and more likely to engage in an active and performative way, manifesting their potential as co-creators of the production. This may be particularly true in productions which invite complex participation.

The extent to which audience members are willing to contribute actively to the unfolding of narrative is therefore dependent on characteristics of the individual as well as the design of the production. Thus,

agencies interact in the realisation of the performance: those of the spect-actors with those of the creative team (writers, directors, designers and performers). In designing the work, the creatives cannot make assumptions about each audience member's "serendipitous proclivity" (de Rond, 2014): their preparedness, in this context, to identify with their role as co-creator and make use of the opportunities provided by the environment. Rather, each spect-actor will explore in a way that cannot be individually planned for (see Björneborn, 2017). They can, however, design a spatial context that encourages spect-actorship, workshop potential audience interactions and develop plans for performers to steer the action in order to facilitate communication of the narrative. We now turn to the elements that constitute this context.

Site, Space and Sound

> ...the memorable is that which can be dreamed about a place. In this place that is a palimpsest, subjectivity is already linked to the absence that structures it as existence and makes it "be there". (De Certeau, 1988, p. 106)

A "palimpsest" is a parchment or writing material from which text has been erased or obscured by later writing, but that still holds visible remnants of its earlier message. In an architectural sense, the palimpsest exists as traces in or on buildings or structures that signal a previous use. Immersive theatre sites tend to have present or historic functions beyond being performance venues, as town halls, warehouses, or fire stations, for example. The palimpsest manifests as signifiers (such as building materials and signage) that denote the site's alternate or previous functions.

Dreamthinkspeak's production "Underground" (Sharps, 2005), based on Dostoyevsky's (1866/1956) "Crime and Punishment", took place in a disused abattoir in central London. The physical attributes of the space—a maze of stone walls and damp rooms—emulated the crowded streets of 1860s St. Petersburg; the setting of Dostoyevsky's novel. At this site, audiences encountered characters and witnessed sections of

Dostoyevsky's text performed, while being free to explore the venue by their own volition. The dark and damp smell of the abattoir reflected the sensory experiences depicted in the first chapter of the novel. The traces of the abattoir, both sensory and atmospheric, emphasised the narrative's themes of crime, punishment and death. *Guild of Misrule's* long-running production of "The Great Gatsby" (Wright, 2017), kitted out the tunnelled structure of London's underground Vaults venue with décor representative of Gatsby's mansion, and for "On the Ropes" (Carmichael, 2014), *Salon:Collective* constructed an underground boxing ring in the cellar of an old BBC (British Broadcasting Corporation) building. In such set-ups the real juxtaposes with the fictitious. This displacement of order or "cross-programming" (Tschumi, 1996, p. 205) serves to defamiliarize the space and prepares the spect-actor to readdress and engage with it in new and different ways. In other words, if the space is presented in an unexpected way, traditional modes of being in that space become disrupted.

Moving Through Space

Immersive theatre audiences are encouraged to journey through the space in a way that activates, entices, and invites exploration and rediscovery. Unlike general modes of moving through the world, such as meandering, strolling or travelling somewhere specific, this approach can be understood as akin to the dérive, a spatial practice used by the situationists that offers a new approach to negotiating urban landscapes:

> It is the pedestrians who transform the street into a space. Yet this walking is often orientated. We are drawn back to significant places, familiar places, memorable places, weaving them together in improvised narratives. We both read and write. Through memory and imagination, we can claim a measure of control. (Pearson & Shanks, 2001, p. 149)

In the mode of the dérive, people abandon their usual motives for movement and action, and instead let themselves be "drawn by the attractions of the terrain and the encounters that they find there" (Debord, 1958/1981, p. 2). This instinctive practice allows for the discovery of

space extricated from expectations about how and why it should be used. Spect-actors of immersive theatre are invited to adopt this mode by responding to the environment and its affordances, rather than to pre-existing agendas (this responsiveness brings to mind the notion of metis, see Copeland, this volume). In this way, the act of repurposing space functions to initiate a new attitude or "spirit of discovery" (Debord, 1958/1981), and invites curiosity and exploration (see Glăveanu, this volume).

A porous space is one which allows for exploration via a range of movement options such as through doors and corridors, up and down stairs and elevators. Such spaces provide "safe" zones for inquisition and support the spect-actors' sense of having "creative agency" (Machon, 2016, p. 36). In these zones, spect-actors can feel safe to interact playfully with objects, characters and space ("can I climb through that window?"; "should I follow this person down that dark corridor?"; "shall I see what's through this door marked *do not enter?*"), opening up new possibilities for discovery.[7]

The dérive is both a generative and an iterative process (as is serendipity itself; McCay-Peet & Toms, 2015, see also Piñeyro, this volume): it initiates encounters which, in turn, inform and direct the experience of the dérive. It also involves moments of non-activity, stopping and emptiness (e.g., Lavery, 2018), which provide opportunities for reflection on what has gone before, and what might be sought after next. Thus, the dérive requires live and conscious responses to stimuli and reflection on the opportunities presented in the space. It is a mode in which prior decisions affect future ones, and so moments of serendipity that arise are temporally situated. For example, a chosen route may be unexpectedly obstructed or empty, prompting a new pathway that leads to a space overfilled with other spect-actors. Because of the prior dead-end, the spect-actor may find themselves enticed by the new, more populated space, and more ready to interact with what they find there.

Auditory aspects of the performance (music, soundscape, performers' lines, audience voices and footsteps) can also guide the dérive. Sounds

[7] The emphasis on risk-taking has led this mode of participation to be described as "entrepreneurial"; Alston, 2013).

are differently processed depending on the listener's orientation in, and movement through, space. Therefore, a unique soundscape is experienced by each audience member, providing atmosphere, drawing attention and guiding action. Auditory atmospheres can juxtapose with scenographic elements and defamiliarize the space, and so engaging with sound stops being a passive experience; rather, auditory cues (designed by the creative team) can guide the drive.

> ...whilst the listener resides in the medium of sound, this medium must be attended, explored and travelled through. Being-in-sound, like being-in-the-world, does not consist of a static, passive and spherical existence, but is characterised by a dynamic, three-dimensional, ongoing engagement with any given sonic environment. (Home-Cook, 2015, p. 131)

Spatial and sensory configurations provide the "source material" (Howson-Griffiths, 2019, p. 4) for the spect-actor's choices as they travel through the space and develop their unique experience of the narrative. *Punchdrunk's* "The Drowned Man" (Barrett & Doyle, 2013, 2014) was set within a fictional Hollywood film studio but located in a disused postal sorting office in a busy area of London. Spect-actors were instructed to enter an elevator, then divided into groups and ushered out at different levels of the building. After arriving at their floor of the building, they were able to explore a range of spaces and props: one room full of racks of clothes, a caravan in another, elsewhere a bar with a singer. Depending on the floor visited first, and subsequent routes taken, the spect-actor would have encountered some, but not all, of these elements, their unique experience of the narrative arising from sequences of choices made in response to spatial layouts. Witnessing others exit on different floors underlined the range of routes through the site and consequent divergence of experiences. Individuals may have wondered whether their floor was the "best" place to start, facilitating reflection on the various encounters that formed their unique perspective on the production.

In the mode of the dérive, environmental and sensory elements become inseparable from the individual's decision-making processes when choosing routes through space. The space is curated in such a way

as to invite playful and inquisitive behaviours so that the "unexpected can be prepared for and thus acted upon when it explodes into view" (Lavery, 2018, p. 7). These behaviours can lead to surprising encounters which both contribute to the individual's understanding of the narrative and invite further interaction, ultimately developing their experience of the production.

People and Things in Space

In immersive theatre, narratives are deconstructed and distributed throughout the spatial environment (White, 2012). Spect-actors encounter fragments of narrative conveyed through performers and objects as they journey through the space. They respond to both the physicality of objects in space (physical affordances) and their symbolic meaning (perceptual affordances). For example, a key innovation of *Punchdrunk*'s method is the provision of masks to the audience. These symbolically imbue individuals with "ghost" or "spirit" identities (by hiding the spect-actors' identities from the characters), whilst distinguishing performers from audience and signifying theatricality (masks have historically been used in theatrical productions throughout the world). Spect-actors experience the cognitive and behavioural effects of wearing masks on their faces: focusing the gaze, the lack of peripheral vision's impact on attention and movement, the disinhibiting effects of anonymity and reduction in visibility of other audience members (Papaioannou, 2014; White, 2012; see also, Adam & Galinsky's, 2012, work on "enclothed cognition").

The spect-actor's responses to objects and encounters during the performance are modulated by associated knowledge (e.g., of similar objects or scenes), personality factors (e.g., curiosity or "openness to experience", Costa & McCrae, 1992), mood states (e.g., optimism or anxiety), memories, associations and preferences (Howson-Griffiths, 2019), values and personal histories (Heddon et al., 2012), as well as the site's traces (Biggin, 2017). Reception of mainstream theatre is also influenced by the individual's characteristics: spectators may derive different

meanings from the same scene. However, in immersive theatre, the relationship between these characteristics and properties of the space can directly impact the unfolding narrative (Hogarth et al., 2018). If a space is darkly lit, for example, it may generate suspicion, foreboding, or excitement, and this response will affect the way that the individual enters the space and engages with what he or she discovers there (see Debord's, 1958/1981, articulation of "psychogeography"). If an isolated object (or character) appears in an otherwise sparse area, it may incite interest or trepidation. The first spect-actor might ignore a locked drawer, but the second may search for the key. Perhaps the drawer contains a note to be given to a character in the next room, leading to a confession: a plot twist. The first spect-actor will never encounter this part of the narrative, but for the second, this represents a moment of serendipity: a discovery that results from a choice, made in a particular moment, in response to an (pre-designed) environmental affordance.

By setting up the space to invite playful exploration, performative behaviours and risk-taking, immersive theatre can disrupt relatively stable individual traits; a person who tends to be cautious in the real world may be adventurous when travelling through the safe zone of the dérive (see also Le Hunte, this volume). The notion of the "punctum" provides an explanation of idiosyncratic engagement that emphasises the roles of both (defamiliarized) objects in the environment and individually guided action: The punctum is the intensely subjective effect of a photograph on the viewer. It is an aspect—often a tiny detail—that ignites a personal thought or memory; "that accident which pricks me (but also bruises me), is poignant to me" (Barthes, 1980/2000, p. 27). In immersive theatre, the punctum will guide spect-actors to engage with objects and may be intentionally introduced by the theatre-makers (e.g., defamiliarization of a social scene or a particular object via illumination with a spotlight), or accidental, arising from personal resonances felt by individuals (e.g., fragrances, textures or dialogue that trigger a latent memory). The creative potential of the performance, therefore, resides not only with agents (audiences and creatives), but also in the affordances of objects, and is realised through their interaction.

After "curtain-up"—the start of the performance—the writers, directors and designers relinquish control over the environment they have

created. Instead, performers and spect-actors share responsibility for shaping the narrative (see also Lock & Sikk, this volume). Transgression of conventional performer–audience boundaries generates proximal intimacy between performers and audience, from which emotional intimacy can arise:

> I have fun improvising with audiences in interactive shows. I enjoy the back-and-forth with audiences in some relaxed performances I run. I like having to focus on an audience member so much in a one-on-one show that I'll know how they're feeling from how they're breathing. I like the immediacy of everyone being in the same space, of that instant response, of the space for feedback in the moment. (Mashiter, interviewed in Coney, 2018, para. 7)

However, there is a power dynamic at play in the relationship between performer and audience: the performer represents a character whereas the spect-actor enters the space as themselves (Hogarth et al., 2018). Nevertheless, the success of immersive theatre is contingent on the spect-actor's willingness to influence the narrative, a power that resides solely with the performers in proscenium arch theatre.

Spect-actors may become characters in the performance: instigators, agitators, confidantes, messengers or witnesses. A willing spect-actor might initiate a new scene and become involved in dialogue or respond as a "player" in a game (e.g., Coney, 2018). Performers can elaborate or encourage these behaviours depending on their effects on the scripted narrative. The spect-actor becomes imbued with a sense of creative freedom although they may have limited influence over the narrative (e.g., they may "play a role" but not that of the protagonist).[8] Nevertheless, if a performer successfully encourages audience participation, the spect-actor will feel that they have been uniquely integral to the piece (Hogarth et al., 2018). By encouraging individuals to take ownership

[8] The reality of a spect-actors' impact on the narrative varies between productions. In "Sleep No More", individuals were able to construct their own plotlines based on their movements in space, but were still positioned as voyeurs rather than agents (as if invisible yet still able to approach characters and explore the environment). The impression of having agency, of being able to make choices that impact the narrative, is key to the immersive theatre experience, rather than the actual impact of those choices (see White, 2012).

over interactions and, consequently, the art being shaped, performers can cultivate the spect-actor's sense of agency and recognition of their role as co-creator. This reflective element, which focuses on the process rather than just the outcome, is essential for the emergence of serendipity (Copeland, 2019; McCay-Peet et al., 2015).

The immersive theatre performer's job is complex. It requires a range of skills including listening, the ability to interpret gestures and relationship-building (Hogarth et al., 2018). They must develop sufficient rapport with the audience to facilitate meaningful interactions and competently improvise in these interactions. At the same time, they are required to meet their "marks": the predetermined, rehearsed elements of script (designed by the creative team) which may include spoken text, actions and timed interactions with other characters, visuals or sounds. This results in tension between the rehearsed script, the organisation of objects in the environment and the influence of the spect-actors. Consequently, the story emerges from the coalescence of the scripted world (imagined by the writer, director and performers), the real world of "now" (the world created through audience participation) and the imagined world (privately produced in the minds of spect-actors; Hogarth, et al., 2018). Because each interaction (with performers, objects, or other spect-actors) affords a range of subsequent unpredictable actions, there emerge as many imagined worlds as there are spect-actors.

Moreover, as spect-actors are not isolated but are free to interact with one another, their inter-relationships may further evolve the narrative. A particularly evocative example of the ways that spect-actor interactions impact the work can be seen in Marina Abramović's (1974) performance art piece "Rhythm 0" (like immersive theatre, performance art tends to centralise audience subjectivity whilst disrupting audience–performer boundaries). In the piece, Abramović positioned herself alongside a table of objects with the following instruction: "*There are 72 objects on the table that one can use on me as desired. Performance. I am the object. During this period I take full responsibility. Duration: 6 h (8 pm – 2 am)*". Some spect-actors used "pleasure" objects (e.g., perfume, feather, honey) on the artist's body, whereas others used "pain" objects (e.g., scissors, knife, a loaded gun). Theatre critic McEvilly, present at the performance,

described how conflict was instigated when spect-actors began to adopt contrasting roles:

> Faced with her abdication of will, with its implied collapse of human psychology, a protective group began to define itself in the audience. When a loaded gun was thrust to [the artist's] head and her own finger was being worked around the trigger, a fight broke out between the audience factions. (Ward, 2012, p. 120)

"Rhythm 0" thus emerged as a work of performance art through the interactions of multiple agents and objects. As a result, no two performances would be the same and could, in fact, differ dramatically. The same process occurs in immersive theatre: each iteration of a production necessarily varies from the first, as it is constituted through new configurations of curator, performer and spect-actor co-creativity.

Serendipity in Immersive Theatre: Preparation to Reflection

In mainstream theatre, the proscenium arch frames the action, offering the audience one specific viewpoint (e.g., "fly-on-the-wall") on the story. Immersive theatre, on the other hand, affords a plurality of perspectives. The configuration of site and set elements functions to provide a context that engenders active engagement and participation. These components operate both as fictitious frame (the edges of the fictional world) and as a framework that invites a playful, exploratory mindset. Before the piece begins, carefully curated parameters (scripted scenes, cross-programmed space and set elements) are designed to convey particular meanings, as well as to defamiliarize the audience and invite them to adopt playful and inquisitive modes of thinking and behaving (e.g., the mode of the dérive). These elements prepare the mind for serendipity. During the production, differences in individuals' interactions are triggered by idiosyncratic thoughts, memories and motivations in response to environmental elements (the punctum). These features do not guarantee serendipitous moments, but weave opportunities for playfulness

and discovery into the relationship between curated space, performers and the audience (Howson-Griffiths, 2019): "we cannot 'engineer' nor 'design' serendipity per se, but can design affordances for serendipity" (Björneborn, 2017, p. 1053). Serendipitous moments emerge via inseparable combinations of individual agencies and environmental elements.

The embodied experience of entering the theatrical space and engaging with objects in the fictional world promotes a heightened awareness of the role of the self within the space as co-creator of the artwork. This sense of one's own creative agency (ability to influence the emergent art product and one's own experience of it), awareness of the range of possible choices about where to go and who or what to interact with and the presence of others making different choices, prompts reflection on the personal nature of encounters (Shearing, 2017). Reflection is central to the construction of the immersive theatre experience as well as to conceptions of serendipity itself: in both, the process of discovery is as important as the outcome (Copeland, 2019; McCay-Peet et al., 2015).

Audience reflections are not confined to the timeframe of the production: meaning may be construed in the moment, after the production has finished, and even long after (see Foster & Ellis, 2014). For example, in subsequently comparing their respective journeys through a production, two spect-actors may begin to appreciate the uniqueness of their experience (see Shearing, 2015). Following a conversation with a friend who also attended the same show, I might learn of a room or floor in the venue that I missed or, after sharing details of a one-to-one interaction with a character, I might discover that my friend had no such interaction. Through our conversation, we gather additional information about the narrative and reflect on how our choices during the production helped to create our unique and personal perspectives on it. The immersive theatre performance continues to be written after the show has closed. Serendipities may continue to arise as new associations in the real world alter perceptions of the theatrical event. Furthermore, because it initiates reflection both during and after the event, immersive theatre may prime individuals to recognise serendipitous encounters that emerge

through interactions between agents, material and social environments, not just in art but in the everyday.[9]

A Note on Terminology

The term "immersive theatre" has been used throughout this chapter to describe the brand of theatrical storytelling developed by *Punchdrunk* and others: that which is, we suggest, constituted by serendipitous moments arising from the interplay between agents, environment and narrative elements. However, as a prepared, reflective mindset is a precondition of serendipity (see Copeland, 2019; McCay-Peet et al., 2015), the term "immersive" invites some reconsideration. "Immersion" is a heterogenous concept (Shearing, 2017; see also, Howson-Griffiths, 2019), but it is commonly associated with the non-critical process of becoming temporarily absorbed in an activity or atmosphere, or "transported" into a narrative world (e.g., Gerrig, 1993). The influence of immersive stories (in literature, theatre or film) occurs unconsciously and peripherally; for example, a compelling story may affect a person's beliefs about the world outside of their conscious awareness. However, stories can also influence people via more central, analytical routes (Chaiken, 1987; Escalas, 2007; Petty & Cacioppo, 1986) and this kind of process may be prompted by defamiliarization. As we have discussed, rather than becoming passively absorbed or "immersed", immersive theatre audiences are invited to actively engage with and reflect on their experiences. We suggest, therefore, that the designation of "immersive" to this theatrical genre is a misnomer. Instead, we define immersive theatre

[9] Immersive theatre may also develop other faculties. For example, engaging with narratives has been shown to develop empathic abilities (e.g., Dodell-Feder & Tamir, 2018) and improvisation may support divergent thinking and creative problem-solving (e.g., Lovatt, 2018). The positive impact of narrative-engagement has led to its employment across a range of social enterprises and projects aimed at developing social relationships and skills (e.g., Clean Break, n.d.; Empathy Museum, n.d., Ladder to the Moon, 2015). Whilst the individual spect-actor co-creates the immersive theatre piece, the piece may also have lasting implications for the individual's creative mindset.

as emerging, and only emerging, via conscious interpretation of unique and personal experiences and meanings, which arise serendipitously from the dynamic interplay between agents, narratives and the theatrical environment.

Space for the Unexpected: Summary

The purpose of immersive theatre is not to invite immersed, passive engagement, but to awaken, illuminate and involve. Inviting audiences to share responsibility for shaping the narrative offers the opportunity to disrupt authorial intentions and imbue the narrative with new and personal meanings. In mainstream proscenium arch theatre, the demarcation between performer and audience offers little opportunity for new or unexpected moments to occur. Immersive theatre, on the other hand, both requires, and is constituted through, the active engagement of individuals leading to moments of serendipity which function as narrative pivots.

Moments of serendipity do not occur by chance alone, nor are they merely the remit of particularly open-minded audiences. In immersive theatre, the encounters that make up an individual's unique experience of a production and, consequently, a version of the emergent art product, are enabled by (a) a carefully designed narrative structure monitored and developed by performers, and (b) the purposefully curated conditions of the space and presentation of objects within it. The narrative is not transmitted from one mind to another via performers; rather, the creative team, performers and audience become its co-creators. The creative team designs an environment with a specific set of affordances. This context prepares the minds of spect-actors to engage with and reflect on unexpected moments of serendipity, which develop their personal experience of the narrative. This symbiosis of agents and spaces represents the unique promise of immersive theatre.

References

Abramović, M. (1974). *Rhythm 0* by M. Abramović [Performance art production]. Studio Morra, Naples.

Adam, H. & Galinsky, A. D. (2012). Enclothed cognition. *Journal of Experimental Social Psychology, 48*, 918–925. https://doi.org/10.1016/j.jesp.2012.02.008

Alston, A. (2013). Audience participation and neoliberal value: Risk, agency and responsibility in immersive theatre. *Performance Research, 18*, 128–138. https://doi.org/10.1080/13528165.2013.807177

A Sky Filled with Shooting Stars. (2010, March 10). *"The knife is real, the blood is real, and the emotions are real." —Robert Ayers in conversation with Marina Abramović.* http://www.askyfilledwithshootingstars.com/wordpress/?p=1197

Barker, C. (2004). *Sage dictionary of cultural studies.* Sage.

Barrett, F., & Doyle, M. (2007). *The masque of the red death* by Punchdrunk [Theatre production]. Battersea Arts Centre.

Barrett, F., & Doyle, M. (2011). *Sleep no more* by Punchdrunk [Theatre production].

Barrett, F. & Doyle, M. (2013–2014). *The drowned man* by Punchdrunk [Theatre production].

Barrett, F., & Machon, J. (2007). Felix Barrett in discussion with Josephine Machon. *Body, Space & Technology, 7*(1). http://people.brunel.ac.uk/bst/vol0701/felixbarrett/.

Barthes, R. (1974). *S/Z: An essay.* Hill and Wang.

Barthes, R. (1980/2000) *Camera Lucida.* Vintage

Biggin, R. (2017). *Immersive theatre and audience experience: Space, game and story in the work of Punchdrunk.* Palgrave Macmillan; Springer Nature.

Björneborn, L. (2017). Three key affordances for serendipity: Toward a framework connecting environmental and personal factors in serendipitous encounters. *Journal of Documentation, 73*, 1053–1081. https://doi.org/10.1108/JD-07-2016-0097

Boal, A. (1974/2000). *Theater of the oppressed.* (C. A. McBride, M.-O. L. McBride & E. Fryer, Trans.). Pluto. (Original work published 1974).

Bond, K., & Lloyd, M. (2012). *You Me Bum Bum Train* by K. Bond & M. Lloyd [Theatre production].

Brecht, B. (1941/1993). *The resistible rise of Arturo Ui* (S. S. Brecht, Trans.). Methuen. (Original work published 1941).

Bull, J. (2004). The establishment of mainstream theatre, 1946–1979. Since 1895In B. Kershaw (Ed.), *The Cambridge history of British theatre* (Vol. 3, pp. 326–348). Cambridge University Press.

Carmichael, L. (2014). *On the ropes* by Salon:Collective. [Theatre production]. Theatre Delicatessen.

Chaiken, S. (1987). The heuristic model of persuasion. In M. P. Zanna, J. M. Olson, & C. P. Herman (Eds.), *Social Influence: The Ontario Symposium* (Vol. 5, pp. 3–39). Erlbaum.

Clean Break (n.d.). *About us.* Clean Break. https://www.cleanbreak.org.uk/about/

Copeland, S. (2019). On serendipity in science: Discovery at the intersection of chance and wisdom. *Synthese.* https://doi.org/10.1007/s11229-017-1544-3

Coney (2018). *Switching audiences for players: Chloe Mashiter writes.* Coney. https://coneyhq.org/2018/10/12/switching-audiences-for-players-chloe-mashiter-writes/

Costa, P. T., & McCrae, R. R. (1992). *NEO PI-R professional manual.* Psychological Assessment Resources.

Debord (1955/1981). Introduction to a critique of urban geography. In K. Knabb (Ed., & Trans.), *Situationist international anthology* (pp. 5–8). Bureau of Public Secrets.

Debord, G. (1958/1981). Theory of the derive. In K. Knabb (Ed., & Trans.), *Situationist international anthology* (pp. 50–54). Bureau of Public Secrets.

De Certeau, M. (1988). *The practice of everyday life.* University of California Press.

De Rond, M. (2014). The structure of serendipity. *Culture and Organization, 20,* 342–358. https://doi.org/10.1080/14759551.2014.967451

Dodell-Feder, D., & Tamir, D. I. (2018). Fiction reading has a small positive impact on social cognition: A meta-analysis. *Journal of Experimental Psychology: General, 147,* 1713–1727. https://doi.org/10.1037/xge0000395

Dostoyevsky, F. (1866/1956). *Crime and punishment.* (C. Garnett, Trans.). Random House.

Empathy Museum (n. d.). *A mile in my shoes.* Retrieved from Empathy Museum. https://www.empathymuseum.com/a-mile-in-my-shoes/

Escalas, J. E. (2007). Self-referencing and persuasion: Narrative transportation versus analytical elaboration. *Journal of Consumer Research, 33,* 421–429. https://doi.org/10.1086/510216

Forster, E. M. (1974). *Aspects of the novel.* Penguin. (Original work published 1927).

Foster, A. E., & Ellis, D. (2014). Serendipity and its study. *Journal of Documentation, 70*, 1015–1038. https://doi.org/10.1108/JD-03-2014-0053

Frampton, D. (2006). *Filmosophy.* Wallflower Press.

Gardner, L. (2012). *Lyn Gardner's theatre roundup: Advice for playwrights.* Guardian Theatre Blog. http://www.theguardian.com/stage/theatreblog/2012/apr/30/lyn-gardner-theatre-roundup

Gerrig, R. (1993). *Experiencing narrative worlds. On the psychological activities of reading.* Yale University Press.

Heddon, D., Iball, H., & Zerihan, R. (2012). Come closer: Confessions of intimate spectators in one to one performance. *Contemporary Theatre Review, 22*, 120–133. https://doi.org/10.1080/10486801.2011.645233

Hogarth, S., Bramley, E., & Howson-Griffiths, T. (2018). Immersive worlds: An exploration into how performers facilitate three worlds in immersive performance. *Dance and Performance Training, 9*, 189–202. https://doi.org/10.1080/19443927.2018.1450780

Home-Cook, A. G. (2015). *Theatre and aural attention.* Palgrave Macmillan.

Howson-Griffiths, T. (2019). Locating sensory labyrinth theatre within immersive theatres' history. *Studies in Theatre and Performance*, 1–16. https://doi.org/10.1080/14682761.2019.1663649

Keefe, J. (2015). The spectator, the new, and a disrupting creative participation. *Media Transformations, 11*, 50–72. https://doi.org/10.7220/2029-8668.11.03

Kershaw, B. (1999). *The radical in performance: Between Brecht and Baudrillard.* Routledge.

Kershaw, B. (2007). *Pathologies of hope: Interview with performance paradigm.* http://performanceparadigm.net/index.php/journal/article/viewFile/37/38

Kidd, D. C., & Castano, E. (2013). Reading literary fiction improves theory of mind. *Science, 342*, 377–380. https://doi.org/10.1126/science.1239918

Ladder to the Moon. (2015). Personalised wellbeing. *Ladder to the Moon.* http://www.laddertothemoon.co.uk/whyladder/

Lavery, C. (2018). Rethinking the derive. Drifting and theatricality in theatre and performance studies. *Performance Research, 23*, 1–15. https://doi.org/10.1080/13528165.2018.1557011

Lehmann, H. -T. (2006). *Postdramatic theatre* (K. Jürs-Munby, Trans.). Routledge.

Lovatt, P. (2018). *Dance Psychology.* Dr Dance Presents.

Machon, J. (2016). Watching, attending, sense-making: Spectatorship in immersive theatres. *Journal of Contemporary Drama in English, 4*, 34–48. https://doi.org/10.1515/jcde-2016-0004

Mandell, J. (2016). *Immersive theatre define: Five elements in Sleep No More, Then She Fell and more.* Howlround Theatre Commons: https://howlround.com/immersive-theatre-defined

McCay-Peet, L., & Toms, E. G. (2015). Investigating serendipity: How it unfolds and what may influence it. *Journal of the Association for Information Science and Technology, 66*, 1463–1476. https://doi.org/10.1002/asi.23273

Papaioannou, S. (2014). Immersion, "smooth" spaces and critical voyeurism in the world of Punchdrunk. *Studies in Theatre and Performance, 34*, 160–174. https://doi.org/10.1080/14682761.2014.899746

Pearson, M., & Shanks, M. (2001). *Theatre/archaeology.* Routledge.

Petty, R. E., & Cacioppo, J. T. (1986). *Communication and persuasion: Central and peripheral routes to attitude change.* Springer.

Reviglio, U. (2019). Towards a taxonomy for designing serendipity in personalized news feeds. *Proceedings of the Tenth International Conference on Conceptions of Library and Information Science, Ljubljana, Slovenia, 24*(4). http://informationr.net/ir/24-4/colis/colis1943.html

Schultz, P., & Searleman, A. (2002). Rigidity of thought and behavior: 100 years of research. *Genetic, Social and General Psychology Monographs, 128*, 165–207.

Sharps, T. (2005). *Underground* by Dreamthinkspeak [Theatre production]. Unnamed site.

Seegert, A. (2009). "Doing there" vs. "being there": Performing presence in interactive fiction. *Journal of Gaming and Virtual Worlds, 1*, 23–37. https://doi.org/10.1386/jgvw.1.1.23/1

Shearing, D. (2015). *Audience immersion and the experience of scenography.* (Doctoral thesis, University of Leeds, Yorkshire, England). https://core.ac.uk/download/pdf/30268385.pdf

Shearing, D. (2017). Audience immersion, mindfulness and the experience of scenography. In J. McKinney & S. Palmer (Eds.), *Scenography expanded, an introduction to contemporary performance design* (pp. 139–154). Bloomsbury.

Shklovsky, V. (2015). Art as device. *Poetics Today, 36*, 151–174 (A. Berlina, Trans.). https://doi.org/10.1215/03335372-3160709 (Original work published 1917)

Trueman, M. (2010). Immersive theatre: Take us to the edge, but don't throw us in. *The Guardian.* https://guardian.co.uk/stage/theatreblog/2010/apr/07/immersive-theatre-terrifying-experience?INTCMP=SRCH

Tschumi, B. (1996). *Architecture and disjunction.* MIT Press.

Van Andel, P. (1994). Anatomy of the unsought finding. *British Journal for the Philosophy of Science, 45*, 631–648.

White, G. (2012). On immersive theatre. *Theatre Research International, 37*, 221–235. https://doi.org/10.1017/S0307883312000880

Wright, A. (2017). *The great Gatsby* by Guild of Misrule [Theatre production]. Vaults.

Fostering Creative Opportunities by Embracing the Accidental Within Practices of Making

Ana Piñeyro

For artists and designers, particularly those engaging in the creative manipulation of materials and direct handling of tools, the occurrence of accidents or mistakes that positively impact the work is a well-known experience. In turn, strategies that purposefully allow the accidental to permeate the creative process have been devised, acknowledging the potential of accidental events as a source of unforeseen opportunities. Whether unexpectedly encountered or intentionally sought, the history of art offers examples of how the productive potential of the accidental has been successfully used as a key component of creative strategies.

This research was carried out while at the Royal College of Art, London, and has received funding from the European Union's Horizon 2020 research and innovation programme under the Marie Sklodowska-Curie grant agreement No. 642328.

A. Piñeyro (✉)
London, UK
e-mail: ana.pineyro@network.rca.ac.uk

W. Ross and S. Copeland (eds.), *The Art of Serendipity*,
Palgrave Studies in Creativity and Culture,
https://doi.org/10.1007/978-3-030-84478-3_6

The accidental is inherent to the process of serendipity (see also Ross, this volume but also March & Vallée-Tourangeau, this volume). As originally conceived by Walpole in 1754, serendipity defines "making discoveries by accident and sagacity, of things which [one] is not in quest of" (Foster & Ellis, 2014; Merton & Barber, 2004, p. 2; Roberts, 1989, p. ix). Accidents involve chance—by definition, they happen "unexpectedly and unintentionally" or "without apparent or deliberate cause" (Oxford Dictionary of English, accident entry). Nevertheless, not every accidental or chance encounter leads to a serendipitous experience: the latter concerns those accidental events whose outcome is perceived as valuable or beneficial in some way (Cunha et al., 2010)—e.g., expanding existing knowledge in a relevant and meaningful direction (Merton, 1968). Hence, the notion of serendipity offers a way to conceptualise the inherent potential of the accidental to lead to a beneficial outcome. Additionally, van Andel (1994) describes the "unsought finding" involved in serendipity—as it occurs in the arts—as the original combination of "two or more elements" (e.g., "observations, hypotheses, ideas, facts, relations or insights"), into something "new and fascinating". Thus, serendipity captures the potential of the accidental to lead to the "new"—i.e., that which is as yet not known or does not exist—so often sought for in art and design practice (see also Sneddon, this volume).

This chapter looks at salient examples of how accidental events have been beneficially incorporated into the creative process in artistic practice. Whilst the degree of intentionality underpinning the use of the accidental within the processes and strategies presented here varies, the selected examples have the peculiarity of arising themselves from accidental events that occur without practitioners intentionally seeking them. In this way, this overview illustrates how unexpected chance encounters may lead to the development of formal or organised work, which, in turn, may allow the accidental to further permeate the creative process. From this context, the chapter goes on to examine an accidental encounter within my own creative practice as a textiles and materials design researcher. Framing my experience of productively incorporating the accidental into the creative process within the serendipity model proposed by McCay-Peet and Toms (2015), the discussion focuses on

how this event pivoted my research and informed the methodological approach adopted in a subsequent exploratory process.

The Accidental in the Creative Process

Accident, Opportunity, and Intention

Accidents taking place during the creative process certainly constitute disruptions to the planned or foreseen development of the work. Forcing us to stop and think, they may be experienced as frustrating, annoying, and blocking (see also Lockhard & Sikk, this volume). In halting our planned course of action, accidents invite us to abandon control over the creative process and demand of us flexibility towards the planned direction. Alongside the anxiety that this may cause, accidental events offer practitioners an opportunity to explore alternative, unforeseen creative paths, allowing them to overcome artistic conventions and individual limitations, taking the work into previously unknown territories (Safán-Gerard, 2018; see also Sneddon, this volume).

In his analysis of the use of chance procedures in art practice, George Brecht (1966), explains that what defines chance are its "consciously unknown causes". Influenced by psychoanalytic theory, Brecht distinguishes between two types of chance occurrence. One in which the underlying cause is "unknown because it lies in deeper-than-conscious levels of the mind"; and the other resulting from some kind of "mechanical processes not under the artist's control". In both cases, he notes, there is a "lack of conscious design". On a similar note, Iversen (2010, pp. 19–20) differentiates between "retrospectively incorporating an accident", which has spontaneously occurred, and "intentionally harnessing chance".

In the latter case the accidental event results from the deliberate application of a system or procedure that is specifically devised for that purpose, and whose control intentionally falls beyond the artist's reach (Brecht, 1966; Iversen, 2010). Such strategies constitute a conscious way of bringing "uncertainty and contingency" into the creative process,

making it unpredictable and open-ended. What these strategies determine are the conditions for the accidental event to occur; the unpredictably lies thus in the outcomes of the process that is launched (Iversen, 2010).

A range of processes and systems can be found within this kind of practice. Some examples are: (a) the generation of instructions for processes or actions that specify the initial conditions for an experiment or experience without determining its results (e.g., Marcel Duchamp's *3 Standard Stoppages*); (b) the use of coins, dice, roulette wheels (e.g., Huáng Yǒng Pīng's *Roulette* series) or the I-Ching (e.g., the musical compositions of John Cage), which allow the artist to externalise decisions pertaining to the "selection and arrangement" of the components of the work (Brecht, 1966); (c) opening the work to the influence of an unpredictable element external to it (e.g., Bruce Nauman's *Mapping the Studio I [Fat Chance John Cage]*), including the unpredictability effect of forces (e.g., gravity) on materials (e.g., Robert Morris' feltwork).

Benefiting from "unplanned" accidents—i.e., those whose occurrence is not purposefully sought—within the creative process, on the other hand, implies slightly different conditions. Their generative impact hinges on the interaction between the capacity of the surprising encounter to suggest some kind of insight or idea to the practitioner, and her ability and disposition to accept the invitation they extend to take the work into an unknown territory. This ability to seize on the unexpected encounter implies thus the practitioner's preparedness and her openness and flexibility towards the process and outcome of the work. Whilst not necessarily readily recognised, this openness and flexibility should nevertheless be at least latently present. From the midst of such interaction, a suggestion to further the work in a direction not previously considered may emerge, prompting the development of subsequent planned work. In this way, accidental or chance occurrences that are not purposefully sought, or even mistakes, may become fruitful triggers from which formal procedures, techniques, methods or experiments may emerge during the creative process. In turn, such formal, organised work may seek, in itself, the further incorporation of accidental elements into the process, becoming thus connected with the type of practices previously described.

Whether purposefully sought or unintentionally found, the rationale underpinning both the motivation and aim of practices that allow the accidental to permeate the creative process, is generally concerned with freeing the imagination and the intellect from personal limitations imposed by sociocultural and artistic conventions (Safán-Gerard, 2018) by evading the unconscious bias that these generate (Brecht, 1966). Further, in requiring practitioners to relinquish control over the creative process, ideas of creative authorship are also challenged through these practices (Brecht, 1966; Iversen, 2010).

The next section looks at specific examples of the beneficial incorporation of chance and the accidental into the creative process. Most of these cases illustrate how formal and planned work, which seeks the accidental in itself, has been derived from the occurrence of unintended and unexpected events or observations.

Accidental Encounters in Creative Practice

Perhaps the first and simplest form in which the accidental has permeated creative processes are "chance images", i.e., "meaningful visual figurations perceived in materials—most often rocks, clouds, or blots—that have not been, or cannot be, consciously shaped by men" (Janson, 1973, p. 340). Artists throughout history have used this sort of images to derive artistic work, by making explicit the resemblance suggested in the material, through means such as painting or sculpture.

Understanding of this kind of images and their use as an inspiration for artistic work has oscillated together with the prevailing attitude towards chance. A stance characteristic of—but not exclusive to—pre-scientific cultures credited the occurrence of chance images to divine intervention. Acknowledgement of the role that the observer's imagination plays in making these images explicit started to emerge during the Renaissance, through the works of Leon Battista Alberti first and Leonardo da Vinci later, prompting the overt recognition of the simplicity and ambiguity inherent to chance images (Janson, 1973).

Until early Modernity, chance images were exclusively found; the artist's role was to discover them and "make the resemblance complete".

It is with Alexander Cozens' treatise *A New Method of Assisting the Intention in Drawing Original Compositions of Landscape* (1785–1786) that chance images first become an intentional creation of the artist. Cozens' method consisted in making spontaneous ink blots with a brush over paper, which had been previously crumpled and stretched back. The resulting blots were meant to suggest landscape compositions, which the artist would further define by tracing selected areas of a blot over transparent paper. The artist was encouraged to refrain from bringing into the composition features that were not exclusively suggested by the blot. The blots produced through this method were not intended to be completely accidental, given that a rough conception of the intended landscape was expected from the artist whilst generating them. This is revealed in Cozens' characterisation of these blots as "a production of chance, with a small degree of design". Whilst not in tune with neoclassical precepts, the aim of the method was to liberate artists from established conventions of landscape composition by supporting them in abandoning, to some extent, unconscious control over their gestures (Janson, 1973).

The inherent ambiguity that makes chance images a stimulus to creative endeavour can also be seen at work in subsequent periods. Pablo Picasso's sculptures *Bull's head* (1942) and *Baboon & Young* (1951), are relevant examples of this practice, where found objects become alternative configurations through the artist's intervention (a found bicycle seat and handle, in the case of the former; a toy car forming a monkey's face, in the case of the latter; Janson, 1973).

Accidental observations have also led to the discovery of novel forms of expression in the context of creative practices. For example, the origin of abstract art has been credited to an accidental encounter, one in which Wassily Kandinsky saw one of his paintings from an unconventional angle. In a diary entry Kandinsky notes:

> The painting had no subject at all, did not show any recognizable subject and consisted only out of clear fields of color. At last I came nearer and recognized it, for what it was—my own painting standing on its side on the easel [...] One thing became clear to me—that objectivity, the depicting of objects, was not necessary in my paintings and could indeed even harm them. (Schippers, 1982, as quoted in van Andel, 1993)

So seems to have been the role of the accidental in the emergence of Pablo Picasso's "blue period". Apparently with no other colour at his disposal, Picasso decided to work exclusively with blue. Intrigued by the resulting effect, he continued exploring it in his now renowned monochromatic work (Parmelin, 1969, as cited in van Andel, 1993).

A fresh and radical approach to the use of chance within creative strategies appears in Western art during the first decades of the twentieth century, with Dada and Surrealism. In their rejection of artistic traditions and cultural values and conventions, artists within these movements turned to the unconscious as an unbiased source of creativity (Brecht, 1966). In this quest, chance became a prime "stimulus to artistic creation" (Richter, 1997, p. 51), a way to by-pass reason and logic and access the unconscious mind. By fostering accidental encounters, artists sought to evade conscious control over the creative process, freeing it from rational constraints.

Marcel Duchamp was one of the most prominent artists associated with Dada. His *3 Standard Stoppages* (1913–1914) is often cited as a salient example of the role of chance in modern art (Brecht, 1966; Iversen, 2010; Molderings, 2006). The work consists of an instruction for an experiment, recorded as a note within Duchamp's *"Box of 1914"*, which reads:

> If a straight horizontal thread one meter long falls from a height of one meter on to a horizontal plane distorting itself *as it pleases* and creates a new shape of the measure of length. —3 patterns obtained in more or less similar conditions: *considered in their relation to one another* they are an *approximate reconstitution* of the measure of length. (translation from Sanouillet & Peterson, 1973, p. 22, as quoted in Molderings, 2006, p. 1; italics in original)

The threads, in the wavy shape they had adopted when falling, were later fixed with varnish to a canvas that had served as a horizontal plane. Three wooden templates were then built following the patterns formed by the fixed threads, offering an alternative conception of the standardised length unit of the meter. Duchamp referred to the results of this experiment as "canned chance" (Iversen, 2010; Molderings, 2006).

Whilst the instruction from which the work initiates provides the conditions for the experiment, it does not define its result. Rather, it introduces an element of unpredictability to the work, by allowing forces (such as gravity) and objects to shape the outcomes. As such, the instruction constitutes a means to limit the artist's control over the fabrication process, by provoking accidental events that carry unexpected outcomes (Iversen, 2010; see also Turner & Kasperczyk, this volume).

Even though this instruction represents an intentional and formalised way of incorporating the accidental into the creative process, the idea from which it stems was nevertheless prompted accidentally. As Duchamp described in an interview with Katherine Kuh:

> My first accidental experience (that we commonly call chance) happened with the Three Stoppages, and, as I said before, was a great experience. The idea of letting a piece of thread fall on a canvas was accidental, but from this accident came a carefully planned work. Most important was accepting and recognizing this accidental stimulation. Many of my highly organized works were initially suggested by just such chance encounters. (Kuh, 1962, p. 92, as cited in Molderings, 2006, p. 32)

Hence, from a simple accidental observation of how a thread deforms when falling, Duchamp derives a complex work, entailing not only an (ironic) commentary on Euclidean geometry and the contingent nature of a standardised unit of length, but also theorems of the then new non-Euclidean geometry (Molderings, 2006). It is also interesting to note, given Duchamp's assertion, that his ability to notice or recognise the "accidental stimulation" and "accept" its occurrence as an intrinsic part of the creative process played a key role in his capacity to seize on the initial accidental encounter and positively incorporate it into subsequent organised work (see also Copeland, this volume).

Whilst Duchamp's *3 Standard Stoppages* offer an example of a systematised way of introducing chance and indeterminacy into the creative process, the collages of Jean Arp—another prominent Dada artist—developed since 1916, exemplify the use of rather spontaneous and casual strategies (Iversen, 2010). Apparently dissatisfied at not being able to achieve the desired expression on a drawing he was working on, Arp

tore the drawing up and tossed the pieces, which fell onto the floor of his studio. Later on, he happened to notice the scraps of paper lying on the floor and was struck by the expressiveness of the pattern they had formed, an effect he had not been able to achieve willingly. He thus pasted the scraps of paper in the pattern "which chance had determined" (Richter, 1997, p. 51). Arp would continue using similar procedures in his collages, as evidenced by the series *According to the Laws of Chance*.

Within the range of techniques that Surrealist artists developed in their quest to prompt chance encounters that would evade conscious control over the creative process (e.g., found objects, cadavre exquis, or automatism, amongst others), the origins of frottage are of particular interest to this overview. Frottage was discovered by Max Ernst in 1925, as a result of an accidental observation. As Ernst examined an old wooden floor, the conspicuous grain-patterns of the floor planks called his attention, recalling childhood memories of false mahogany panelling which had, back then, sparked associations to organic forms. Inspired by the peculiar images suggested by the patterns of the wooden floor, he spontaneously placed a sheet of paper over the planks and rubbed over it with a pencil. As he later noted, what surprised him was that "the drawings thus obtained steadily lose [...] the character of the material studied—wood—and assume the aspect of unbelievably clear images of a kind able to reveal the first cause of the obsession". Ernst equated frottage to the automatism promoted by André Breton (e.g., 1969), and regarded it as a way to subside the artist's control over the creative process. Ernst went on to adapt frottage to oil painting, in a process known as grattage (Turpin, 1979, pp. 7–8).

Dada's and Surrealism's approach to chance as a creative stimulus and strategy had a profound influence on subsequent creative practices of the twentieth century, of which the work of John Cage is perhaps the most iconic. Although beyond the scope of this overview, Cage's work traces a line through the use of chance procedures that reaches contemporary practices. Such is the case of the work of Bruce Nauman. Nauman's piece, *Mapping the Studio I (Fat Chance John Cage)*, 2001, offers another example of how unexpected, accidental events may be incorporated into the creative process, giving rise to planned, organised or intentional work that further allows the accidental to permeate the process. "What

triggered this piece were the mice", Nauman explains (Nauman, 2010, p. 198). According to his account, field mice had flooded his studio one summer, at a time when he "had run out of ideas for new work". The presence of the mice prompted him to "use what [he had] at hand to create artwork"; that is, the mice, a cat, and an infrared-enabled video camera. Having thought earlier of mapping his studio—with all its stuff and left-over material—the mice-flood suggested the idea of letting the mice and the cat make the mapping. Selecting seven positions for the camera within the habitual routes of the mice, Nauman would turn it on during the night and go out in the morning "to see what had happened"—to see "what [the mice] would do 'among' the remnants of the work". The final piece, consisting of the edited material, was exhibited as seven simultaneous viewpoints projected onto the exhibition space.

Lastly, the approach taken by the Process art movement towards the use of the accidental in the creative process explicitly locates the active role that matter plays within processes of formation as a means of incorporating indeterminacy and the unexpected into the work. Whilst lacking the element of spontaneous, unplanned, and unintentional occurrence of the accidental, central to this review, this example is of particular relevance to contemporary practices of making in their move towards neo-materialist ontologies—where the focus is on processes of formation, in which humans and non-humans participate, as these unfold in a world of matter, force and energy.

"[C]hance, contingency, indeterminacy" are fundamental to Process art, as Robert Morris, one of the movement's central figures, identifies in his writings (Morris, 1993, p. 67). In this approach, "stuff" and "substances in many states" become both the starting point and the means for the work. Artistic activity is not bound to a projected or preconceived end, image or form. Rather, the focus is on "acknowledging and even predicting perceptual conditions for the work's existence". Matter and its transformation take primacy over formal outcomes. Form becomes a transient attribute, resulting from incidental forces and random processes of organisation. In his essay *Anti form*, Morris (1993, pp. 41–49) explains:

The focus on matter and gravity as means results in forms that were not projected in advance. Considerations of ordering are necessarily casual and imprecise and unemphasized. Random piling, loose stacking, hanging, give passing form to the material. Chance is accepted and indeterminacy is implied, as replacing will result in another configuration. Disengagement with preconceived enduring forms and orders for things is a positive assertion. It is part of the work's refusal to continue estheticizing the form by dealing with it as a prescribed end. (p. 46)

Morris' work with felt embodies these ideas. Silted sheets of industrial felts are hung or placed on the floor and allowed to adopt accidental configurations that emerge through the interaction between the properties of materials, forces such as gravity, and the artist's actions. The workings of Process art, as described by Morris, seem thus to support Brecht's (1966) remark that when the "matter of materials" is considered, the wide range of applications of chance methods "is compounded".

The examples presented here offer an overview of the motivations and attitudes that have allowed creative practitioners to benefit from accidental encounters. These also illustrate the ways in which creative processes have been enhanced not only by embracing the accidental, but also by purposefully seeking its further incorporation into the work through intentionally devised strategies—often derived from the workings of initially unexpected events. The next section examines my own experience of a productive accidental encounter in the context of practice-based design research.

Experiencing Serendipity

As a designer working in the field of textiles and materials, I often deal with the unexpected within my practice. This mostly comes in the form of accidental results, stemming from chance encounters and mistakes, particularly when engaging in direct, hands-on work with materials. During these processes, I experience the material's resistances

and compliances to my actions and intentions; it is through this interaction with the material that physical outcomes are forged within my practice. This section discusses my experience of an accidental event taking place during the initial stages of my doctoral research, which pivoted the direction in which the research developed, fruitfully impacting my work. Framing this experience within current understanding of the process of serendipity, I use McCay-Peet and Toms' (2015) model of a serendipitous experience to examine this event.

McCay-Peet and Toms' Model of Serendipity

In consolidating previous accounts of serendipity (i.e., Cunha, 2005; Rubin et al., 2011; Makri & Blandford, 2012; McCay-Peet & Toms, 2010; Sun et al., 2011), the model proposed by McCay-Peet and Toms (2015) identifies five main components of a serendipitous process, that constitute its perception and experience: the "trigger", the "connection", the "follow-up", the "valuable outcome", and the "unexpected thread".

The "trigger" refers to that which prompts the experience of serendipity—the cue that results from the accidental or chance event and which precipitates the process. Triggers are most often external to the person experiencing serendipity, and can be found in visual, verbal or textual form (see also Ross, this volume). The "connection" is the identification of a link between the trigger and the person's previous knowledge or experience. Connections can be made between the trigger and either a known, present problem, or a new, unforeseen one. Given that connections may not always follow immediately from the experience of a trigger, the authors contemplate a contingent element, which they term "delay"—i.e., the time that passes between the point when the trigger appears, and a connection is made.

In order for the trigger and the connection to have a positive impact, action needs to be taken; this is defined as the "follow-up" (see also Copeland, Ross this volume). Follow-ups may include ways in which the trigger or the connection are dealt with before using them, the preparation towards the application of the trigger or the connection, and the type of opportunity pursued. The "valuable outcome" concerns the

perception of a positive impact of the serendipitous experience. It can be related to one or several elements of the process, and can operate at a personal, organisational/community, or global level.

Unexpectedness is possibly the most characteristic feature of a serendipitous experience. It relates to the accidental, chance or surprising nature of an event and can be present in one or several elements of the process, forming the "unexpected thread". The "perception of serendipity" is then built through an *awareness* of the four main elements of the process: trigger, connection, valuable outcome, and unexpected thread. A valuable outcome may be anticipated or expected even before it is realised, rendering this realisation not necessary for an experience to be perceived as serendipitous.

Context of the Research

My doctoral research set out to explore the potential of movement as a layer of dynamic expression in textiles. Movement has the ability to convey different tones or qualities regardless of the specific shape or form through which it is displayed (Bianchini et al., 2016; Mori, 2012; Saez-Pons et al., 2014), bearing the potential to affect those who experience it. Whilst textiles are ideally suited for shape transition—given their inherent softness and flexibility— shape change that comes from within the material itself is an underexplored source of expression.

A review of soft, flexible, stimulus-responsive, shape-change materials available at that time, led me to identify twisted and coiled polymeric actuators (TCPAs; Haines et al., 2014a) as a suitable material with which to conduct the research. These actuators are pliable, light weight, and strong, and present a yarn-like configuration. They can be formed from off-the-shelf materials, such as fishing lines or sewing threads, through relatively simple methods based on twisting and coiling (Haines et al., 2014a, 2014b). When exposed to heat, TCPAs reversibly contract or expand in the direction of their length.

Since these actuators could not be sourced commercially, my goal at the outset of the research was to learn how to form them, in order to subsequently explore how expressive behaviours could be designed in

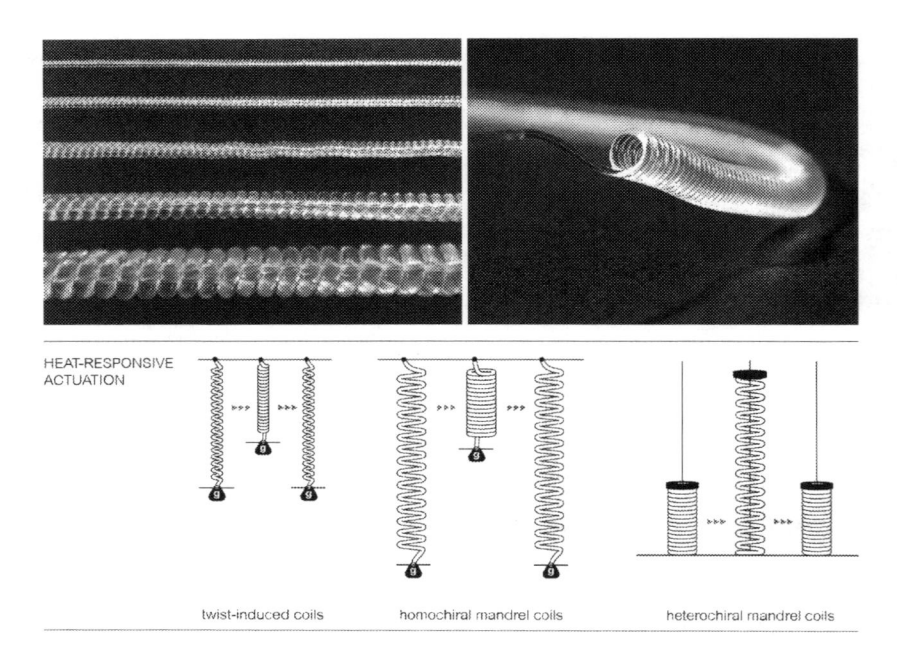

Fig. 1 Twist-induced coils from various monofilament diameters (top left), mandrel coil (top right), and diagram of their heat-responsive linear actuation (bottom; diagram by the author, based on descriptions by Haines et al., 2014a, 2014b)

woven and knitted textiles through their integration. Adapting procedures described in the literature (Haines et al., 2014a, 2014b) to my studio, I learnt how to form the two basic types of coils: twist-induced and mandrel coils (Fig. 1, top).

When Things Go Wrong: Noticing a Visual Trigger

As I was testing the actuation of a homochiral mandrel coil for the first time, I inadvertently overloaded it when attempting to stretch it. When applying heat with a heat-gun, the coil deformed—instead of contracting—revealing an intriguing looped morphology (Fig. 2, top and bottom). To my surprise, this structure also moved as I applied heat,

Fig. 2 Emergence of a looped morphology as a result of applying heat to a mandrel coil under tension (top); heat-responsive behaviour of the looped morphology (centre; overlaid stills from video); and close up of the looped morphology (bottom)

but in a different way to the basic coiled form; it rotated back and forth around its longitudinal axis (Fig. 2, centre). Playing around with the morphology to see how it responded to heat, I started wondering in which other ways basic coiled structures could be transformed into alternative morphologies, and what type of behaviour these potential morphologies would display in response to heat. In this way, the heat-responsive, looped structure—unexpectedly revealed through my mistake—sparked a range of insights and connections that took the work in an unforeseen direction (Piñeyro, 2019).

Making Connections

The emergence of the looped structure, together with the questions that the event prompted, sparked an intuition that monofilament morphologies—other than basic coiled ones—could also change shape in response to heat. Possibly supported by my awareness of the mechanisms underlying the kinetic behaviour of other materials, this intuition hinted at the potential value of further exploring the relationship between morphology—i.e., form and structure—and ability for shape change for the case of nylon monofilament. Additionally, having already regarded TCPAs as yarn-like structures, my textile designer "mind" could not avoid seeing a strong resemblance between the accidental looped morphology and some structures of fancy yarns such as looped ones (e.g., Gong & Wright, 2002).

Spotting Valuable Opportunities and Following-Up: A Shift in Direction

Jointly, these insights pointed to an opportunity to reframe the research by suggesting a shift in the level of the structural hierarchy of textiles (Kapsali et al., 2013; Lomov et al., 2001) on which the research had been previously focusing—i.e., moving from the level of fabric, towards the level of the fibre and the yarn. Instead of exploring how coiled actuators could be integrated into woven and knitted structures, as I had intended, I would now explore ways of forming alternative monofilament

morphologies and understanding the type of heat-responsive behaviour they displayed. These morphologies, I speculated, could eventually be used as responsive kinetic components of flexible material systems, allowing me to ultimately explore the dynamic expressions of these structures—hence feeding into to my original motivation to undertake the research in the first place. Thus, the connections prompted by the emergence of the heat-responsive morphology, oriented my research into an exciting alternative direction, one which I could not have otherwise foreseen.

Making Connections (Again): A Delayed Insight

The accidental appearance of the looped morphology sparked an additional insight that strongly influenced my approach to subsequent stages of the exploration: the event made explicit the active role that the material had played in the emergence of form. Despite my intentions in testing the actuation of a mandrel coil, the material had responded to force and energy according to its own inherent qualities.

This acknowledgement drew my attention to the notion of morphogenesis. Conceived as a model for the generation of form and structure within contemporary neo-materialist discourses, morphogenesis conveys an understanding of matter as something that is inherently active, holding intrinsic resources for self-organisation (e.g., DeLanda, 1997, 2004). It provides an alternative to the traditional hylomorphism, which denotes a conception of matter as something inert, over which form is externally imposed (Deleuze & Guattari, 1987; DeLanda, 2004; Ingold, 2010, 2013; see also March & Vallée-Tourangeau, this volume).

In *The Textility of Making*, Ingold (2010) argues that assumptions contained in the hylomorphic model are still at work in "contemporary discussions of art and technology [...] even as they seek to restore the balance between its terms". Following Deleuze and Guattari (1987)—who join Simondon (1992) in his critique of the hylomorphic model as a paradigm for the origin of form—Ingold's aim is to "overthrow the model itself and to replace it with an ontology that assigns primacy to the processes of formation as against their final products, and to the flows

and transformations of materials as against states of matter" (Ingold, 2010). Along this line, Ingold (2013, pp. 21–22) invites us to think of making as a "process of growth", where the practitioner "joins forces" with active materials in the generation of form. He suggests to conceive of making as a "morphogenetic" process, a "confluence of forces and materials" through which form is generated.

DeLanda (2004) notes that the hylomorphic model has been promoted and perpetuated by centuries-long processes of homogenisation of materials, linearisation of their behaviours and routinisation of design and production processes. He maintains that, even the simplest forms of matter possess intrinsic tendencies and capacities, which constitute endogenous morphogenetic resources (DeLanda, 2004, 2011). Referencing Deleuze and Guattari (1987), he explains, however, that,

> ...if the material in question is homogeneous and closed to intense flows of energy, its singularities and affects will be so simple as to seem reducible to a linear law. In a sense, these materials hide from view the full repertoire of self-organizing capabilities of matter and energy. (DeLanda, 2004, p. 19)

Whilst the morphogenetic potential of matter is best manifested when heterogeneous materials find themselves in far-from-equilibrium conditions (DeLanda, 2004), even simple, homogeneous materials may exhibit their endogenous morphogenetic capabilities when open to intense flows of energy.

Devising a Methodological Approach: A Further Follow-Up

Linking the previous ideas to my experience of the accidental event motivated me to explicitly seek a space within the exploratory process for the material to express its full morphogenetic potential. Allowing material tendencies and capacities to be revealed became thus a core creative

strategy during the following stages of the exploration. Adopting the bottom-up and open-ended nature of the accidental event, subsequent exploration sought to find relevant ways of intervening in the material, opening it to energy flows to allow it to reveal potential forms and (heat-responsive) behaviours. Instead of planning or projecting specific target forms to be created with the monofilament, the work favoured the exploration of processes of formation. In this approach, form is neither predefined nor expected: it becomes that which results from interactions between matter, force, and energy; a potential that becomes expressed through consecutive operations and interventions, rather than a predefined goal or an intended end product.

This move away from final forms towards processes of formation required, and at the same time promoted, a heightened attention to the cues that the material manifested in response to my interventions. Being perceptually receptive, I continually adjust my gestures to the material's response, anticipating how it may evolve, as I mechanically and thermally affect the samples. Internal impulses drive my handling and observation of the material and, in turn, are fed by sensory inputs arising from its manifestations in response to my interventions. Ingold explains that in responding to matter that is inherently active, in constant fluctuation, we improvise in an attempt to encompass our actions to the occurring variations, in anticipation of what is going to happen next. This process involves "continual correction, in response to an ongoing perceptual monitoring of the task as it unfolds" (Ingold, 2010). Operating in this tacit domain, the exploration evolves as a spontaneous, non-verbal dialogue with the material. Abandoning control over the making process, I "try things out and see what happens" (Ingold, 2013, p. 7), creating a space within my practice for the material to express itself. Intuition, spontaneity and improvisation become thus core elements of my making.

This exploratory process supported in itself the emergence of further unforeseen monofilament morphologies that reversibly change shape in response to heat (Fig. 3).

Fig. 3 Examples of monofilament morphologies with heat-responsive kinetic capacity, arising from the exploratory process motivated by the accidental event

Perceiving Valuable Outcomes

In sparking the insights discussed earlier, the accidental event impacted the research in several positive ways. First, it foregrounded an opportunity to reframe the research in an unexpected direction, pivoting its focus from the level of the fabric to the levels of the fibre and the yarn. Second, it prompted my expectation that a distinctive and as-yet-not-known material outcome would arise from the reframed exploratory route, uncovering novel monofilament morphologies with heat-responsive kinetic capacity. Consequently, I was able to imagine how these material outcomes could open up opportunities for future exploration, e.g., of their assembly into flexible kinetic material systems, and their dynamic expression. Lastly, the process triggered by the accidental event influenced the methodological framework later used in the exploration, allowing me to explicitly seek working methods that would, in themselves, support the further emergence of the unexpected within my practice.

Reflecting on the Serendipitous Experience

This section identifies key factors involved in the unfolding of the accidental event and examines their role in the process that leads to its perception as a valuable opportunity for the research. The reflection focuses first on the conditions that enabled the unexpected to emerge; second; on the elements involved in allowing me to regard the accidental event as a creative opening rather than a failed trial; and lastly, on the methodological features derived from the accidental event that were fed back into the work, introducing in themselves uncertainty and unpredictability into the creative process.

Allowing the Unexpected to Emerge

In attempting to identify the conditions under which the looped morphology was revealed, my lack of hands-on experience with nylon coils and my limited knowledge of their properties at that time became conspicuous—being unaware of the range of weights that a coil could tolerate whilst being exposed to heat was what led me to unintentionally overload the sample.

Comprehensive understanding of materials is undoubtedly necessary when working with them in the long run. However, recognising the productive impetus that the unexpected event eventually meant to the research, brings to the fore the value that fresh or naïve approaches to a material, a technique or a process may hold in promoting the occurrence of mistakes or accidents with the potential to lead to surprising and generative outcomes from practice. Along this line, Philpott (2011, pp. 48–49) notes that "having to improvise alternative methods due to lack of skill or equipment and being ignorant of or ignoring established rules of production can all produce innovation that advances practice". Enabling as a thorough knowledge of materials is, it may also constrain unpredictability in the context of creative practice, limiting opportunities for the unexpected to occur. Whilst a "prepared mind" (see e.g., Copeland, 2019; Foster & Ellis, 2014; McCay-Peet & Toms, 2015;) is certainly relevant in seizing on the accidental, not knowing carries the

potential to contribute to generating the space for the accidental to occur in the first place. Hence, exploratory processes may benefit from considering the balance between informed and naïve approaches, as well as the stage of the process at which comprehensive theoretical material knowledge is incorporated into the practice (Piñeyro, 2019; see also Copeland, this volume).

Perceiving an Opportunity

So, a distinctive heat-responsive morphology emerges from my mistake. But this unexpected event—on its own—would not have had any further consequences. In fact, similar looped structures have been described in DIY accounts of coil formation, but have been discarded as damaged coils (e.g., Head, 2015). As Friedel (2001) puts it, "…the creative achievement lies not so much in creating the surprise but in seeing what it 'means'". Then, how do I come to experience this accidental event as a creative opening rather than a failed trial? That is, how does such an event become a trigger for the serendipitous experience?

Reflecting on the fleeting instance of noticing the trigger reveals the prominent role that curiosity, aesthetic appeal, an exploratory attitude, and close attention to the manifestations of the material played in this process (see also Glăveanu, this volume). Surprises elicit curiosity (Arnone, 2003), and curiosity is intrinsically linked to exploratory behaviour (Kashdan et al., 2009). Experiencing the emergence of the looped morphology was undoubtedly unexpected. It was possibly the aesthetic appeal I found in this structure what first caught my attention, making me instantly wonder how it would respond to heat. This, in turn, motivated me to test the morphology's behaviour further—to continue to expose it to heat to see how it responded. The fact that I was already looking for a movement effect in the material, possibly steered my curiosity in this particular direction. This curiosity-led and aesthetically motivated exploratory action of persistence allowed me to observe, after a while, the distinctive back and forth movement that this particular structure displayed in response to heat. Noticing this movement raised new questions, allowing me to perceive the opportunity

embedded in the accidental encounter. Hence, the interaction between aesthetic appeal, curiosity, exploratory attitude, and close attention to the manifestations of the material, seems to have played a prominent role in leading me to perceive the accidental emergence of the heat-responsive looped morphology as a creative opening.

Openness and flexibility towards the research goal and its planned process were also at work in allowing me to perceive a creative opportunity in the accidental event. The perception of failure or success in making is contingent on the intentions and expectations with which an intervention is performed. Intentions concern the purpose with which we carry out an intervention—the aims or goals that motivate it; whereas expectations relate to what we believe will arise from such intervention—the direction in which we believe the result of our intervention will lead us. When neither our intentions nor expectations are met by the outcome of our intervention, the perception of failure may set in. In terms of the specific task at hand, the emergence of the looped morphology as a result of applying heat to the coil under tension was undoubtedly a failure: it did not align with either my intention of testing the performance of the coil or my expectation of observing its linear contraction. However, the looped morphology—with its heat-responsive behaviour—did align with a higher-level intention, one contained in the ultimate goal of the work: i.e., working with a flexible, responsive, shape-change material to explore through my creative practice the design of expressive behaviours in textile structures.

In supporting the goal of the research, the accidental event prompted me to overlook the aim of the specific task at hand; and in doing so it offered an opportunity to approach the research goal in an unexpected way, one alternative to that which was originally intended. Hence, keeping an open mind in terms of the specific way in which the goal of the research could be addressed, and a flexible attitude towards predefined aspects of the process, played a crucial role in allowing me to spot an opportunity in the accidental event rather than considering it a failed trial.

Whilst my previous knowledge and experience may have influenced the type of connections I was able to draw from the accidental event, it seems to have been an interplay between this ability to draw connections

and the openness and flexibility required to embrace a shift in direction that ultimately enabled the serendipitous process to develop.

Copeland (2019) argues that serendipity takes place "when the limitations of epistemic expectations are exposed"; by defying these expectations, serendipity "changes them". In laying bare the boundaries of my expectations on how heat (and force) would affect the coil that I was working with, the accidental event expanded these expectations. It was from such an expansion that an opportunity for further exploration emerged, rendering the unexpected outcome of potential value to the research.

Incorporating Unpredictability into the Creative Process: Enhancing the Opportunities for the Accidental to Emerge

The working method derived from the accidental encounter promoted the incorporation of unpredictable elements into the exploration, fostering in itself the emergence of further unexpected outcomes. The open-endedness concerning formal outcomes, resulting from the move away from target forms and towards processes of formation, was key in this regard. In removing all expectations concerning final forms, the formal outcomes emerging through my focus on trying things out on the material and attending to how it responded, were thus inevitably unexpected. Additionally, having no specific forms to arrive at, my fear of failure when manipulating the material vanished. In turn, this motivated a daring attitude that allowed me to venture into a wide range of exploratory routes, which I would probably not have been able to anticipate, be it not through this direct and open-ended engagement with the material.

Relationality has been identified as one of the "precipitating conditions" for serendipity (Cunha, 2005). Although generally described in regard to social interactions, the kind of relationality implicit in thinking of making as a morphogenetic process may also be considered with respect to its role in opening the creative process to uncertainty and

unpredictability. Adopting a morphogenetic approach to the exploration orients the work towards allowing materials to reveal their tendencies and capacities, rendering matter, force and energy active participants in the making process. The intuitive and spontaneous dialogue that unfolds creates a space for the material to express itself. In this way, the "voice" of the material comes into play. Being independent from the practitioner, this voice evades her full control, thus having the potential to lead to unexpected encounters. These unexpected encounters, in turn, may become fruitful triggers of serendipitous experiences, taking the work (and the practitioner) in exciting new directions.

Conclusions

This chapter looks at ways in which creative processes have been enhanced by accidental encounters, sparking the discovery of fabrication processes, methods, techniques or forms of expression. In turn, these accidental encounters have often motivated creative practitioners to purposefully seek strategies that open the work to uncertainty and unpredictability, promoting thus the accidental within their planned processes.

Salient examples from the field of art illustrate this generative role of the accidental; and an in-depth examination of my own experience of an accidental encounter in the context of practiced-based design research in the field of textiles and materials offers further insights. Framed within McCay-Peet and Toms' (2015) model of serendipity, reflection on this experience shows how the accidental encounter led to reframing the research in an unforeseen direction, and outlines the ways in which this encounter influenced the methodological framework applied in subsequent stages of the exploration.

Highlighting the key role of not knowing in enabling the occurrence of the accidental event, this experience suggests that initial stages of exploratory processes may benefit from adopting naïve or not-thoroughly-informed approaches to materials, processes or techniques, as a means to enhance the opportunities for generative, unexpected encounters to arise in the context of creative practice. The reflection

further foregrounds the enabling influence that curiosity, the exploratory attitude it entails, aesthetic appeal, and a heightened attention to material manifestations may have in the spotting of an opportunity within the accidental event. The serendipitous process is depicted as hinging on the interplay between the previous knowledge and experience that enables relevant connections to be made, and the openness and flexibility towards the goal and process of the research that allow one to embrace a shift in the planned direction. Lastly, the bottom-up, open-ended nature of the accidental event inspired the incorporation of key methodological features into the rationale of subsequent exploration, which further introduced uncertainty and unpredictability into the creative process. Thus, by promoting indeterminacy concerning formal outcomes, and purposefully seeking a space within making for material tendencies and capacities to be expressed, the opportunities for the unexpected to emerge within creative practice were enhanced.

References

Arnone, M. P. (2003). *Using instructional design strategies to foster curiosity.* ERIC Clearinghouse on Information and Technology. https://doi.org/10.1037/13147-000.

Bianchini, S., Levillain, F., Menicacci, A., Quinz, E., & Zibetti E. (2016). Towards behavioral objects: A twofold approach for a system of notation to design and implement behaviors in non-anthropomorphic robotic artifacts. In J.P. Laumond & N. Abe (Eds.). *Dance notation and robot motion* (pp.1–24). Springer International Publishing.https://doi.org/10.1007/978-3-319-25739-6_1.

Brecht, G. (1966). *Chance-imagery.* Something Else Press.

Breton, A. (1969). Manifesto of surrealism. In *Manifestoes of surrealism* (R. Seaver & H. R. Lane, Trans.). University of Michigan Press (Original work published 1924).

Copeland, S. M. (2019). On serendipity in science: Discovery at the intersection of chance and wisdom. *Synthese, 196*, 2385–2406. https://doi.org/10.1007/s11229-017-1544-3

Cunha, M. P. E. (2005). *Serendipity: Why some organizations are luckier than others* (FEUNL Working Paper no. 472). https://doi.org/10.2139/ssrn. 882782

Cunha, M. P. E., Clegg, S. R., & Mendonça, S. (2010). On serendipity and organizing. *European Management Journal, 28*, 319–330. https://doi.org/10. 1016/j.emj.2010.07.001

DeLanda, M. (1997). Immanence and transcendence in the genesis of form. *The South Atlantic Quarterly, 96*(3), 499–514.

DeLanda, M. (2004). Material complexity. In N. Leach, D. Turnbull, & C. J. K. Williams (Eds.), *Digital tectonics* (pp. 14–21). Wiley.

DeLanda, M. (2011). *Philosophy and simulation: The emergence of synthetic reason.* Continuum.

Deleuze, G., & Guattari, F. (1987). *A thousand plateaus.* Bloomsbury Academic.

Foster, A. E., & Ellis, D. (2014). Serendipity and its study. *Journal of Documentation, 70*, 1015–1038. https://doi.org/10.1108/JD-03-2014-0053

Friedel, R. (2001). Serendipity is no accident. *The Kenyon Review, 23*(2), 36–47. https://www.jstor.org/stable/4338198

Gong, R. H., & Wright, R. M. (2002). The design and application of fancy yarns. In R. H. Gong & R. M. Wright (Eds.), *Fancy yarns: Their manufacture and application* (pp. 92–125). Woodhead Publishing Ltd.

Haines, C. S., Lima, M. D., Li, N., Spinks, G. M., Foroughi, J., Madden, J. D. W., Kim, S. H., Fang, S., De Andrade, M. J., Göktepe, F., Göktepe, Ö., Mirvakili, S. M., Naficy, S., Lepró, X., Oh, J., Kozlov, M. E., Kim, S. J., Xu, X., Swedlove, B. J., ... Baughman, R. H. (2014a). Artificial muscles from fishing line and sewing thread. *Science, 343*(6173), 868–872. https:// doi.org/10.1126/science.1246906

Haines, C. S., Lima, M. D., Li, N., Spinks, G. M., Foroughi, J., Madden, J. D. W., Kim, S. H., Fang, S., De Andrade, M. J., Göktepe, F., Göktepe, Ö., Mirvakili, S. M., Naficy, S., Lepró, X., Oh, J., Kozlov, M. E., Kim, S. J., Xu, X., Swedlove, B. J., Wallace, G. G., & Baughman, R. H. (2014b). Supplementary materials for artificial muscles from fishing line and sewing thread. *Science, 343*(6173). https://doi.org/10.1126/science.1246906.

Head, J. (2015, April 4). *New approaches for muscle creation, and adjusted strategy [Blog post].* Retrieved 18 August 2016 from: http://robotics.jasonm head.com/new-approaches-muscle-creation-and-adjusted-strategy

Ingold, T. (2010). The textility of making. *Cambridge Journal of Economics, 34*(1), 91–102. https://doi.org/10.1093/cje/bep042

Ingold, T. (2013). *Making: Anthropology, archaeology, art and architecture.* Routledge.

Iversen, M. (2010). The aesthetics of chance. In: M. Iversen (Ed.), *Chance* (pp. 12–27). Whitechapel Gallery.

Janson, H. W. (1973). Chance images. In: P. P. Wiener (Ed.), *Dictionary of the History of Ideas: Studies of selected pivotal ideas* (Vol. I, pp. 340–353). Charles Scribner's Sons.

Kapsali, V., Toomey, A., Oliver, R., & Tandler, L. (2013). Biomimetic spatial and temporal (4D) design and fabrication. In N. F. Lepora, A. Mura, H. G. Krapp, P. F. M. J. Verschure, & T. J. Prescott (Eds.), *Biomimetic and biohybrid systems: Living machines 2013.* Lecture Notes in Computer Science, 8064. Springer. https://doi.org/10.1007/978-3-642-39802-5_43

Kashdan, T. B., Gallagher, M. W., Silvia, P. J., Winterstein, B. P., Breen, W. E., Terhar, D., & Steger, M. F. (2009). The curiosity and exploration inventory-II: Development, factor structure, and psychometrics. *Journal of Research in Personality, 43*(6), 987–998. https://doi.org/10.1016/j.jrp.2009.04.011

Kuh, K. (1962). Marcel Duchamp. In *The artist's voice: Talks with seventeen artists* (pp. 81–93). Harper & Row.

Lomov, S. V., Huysmans, G., & Verpoest, I. (2001). Hierarchy of textile structures and architecture of fabric geometric models. *Textile Research Journal, 71,* 534–543. https://doi.org/10.1177/004051750107100611

Makri, S., & Blandford, A. (2012). Coming across information serendipitously: Part 1: A process model. *Journal of Documentation, 68*(5), 684–705. https://doi.org/10.1108/00220411211256030

McCay-Peet, L., & Toms, E. G. (2010). The process of serendipity in knowledge work. In *Proceedings of the third symposium on information interaction in context* (pp. 377–382). ACM Press. https://doi.org/10.1145/1840784.1840842

McCay-Peet, L., & Toms, E. G. (2015). Investigating serendipity: How it unfolds and what may influence it. *Journal of the Association for Information Science and Technology, 66*(7), 1463–1476. https://doi.org/10.1002/asi.23273.

Merton, R. K. (1968). *Social theory and social structure.* The Free Press.

Merton, R. K., & Barber, E. (2004). *The travels and adventures of serendipity. A study in sociological semantics and the sociology of science.* Princeton University Press.

Molderings, H. (2006). *Duchamp and the aesthetics of chance.* Columbia University Press.

Mori, M. (2012). The uncanny valley (K. F. MacDorman, & N. Kageki, Trans.). *IEEE Robotics and Automation Magazine, 19*(2), 98–100. https://doi.org/10.1109/MRA.2012.2192811 (Original work published 1970).

Morris, R. (1993). *Continuous project altered daily: The writings of Robert Morris*. The MIT Press.

Nauman, B. (2010). On mapping the studio I (Fat chance John Cage) (2001)//2002. In M. Iversen (Ed.), *Chance* (pp.198–199). Whitechapel Gallery (Reprinted from Bruce Nauman Talks about Mapping the Studio, Artforum, 2002, March, pp. 120–21).

Philpott, R. (2011). *Structural textiles: Adaptable form and surface in three dimensions* (Ph.D. thesis, Royal College of Art, London, England). https://researchonline.rca.ac.uk/434/.

Piñeyro, A. (2019). Kinetic morphologies. Revealing opportunity from mistake. *The Design Journal, 22*(sup1), 1871–1882. https://doi.org/10.1080/14606925.2019.1595027

Richter, H. (1997). *Dada art and anti-art*. Thames & Hudson.

Roberts, R. M. (1989). *Serendipity: Accidental discoveries in science*. Wiley.

Rubin, V. L., Burkell, J., & Quan-Haase, A. (2011). Facets of serendipity in everyday chance encounters: A grounded theory approach to blog analysis. *Information Research, 16*(3), paper 488. http://www.informationr.net/ir/16-3/paper488.html

Saez-Pons, J., Lehmann, H., Syrdal, D.S., & Dautenhahn, K. (2014). Development of the sociability of non-anthropomorphic robot home companions. In *4th Joint IEEE international conference on development and learning and on epigenetic robotics*, 13–16 October 2016, Genoa, Italy (pp. 111–116). IEEE. https://doi.org/10.1109/DEVLRN.2014.6982964

Safán-Gerard, D. (2018). *Chaos and Control. A psychoanalytic perspective on unfolding creative minds*. Routledge.

Simondon, G. (1992). The genesis of the individual. In J. Crary & S. Kwinter (Eds.), *Incorporations* (pp.297–319). Zone Books. https://doi.org/10.1109/JPROC.1998.658758

Sun, X., Sharples, S., & Makri, S. (2011). A user-centred mobile diary study approach to understanding serendipity in information research. *Information Research, 16*(3), paper 492. http://informationr.net/ir/16-3/paper492.html

Turpin, I. (1979). *Max Ernst*. Phaidon.

van Andel, P. (1993). Serendipity: Its origin, history, domains, traditions, patterns, appearances and programmability. In M. P. C. Heljnen & A. A. H. Drinkenburg (Eds.), *Precision process technology perspectives for pollution*

prevention (pp. 689–704). Springer. https://doi.org/10.1007/978-94-011-1759-3

van Andel, P. (1994, June). Anatomy of the unsought finding. Serendipity: Origin, history, domains, traditions, appearances, patterns and programmability. *The British Journal for the Philosophy of Science, 45*(2), 631–648. https://doi.org/10.1093/bjps/45.2.631

Briefing for a Systemic Dissolution of Serendipity

Paul L. March and Frédéric Vallée-Tourangeau

No sooner had Horace Walpole invented the word "serendipity" in a letter to his friend Horace Mann, he split the concept in two, describing it as a combination of "accident and sagacity". The interplay between chance and wisdom underpins the concept of serendipity to this day and provides the basis for research into the role of accidents in scientific discovery and the place of the unpredictable in creative activity in general. Later in the letter, Walpole offers another, much less cited definition of serendipity: "accidental sagacity". The subtle, syntactic recombination of "accident" and "sagacity" belies a substantial semantic

P. L. March (✉)
Oxford University, Oxford, UK
e-mail: p.march@keble.ac.uk

F. Vallée-Tourangeau
Kingston University, Kingston upon Thames, UK
e-mail: f.vallee-tourangeau@kingston.ac.uk

W. Ross and S. Copeland (eds.), *The Art of Serendipity*, Palgrave Studies in Creativity and Culture, https://doi.org/10.1007/978-3-030-84478-3_7

and ontological leap which may explain why the second definition is passed over in favour of the first. Although in common parlance, "accidents" and "sagacity" are loosely defined concepts, operationalising them is a usefully rigorous first step in a research programme aimed at considering how they might be recombined to create positive outcomes. That is how science proceeds, through a process of reduction, abstraction and recombination (see Gilhooly, Ross & Simonton, this volume).

"Accidental sagacity", on the other hand achieves such delightful levels of ambiguity that it fails even to attain the paradoxical certainty of an oxymoron. It is therefore no surprise that research projects do not queue up to be launched under its quixotic ensign. But we are drawn to "accidental sagacity" precisely because it does not immediately seek to capture and compartmentalise the concept of serendipity. It manages instead to maintain, cherish and even extend its mystery. In particular, we like the way the self-deconstructive notion of accidental sagacity widens the agential possibilities of the serendipitous process. In her encyclopaedia entry on serendipity, Ross (2020, p. 8) points out that, despite the relational nature of the term, existing models of serendipity tend to describe agency in individual human terms.

> There is an ever-present tug toward a human-centric model of action, even in a concept such as this one which is, by its very nature, enmeshed and entangled. What is possible in serendipity studies is constrained by the way it is approached.

From the perspective of an individual human, serendipity can be understood to be marked by four features: first, an unexpected event occurs beyond the agent's intentional ambit. Second, the agent finds the event surprising and thereby notices the experience. Third, the event gives the agent a new idea; a moment of insight.[1] Fourth, as a result of the idea, the agent changes his/her intentions which eventually brings about a positive result (Copeland, 2019). An individual experience of serendipity depends upon there being a good outcome requiring an "ah-ha!" moment to be temporally retrofitted to a past event. The "ah-ha"

[1] We call these moments "outsight" see below, p. 12.

must be exclaimed anachronistically in relation to the memory of a past event whose significance can only now be appreciated. In her analysis of the discovery of penicillin, Copeland (2019) makes a similar point.

> Rather than a moment of "eureka" upon making what has been deemed a serendipitous observation in light of the exceptional value it is now known to have had, Fleming is reported to have said something more like "That's funny". (Hare, 1970, p. 65, cited in Copeland, 2019)

The retrospective coronation of serendipity requires the individual to use hindsight to draw a direct causative line from the outcome towards its putative determinant. By using "accidental sagacity" as a working definition for serendipity, we hope to avoid being tugged into explanations that divide the world into human agents and environmental contingencies. We will concentrate instead on the entanglement itself and explore what happens to the concept of serendipity if we consider the origin of intention to be not the product of an agent but of a process—that of getting tangled up.

We begin with a brief introduction to Material Engagement Theory (MET): a methodological approach that we will use to help prevent us straying too much onto the straight and narrow. MET was developed within archaeology and it focuses attention, not on the relationship between humans and things per se but on the exploration of relational processes over time and their influence on human-thing becoming in systemic terms. We focus on the MET notions of "extended intentional state" "intention-in-action" and "creative thinging" to develop the notion of accidental sagacity in terms of an ongoing experience that accompanies an unpredictable pattern of creative activity which simultaneously and interdependently creates knowledge by making things and creates things by making knowledge. We refer to this process as "learning into existence" (see March & Malafouris, forthcoming). We accept that the chaotic nature of the entangled descriptions that we are embracing make it difficult to grasp when described in these abstract terms and so we present two case studies to exemplify the apparently haphazard but inseparable ontogeny of things and ideas. The bulk of the chapter is devoted to the first of these case studies. It describes a programme of activity

that, while taking place in an artist's workshop, is experienced as being of uncertain artistic purpose. The report is given by the artist, Paul March (PM). We describe it as phenomenological and whereas it is certainly not an objective account, it is not, strictly speaking, a subjective account either (see Le Hunte, this volume). We will go into this in more detail later but for now it is enough to say that the case gives us a glimpse of what it is like to be inside one, specific system.

The second case is drawn from the experimental psychology of creative problem solving. We give a briefer summary because, given the constrained nature of laboratory, problem-solving tasks, they have a short timescale and are considerably less complex than the problems faced by the artist. More importantly, the laboratory case reports the movement of artefacts that correspond to features of the problems to be solved. Unlike the workshop case, it does not draw on the phenomenological experience of the participants as they work on the problem and produce new ideas. The experiment we report captures the process of problem solving as it takes place in, with and through the world (as opposed to in the head, via the putative manipulation of mental models of the world). This view from beyond the problem-solving system, provides a way of triangulating the phenomenological account and making activity visible, recordable and in some sense, verifiable. It shows that the path to the solution takes a haphazard, unpredictable course and the solution, if it is reached at all, happens through a change in the pattern of activity that does not reflect the premeditated implementation of a problem-solving strategy. Put another way, the systemic reorganisation of movement patterns heralds a solution which the participant realises only when she sees it. We close the chapter by considering how a phenomenological analysis of a specific creative process which is partially scaffolded by an empirical study of problem solving can inform our understanding of serendipity.

Material Engagement Theory in Context

MET was introduced by Renfrew and Malafouris (Renfrew, 2004) and the concept of the extended intentional state by Malafouris (2010). Malafouris (2013) further developed MET into a detailed methodology with the addition of important concepts (Malafouris, 2014, 2015, 2019). MET is founded on the work of Whitehead, Merleau-Ponty, Husserl, Heidegger and Bergson, to name some of the more important influences, and MET shares these foundations with other approaches from within archaeology and anthropology (e.g., Hodder, Ingold, Hutchins) as well as ecological psychology and the recent 4E (embodied, embedded, enactive and extended) movement in philosophy and cognitive science alongside the influential work of Latour (e.g., 1999). Silberstein and Chemero (2015) argue that these 4E, phenomenological and ecological approaches are underpinned by James's philosophical views: a version of neutral monism that James called *Radical Empiricism* (1905). We would argue that MET fits comfortably under the same umbrella (see Gosden & Malafouris, 2015). Whether or not neutral monism resolves the immiscibility of mind and matter is beyond the scope of this chapter (see Silberstein & Chemero, 2015 for a discussion and Seager, 2016, chapter 15, for a review of neutral monism) but we will briefly describe James's ontological position because it provides a philosophical basis for the argument that we employ in this chapter, namely that things (matter) and ideas (mind) are existentially interdependent to the point of being inseparable.

James makes no distinction between the physical world and our experience of it: there is no bedrock of objective reality over which a layer of subjectivity is more-or-less accurately stretched. The objective and subjective are analytical abstractions derived from a single, fundamental substrate called "Pure experience"—termed neutral because it is neither mental nor physical. It is important to emphasise that pure experience is <u>not</u> a heightened form of first-person experience because, within pure experience, there is no personal self any more than there are material things. James (1904, p. 484) describes pure experience as follows.

> In its pure state, or when isolated, there is no self-splitting of it into consciousness and what the consciousness is 'of.' Its subjectivity and objectivity are functional attributes solely, realized only when the experience is 'taken,' *i.e.*, talked-of, twice, considered along with its two differing contexts respectively, by a new retrospective experience, of which that whole past complication now forms the fresh content. The instant field of the present is at all times what I call the 'pure' experience. It is only virtually or potentially either object or subject as yet. For the time being, it is plain, unqualified actuality, or existence, a simple *that*.

Our interest here is to highlight James's contention that the division of the world into subject and object occurs through retrospective analysis and that by remaining within the experience of the present, neutral monism provides a basis to extend a phenomenological account beyond the subjective (first person), making it possible to conceive of what Silberstein and Chemero (2015, pp. 7–8) call, "extended-phenomenological-cognitive systems":

> Events, such as everyday experiences of flat tires, concerts, conversations, etc., which are neither essentially physical nor mental, are fundamental and exhaustive, and they are grounded in and one with the neutral "Presence"—what James calls the "instant field of the present".

The Theory of Material Engagement

MET, as laid out in Malafouris (2013) contains three, interrelated concepts.

The Extended Mind

Unlike Clark and Chalmers's (1998) original description, Malafouris views the extended mind, not as a network of objects co-opted into a cognitive system by a central, cranial executive but as a process of

extended activity that evolves over time between person and environment (see also Glăveanu, this volume). In Clark and Chalmers's version, the mind is extended in space from an anatomical centre, its extra-corporeal borders delimited by functional requirements. In the MET version, the mind is more usefully conceived of as inhabiting a temporal dimension, anchored spatially in the present at the point of a specific human-material interaction, it extends retrospectively to engulf habits and cultural patterns through which the ongoing activity finds its rhythm and anterospectively by anticipating the variations, improvisations and ruptures of habit necessary to create a viable future.

Enactive Signification

With the mind as an emergent property of temporally extended material engagement, prospective activity becomes the motor, both of making and of signification; with no need for meaning to be experienced through the interpretation of symbolic content nor action in the world to be converted and represented into another format in order to make sense. This is important for understanding how art *works*: enactive signification provides a mechanism by which the process of making and beholding art becomes a direct, active, integrated experience, unmediated by language.[2]

Material Agency

Malafouris's concept of the extended mind makes it difficult to pinpoint a single source of agency. If the mind is a temporally extended process that finds a transient home on earth exclusively during the making-thinking-sensing activity of the moment, then agency too is best seen as similarly extended—within a work in progress rather than a person. In this way, and as described above, preceding patterns of worldly activity develop auto-genetically into an *extended intentional*

[2] We are not arguing that symbolic content does not exist—only that it is not an exclusive or essential pathway to meaning.

state that predicts and creates a future state. The temporal extension of the intentional state occurs within and between shifting, recursively intercalated systemic configurations that operate along different time scales—cultural-phylogenetic, ontogenetic, task-related—all of which are expressed in a spatially and materially specific extended present moment of action: what Malafouris refers to as the *hylonoetic field* (2013, 2019). Malafouris (2013) subsequently developed the concept of the extended intentional state by aligning it with Searle's (1983), concept of *intention-in-action* which points to the essential intention-forming nature of habitual activity. We use *extended intentional state* here when we wish to invoke a wider network of intentional genesis than a single, ongoing thread of contingent action.

The above themes are usefully integrated, particularly in relation to the experience of art, by Malafouris's concept of *creative thinging* (2015). The word *thinging* comes from Heidegger who used it to underline the proposition that things were not passive, immutable objects but forcefields of continuous, active transition. Consistent with the neutral monism of James, *creative thinging* invites us to consider the development of mind and the mutability of things to be recursively interdependent, focusing attention at a point in time and space where movement makes mind and matter indistinguishable (see also Le Hunte, this volume). From the perspective of this brief summary of MET, it makes no sense for Walpole to separate sagacity from the exigencies of the environment nor to excise Pasteur's "prepared mind" from the web of historical and prehistorical cultural-evolutionary influences that connect it to humanity (see also Ross, Copeland this volume).

Having presented MET and before going onto the first case study, we want to return to our hesitation, voiced earlier about referring to PM's report as a phenomenological account. Our problem is with a first-person experiential perspective: reporting the experiential corollaries of individual intention, personal agency and the private content of internal representational models, does not fit well with the ontological implications of MET. The phenomenology of *creative thinging* requires a description of what it is like to be part of an extended mind with an extended intentional state in which the experience of meaning is enacted through material. We need a phenomenal construction more similar to

Heidegger's concept of *Dasein* (being in the world). We maintain that PM's account cannot be called subjective because it gives voice to the experiences of an extended-phenomenological-cognitive system which by implication manifests a form of extended consciousness. We accept that the chapter introduces a complex and controversial concept with little space to elaborate but we think it important to make clear that the notion of an extended form of being constrains the way we approach serendipity in what follows. Finally, given the phenomenological ambiguity that we have just outlined, we find it unfortunate that we have to rely on a first-person account, but we lack the language structure for a first-system account.

Case Study 1: Fossilized Flowers Reified

Most of the action of the case study takes place in a ceramic workshop in Geneva before moving briefly but dramatically a few kilometres down the road to the United Nations. I am an artist who works mainly with clay. For most projects I mix the clay with small quantities of paper and flax fibre. For 10 kg of clay, I usually add 25 g of flax and 50 g of paper—about the maximum recommended (Reijnders, 2005). The addition of fibre makes a composite material which increases the strength of raw clay while maintaining its plasticity and helps prevent cracking during the drying process.

About five years ago while mixing paper and flax into a batch of clay I tried adding a little clay at the stage when I was mixing the fibre and water to see if would make it easier to mix all the ingredients together later. Kneading clay is hard work, and I was keen to avoid unnecessary physical labour. As I mixed clay and fibre together, my attention was caught by the odd, slimy, fibrous substance that was forming between my hands and I began wondering what would happen to the workability of clay and its fired visual aspect if the ratio of fibre was markedly increased.

I continued to add fibre to clay until the mixture became more-or-less unworkable. I squashed it into a plaque, and once dried, I fired it. The resulting material was surprisingly light and had the intriguing aspect of friable rock but, given that I had made an unworkable material, it was

ludicrously inevitable that I could find nothing do with it except put it on the windowsill where it stayed for a couple of years (see later reference to Keller about stuff lying around in a workshop).

In 2017 I spent six months modelling a tonne of clay into a large ceramic sculpture, the construction, drying and firing of which was a significant technical challenge (see March and Malafouris, forthcoming; and *Another Part of the World* [artwork by the first author]). Before beginning the project, I considered increasing the fibre-clay ratio to gain strength, decrease weight and stabilise drying but decided against doing so, partly because of received wisdom and partly because of the experience, just described of trying to work with high-fibre clay.

Once the sculpture was finished, I was in my workshop one day reviewing the struggles of the previous months and, with the view of the sample from the windowsill acting as an idea-catalyser, I wondered whether I had misremembered the sensation of working with heavily fibred clay. I picked up the sample and was once more drawn to its feel and appearance. I started work on a second sample but approached the task more empirically this time. I began with a very high ratio of dry-weight fibre (50%) adding more clay until the mixture approached workability. I stopped at a ratio of 10% fibre at which point the material was not at all elastic, tore easily, was unresponsive to the touch and had a tendency to resist all modelling gestures (see Fig. 1). However, since the last encounter with this intransigent material, I had begun a doctoral research project focusing on sculpting in relation to MET. The experience of being thwarted once again by the fibre-clay but this time in the context of MET, confronted me with the obvious fact that, on the last occasion, I had engaged with the material as though I was already familiar with it. Instead of seeking a relationship with the clay-fibre, instead of exploring its qualities with a view to discovering what we were capable of together, I had tried imposing well-learned but ill-adapted sensory-motor habits onto it. Normally we call these sorts of moments of realisation "insight". But in this case, the change of view was quasi-literal. It did not take place in the obscurity of an internal conceptual space of abstract reflection: it occurred in the visible and touchable external world during specific, gestural activity. We have therefore coined

Fig. 1 Fibre-clay thwarted all attempts to engage with it as though it was normal clay

the term "outsight" to refer to such events (Vallée-Tourangeau & March, 2020).

We can look at this episode of outsight in two different ways. First, from the perspective of a mind-material separation, it appears as though my decision to change the nature of the task from making art to making academic ideas transformed my view about the clay, but did not change the clay itself—how could it? But from the perspective of enactive signification, the sensorial qualities of fibre-clay **are** manifestly different. The moment of outsight arose from material engagement, transforming the material quality of the clay by this act of realisation.

From the perspective of serendipity as accident and sagacity, we have the following so far. A technical innovation in mixing clay and fibre leads to the accidental formation of a novel material. The wise artist recognises this and explores its potential which leads to a dead end—not so wise after all. At this point, there is no happy ending and so no serendipity. Two years later, the epistemological environment has changed. MET has

prepared the artist's mind to see a dead-end as a research opportunity. If the final outcome (that is, the point where we decide to stop the story and from the perspective which the story is told) turns out to be a happy one, then we now have all the elements in place to be able to look back from the future and see serendipity at play. In our view, such a perspective—one that separates entities and ideas from themselves and from each other and then lines them up by cause and effect avoids the very complexity that it is necessary to protect if we are to appreciate the nature of serendipitous experience. But let us continue with the case.

Outsight shifted the haptic signification of the slimy, fibrous mass away from being a source of creative frustration and towards becoming a research opportunity. The extended intentional state stopped seeking mastery and began an attitude of free-floating sensory attention which was, in turn associated with a change in gestural intention. By massaging and kneading the fibre-clay in an exploratory fashion, the gesture-fibre-clay system began to learn that, unlike ordinary hand-clay interactions which encourage the whole hand to be involved, fibre-clay demands only the fingers to be engaged. It is completely unresponsive to large movements, yielding only to a sliding pressure between the thumb and a finger. This gesture of sliding clay and fibre together has the effect of cementing the components into layers a few millimetres thick. Any attempt to work with thicker sections ends in tearing. We argue that, in learning this technique, the gesture-fibre-clay system learned itself into existence (see also Piñeyro, this volume). From a phenomenological-systemic perspective, by extending into the future, the activity of the present is positively affirmed, not retrospectively but in real time. If we can refer to it as such without reaching the semantic limits of the word, we might say that serendipity is synchronically enacted and habitualised. In her analysis of the practice of science, Copeland (2019, p. 2389) concluded serendipity to be "more ubiquitous than momentous". We certainly found this to apply to the fibre-clay system. In contrast, I (the individual artist) only became aware of this episode of implicit learning two years later, when I wrote those words. This underlines our earlier point concerning the anachronistic nature of an individual retrospective perspective. We will return to the notion that systemic learning can take

place without the awareness of the individual when we look at problem solving in the lab.

While kneading clay, I began thinking about my morning coffee cup—rather, not the cup itself, but drinking coffee from it. Although a memory, it was not a memory of a specific, past event. It was the evocation of a habitual activity, made present in relation to the restricted behaviour of the novel clay.[3] As Malafouris and Koukouti (2018, p. 161) put it,

> re-experiencing events from the past are increasingly recognized as forms of context-dependent embodied simulation and re-enaction: a person remembering an event in the past re-enacts similar visual, kinaesthetic, spatial, and affective aspects to the original experience.

I began encouraging the clay to make the form of a vessel. By that action, the morning coffee cup was drawn into the story as a stepping stone in the fibre-clay's journey.[4] Gestural activity was subverted by the evocation of coffee drinking and reoriented away from open exploration, reverting to a well-established ceramic construction technique known as coiling. The method involves rolling the clay into long, sausage-shapes and coiling them into the desired form before smoothing the walls to form the sides of the vessel. But here, the fibre-clay immediately resisted being rolled; the fibre mitigated the clay's plasticity, preventing it from sliding along itself. By adjusting the technique, by combining rolling and coiling with the method I have described of pinching-sliding the clay flat between finger and thumb I did manage to make two beakers, but the work was clumsy and unsatisfying (see Fig. 2).

Chastened, I returned to making what was possible using the pinching-sliding technique alone—small plaques of clay—about 2–3 mm thick and 60 mm diameter. Beyond 60 mm the plaques began to tear or disintegrate. Once they had dried a little, the small pieces could

[3] Word limits prevent us exploring the reasons why fibre-clay and morning coffee came together—even a systemic account must be hacked away from the rest of the universe. But a sequel does exist (March & Glaveanu, 2020).

[4] If I were telling a story from the perspective of a transformation in my coffee drinking experience then the cup-to-be would be the principal character, with the fibre-clay taking the role of material stepping stone.

Fig. 2 One of the beakers: the form was determined by the mismatch between the rolling gesture and the material possibilities of fibre-clay

be joined and shaped into hollow lumps around the internal support of a screwed-up ball of paper, but the fragility of the clay-fibre also limited these lumps to a diameter of 60–70 mm (see Fig. 3, left panel). However, by sticking several of them together, individual lumps could grow, blastomerically into a larger form (Fig. 3, right panel). Within the gesture-fibre-clay system the decision to grow in size took place without reflection: as intention-in-action linked separate units of gestural patterns to make something bigger and, in so doing developing the extended intentional state of the system. Once again, only in retrospect did I

Fig. 3 A selection of lumps (left panel); Blastomeric lumps (right panel)

consider that the intention to grow was linked rather more to a system of sculpture than it was to a system of research.

By this stage I was unsettled, perhaps in part because of the unrecognised mismatch between the system and the individual epistemic positions just mentioned. I wrote in my notes "Difficult to describe the extent to which I am lost - unsure why I am doing this - what is happening" (19.9.18; see also Sneddon, this volume). Before starting the PhD, I would have launched into an investigation of fibre-clay for a specific artistic reason and the learning-into-existence of clay-fibre possibilities would have occurred, probably un-noticed in the margins of more explicitly creative aspects of the workshop routine. But now, in the context of doctoral research, the primary task became to monitor the quality of engagement between the hand-fibre-clay system and an unfamiliar material and this had the disturbing effect of removing the assumption that an artwork would develop from process. The intentions associated with the new activity became obscure and destabilising. The experience bears some parallels with Kirchhoff and Kiverstein's (2020) analysis of culture shock as a breakdown of phenomenal attunement (see also Sneddon, Turner & Kasperczyk, this volume).

Obscured from intention, I had a vivid memory of my childhood efforts at flower arranging. As long ago as I can remember, my mother would arrange flowers and put them around the house. At the age of five or six, I started arranging flowers too. The trouble was, I did not really have a notion of a flower arrangement. I did not understand why I would place the flowers one way as opposed to another. I used my mother as a model but rather than pay attention to the aesthetic effect of the arranged flowers, I copied her actions as though they were ends in themselves. "Arrange" the flowers, stop, step back and look, rearrange, step back again etc. take some flowers out, put others in and finally add a few leaves. Stepping back, I had no idea that I was supposed to be making a judgement about beauty.

In the workshop, the sensory-motor feeling of arranging flowers with no guiding aesthetic intention came back with a shock. As the lumps piled up, engagement between material and gesture improved but the sculptural form of this engagement seemed to hold no relevance for the developing choreographic pattern of the gesture-fibre-clay system.

With no aesthetic traction, no "kinetic melody" (Luria, 1973, p. 73), the system felt limp and exhibited no intentionality. Individual lumps were unforthcoming when it came to exhorting some sort of differential sensation. As a group, they did begin to interact but the presence that developed between them was feint and gave no discernible direction to gestures which either ground to a halt or were thrust forward—away from the fear of touching a void of inactivity. Swirling in contradictory directions, a miasma of agency gave only a tenuous sense of purpose and I found the unsettling uncertainty difficult to withstand. Grasping for a resolution, the idea of creating a photo inspired by a previous art project became irresistible (see Figs. 4 and 5).

I began experimenting but soon found it impossible to ignore the growing conviction that the activity was motivated by the wish to escape

Fig. 4 *Still Live* (2003) one of two photos printed on aluminium (1.0 m × 1.0 m)

Fig. 5 The blastomeric lumps following *Still live*, shown in Fig. 4

a sense of self dissolution[5] (March, 2019). Milner (1950, pp. 75–76) describes a similar situation during certain drawings:

> They were the kind in which a scribble turned into a recognisable object too soon, as it were; the lines drawn would suggest some object and at once I would develop them to make it look like that object. It seemed almost as if, at these moments, one could not bear the chaos and uncertainty about what was emerging long enough, as if one had to turn the scribble into some recognisable whole when in fact the thought or mood seeking expression had not yet reached that stage. And the result was a sense of false certainty, a compulsive and deceptive sanity, a tyrannical victory of the common-sense view which always sees objects as objects.

Despite recognising the impulse as a defence, more ideas came piling in, all trying to attenuate the anxious sense of dissolution surrounding the act of modelling clay in the absence of intention. The activity continued in this desperate mood and a work-rhythm eventually established itself as, one after another, lumps emerged with the form and regularity of dung, with nothing to distinguish one from another.

[5] To complicate matters, once this project was finished a new project, Sending the Blessings Back, did develop from Still Live.

Fig. 6 At the bottom of the notebook page my mind wanders back to the preoccupations of the workshop (left panel); the enclosed basin of the Musée Ariana (middle panel); a systemic call for action provokes further doodling (right panel)

A week later, I was at a meeting at the United Nations in Geneva as part of my work with an NGO. After about 20 minutes of careful concentration, my mind began to wander as we can see in my notebook (see Fig. 6, left panel). At the foot of the page, I am doodling lumps while thinking about the Swiss Ceramics Museum, an ostentatious building set in spacious grounds just beyond the UN conference hall. Earlier that summer, while wandering the museum gardens I came across a cloistered area containing a rectangular basin. Perhaps a former water basin, it was now beautifully planted with wildflowers and grasses (see Fig. 6 middle panel). Someone on the podium said "… call to action… systemic response…". In my notebook, I wrote these words at the top of the next page where there is also a recognisable sketch of a flower and the word *Hortus* (Fig. 6, right panel). Latin for enclosed garden, I had learned the word a few weeks earlier when the theme for a biannual ceramics competition was announced—"*Hortus*. The Garden Invades the Table". Perhaps it appears here because of the proximity to the cloistered area in the museum gardens.

As the doodle creatively thinged about *hortus*, it provoked a memory of two themes in the paintings of Anselm Kiefer; ancient landscapes and sunflowers (see for example Osiris and Isis [1985–1987] and Morgenthau Plan [2013] at the Royal Academy website, London). The memory led in turn to thinging-through-doodling about whether it was possible to conceive of something that was both a flower and a landscape. As the doodle conceded with disappointment that it was not, the possibility of fibre-clay developing into flowers did become a thingeable idea.

Fig. 7 Detail from the installation *Welcoming Down the Blessings*, 2019

Back in the workshop that afternoon, I returned to the familiar gesture of pressing fibre-clay between thumb and forefinger but now the gesture enacted a different significance—a damaged, desiccated petal was learned into existence in front of me, one that suggested a fossilised flower or one that had been petrified by the ash of Pompei (see Fig. 7).

Interim Summary

The story places the thingeable idea (thingeable idea—a novel possibility that inhabits the cusp between material and epistemic transformation) "fibre-clay as flowers" within a network of events and processes: remembering a flower-arranging past while pressing fibre-clay into the form of dung, doodling while attending a UN meeting adjacent to the garden of the ceramics museum, the use of the word *hortus* in a competition title, the work of Anselm Kiefer etc. If the thingeable idea comes good, we might be tempted to make a link to a moment of serendipitous reverie at a conference by taking the knotted gathering of the doodle and disentangling it in the belief that some threads will lead to wisdom and others to chance. But we suggest that the idea became thingeable because of the messy process by which events and processes became entwined within and along the trace of a doodle. By drawing a unidirectional causal link we fail to see that it was the entangling act of doodling that

created the memories of things in a form that was uniquely related to the doodle. The doodle can do this because memories and the experience of things occur in the present, not in the past. In "*On not being able to paint*" Milner (1950, p. 24) describes her discovery of two different experiential states which seem to correspond to the above two perspectives on serendipity: one is experienced in the present, the other only in retrospect.

> One way had to do with a commonsense world of objects separated by outline, keeping themselves to themselves and staying the same, the other had to do with a world of change, of continual development and process, one in which there was no sharp line between one state and the next, as there is no fixed boundary between twilight and darkness but only a gradual merging of the one into the other. But though I could know, in retrospect, that the changing world seemed nearer the true quality of experience, to give oneself to this knowledge seemed like taking some dangerous plunge; to part of my mind the changing world seemed near to a mad one and the fixed world the only sanity.

Interim Conclusions

The case study highlights a problem with the adjective "accidental" in "accidental wisdom (or sagacity)". Despite beautifully capturing the essential muddle of the process, "accidental" suggests that events have escaped the influence of human agency in favour of chance. But if we focus, not on the individual human agent but on an extended intentional state then the concept of accident is undermined because agency is not connected to an individual but is an emergent property of activity in the world. Put simply, whether something is viewed as accidental depends upon where we choose to draw the limits of our agential process and how permeable we choose to make that border (see Ross, this volume). For example, the separation of human agency from environmental accident appears more pronounced from the perspective of an observer as opposed to a practitioner (see Lock & Sikk, this volume), as Keller (2001) demonstrates in his comparative account of the two. He argues that whereas the observer has access only to the single, final, visible production pathway,

practitioners sense a wide network of potential influences on workshop activity and can:

> ...make us aware of the many factors that influence production. These insights argue against deterministic or single causal accounts of what only appears to be linear sequences in production. Instead, practitioners can point to the sundry ties among ideas and artefacts deriving from their complex reciprocal relations. (Keller, 2001, p. 35)

Thus, from an observer perspective, what appears to be the accidental presence of a piece of scrap is, from the practitioner perspective, a systemic part of workshop activity.

> The tendency of blacksmith's shops to be littered (to the eyes of some) with scrap and other odds and ends is explained by the potential of this "debris" for application to particular tasks. (Keller, 2001, p. 37)

Guided by MET, the case of the fibre-clay makes manifest this messy process that resists linear and reductive explanations; first and foremost because the account is generated and communicated from *within* a creative system (a human-centric model would call this a subjective description). We argue that this sort of intra-systemic tale is uniquely capable of providing an answer to the question "what is it like?". However, an answer from the inside cannot be used to make claims about activities that lie beyond the system from which it was generated. It provides weak evidence that other phenomenologically active systems behave and exist similarly. In contrast, whereas a scientific perspective can tell us nothing of what a system feels like, it can monitor and generate a view of the system from the outside which can be shared and tested. By transitioning from a phenomenological report of the trajectory of a creative system to recording the trajectories of participants solving problems in a psychology experiment we hope to demonstrate that the experiential phenomenon "learning into existence" also leaves traces that are visible from outside the experiencing system. Despite the simplicity of laboratory-based problems, by taking an enactive perspective of participant behaviour, we think it is possible to reveal something

of "the sundry ties among ideas and artefacts deriving from their complex reciprocal relations" which Keller finds in workshops and we described in the fibre-clay case study.

Movement Is Thinking

In many respects, this transition must bridge a chasm. For one, the artist's case study narrates a trajectory that spans years, crosses places, continents, and lifespan periods; the trajectory is populated with a multitude of characters, both human and non-human. The artist has a level of expertise, professional motivation and meta-reflective training that is simply absent in the typical, university undergraduate participant in a psychological experiment. While the artist creates and solves a problem that arises within a creative trajectory that may stretch back decades, in the laboratory, we observe the participant for a few minutes as she tackles a small, well-defined problem from outside her own life trajectory. It might appear that any attempt to bridge the chasm is foolhardy, if not downright dangerous but we believe that, although lab-based problems and solutions are normatively pre-determined, the participant still has to discover the solution, to learn it into existence, and this offers some common ground between workshop and laboratory that has further implications for the concept of serendipity. Before we sketch out these parallels, we provide a brief introduction to the research methodology employed by psychologists working on problem solving.

The Laboratory Approach

Approaches taken to study creative problem solving in the psychological laboratory take one of two broad routes, let us call them the sequestered route and the enactive route. The sequestered route employs a methodology where the problem solver (the agent) reads a problem description or inspects a static, schematic representation of a problem. The agent may be presented with a series of letters and asked to generate as many words as she can in a given time period. Or she may be asked to solve

a verbal riddle (a stumper).[6] Or she may be asked to figure out how to re-arrange the elements in a visuo-spatial problem to reconfigure one shape into another. Crucially, the agent is not embedded in a physical environment where she can think with and through the world. Rather, solutions must be internally cogitated in the absence of interaction with the world. This methodological sequestering (Vallée-Tourangeau & Vallée-Tourangeau, 2014) is motivated by an implicit allegiance to good old-fashioned Cartesian dualism (GOfCD).

Methodological sequestering aims to reveal the purity of mental processes. The data obtained are lean: Solution rates and latencies are recorded, but trajectories towards new thoughts are not because, since the work is all done in the head, there are no material traces of thinking to record. Psychologists have several techniques for filling this eviden- tial gap. Crafty neuroscience procedures may map different areas of the brain that are selectively correlated with solutions (Kounios & Beeman, 2014). Or researchers may solicit verbal protocols from their participants (Fleck & Weisberg, 2013), or record the participants' eye gaze to trace the allocation of attention to different problem elements (Bilalić et al., 2019). But the evidence produced by these techniques is circumstantial. More importantly, in our opinion, this form of research proceeds from a category mistake; the purification process transforms the mental into something quite different from how the mind manifests itself in the world. (Here is not the place to expand this argument; see Vallée-Tourangeau & March, 2020; Vallée-Tourangeau, forthcoming). By assuming an orthodox GOfCD perspective, the sequestered proce- dure constrains the agency (and intentionality) of problem solving and idea generation to a single source—viz. the mind of the agent—which, in turn, determines the path and direction of the problem-solving effort.

In contrast, the enactive route blurs the boundary between the partic- ipant and her environment. The focus of problem solving moves from the head to the manipulation of physical artefacts that correspond to

[6] A big brown cow is lying down in the middle of a country road. The streetlights are not on, the moon is not out, and the skies are heavily clouded. A truck is driving towards the cow at full speed, its headlights off. Yet the driver sees the cow from afar easily, and avoids hitting it, without even having to brake hard. How is that possible?" (Bar-Hillel et al., 2018, p. 112). Answer: it's daytime.

features of the problem to be solved. Thinking materializes with and through the world. Actions change the physical environment which in turn offers new perceptions and triggers new actions and, in so doing, the problem-solving system brings itself into being. Thus, the emergence of agency and intentionality follows similar lines to those found in the artist's description of how the flowers became a thingeable idea. We will illustrate the enactive route using a short case study drawn from an experimental procedure in which participants were asked to solve a simple problem by manipulating artefacts. The experimental procedure was instrumentalised to produce data that afforded a granular coding of the iterative relationship between actions and visible changes in the problem which, in turn, allows the psychological researcher to trace the route along which new ideas emerge. Indeed, we would argue that the emerging routes are the new ideas, the gradual reification of the solution to the problem. The case study will be illustrated through the schematized animation of the physical transformations of the problem over time.

Learning a Solution into Existence

The case study is taken from a problem-solving experiment where participants were given 10 minutes to solve the triangle of coins problem. The problem start state was shown as 10 coins arrayed in a triangular shape pointing down (see Fig. 8). The goal is to identify three coins, and only three, that can be moved to transpose the orientation of the triangle. The goal state is a triangular shape that points up and the solution involves the transposition of the three corner coins—the vertices. The 10 coins were labelled with individual letters; each coin occupied a cell on a 9 × 9 grid (with numbered columns and labelled rows). Participants were filmed in an observation laboratory with overhead cameras; the problem was presented on a computer tablet, and coins could be dragged across the grid. Participants could reset the configuration to its initial start state (triangle pointing down) at any time by pressing a reset button on the interface.

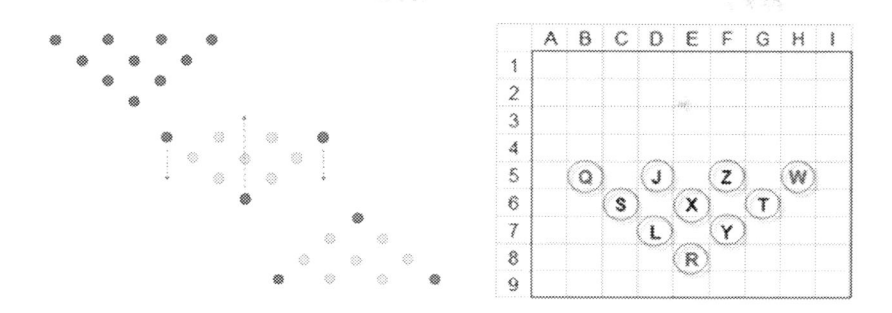

Fig. 8 The triangle of coins problem (left panel: start state at the top, goal state at the bottom); the problem as presented to participants (right panel; the vertices are colour coded here, but they were not for the participants). See Vallée-Tourangeau et al. (2020) for further details; on the importance of instrumentalising the procedure, see Vallée-Tourangeau and Vallée-Tourangeau (2020)

From the video data, the granular coding of movement was then transcribed, each new move and the resulting change in the configuration of the triangle was captured. We could thus create a schematic animation of the unfolding trajectory from start state to goal state for the successful participants (and indeed map all the other unproductive trajectories that did not eventuate in a solution in the time allocated for the unsuccessful participants). In the animation presented below the coins are shown with the letter with which they were labelled. On the right is plotted the move latency (red data series) as a running average over the previous five coin moves as well as the migration ratio (black data series); the migration ratio is an index that measures the degree to which the coins are primarily migrated up or down (see Vallée-Tourangeau et al., 2020, for a detailed description of this index; we return to the migration ratio below). As described earlier, the task is to reverse the vertices of the triangle coins 180° by moving only three coins. Thus, what is animated is the movement of letters, the red ones corresponding to the vertices, and these letters corresponded to the coins (the vertices were not colour coded in this manner for the participants). Let us watch the animation: https://osf.io/vh43b/; Vallée-Tourangeau et al. (2020) provide a detailed analysis but for our purposes here, we wish to draw attention, once again to the role of the dynamic change to the physical model of the problem. The

animation shows that most moves (40 or so) migrate the coins north, but, for this participant (as for all), this strategy fails because moving north requires too many coins to reverse the triangle's orientation. In the last 12 trials the participant begins moving the coins south to form the lower base of the triangle and this new pattern of movements gradually enacts the correct configuration.

The case study highlights several characteristics of the process of thinking as revealed through the manipulation of an object. We limit our discussion to two.

Movement and Thinking Are Indivisible

The animation demonstrates the difficulty of separating participant from environment in such a way that leaves the agency of wisdom exclusively on the side of the participant. We must suppress the GOfCD Pavlovian reflex that seeks to identify the independent causal attribution of either the agent on the one side or the environment on the other. Of course, these participants have thoughts and of course the environment throws up leading cues; but the creativity on display by these participants is irreducible to either. While it is possible to transactionalise the process, we argue instead that what is on display in this animation is the sort of dynamically unfolding intentional states captured by the concept of creative thinging. Methodologically, the process of creative thinging is revealed by the instrumentalised research procedure that affords the detailed coding of actions and changes in the world, which in turn provide the data with which the animated pathways can be constructed and then inspected. A particular problem-solving system is created by the constraints of the experimental design and these constraints in turn reveal that thinging takes place with and through the interactive materiality offered by the computer tablet and the physical model of the problem.

The triangle of coins study provided additional information about the cognitive role of movement. Alongside the animation, an index was created to capture the general transformation of the physical model as either involving coins migrating north (low ratio) or coins migrating south (high ratio): the "migration ratio" captures moves that bring coins

down to form a base along row 7 and is a numeric indication of the extent to which step-by-step configuration changes approximate to the solution. In this case, the migration ratio identifies that the direction of migration turns towards a potentially successful solution at move 46. Once again, we are confronted with the question of whether this suggests an enacted realisation (learned and experienced systemically as outsight) or whether we should view the reversal of movement as a conscious strategy change by the participant, provoked by what she learned during the previous 45 moves. In support of enactive realisation, the gradual rise in the migration ratio strongly suggests that the participant did not have a solution in mind until it appeared in front of her. This is further supported by the fact that she incorrectly announced the solution at the point when she had moved four coins to create a triangle pointing up. Only after being told that her solution was wrong did she go on to create the right configuration and see it as such.

Local Contingency and Epistemic Myopia

We therefore suggest that the solution to the triangle of coins is a story of gradual emergence rather than one that is internally cogitated and then physically implemented. This gradual emergence is in turn embodied by the evolving shape of the model of the solution. The pattern of previous moves combined with feedback from the real-time physical configuration of the coins constrain and guide the subsequent movements that adumbrate a solution. The unproductive series of moves illustrated in the animation, followed by the gradual approximation of the normative configuration, reflect a path-dependent and locally contingent process of move-selection that in turn illustrates the epistemic myopia of the individual agent: The knowledge of the solution and the physical construction of the normative configuration co-evolve gradually and systemically. Rather than being dictated by a well-articulated plan, each move is triggered by the previous one (see Copeland, Glăveanu, this volume). The transformation of the object does not proceed by implementing a plan that casts some moves as necessary, while others as unproductive (see Lock and Sikk, this volume). In turn, agency and

intentionality are locally contingent on the physical appearance of the configuration-qua-model of the solution. It is this path dependency and local contingency that give rise to the gradual emergence of the solution. After the participant's incorrect announcement, the transformation of the configuration is most assured and swifter, to be sure. Despite appearing to indicate that the participant knows the answer at this stage, she does not stop to announce it before first creating it. It is important to note that the task instructions did not force participants to construct a solution before announcing it (see Vallée-Tourangeau et al., 2020). Yet, she does so, and while the move latencies are shorter, it is also plausible to conjecture that these last moves were needed to physically reify the participant's hunch. In a separate case study reported in Vallée-Tourangeau (forthcoming), there is clear evidence that a participant recognises the correct configuration only after constructing, and not before. Thus, the object secures its ontological stability as the normative solution only once it is constructed.

Conclusions

The case of fibre-clay presents a systemic account of how activity in an art workshop called into question the ontological status of that activity. The case demonstrates how the disorienting brume of uncertain agency and sense of purposelessness that ensued, robbed the concepts of "accident" and "wisdom" of their traction. Later in the story, when a doodle suggested a thingeable idea, the case study indicated that the realisation of this possible future would depend, not on accidental events but on the extended period of incertitude that preceded the doodle. We suggest that the incertitude reported by the artist finds a parallel in the participant's movements seen in the triangle of coins animation. The migration ratio reflects how erstwhile purposeless moves (as defined by the goal state) begin to make sense (to the researcher, not necessarily the participant) when they turn southward. It is tempting to view both the doodle and the change in migration direction as serendipitous turning points: as externally mediated eureka moments of sagacity during which everything falls into place. But, although we know that the participant solved

the problem and that this was contingent upon the change in move-direction, to draw retrospectively a linear, causative link between solution and direction-change, removes from consideration the influence of the disorganised pattern of movement from which the latter emerged.

What Future for Serendipity?

Our first case shifted the focus of research from the intention of the artist to the development of the extended intentional state of the workshop. In case study two, rather than trying to elucidate the participant's strategy, the experimental design concentrated on the migration ratio as an interactional marker. Through these two changes in perspective, we hope to have demonstrated first, that a system can learn in real-time and second, that a system acknowledges this learning, not retrospectively, but prospectively through animated reorientation. We argue that a detailed examination of the process of creative change is better captured by the notions of MET that we have introduced in the chapter rather than by attributing it to the combinatorial consequences of accident and wisdom.

So where does this leave the concept of serendipity? In relation to scientific research, Latour (1999) description of Pasteur's discovery of lactic fermentation, demonstrates that, to be taken seriously, a scientific report must present a story in which the research programme appears to move systematically and unerringly towards the discovery of a fully formed natural phenomenon that had been passively waiting to be found for millennia. Traditional scientific methodology requires the researcher to take on the role of an impartial and invisible observer, imposing "epistemic limitations" (Copeland, 2019) that edit out the messy materiality of laboratory life along with its role in creating scientific ideas. This rational reconstruction of scientific discourse overlooks the important role played by the process of entanglement and so it is no surprise that, in the handful of frequently cited cases in which scientific discoveries are attributed to environmental change outside the research protocol, such discoveries are experienced, not as an inevitable part of the process of research but as lucky accidents, opportunistically and cleverly picked up by the observant scientist.

The domain of art suffers similar constraints. The cult of the artist-genius that developed during the renaissance (Sennett, 2008), blossomed into the romantic period and is now underwritten by conceptual art and supported by the requirements of the contemporary art market, emphasises human over material agency. However, the art market judges artists on their product rather than the purity of their process and this provides first, some flexibility for art-making to extend epistemic limitations by embracing methodological indeterminacy and second, for artists to become more familiar with the dynamic, creative potential of their medium and equipment, experienced, depending on their perspective, as either incertitude or as accidental (see also Copeland, Lock and Sikk, Turner & Kasperczyk, this volume). Francis Bacon refers to both. He makes accidental marks with paint in order to "trap images" but describes:

> …how hopeless and impossible this thing is to achieve. And by making these marks without knowing how they will behave, suddenly there comes something which your instinct seizes on as being for a moment the thing which you could begin to develop. (Sylvester, 1975, p. 54)

In the above terms, although our case studies extend epistemic limitations beyond an individual account, they implicitly reinstate the boundary (albeit as a border, see March and Malafouris, *forthcoming*, for a description of the boundary-border distinction) around a system. For example, by extending the mind as far as the door, we may have succeeded in dissolving serendipity within the creative system of the workshop but, unpredictable and unforeseen events may still hover beyond the new epistemic threshold, offering to disrupt the system, to create surprise, and perhaps, to precipitate a serendipitous event (see Glăveanu, Ross, this volume). Of course, for this to come to pass, it needs to be picked up by an entity that is capable of experiencing surprise (see Lock and Sikk, this volume). Whether the capacity for surprise is uniquely human or whether it extends to socio-material systems is not something we can explore further in this chapter but, in his analysis of organisational change, Hutchins (1995, p. 360) nicely summarises the issue:

> …human institutions can be quite complex because they are composed of subsystems (persons) that are "aware" in the sense of having representations of themselves and their relationships with their surroundings. Whether we consider a particular change at the upper system level to be the result of evolution or the result of design depends on what we believe about the scope of the awareness of the subsystems. If we think that some of the subsystems have global awareness, and that they can represent and anticipate the consequences of possible changes, then we may view an organizational change as a result of design. If we believe that the subsystems do not form and manipulate representations of system operation, then we must view organizational change as evolutionary.

Whether we consider organisational change to be a function of design or evolution depends on whether or not we believe that awareness of change can cross system boundaries: a notion that we can equally apply to the issue of serendipity. If change is viewed as a result of design, then serendipity has a role to play whereas in an evolutionary system it loses its explanatory power.

We have argued in this chapter that things and ideas are two sides of the same coin—experience. Both are learned into existence not through accident and wisdom but by waiting in uncertain hope for a transient system of creativity to bring itself into being. Such a system becomes increasingly certain by accruing knowledge in the form of skilled actions but the mounting certainty is not necessarily experienced by the person in the system. The corollary of this is that as long as the knowledge-gain remains implicit, the ubiquity of serendipity is overshadowed by the individual's retrospective search for a momentous event.

References

Bar Hillel, M., Noah, T., & Frederick, S. (2018). Learning psychology from riddles: The case of stumpers. *Judgement and Decision Making, 13*(1), 112–122.

Bilalić, M., Graf, M., Vaci, N., & Danek, A. H. (2019). The temporal dynamics of insight problem solving—Restructuring might not always be sudden. *Thinking & Reasoning*. Advance online publication.

Clark, A., & Chalmers, D. (1998). The extended mind. *Analysis, 58*(1), 7–19. https://doi.org/10.1093/analys/58.1.7

Copeland, S. (2019). On serendipity in science: Discovery at the intersection of chance and wisdom. *Synthese, 196*, 2385–2406. https://doi.org/10.1007/s11229-017-1544-3

Fleck, J. I., & Weisberg, R. W. (2013). Insight versus analysis: Evidence for diverse methods in problem solving. *Journal of Cognitive Psychology, 25*(4), 436–463.

Gosden, C., & Malafouris, L. (2015). Process archaeology (P-Arch). *World Archaeology, 47*(5), 701–717.

Hare, R. (1970). *The birth of penicillin and the disarming of microbes*. Allen & Unwin.

Hutchins, E. (1995). *Cognition in the wild*. MIT Press.

James, W. (1904). Does 'consciousness' exist? *Journal of Philosophy, Psychology, and Scientific Methods, 1*, 477–491. Reprinted(2010)in *Mind and Matter, 8*, 131–144.

James, W. (1905). The thing and its relations. *Journal of Philosophy, Psychology and Scientific Methods, 2*(2), 29–41. Reprinted in James, W. (1912). *Essays in radical empiricism* (pp. 92–122). Longman Greenand Co.

Keller, C. M. (2001). Thought and production: Insights of the practitioner. In M. B. Schiffer (Ed.), *Anthropological perspectives on technology* (pp. 33–45). University of New Mexico Press.

Kirchhoff, M. D., & Kiverstein, J. (2020). Attuning to the world: The diachronic constitution of the extended conscious mind. *Frontiers in Psychology, 11*, 1966.

Kounios, J., & Beeman, M. (2014). The cognitive neuroscience of insight. *Annual Review of Psychology, 65*, 71–93. https://doi.org/10.1146/annurev-psych-010213-115154

Latour, B. (1999). *Pandora's hope*. Harvard University Press.

Luria, A. R. (1973). Trans B. Haigh (Ed.), *The working brain: an introduction to neuropsychology*. Penguin.

Malafouris, L. (2010). Knapping intentions and the marks of the mental. In L. Malafouris & C. Renfrew (Eds.), *The cognitive life of things: Recasting the boundaries of the mind* (pp. 13–22). McDonald Institute Monographs.

Malafouris, L. (2013). *How things shape the mind: A theory of material engagement*. MIT Press.

Malafouris, L. (2014). Creative thinging: The feeling of and for clay. *Pragmatics & Cognition, 22*(1), 140–158. https://doi.org/10.1075/pc.22.1.08mal

Malafouris, L. (2015). Metaplasticity and the primacy of material engagement. *Time and Mind, 8*(4), 351–371. https://doi.org/10.1080/1751696X.2015.1111564

Malafouris, L. (2019). Mind and material engagement. *Phenomenology and the Cognitive Sciences, 18*(1), 1–17. https://doi.org/10.1007/s11097-018-9606-7

Malafouris, L., & Koukouti, M. D. (2018). How the body remembers its skills: Memory and material engagement. *Journal of Consciousness Studies, 25*, 158–180.

Malafouris, L., & Koukouti, M. D. (2021). Thinging beauty: Anthropological reflections on the making of beauty and the beauty of making. *Reti, Saperi, Linguaggi, VII*(2), 211–238.

March, P. L. (2019). Playing with clay and the uncertainty of agency: A material engagement theory perspective. *Phenomenology and the Cognitive Sciences, 18*, 133–151. https://doi.org/10.1007/s11097-017-9552-9

March, P. L., & Glavneau, V. (2020). Craft. In S. Pritzker & M. Runco (Eds.), *Encyclopaedia of creativity* (3rd ed., pp. 215–221). Elsevier.

March, P. L., & Malafouris, L. (forthcoming). Art though material engagement...and vice- versa. In L. J. Ball & F. Vallée-Tourangeau (Eds.), *Routledge handbook of creative cognition*. Routledge.

Milner, M. (1950). *On not being able to paint*. Madison: International Universities Press.

Reijnders, A. (2005). *The ceramic process: A manual and source of inspiration for ceramic art and design*. A. & C. Black.

Ross W. (2020). Serendipity. In Glăveanu V. (Ed.), *The Palgrave encyclopedia of the possible*. Palgrave Macmillan. https://doi.org/10.1007/978-3-319-98390-5_47-1

Renfrew, C. (2004). Towards a theory of material engagement. In E. De Marrais, C. Gosden, & C. Renfrew (Eds.), *Rethinking materiality: The engagement of mind with the material world* (pp. 23–31). McDonald Institute of Archaeological Research.

Seager, W. (2016). *Theories of consciousness: An introduction and assessment* (2nd ed.). Routledge.

Searle, J. (1983). *Intentionality: An essay in the philosophy of mind*. Cambridge University Press

Sennett, R. (2008). *The craftsman*. Yale University Press.

Silberstein, M., & Chemero, A. (2015). Extending neutral monism to the hard problem. *Journal of Consciousness Studies, 22*(3–4), 181–194.

Sylvester, D. (1975). *Interviews with Francis Bacon.* Thames & Hudson.

Vallée-Tourangeau, F. (forthcoming). Insight in the Kinenoetic field. In L. J. Ball & F. Vallée-Tourangeau (Eds.), *Routledge handbook of creative cognition.* Routledge.

Vallée-Tourangeau, F., & March, P. L. (2020). Insight out: Making creativity visible. *Journal of Creative Behavior, 54*(4), 824–842. https://doi.org/10.1002/jocb.409

Vallée-Tourangeau, F., Ross, W., Rufflato Rech, R., & Vallée-Tourangeau, G., (2020). Insight as discovery. *Journal of Cognitive Psychology, 33*(6–7), 718–737. https://doi.org/10.1080/20445911.2020.1822367

Vallée-Tourangeau, F., & Vallée-Tourangeau, G. (2020). Mapping systemic resources in problem solving. *New Ideas in Psychology, 59*, 100–812. https://doi.org/10.1016/j.newideapsych.2020.100812

Vallée-Tourangeau, G., & Vallée-Tourangeau, F. (2014). The spatio-temporal dynamics of systemic thinking. *Cybernetics and Human Knowing, 21*, 113–127.

Accident and Serendipity in Music Composition, Improvisation and Performance Art

Gerhard Lock and Jaak Sikk

This chapter introduces the ideas of accident and serendipity within the overarching framework of the concept of 'fault' in music composition, improvisation and performance art with a special focus on the education system. Improvisation can be seen either as a goal in itself or as a part of music composition. In the case of the latter, it is the art of applying chance operations or aleatoric tools in the composing process and/or the interpretational opportunities given by the composer to the performer. In performance art improvisation is also a relevant tool either in the preparation and/or the performing situation—even

G. Lock (✉)
Baltic Film, Media and Arts School, Tallinn University, Tallinn, Estonia
e-mail: gerhard.lock@tlu.ee

J. Sikk
Estonian Academy of Music and Theater, Tallinn, Estonia
e-mail: jaak.sikk@eamt.ee

W. Ross and S. Copeland (eds.), *The Art of Serendipity*,
Palgrave Studies in Creativity and Culture,
https://doi.org/10.1007/978-3-030-84478-3_8

if the artist doesn't apply it deliberately as a method—often through a playful mindset (see also Turner & Kasperczyk, this volume). We use the word 'performer' throughout this chapter as a collective term that refers to the interpreting and improvising musician as well as to the performance artist, and also to the composer (in a more abstract meaning) during the process of creating. In this chapter, we will start by defining central concepts and terms based on their meaning in the artistic practice and their etymological roots, before moving to introduce a model that explains how these concepts and terms are interrelated, how they are perceived and what role they play for a performer to get into the serendipity zone. Finally, we will explore several underlying cognitive mechanisms, philosophical and pedagogical understandings relevant in an educational context: awareness, consciousness, prediction, repetition, play, the 'right-wrong' framework, normativity, "free will", fear and positive outcomes creating tension, the "interior reality" of the performer, possible alternative and future scenarios, and the 'potential self'.

In western music, composition and improvisation are historically intertwined (Bandur, 2002). What is more, improvisation (sometimes also called instant composition [Interdisciplinary Instant Composition, 2021]) has also been accorded the status of a method or a genre (Duch, 2015). Questions about the status of 'group improvisation' have also been raised, concerned with whether it should be seen through the lens of the Western tradition, with elitist aesthetic goals similar to those of composition, or as a collective practice that requires neither virtuosity nor years of education, and is characterised instead by idiosyncratic goals in relation to the specific musical and social situation (Karkoschka, 1971, 1999). This form of group practice is based on the musicians' social and creative activity and the role of freely used notation; it has been studied through ethnographic case-studies based on the concept of 'microtopia' (Schuiling, 2016). Performance art is, like other arts, music composition and improvisation, a mode of communication (Mukhametzyanov et al., 2018; Sandström, 2010). That is, it uses sound either deliberately or arbitrarily (including through improvisation) and generally has the aim to challenge oneself (the performer) and the audience both. In contrast to composition and improvisation, the 'fault' (accident, error, or failure) in performance art is part of the satisfaction and the desired

outcome, allowing the most space for ambiguity, and can include involuntary actions, sagacity and other surprising aspects of the performance (see also Turner & Kasperczyk, this volume).

The chapter mainly focuses on the role of accident in improvisation, and analyses it through the lens of serendipity. In our view, serendipity as it relates to musical performance can best be seen as an attitude, in which every situation, including the accidental ones, becomes interpreted as somehow beneficial and incorporated into the musical outcome (see also Copeland, this volume). Being serendipitous means that accidents and surprises inspire a performer (whether improvisor and performance artist or composer in the composing process) to reconfigure one's relation to the performance situation and adapt quickly to changes in order to gain and create new possibilities, musical rearrangements, experiences and knowledge (see also Pineyero, Sneddon, this volume). We suggest that this ability to adapt, which is a basic skill itself and a pre-requirement for a serendipitous approach, may lead to obtaining new skills in the long term. Serendipity advocates one to never say "no" to the situation, but rather to take the best possible from each performative event.

The practice of musical performance generates a tension for the performer between the interior imaginary, projected scenario and the feedback, monitoring and understanding of the simultaneous input from exterior reality. This mismatch is unavoidable in the dichotomous process of relating to and coping with the situation. In our view, sagacity emerges when the performer suddenly understands how to shift the interior imaginary scenario in such a way that it connects with the input from the exterior reality in a beneficial way and thereby supports and changes the performance. If the performer does not accept this contradiction and does not make adaptive changes, such accidental situations may develop further into error and even failure. The latter situation indicates a non-serendipitous mindset. However, no error or failure is final, and the possibility remains to create something artistically meaningful out of error or failure through sagacity and insight, which may lead back to a serendipitous understanding.

A central background concept to all forms of creativity is that of 'ambiguity' (McLaughlin, 2020), the quality of being open to more than one interpretation as well as to inexactness (see also negative capability

as outlined by Sneddon, this volume). In this ambiguity the composer, improvisor and the performance artist as well as the listener find themselves moving between satisfaction (the desirable) and dissatisfaction (the undesirable outcome). Within the space between those states a kind of "problem"[1] may arise. This problem can be experienced as either an uneasy feeling or can be a trigger for developing into a sensation of pre-accomplishment—both phenomena are difficult to explain unambiguously, due to their complexity. Beyond these, the problem may be considered an accident, error or even failure (see also Sneddon, this volume).

In order to systematise and hierarchise these terms we will henceforth use the term 'fault' as a subsuming, general concept. The term 'fault' covers the largest scope of meanings in the English language that are relevant for this context.[2] Its origin in the Middle English faut(e), a 'lack, failing' (see Oxford Dictionaries/Lexico), shows that it embraces the whole spectrum, from missing something (a "problem"/an uneasy feeling, but also 'ambiguity') to failure. Due to the popular understanding of the concept of 'fault', people (including musicians) tend to force themselves to make changes in order to avoid it, considering it as negative, and to move rather towards more desired, putatively positive outcomes.

[1] (1) Cambridge Dictionary: a situation, person, or thing that needs attention and needs to be dealt with or solved. (2) Oxford English Dictionary (Lexico): Late Middle English (originally denoting a riddle or a question for academic discussion): from Old French probleme, via Latin from Greek problēma, from proballein 'put forth', from pro 'before' + ballein 'to throw'. Therefore a problem is a starting point for discussion and connected to the method how to proceed. See Oxford English Dictionary (Lexico): via Latin from Greek methodos 'pursuit of knowledge', from meta- (expressing development) + hodos 'way'.

[2] (1) Cambridge Dictionary: a mistake, especially something for which you are to blame; a weakness in a person's character; a broken part or weakness in a machine or system; to have done something wrong; to criticise someone or something, especially without good reasons; (americal dictionary) a quality in a person that shows that the person is not perfect, or a condition of something that shows that it is not working perfectly; responsibility for a mistake or for having done something wrong. (2) Oxford English Dictionary (Lexico): an unattractive or unsatisfactory feature, especially in a piece of work or in a person's character; a break or other defect in an electric circuit or piece of machinery; a misguided action or habit; responsibility for an accident or misfortune; criticise for inadequacy or mistakes; do wrong.

When a 'problem' or the ambiguous combination of uneasy feeling[3] and sensation of pre-accomplishment is evoked and is interpreted as 'fault'—when the performer's awareness of the desire for (re)solution[4] appears—it often leads her to consider 'right' vs 'wrong', 'good' vs 'bad' or other dichotomous decision-making frameworks, such as prediction error, imagination and planning, to cope with and get rid of or minimise a "problem"/uneasy feeling and 'fault'.

If, however, the "problem" or uneasy feeling/sensation of pre-accomplishment grows and rather starts to influence the process and perception of performance, it will then be deemed a significant aspect of the performance.

We offer here a hierarchy of terms that are connected to the overarching concept of 'fault' and which reflect the mounting impact it can have on performance and also performer confidence: accident becomes an error,[5] and error can become a failure.[6] The hierarchy scales according to the performer's awareness of the accident as error and then as failure. That is, the notion of accident is thereby the weakest: it is something of which we are unaware before it appears. Error can be regarded as stronger in terms of our being at least somewhat aware of it. Failure may be regarded as the strongest in light of our being clearly aware and conscious of it, often also in its perceived finality. What all three concepts have in common is that they are involuntary and may be surprising. An accident is always surprising and its recognition as error and/or failure follows promptly, for example, if the performance cannot be continued; accident, error and failure can form a surprising complex unity. However,

[3] Uneasy feelings and the impact of mental preparation in improvisation has been studied by Sikk (2020).

[4] Either convergently or divergently. Creative thinking in music between convergent and divergent thinking (Webster, 1990) and its generative process of proliferation and successive solution implementation have been researched in a compositional process case study (Collins, 2005). Despite not using the term serendipity Collins (2005) describes a number of situations and principles that belong actually to serendipitous understanding, e.g. when saying that "[r]estructuring or the 'flash of illumination' occurs when the problem solver/creator may see an unexpected solution to the problem" (Collins, 2005, 195).

[5] The normative understanding of error in music based on perceptual psychology with examples from jazz and Experimental Music has been discussed in McLaughlin (2020). The role of error in free improvisation has been discussed in Lock (2014).

[6] Failure in performance art has been studied by Orav (2014).

when they happen during a dynamic process, they derail the notion of a clearly defined outcome.

The *Functional/Compositional Continuum* (FCC) model (Bruford, 2018, pp. 38–42) suggests that if a musician has the courage and opportunity to "interfere" (Lock, 2011, p. 124) in the creative process (no matter whether it is notated or improvised music, or if it takes place during the process of composing itself), she will end up moving in the direction of compositional performance[7] as described in the model: this interference will supply the unexpected, enable surprise, and move the performer towards the unknown. The performer's awareness and consciousness (see Hohwy, 2012; Mascolo & Kallio, 2019; Velmans, 1999) of a "problem" or uneasy feeling as well as their ability to 'interfere' in the creative process are key cognitive dimensions that open up a discussion of the terms we focus on here—'fault', accident, error, and failure.

A 'Fault' to Serendipity Progression Model (FSPM)

Therefore, in this chapter, we propose an overarching model to explore how these concepts of accident, error and failure interact with serendipity in the contexts of music composition, improvisation and performance art (Fig. 1). The model proposes an approach to accident, error and failure in composition, improvisation and performance art from the viewpoint of the performer and the listener.

The FSPM model in Fig. 1 explores the following categories referring with "it" to the accident, error and failure:

[7] Compositional performance means that the musician takes an active role in the process of a performance that goes beyond notated and previously agreed upon structures, or performs a piece in which compositional elements are included as part of the interpretation. See the definition offered by Interdisciplinary Instant Composition (2021): "INSTANT COMPOSITION" combines the notion of working from the moment (INSTANTaneous creation) with the intention to build something (COMPOSING a piece with an audience present).

Fig. 1 The 'fault' to serendipity progression model (FSPM)

1. **How it happens (the performer's point of view).** The performer's point of view encompasses the uneasy feeling/sensation of pre-accomplishment, and also reasons, involuntariness, surprise and un/awareness; these may create a block if the 'problem' is not resolved. Initially, a discrepancy appears between the mental image the performer has of the current situation and the image they have of how the situation could/should potentially be, or where to go— divergent opportunities emerge, but the performer must be skilled in order to recognise and realise this potentiality.

 If the discrepancy or problem is not solved easily and develops further, the tension starts to build up (see the Lehne & Koelsch's, 2015 Tension model). That tension works as the "fuel" for making changes. The tension has two sides—the fearful side, concerning the potential for going "wrong", and on the other side a potentially positive change. This coincides with the tension/suspense axis spanning from fear ("worst case" outcome) to hope ("best case outcome") proposed by Moritz Lehne and Stefan Koelsch (2015, p. 7). If the problem stays unsolved, it may remain a more or less disturbing

background source of tension, or it can develop further, bringing the tension to the fore. When the tension grows beyond the performer's ability to absorb it, it can push a person towards a sharp rise in negative sensations and self-criticism. Such sharp, negative interpretations can push the understanding of the situation closer to 'failure'.

2. **How it is perceived (the audience and performer's point of view).** The perception of fault by the audience can be negative, but it is not *necessarily* negative. Further, there are aspects of surprise and in/attentiveness and their reasons to consider. Both the performer's and the audience's views of the fault at hand must be understood in the context of their awareness in terms of style awareness and their level of expertise. Indeed, the relational nature of the idea of 'fault' is made clear when we consider the non-expert listener. Much like the expert listener, the non-expert's judgement is based on the value system that is activated while they listen to the piece of music or observe a performance art event. The attention and expectations of the non-expert-listener[8] can differ radically from those of performers and expert listeners. Therefore, the 'problems' of performers can very likely remain unnoticed, and a performance can create impressions that are not in accordance with the mental process of the performers on stage (see also March & Vallée-Tourangeau, this volume).

3. **Time scale.** The relevant time scale can be past-present-future, as well as long- or short-term, and we must also consider whether events are ad hoc (as in improvisation and partly in performance art) or 'prepared' over a longer period of time (as in musical composition and partly in performance art). A challenge to solve a specific personal question or artistic problem can be the whole frame for a show, performance or improvisation. The personal question could be related to a broader contextual problem that can give meaning to for instance the question of "what we do". That kind of problem is definitely not ad hoc but exists on a wider time scale.

During the process of improvising, several situation-based problems can arise, which can also be quite short-term. For example, a

[8] On the other hand, the problems that performers undergo could sometimes remain unnoticed even by expert listeners.

musical theme starts to feel worn out and the mental tension of the performers grows and there is a clear need for bringing about a change. This change can be a challenge—trying something one has never tried before, playing an instrument one has never played before, for example. Such a case is not such a sudden situation as an accident but can still be quite short-term.

A "problem" as such could also be seen on a different time scale, retrospectively. For example, a particular part of an improvisation may have left a very good impression while the form as a whole left an impression of being "out of balance". In such a case, several time scales are mixed. Also the impressions (and memories after the performance) of listeners and performers can differ in this sense, that it seemed for one "in balance" but for the other not (see also Ross, this volume).

4. **How to change it.** Here we suggest several opportunities to 'interfere' in the process, based on the saliency of the accident and the performer's awareness of faults in the domains of composition, improvisation and performance art. The most prominent of these is the choice of whether to repeat or not to repeat faults[9] (Huron, 2006; Whitmer, 1941), in order to stay stable or to make a change. We suggest that this is a key point where a performer can enter what we call the 'serendipity zone'.

Failure and improvisation. Improvisation in its freest form can by its very nature never be a failure, see the topic of creativity and failure concerning improvisation in Duch (2015). One's improvised self-expression is always a positive act from the perspective of improvising. Interpreting something as a failure will therefore instantly push the person outside of the mental territory of improvisation. As discussed above, any 'fault' and therefore any failure needs some system of rules that can be broken in order to be deemed a fault, but such systems of rules do not exist for the freest form of improvisation. So, at its core, there is no failure in improvisation, because the improvising performer has accepted their interior contradictions and is thereby in the 'serendipity zone'. A performer can ask, "did I manage to stay in a

[9] By repeating we mean rather a transformative process including at least some elements of that particular "fault".

mental state where I accept myself as I am?" At the moment she starts to interpret what happened as a failure, she has already moved outside improvisation. This is what we would like to emphasise when considering improvisation: it does not only concern the outward performance but also the dynamic change of the inner mental context that proactively makes everything happening meaningful.

In the centre of Fig. 1, some aspects of analysis/reflection can be found in the (vertical) ambiguity range between satisfaction (desirable) and dissatisfaction (undesirable), as well as an indication of how one can get into the 'zone' of serendipity (Ross, 2020) through sagacity and insight (Krishnamurti, 1977, Vallée-Tourangeau et al., 2020, see also Karlheinz Stockhausen's [1989] Intuitive Music approach). In case of failure, one can regain control and make a deliberate change to also get into the serendipity zone. Thus can one also get from the sensation of pre-accomplishment into the serendipity zone, but we claim that one has no access to the serendipity zone when one interprets a situation as a failure. The problem resolution and its direction of implementation follows the trajectory towards the desirable/satisfaction. This can be done linearly or "recursively" turning faults into non-faults through repetition (Huron, 2006; Whitmer, 1941).[10]

The 'Right-Wrong' Framework

In the case of composition, the awareness of a certain (including a personal) style leads to a 'right-wrong' framework, containing rules that the composer can—and, in the modernist understanding, *has to*—'break free' and that the performer can interpret within the composer's set range of boundaries for what is 'allowed/not allowed'. However, we argue that in case of improvisation we should abandon this 'right-wrong'

[10] As the reader will see in the following sections, this philosophical concept of repetition in the context of education follows Brinkmann (2017), based on Gadamer (2004). Thus, recursivity here is *not* used in the same sense as it has been used in the context of mathematics or computing.

measurement framework and thus move beyond the problem of prediction error, that is the checks constantly performed by the brain (seen as a sophisticated hypothesis tester) to fit to reality (Hohwy, 2012). Possible alternative and future scenarios are constantly created in one's imagination and alongside, thus the performer engages in planning to cope with changing situations (Beach et al., 1996). Maintaining a 'right-wrong' framework in the performer's mind may influence and limit the creation of imaginary future plans. Hereby people depart from their pre-knowledge and experiences. A large discrepancy between the perception of the 'now-moment' and these future, imagined scenarios can lead to anxiety and psychological tension (even being related to bi-polar disorder in severe cases, as shown in Tharp et al., 2015). Instead, we recommend a focus on the 'interior reality' of the performer during the improvisation process, the actual relationship which characterizes this 'now-moment'. While, in *performance art* the 'right-wrong' framework is a considered part of the game to challenge both the performer and the audience, we claim that applying the 'right-wrong' framework to *improvisation* would be misguided. Applying a 'right-wrong' framework takes the performer out of the realm of improvisation and disregards the personality and developmental opportunities for the performer to grow along with the faults. In other words, an excessive focus on what is right or wrong in musical creativity constrains musicality, is pedagogically disruptive, and glosses over the importance of accidents.

Serendipity is widely considered to be game-changing. We argue that it is precisely when the person becomes aware of the uneasy feeling/sensation of pre-accomplishment, in the face of arising problems, accidents, errors, failures and makes changes through negative experience while applying conscious repetition in the sense of Heidegger and Gadamer ("as active process of re-iteration and re-evocation of familiarities or former knowing-that and knowing-how"—see for example Brinkmann 2017, p. 79), that serendipity can arise. Acknowledging a new view and raising awareness can by themselves already bring on a significant change in action (Säljö, 2003).

The "Interior Reality" of the Performer

It is common for a higher education music student attending an improvisation lesson for the first time to suffer from the fear of 'not knowing what to play' or whether what she is going to play is unacceptable or will be judged as 'faulty' (Sikk, 2020). This underlying anxiety may lead her to perceive task-irrelevant information, rather than drawing her attention to dealing with the actuality of the situation (Berggren & Derakshan, 2013). The unconscious attitude presumably derives from the experience of being constantly assessed, using grading systems which put certain expectations on the students. Answers that do not correspond to those expectations are then considered 'faulty' and it is assumed they will lead to negative feedback. A study examining Swedish educational reform (Högberg et al., 2019) concluded that using such a grading system and intensive testing can raise the stress level of students. It may lower academic self-esteem and life satisfaction, and can have a negative impact on students' psychosomatic functioning (Högberg et al., 2019). It is important to hold in mind that the concept of 'fault' is culturally and meaningfully encumbered (see Ross, this volume), and that it reflects a certain paradigm in the education system, in teaching and in information transmission in general, which might be associated with negative feedback and negative experience (Brinkmann, 2017). It is our argument that switching the focus from the fault to the interior reality of the performer can allow students and performers to move beyond this.

A fault appears always in the thought process of the performer as a relationship (see Glăveanu, this volume) between the surrounding physical environment and the performer's mind—this constitutes the interpretation. Through that process, a fault reveals important information concerning developmental trajectory of the performer. When a fault arises as the result of choices and becomes salient at the time of its occurrence—when the performer becomes aware of it instantly—it characterises the 'interior reality' of the performer. A fault is always contextual, it appears in contradiction to habits and to expectations that in themselves assume certain circumstances to hold. In short, a fault appears if something went differently than initially intended, which is also one of the definitions of serendipity: finding something valuable that

one was *not looking for*. Thus, the initial trigger of serendipity can often be perceived as disruptive, or as a fault.

From the perspective of the individual, the context in which the fault appears is the personal relationship towards a phenomenon, thing or situation (see Glăveanu, this volume). A fault evokes ideas on how to deal with that situation. If these ideas are put in action one gets feedback from the surrounding environment helping to proceed further. This thought process changes the performer's way of thinking and thereby the nature of her 'interior reality' and so may enhance their ability to rearrange the aesthetic relationship with the context.

During the course of this relational process, then, the individual's way of thinking changes,[11] and through this process the person arrives at new ideas (see Glăveanu, this volume). We suggest that treating a fault as a negative phenomenon (see 'negative experience', in Brinkmann, 2017, pp. 75–81), creates a psychological tension for the performer, will restrict the breadth of her thoughts, and takes the focus away from the task to something that is unessential in this context (e.g., the costs associated with the fault).

Play, Repetition and "Negative" Experience

One route to understanding 'fault' as generally conceived is through the assumption that repetition, as a central element of learning, entails the recreation of a "correct" copy of what has existed previously, and, consequently, that the brain is constantly testing hypotheses against reality in order to suppress prediction errors (Hohwy, 2012). According to the theory of communication formulated by Claude Shannon, a fully predictable message does not include any new information (Scott, 1990). Based on Heidegger's (1996), Waldenfels' (2001) and Gadamer's (2004) concepts of repetition, Malte Brinkmann (2017) points out that instead of absorbing the negative feedback one gets for being faulty, what is

[11] If the person is not constrained by educational presets or experiential blocks.

experienced as "negative" should be interpreted instead as "highly positive!" Repetition which is "faulty", in other words, generates a space for unintentional discovery and play—in other words, for serendipity.

For instance, Brinkmann underlines that,

> repetition in learning should not be regarded as a boring, monotonous or automatizing and habitualizing practice. If repetition is seen as something productive, one has to take into account the "potential of change" that comes with repetition (Waldenfels, 2001, p. 12). Seen from this perspective, negative experience and its passive character enable an opening, widening and transformation of experience within the temporal difference. Learning-as-experience could then be considered a transformation through repetition. (Brinkmann, 2017, p. 81)

Similarly, Hans-Georg Gadamer's (2004, p. 104) concept of play as an act which renews itself in constant repetition, and his argument that the movement of play as such has no substrate are crucial to understanding the processes taking place in music composition, improvisation and performance art. Repetition can be seen as habitual, but it is important to note, as Vlad Glăveanu (2012) does, habits should not be associated solely with automatic reflex behaviour but rather can be playful and generative; as he suggests, both "improvisational and innovative creativity are embedded in habitual forms" (Glăveanu, 2012, p. 78).

Further, according to Joel Weinsheimer and Donald G. Marshall, Gadamer's understanding of "play is not [as] a subjective attitude of the players, but rather the players are caught up in the shaped activity of the game itself. Where this activity takes on enduring form, it becomes "structure," *Gebilde*" (Gadamer, 2004, p. xiv). The same can be said for improvisation, composition and performance art. As Gadamer (2004, p. 105) explains:

> the structure of play absorbs the player into itself, and thus frees him from the burden of taking the initiative, which constitutes the actual strain of existence. This is also seen in the spontaneous tendency to repetition that emerges in the player and in the constant self-renewal of play, which affects its form (e.g., the refrain).

Repetition includes the recognition of something we already know; Gadamer (2004, p. 113) calls it "the joy of knowing *more* than is already familiar". He brings in imitation as a form of repetition, pointing out that,

> imitation and representation are not merely a repetition, a copy, but knowledge of the essence. Because they are not merely repetition, but a "bringing forth," they imply a spectator as well. They contain in themselves an essential relation to everyone for whom the representation exists. (Gadamer, 2004, p. 114)

We follow Gadamer (2004) and see art as play: "its actual being cannot be detached from its presentation" (Gadamer, 2004 p. 120). Even in a transformed or completely distorted presentation, including self-presentation, when seen as a non-literal repetition, "it contain[s] a relation to the structure itself and submit[s] itself to the criterion of correctness that derives from it. [...] Rather, every repetition is as original as the work itself" (Gadamer, 2004, p. 120). Embracing repetition as a generative playful act that does not require faithful reproduction of what has come before allows the performer to move into the serendipity zone, to embrace differences in repetition not as faults but as opportunities.

Normativity, "Free Will" and Other Approaches

Following Brinkmann (2017, p. 81) we argue that, while repetition should be seen as neither literally 'normal'/normative nor boring, nor monotonous, automatising and habitualising, the actual practice in music still today mostly starts from the premise that one should as far as possible produce the *expected* result (see Bruford's [2018] functional performance mode in his *Functional/Compositional Continuum*). If that is not done, it appears that the performer has failed to understand the logic meant to lead them to the expected result. Such an approach thereby falls into the 'right-wrong' polarity scheme critiqued above. Based on that

polarity, a so-called comparative assessment may take place. In assessment, the performer is informed (based on chosen and often normative, given criteria) to what extent her activity falls into the 'right' or 'wrong' categories. Often this comparative assessment, especially in the context of musical education, fails to take into account the personal development aspects (i.e. 'mini-c' characteristic, from Glăveanu & Kaufman, 2020) of a person, and instead may also slow down that person's gaining of holistic comprehension, creating guilt-feelings or otherwise lowering their intrinsic motivation.

A core problem here is that these assessments rely on the concept of normativity: Gadamer (2004, p. 34) underlines in the context of taste that "even moral concepts are never given as a whole or determined in a normatively univocal way". Even in something which appears as idiosyncratic as free improvisation as genre and as teaching tradition (and for example as method in composing) there is a tendency to create fixed norms and tools which may form a set of rules that may lead away from freedom in improvisation. Therefore, a clear distinction should be made between free improvisation as a genre, a preconceived method and as a mindset. We also argue that the goal of avoiding other norms, like the rules given by classical music, is not necessary. An improvisor should rather feel the freedom of using any means in creative self-expression.

The question is, who has the right, power or necessity to set up the criteria against which such results are assessed as either 'right' or 'wrong'? Taking into account the nature of "free will"[12] one should be able to make decisions based on the personal relation to the immediate context, thus we should leave it to the individual person to decide whether to be functional or to become compositional, as Bruford (2018) has proposed in his *Functional/Compositional Continuum.* Free will also accounts for the range we see in composing, improvisation and performance art. This range moves from intuitive[13] (the most free, least explainable style, and within this frame it remains rather unclear for both the creator and the perceiver what is a fault), systematic (this is still quite free and entails

[12] The free will here is debatable, because one is always influenced by education, experiences, habits, favourites as well as agency, see Mascolo and Kallio (2019).

[13] Developed earlier for analysis methods but enlarged to encompass both creative and analytical processes in Lock (2011, p. 124).

using one's own criteria to assess fault, where both criteria and thus the fault are changeable and explainable), system-based (much less free because reliant on someone else's system; explainable but, under this scheme, a change becomes an error) or automatised/automated methods (the least free, because it relies on either pre-computised or live-triggered algorithms; the most fully explainable style, but with these methods a change always means an error).

In an intuitive approach the *composer* decides upon her solutions spontaneously, based on a subconscious feeling of 'right' and 'wrong'. But those decisions can be retrospectively evaluated and, if needed, corrections or changes can be made in the context of the whole piece. These changes can even be made while giving the piece its sounding form, which also allows the performer much freedom to interpret the score. The free *improvisor* decides instantaneously, based on the flow feeling, how to proceed, and in this state the categories of "right" and "wrong" become meaningless; changes can be made, but they do not have the characteristics of corrections because everything takes place in the very moment and can be changed anyway. The *performance artist* is absorbed by their own activity and if something goes spontaneously differently than intended it is often welcomed as important element, not as a fault (see March and Vallée-Tourangeau, Sneddon, Turner & Kasperczyk, this volume).

In systematic, system-based and automatised/automated approaches for the *composer*, the *improvisor* and the *performance artist*, the level of pre-planning (long- or short-scale) is higher. Consequently, the emphasis on and importance of "right" and "wrong" increases, with it also the attachment to a concept of a norm either for oneself to follow or as expected by the audience—this decreases the level of freedom that can be encountered. In automatised/automated approaches the level of freedom is, from a system point of view, at its lowest and as such a fault can have a major impact. However, taking into account that the living being is still part of the creation (and also, through perception, as audience), there is always the possibility of changes happening passively or unwillingly in the form of accident, error or failure.

In composition these unwilling changes happen indirectly via the performer or a technological device not working as expected—the

composer has rather no impact in this process. In composition a wrongly played note is generally an accident that should be corrected in another performance. Similarly, if something doesn't sound as expected, it is an error or failure that the *composer* erases. In contrast, in improvisation the *improvisor* has the chance to respond to those changes; in *performance art* the artist may even rely on such changes happening. In *improvisation* an accident or error should be repeated in a manner that it appears to be meant to be like it happened. In *performance art*, accident, error and even failure can be part of the structure and result (see Turner & Kasperczyk, this volume).

Despite the little freedom that systems/automatisations allow, it may be liberating to constrain oneself with chosen elements within a system/automatisation—in order to not be overwhelmed by too many possibilities, to contemplate on what really happens/sounds (be in the moment), and to utilise these constraints to develop oneself, to treat them as a platform from which to move farther, when the moment or oneself is mature enough for that. Another case are live-electronic systems that allow the performer to again become free within the open possibilities or AI-based learning processes created by that system.

Further, it takes courage to willingly "interfere" in the system, to either change, ruin or abandon it. Interference may mean creating a fault in the first place, but thereafter, the direction and process of interference becomes most important. Notably, both passive happenings and active interference open the door for serendipity (Ross, 2020).

The Problem of Awareness/consciousness and Prediction Error

Improvisation can be seen as an environment wherein a person is accepted exactly as the self they appear and feel to be. Improvisation cannot be of "somebody else". Nobody can argue that a free improvisation was wrong or that it should have been different. True improvisation, that is, simply removes the distinction between 'right' and 'wrong': It just *is*. Only the improvisor is in the position to assess their activity, to be satisfied or not, to treat something as fault or in need of further

development. On the other hand, during the flow of performing and perceiving one's own improvisation, the improvisor may be more or less conscious (Velmans, 1999), and often perceives her own activity differently than the audience (see March & Vallée-Tourangeau, this volume). Both the performer and the audience may be content with this, but it could also be that one or the other is not so satisfied. We argue here that the problem lies in relation to attention and conscious perception in the hypothesis-testing brain.

According to Michael F. Mascolo and Eeva Kallio (2019, p. 437), consciousness,

> functions as a system for coordinating novel representations of the most pressing demands placed on the organism at any given time. While it does not regulate action directly, consciousness orients and activates preconscious control systems that mediate the construction of genuinely novel action.

According to Jakob Hohwy (2012, p.5),

> [...] conscious perception correlates with activity, spanning multiple levels of the cortical hierarchy, which best suppresses precise prediction error: what gets selected for conscious perception is the hypothesis or model that, given the widest context, is currently most closely guided by the current (precise) prediction errors.

Hohwy (2012, p. 3) also claims that,

> [...] there are two related ways that prediction error can be minimized: either by changing the internal, generative model's states, and parameters in the light of prediction error, or keeping the model constant and selectively sampling the world and thereby changing the input. Both ways enable the model to have what we shall here call *accuracy*: the more prediction error is minimized, the more the causal structure of the world is represented.

Hohwy's suggested ways are both connected to the 'right-wrong' framework, and neither takes into account divergent thinking, inexactness,

play nor negative instances, "as moments of not-knowing-that, not-knowing-how, as failures, interruptions, moments of forgetting and not-readiness-to-hand ("Unzuhandenheit", Heidegger, 1996, pp. 72–73; cited in Brinkmann, 2017, p. 78; see also Sneddon, this volume). But, the first way, "changing the internal, generative model's states, and parameters in the light of prediction error", does come close to our concept of the "interior reality" of the performer, as introduced above. Recall that there is a contradiction for the performer between the interior imaginary, projected scenario and the feedback, monitoring and understanding of the simultaneous input from exterior reality. However, we note that the improvisor doesn't predict any fault, and therefore doesn't minimize prediction errors. Nevertheless, Hohwy's idea of a change in one's internal, generative model's state, to resolve the problem of prediction error, does indeed coincide with our idea of the application of adaption skills in response to the tension of the contradiction between the interior and the exterior world experienced during the performance.

In free improvisation, the performer does predict any error and so abandons the 'right-wrong' framework and rather plays with inexactness, which removes the possibility of not-knowing-how, failures, interruptions, moments of forgetting and not-readiness-to-hand occurring. From a pedagogical perspective, because improvisation enables the person to express themselves, and thus the idea of a negatively-treated faultc is eliminated because the pressure of expectancy is (ideally) taken out of the game, one can create through improvising an ongoing habit that allows the performer to interpret every situation essentially as acceptable (that is the 'serendipity attitude') and to thereby sustain positive development. In the light of what we have already discussed and following Brinkmann's (2017) suggestions, we posit that improvisation can support learning methods to acknowledge fault not as a negative but as a developmental phenomenon. Like Brinkmann (2017), we further suggest that learning quality will rise when faults are welcome in the process of whatever learning and development are taking place, and when they are treated as important carriers of information that characterises the learner in a real situation and guides their further development.

The "Potential Self", Tension and Musical Consciousness

Discussing Martin Heidegger's *Dasein*, the self and authenticity (Sherman, 2009), and the "other's potentiality-for-being-its-self" (Escudero, 2013, p. 306) in "Being and Time" (Heidegger, 1996), Jesús Adrián Escudero (2014, p. 12) proposes that, "each individual lives in a significant network of productive relationships that are projected toward the future and are constitutively defined by the structure of care". Following this idea, we will call the basis for directed actions the 'potential self'. The 'potential self' is an image of the self, doing something differently in the future, perhaps in a better way, achieving something more than one has so far. This kind of self-image exists across different time scales. On the micro level, it can be a mental image or an idea, about how the ongoing improvisation could change into or include something that it is so far lacking, and what would be the logical continuation of the momentum. The discrepancy between the image of the 'self' and the image of the 'potential self' creates a tension that fuels the forward (or backward) motion of action.

One analogy of this kind of tension in 'the difference in the potentials of two points' can be found in voltage: "a measure of the propensity of charge to flow from one place to another" (McGrayne et al., 1998). If the "potential self", (often perceived to be the "better self") is not realised and the situation develops in a way that the value system of the person starts evaluating it as something negative, a "problem" arises. Therefore, one can say that the problem is not objective but is also contextual and derives from this tension; in other words, it is based on the inner mental contradiction (tension) between the interpretation of the 'now', which is based on a specific value system, and the image of the 'potential now'. But the moment when the "problem" emerges must not be a de facto negative thing for the performer. The tension caused by such a "problem", to bring a parallel with voltage, includes simultaneously both positive and negative potential. The value and possibilities for improvement are on the positive side; the negative can be a catalyst for action, either escaping or making a change. So, in the first phase of

the development of a 'problem' or that uneasy feeling/sensation of pre-accomplishment, there is excitement, which can be seen as a mixture of the forwards impulse of both, the negative as well as the positive potential. When the problem develops into a negative process, the tension starts to cause a more and more negative view of the possible outcome. When the negativity of this process is taken away, turned into something different, something positive,[14] one can speak of the emergence of serendipity. An experienced performer can usually stay serendipitous even when the tension is high and there is a pressure to turn towards negativity.

A problem is very likely to pressure a performer to make a shift in the aesthetic understanding of the situation. For example, if the audience was expecting music in the style of Johann Sebastian Bach, but instead the performer was improvising in a contemporary style, a very awkward situation might escalate, full of surprise and aggravation. But if the interior reality of the situation of the audience is shifted into the aesthetics of the performance, the situation goes through a metamorphosis and can turn into something enjoyable.

Musical consciousness (Clarke, 2011) is a spot in time, which extends into the mentally created past and future. To create meanings, one has to perceive what could potentially happen next and also actively remember the short-term past, with this perception being integral with a much bigger mental capacity for perceptions that have been gathered through life. Often the performer already clearly senses, visualises or imagines the upcoming problem through musical consciousness, before the problem has materialised in the physical world. In the imagination of the performer, the process has already developed into the problem-situation and they are able to configure the imaginary future. In this case the problem is solely solved in the imaginary sphere, before it physically

[14] We hereby use then the term "positive" (that usually is part of the negative–positive framework) as more of a meta-criterion that can be understood as being outside the 'right-wrong' framework.

happens, and so the necessary performance-specific creative tension[15] is sustained.

In improvisation, there is a constant change of aesthetic positioning, a switching of value systems and dynamic re-interpretation takes place (at least potentially) within the musical consciousness of the performer and the audience, both in relation to the potential futures and the past. So, an imaginary future can change through an altered projection of possible actions, and the meaning of 'what was before' can change through what is being 'changed now'. This is a key way in which improvisation differs from composition but may be similar to performance art. In composition the time relations work very differently, because the piece is not genuinely composed in the instant now-moment[16]—the composer can switch value systems and changes can be made independently from the performance itself. In performance art such switches in value systems, as one of the goals of performance art, take place rather in the mind of the audience. The performance artist, of course, will either not change anything in situations where the audience may expect changes, or make surprising changes in order to provoke the audiences' aesthetic understanding. And finally, one can say that improvisation in its freest form switches value systems and re-creates them constantly for oneself and for the audience.

Conclusion

A 'fault' always needs a context, wherein something is labelled as either 'wrong' or 'right'; but this is not an objective measure (see Ross, this volume). This 'right-wrong' attitude creates and emanates from a system of reasons for striving towards one thing and avoiding something else. Being and acting in a specific system of reasons becomes a habit, as does

[15] Performance-specific creative tension is necessary in every professional performance. It is different from the tension created by the fault-related 'problem'/uneasy feeling/sensation of pre-accomplishment discussed in this chapter, but if it is partly lacking it can be a background for faults.

[16] If not including live elements that should lead to style change or giving free hands to the performer to end up somewhere completely unplanned by the composer.

seeing oneself through this 'right-wrong' lens, and goes on to shape the way people see their better and more successful 'potential self'.

In free improvisation, this 'right-wrong' paradigm ideally does not exist. So, what then triggers motivation and performative tension? The source for the necessary tension is the interior mental world of the performer with all the inner contradictions that need resolving. From a pedagogical and developmental perspective, we have argued here that if somebody feels uneasy, ashamed or shy, rather than saying "you should have done differently!", we would be better off asking, "how was your relation with your self? What kind of processes did you go through? Did you learn, find something new, even intriguing"? (see the NKI: New-Known-Intriguing approach by Mõistlik-Tamm & Lock, 2014). Therefore, we argue that improvisation can be seen as an environment for working with oneself, solving problems and discovering more about oneself including raising one's awareness and consciousness in the process. Improvisation then becomes vitally important because it relies on a paradigm of a serendipitous attitude, which is very different from the one of 'right-wrong' attitudes. The core essence of a 'fault' is significantly different in improvisation, where it pushes the improvisor to relate to their self in a more accepting and proactive, expressive way. Therefore, improvisation creates a new aesthetic from which to describe and observe a 'fault' as such. What in another context may be a 'fault', cannot be "wrong" in the context of improvisation.

We conclude, therefore, that not only but especially in the modernist attitude towards composition, the 'right-wrong' framework can be and indeed should be—and has always been—there, so that it can be broken or challenged. In contrast, in improvisation we conclude that the 'right-wrong' framework should be rather abandoned; otherwise, one leaves the realm of improvisation. Instead, one should recognise the "other's potentiality-for-being-its-self" and acknowledge one's "interior reality". In performance art, this 'right-wrong' framework works in the background to challenge both the performer and the audience.

Serendipity is a game-changing phenomenon, it arises in the moment when the person becomes aware of her uneasy feelings/sensation of pre-accomplishment, arising problems, accidents, errors, failures and when she makes changes through negative experience while applying conscious

repetition in the sense of Heidegger and Gadamer ("as active process of re-iteration and re-evocation of familiarities or former knowing-that and knowing-how"—see Brinkmann, 2017). Acknowledging a new view and raising awareness brings on a significant change in action (Säljö, 2003, p. 22–23). The repetition of a 'fault' (accident, error, failure) can make the audience believe that what happened was *meant* to be like it happened, and this idea has been suggested and practiced already in improvisation (Whitmer, 1941, Huron, 2006). For us, this kind of repetition, especially in the sense of Gadamer's (2004, p. 114) "bringing forth", the most important tool to make a change, and thereby to open the door via insight (Krishnamurti, 1977; Vallée-Tourangeau et al., 2020) towards serendipity.

References

Bandur, M. (2002). Improvisation, extempore, impromptu. H. H. Eggebrecht (Hrsg.), *Handwörterbuch der musikalischen Terminologie* (HmT, 32. Auslieferung, Winter 2001/2002). Stuttgart: Franz Steiner Verlag. Bayerische Staatsbibliothek München, Retrieved from: http://www.musiconn.de/id/hmt/hmt2bsb00070511f359t370/ft/bsb00070511f359t370?page=359&c=solrSearchHmT

Beach, L.R., Jungermann, H. & DeBruyn, E. E. J. (1996). Imagination and planning. *Decision making in the workplace: A unified perspective* (pp. 143–154). Lawrence Erlbaum Association.

Berggren, N., & Derakshan, N. (2013). Blinded by fear? Prior exposure to fearful faces enhances attentional processing of task-irrelevant stimuli. *The Quarterly Journal of Experimental Psychology, 66*(11), 2204–2218. https://doi.org/10.1080/17470218.2013.777082

Brinkman, M. (2017). Repetition and transformation in learning: A hermeneutic and phenomenological view on transformative learning experiences. In A. Laros, T. Fuhr, & E. W. Taylor (Eds.), *Transformative Learning Meets Bildung* (pp. 73–83). Sense Publishers. https://doi.org/10.1007/978-94-6300-797-9_6

Bruford, B. (2018). *Uncharted: Creativity and the expert drummer*. University of Michigan Press.

Clarke, E. (2011). Music perception and musical consciousness. In D. Clarke & E. Clarke (Eds.), *Music and consciousness: Philosophical, psychological, and cultural perspectives* (pp. 193–214). Oxford University Press. https://doi.org/10.1093/acprof:oso/9780199553792.003.0063

Collins, D. (2005). A synthesis process model of creative thinking in music composition. *Psychology of Music, 33*(2), 193–216. https://doi.org/10.1177/0305735605050651

Duch, M. F. (2015). *Free Improvisation—Method and genre.* Society for Artistic Research. https://www.researchcatalogue.net/view/110382/110595. Februrary 28, 2021.

Escudero, J. A. (2013). Heidegger: Being and time and the care for the self. *Open Journal of Philosophy, 3*(2), 302–307. https://doi.org/10.4236/ojpp.2013.32047

Escudero, J. A. (2014). Heidegger on selfhood. *American International Journal of Contemporary Research,4*(2), 6–17. http://www.aijcrnet.com/journals/Vol_4_No_2_February_2014/2.pdf

Gadamer, H.-G. (2004). *Truth and method* (Second revised edition, J. Weinsheimer and D. G. Marshall, Trans., original title *Wahrheit und Methode*, Tübingen 1960). Continuum.

Glăveanu, V. P. (2012). Habitual creativity: Revising habit, reconceptualizing creativity. *Review of General Psychology, 16*(1), 78–92. https://doi.org/10.1037/a0026611

Glăveanu, V. P. & Kaufman, J. C. (2020). The Creativity matrix: Spotlights and blind spots in our understanding of the phenomenon. *Journal of Creative Behavior, 54*, 884–896. https://doi.org/10.1002/jocb.417

Heidegger, M. (1996). *Being and Time. A Translation of Sein und Zeit* (J. Stambough, Trans.). State University of New York Press.

Hohwy, J. (2012). Attention and conscious perception in the hypothesis testing brain *Frontiers in Psychology, 3*(article 96), 1–14. https://doi.org/10.3389/fpsyg.2012.00096

Högberg, B., Lindgren, J., Johansson, K., Strandh, M., & Petersen, S. (2019). Consequences of school grading systems on adolescent health: Evidence from a Swedish school reform. *Journal of Education Policy.* https://doi.org/10.1080/02680939.2019.1686540

Huron, D. (2006). *Sweet anticipation: Music and the psychology of expectation.* Massachusetts Institute of Technology.

Interdisciplinary Instant Composition. (2021). *Interdisciplinary Instant Composition.* https://instantcomposition.com/. April 22, 2021.

Karkoschka, E. (1971/1999). *Aspects of group improvisation* (First printed in German Melos 1, 1971, Carl Bergstrøm-Nielsen, Trans.). IIMA—International Improvised Music Archive, https://web.archive.org/web/201 10716031159/, http://www20.brinkster.com/improarchive/ek_aspects.htm. Febrauary 28, 2021.

Krishnamurti, J. (1977). *Truth and actuality (Discussions with Prof. David Bohm, Hampshire Krishnamurti Fondation Trust Ltd)*. The Indcom Press.

Lehne, M., & Koelsch, S. (2015). Towards a general psychological model of tension and suspense. *Frontiers in Psychology, 6*, 1–11. https://doi.org/10.3389/fpsyg.2015.00079

Lock, G. (2011). Musical creativity in the mirror of Glaveanu's five principles of cultural psychology. *Culture & Psychology, 17*(1), 121–136. https://doi.org/10.1177/1354067X10388853

Lock, G. (2014). Hüperteadvus ja hetkes olemine. Error'i rollist muusikalises vabaimprovisatsioonis [Hyperconciousness and being-in-the-moment. The role of error in musical free improvisation]. P. Karro & K. Orav (Eds.), *Sõbralik Semiootika. Semiosalongi tekste aastast 2011–2014*, (pp. 131–147) [Friendly Semiotics. Semiosalong Texts 2011–2014]. Semiosalong.

Mascolo, M. F., & Kallio, E. (2019). Beyond free will: The embodied emergence of conscious agency. *Philosophical Psychology, 32*(4), 437–462. https://doi.org/10.1080/09515089.2019.1587910

McGrayne, S.B, Kashy, E., Robinson, F. N. H. (1998). Electromagnetism (physics). *Encyclopaedia Britannica*, https://www.britannica.com/science/ele ctromagnetism. Febrauary 28, 2021.

McLaughlin, S. (2020). Error as music composition: Human and material agencies. In S. Popat & S. Whatley (Eds.), *Error, ambiguity, and creativity* (pp. 187–210). Palgrave Macmillan.

Mõistlik-Tamm, M. & Lock, G. (2014). Conceptualizing adult piano beginners' playing experience through the NKI-approach. In H. Ruismäki & I. Ruokonen (Ed.). *Voices for Tomorrow. Sixth International Journal of Intercultural Arts Education*, 93–106.

Mukhametzyanov, R., Martynova, Y., Martynov, D., & Mingalieva, L. (2018). Cultural and Historical Roots of Performance Art. *Journal of History Culture and Art Research, 7*(4), 62–68.

Orav, K. (2014). The role of failure in contemporary art: "Research on failure". In P. Karro & K. Orav (Eds.), *Sõbralik Semiootika. Semiosalongi tekste aastast 2011–2014* (pp. 163–183) [Friendly Semiotics. Semiosalong Texts 2011–2014]. Semiosalong.

Ross, W. (2020). Serendipity. In V. P. Glăveanu (Ed.), *The Palgrave encyclopedia of the possible* (pp. 1–9). Palgrave Macmillan.

Sandström, E. (2010). *Performance art: A mode of communication* (MA thesis). Stockholm University.

Säljö, R. (2003). *Õppimine tegelikkuses: sotsiokultuuriline käsitlus [Learning in practice: A sociocultural perspective, original publication "Lärande i praktiken. Ett sociokulturellt perspektiv" (2000, Norstedts), Erle Nõmm,m Trans.].* Eesti Vabaharidusliidu Kirjastus.

Schuiling, F. (2016). The instant composers pool: Music notation and the mediation of improvising agency. *Micro-utopias: Anthropological Perspectives on Art, Relationality, and Creativity* (Special Issue "Micro-utopias: anthropological perspectives on art, relationality, and creativity", 5(1), 39–58. https://doi.org/10.4000/cadernosaa.1028

Scott, W. T. (1990). *The possibility of communication.* Mouton de Gruyter.

Sherman, G. L. (2009). Martin Heidegger's concept of authenticity: A philosophical contribution to student affairs theory. *Journal of College and Character, 10*(7), 1–8. https://doi.org/10.2202/1940-1639.1440

Sikk, J. (2020). *Stiimuli abil indutseeritud mentaalse ettekujutuse mõju vabaimprovisatsioonilise mänguprotsessi kvaliteedile* [The Influence of Stimulus Induced Mental Imagery on the Process of Improvising Freely, PhD Dissertation]. Eesti Muusika- ja Teatriakadeemia.

Stockhausen, K. (1989). *Stockhausen: Music Lectures and Interviews* (compiled by R. Maconie). London and New York: Marion Boyar.

Tharp, J. A., Johnson, S. L., Sungchoon, S., Sant, K. (2015). *Goals in bipolar I disorder: Big dreams predict more mania.* Society of Affective Science Conference Poster. https://www.researchgate.net/publication/298768445_Goals_in_bipolar_I_disorder_Big_dreams_predict_more_mania

Vallée-Tourangeau, F., Ross, W., Ruffatto Rech, R., & Vallée-Tourangeau, G., (2020). Insight as discovery. *Journal of Cognitive Psychology*, 1–20. https://doi.org/10.1080/20445911.2020.1822367

Velmans, M. (1999). When perception becomes conscious. *British Journal of Psychology, 90*, 543–566. https://doi.org/10.1348/000712699161620

Waldenfels, B. (2001). Die verändernde Kraft der Wiederholung. *Zeitschrift Für Ästhetik Und Allgemeine Kunstwissenschaft, 46*(1), 5–17.

Webster, P. R. (1990). Creativity as creative thinking. *MEJ: Music Educators Journal (Special Focus: Creative Thinking), 5*, 22–28.

Whitmer, T. Carl (1941). *The arts of improvisation. A handbook of principles and methods for organists, pianists, teachers and all who desire to develop extempore playing, based upon melodic approach* (Third Printing revised edition, first printing 1934). New York: M. Whitmark & Sons.

The Anableps Guide to Serendipity: Intentional Serendipity as Creative Encounter—A Decolonised, Literary Perspective

Bem Le Hunte

A Note on the Method

In the study of psychological afflictions, there are many theories to explain phenomenological experiences—offered by everyone from psychologists to neuroscientists to designers. But, in the mix there are important considerations given to the autobiographical work of those suffering from diseases such as schizophrenia (Rowland, 2020, p. 22), as the lived experience or 'emic' perspective is often more illuminating and authentic than the 'etic' or outsider perspective. Thus the 'emic' inner narrative of the afflicted becomes valuable data for those on the outside. But what if the theoretical perspective could also help make sense of that inner, emic experience? This is the question I explore through the way I have unpacked serendipity.

B. Le Hunte (✉)
University of Technology Sydney, Sydney, NSW, Australia
e-mail: Bem.LeHunte@uts.edu.au

© The Author(s), under exclusive license to Springer Nature Switzerland AG 2022
W. Ross and S. Copeland (eds.), *The Art of Serendipity*,
Palgrave Studies in Creativity and Culture,
https://doi.org/10.1007/978-3-030-84478-3_9

222 B. Le Hunte

In this chapter, I have begun by indulging in a piece of creative writing (below) specifically designed to explore and bear witness to a personal, inner encounter with serendipity—acutely observing the many accidental ways that I glean insights and inspiration through a series of signposts (or symbols). But at the end, I return to an etic/outsider's perspective to unpack some of the processes I have used to explore the ways I have forced the hand of serendipity to craft an encounter with a very personal muse.

Whilst this piece of text below may depart from a more traditional analysis of serendipity, 'reflexive' and/or 'autobiographical' ethnographies are a useful method for exploring personal experience as part of a more general enquiry (Davies, 2008). This type of reflexive ethnography differs from traditional ethnography, where the researcher is invisible and the research is positioned as objective. As an established author of literary fiction, I have a process and am able to observe and learn from it (see also March & Vallée-Tourangeau, this volume). Therefore, I have chosen a more reflexive approach to demonstrate the relationship between self and my creative encounter with serendipity in a more personalised, imaginative enquiry, to gain better insight into myself as well as into the topic itself.

I also chose a 'stream of consciousness' style championed by writers like Virginia Woolf; a style that she used for her fiction as well as for her research into the lack of women in the literary canon which was a topic where very few facts were available (Woolf, 1931). Given the lack of information and research on serendipity from the perspective of the ephemeral, lived experience, I felt this style would be appropriate. Stream of consciousness is a term first used by psychologist William James and is defined as a "narrative technique in nondramatic fiction intended to render the flow of myriad impressions – visual, auditory, physical, associative and subliminal – that impinge on the consciousness of an individual and form part of their awareness, along with the trend of their rational thoughts" (Augustyn, 2014).

This type of writing enabled a more liberated, generative, divergent encounter with my theme of serendipity (and my encounter with the muse). It is also more closely aligned to the divergent creative phase of

writing described as 'loose construing'—rather than the rational, convergent type of consciousness known as 'tight construing', which is required for processes such as editing (Cipolletta, 2013). It was chosen as a method because of its ability to elucidate a more immediate understanding of how a writer might encounter happenstance, accident and serendipity in the writing process.

This work moves fluidly between inner experience and theories held by experts—between the emic and etic. And so, it is part autoethnography, part narrative non-fiction, part speculative research and fiction combined. The referencing, cross-referencing and some of the sense-making took place after the first phase or 'loose construing' had taken place, as a way to better theorise my encounter and relationship with serendipity.

I hope you enjoy the journey below.

The Journey (Hope)

A creative life is an endless journey in my mind, replete with serendipitous encounters with my heroes, because my creative practice didn't start when I began and it certainly will not finish when I clock out (see also Turner & Kasperczyk, this volume). It's a journey taken in many directions over the course of millions of lifetimes and beyond the pulse of all our human lifetimes, in the sap and flow of nature; in the interpretations of drawings made by the planets in our sky. One could say that this is a panpsychic experience, and yet everything I invent emerges in my mind, at the moment I need it most.

Every journey takes time, so I hope you will indulge a little of yours with me now, because writing is about communication or communion—a process that has 'union' at its core. (What are the trees trying to communicate, or the skies? What can we read into our interpretations and how can we share these?) Writers, prophets, shamans, have all attempted to interpret these phenomena. Inevitably, they land on metaphors and symbols to point the way into the other dimensions where these have meaning. And so, I have selected a few symbols to take you into an inner world where we will encounter serendipity

together. And I hope to demonstrate, by sharing this journey with you, that everything is connected to everything. I am connected with you, and everything around me in this world—with everything I have encountered—my memories, my loves, my environment, my people, my stories, my beliefs, my heroes, my past. (Note here the use of the word 'my,' because whilst I tell the story of everything, I can only tell my version of it.) This idea of connectedness—of people to rocks to heavenly bodies to animals—is not a concept that comes from the Judeo-Christian world, but it is present in other world views including the 'Dreaming' of Indigenous Australians. This can barely be described in the languages of colonisers. One Indigenous scholar says it's almost impossible to describe in English, except to say "supra-rational interdimensional ontology endogenous to custodial ritual complexes every five minutes. So Dreaming it is" (Yunkaporta, 2019).

But first we need a symbol as a portal to transcend past the physical, material, outer world. Lewis Carroll had a rabbit hole for Alice to bridge these worlds (Carroll & Tenniel, 1866). C.S. Lewis had a wardrobe to step inside (Lewis & Baynes, 1950). Others, like Charlie Kaufman, created a hole in an office wall to escape the restrictions of concrete, political, gendered reality and find another truth, another body to live inside (Kaufman, 1999). So, on this occasion, I will give you the body of an Anableps to inhabit. The Anableps has eyes that look both above the water and below the water, simultaneously. It skims the surface, aware of its physical surroundings, whilst watching the subconscious world below, within (Fig. 1).

Let's ask the fish a question.

The Quest(ion) (Intention)

I have a quest to better understand my personal muse—the one that is uniquely placed to inspire me. On the most pragmatic level, some might say my muse is fictional—but this is the most banal and prosaic dissection of the muse. When presented with such a dry 'yeastless' assessment of the muse, a writer like myself might respond—"hell, if the muse is imaginary, then I'll make my imagination the very the best home for

Fig. 1 The Anableps (Golembiewski, 2021)

her!" It is more enriching and rewarding to believe in the miraculous, or in the 'better story' that Yann Martel advocates in *Life of Pi* (Martel, 2009).

So, I have a question to understand her—not a quest to **find** her, because I find her ever-present, giving wings to every thought. Even in my most prosaic moments when I'm required to sit on my swivel chair and analyse spreadsheets, she suggests that I take flight with her to somewhere more beautiful—swivel enough and I can go anywhere I want! She is engrained in my being, this muse, and yet I do not dare to question her too frequently about her ways.

On this occasion, though, I have many, many questions, but I know I cannot present her with a dull list. She doesn't listen to requests as much as to dreams. So, I have to cajole her with stories. I must fascinate my muse with my musings—fascinate myself with my own musings. *Do you have a sister by the name of Serendipity? Or is Serendipity just your alter-ego? How does Serendipity like to dress? And how does she like to wear her hair?* But more than anything, I want to know this: *how can I better rely on her, and at all times? How might I sit in her inner chamber, with or without an invitation?*

My muse smiles. She has already given me her first gift.

The Signpost (Direction)

With my inner eyes open to the waters below I see my next symbol—a signpost. This is like the ones you see in familiar tourist locations with a thousand signs pointing in all the different directions. It's the starting point, not the finishing point. The place where everything is contained all together, all at once, in synchronic time. Only from this level of coherence, in synchronic time, is it possible to diverge into all the stories imaginable in diachronic time.

This is my metaphor for the unified place where all our stories exist together. Whilst studying anthropology I learned about Ferdinand de Saussure and his theory about the two different aspects of language (Saussure et al., 1966). The first was 'la langue'—the place where language exists all together in one place—think 'grammar book'—or if you're imagining a story—think of the generative, synchronic source of all stories. (Italo Calvino personified this place through his character, the 'father of all stories,' although in my mind there could equally be a 'mother of all stories') (Calvino, 1981).

As well as a single place where all language (and therefore all stories) exist together, Saussure described a second place where the spoken language travels—'la parole' (Saussure et al., 1966). Now if language has a single source (where it finds unity) it must also have diversity— it must be able to travel the myriad directions that speech and stories travel down, depending on the time, place and cultural context of their telling. I call this the possibillionism of stories—the creative, serendipitous multi-directional pathways (see also Turner & Kasperczyk, this volume). And the most exciting part of any journey is the unknown regions you explore and discoveries you make when you take off on one of these serendipitous trails from the unified field to the diverse time/space/culture dimensions of narrative.

From this signpost, my inner eye lands on one of the directions—a sign pointing towards 'The Park Bench.' Not the most glamourous place to encounter the Queen of Serendipity. In the past, she's been known to send me to live with eunuchs by the banks of the Ganges and up, up,

up to the Valley of Saints in the holy mountains of the Himalayas (Le Hunte, 2000). But like I say, I don't like to question her directions too much. And I can instantly fathom her reason for sending me to the Park Bench, as you, too, will see.

The Potent (Ambition)

Did I mention that I'm carrying a book on this journey? Part note-book, part scrapbook, a patchwork of quotes and inspiration taken from some of my favourite writers, thinkers, artists, teachers. This book is the mirror for my own work and sometimes I 'borrow' from my forbears, but as with any mirror writing, the words are always in reverse and the translation is indecipherable to most.

I take this book with me as a prayer and talisman. I also take it with me to keep my sights high and my intentions noble, as well as to keep my faith in the journey ahead. For whilst I trust my muse to take me to the edge of a cliff and fly me across the ocean on the wing of a dragon, I am not an entirely irrational human being. I want to know that others have been supported by the currents of air before me. Indeed, if we are living in a universe where not a single atom has been deleted since the beginning of time, I am surely travelling on the same air as my heroes travelled before me. After all, the unreachable, undoable, impossible is only achievable if we share the same elements.

I touch the book, as a prayer, for the blessings of my heroes, and continue on to The Park Bench.

The Park Bench (Encounter)

I read a story recently about Kafka (Blackwell, 2017). According to this beautiful story, he met a young girl at a park bench and she'd just lost her favourite doll. Wanting to soothe the child he told her to return the next day and he came with a letter written from the girl's doll. The letters from this doll continued into an extraordinary ongoing daily narrative, telling tales of how the doll had travelled the world and learned many, many things on this journey…

So, I am sitting at Kafka's bench, wondering what I might learn. And clearly, I've been sent here for a reason. (Did I mention that I'm an incredibly trusting person?) Yet, I also chose to come here after reading the many, many signs leading in every possible direction, so there was a great and abundant offering followed by a singular choice, which I was instrumental in making. (From the unity of all possibilities, I diverged because I wanted to tell a very specific story.)

And I chose this direction because I wanted to explore a trail of a memory of a theory that could perhaps give me some insight into how Serendipity might work. I wanted to sit down in a park bench and think about 'affordances,' a keystone of the Ecological Theory of Perception (ETP) (Gibson, 2014). (And for this moment we're going to have to use our eyes to look above the water, jumping out of our unconscious world and into the conscious, physical domain.)

(Fish looking upwards)

According to ETP, we live in a material world surrounded by objects and we're utterly unaware of how those objects command our behavioural responses (Gibson, 2014). Imagine this… our objects, that we take for granted as inanimate and powerless, are not just **designed by us**—deliberately to solicit such effects, but they also end up **designing us** (Golembiewski, 2015). Preposterous, you might say! This is science fiction! It speaks of our human fears of designing robots that then take control of us. But this is already happening. So much so that even our most innocent objects speak to us without us knowing. For example, an apple in a fruit bowl says 'eat me' (Golembiewski, 2013)…

…And so, in this inner world of my imagination, this park bench says 'sit on me.'

So I sit, and then the fish's eyes look inwards, downwards, away from the world of material objects to the world of re-created objects in the water of our unconscious. In this inner world, our objects blur with experiences, memories, people, philosophies, lessons, conversations, other stories. Indeed, anything can be an 'object' that serves in a serendipitous generative encounter, as anything can design itself into our inner creative process—into our stories—with a purpose to reconnect and direct our words into new formations, new narratives.

Just as the park bench says 'sit on me,' all of the other 'objects' in this water-world of mine find their way into my stories. For example, stories I've heard about a 200-year-old guru who lived down the road from our farmhouse in Delhi are included in my latest novel, 'Elephants with Headlights,' as is the farmhouse itself. A chemist shop I once saw in India that also sold alcohol finds its way into this story re-named as the Al-chemist. A psychic vision I had of the date of birth for my third child is given to another pregnant woman in this same story, who is modelled on a friend of mine who took her own life in the world that I actually inhabit (with eyes above water, crying now). There's a story in there about my husband almost dying, too, but rather confusingly he's not my husband. Then there's another story of a wedding party in the dunes of the Rajasthani desert, based on my own honeymoon (Le Hunte, 2020a). The list goes on and on and on, just as my eyes flick above and below the water, searching for my muse, from the real, from the unreal, or any combination of the above.

Can you see the Queen of Serendipity now making her appearance on my humble throne on this bench? She arrives bringing a gift from the story of my own life—as if it were hers! The only thing I cannot quite fathom is how much of the serendipity is hers—how much credit I can take, and whether any of us can take credit for anything when our inspiration is so embedded in the lives of others (see also Glăveanu, this volume).

These questions are part of a greater mystery, and these mysteries need an even deeper kind of encounter. They are questions we take with us to our temples, wherever these might be situated.

The Temple (Trust/the Gift)

My temple is a strange one, filled with icons from India and the west: the holy mother of Jesus, next to goddesses and gods that all find a place in the pantheon of my experiences. Just as I have trust in being able to fly over cliffs in this water-world, I have faith in some sort of ultimate encounter, together with patience and reverence for the creative process that will allow me to encounter mystery. (Now we're getting into

a very cosmic/encultured view of serendipity—please forgive me if my ideas represent a religion you cannot follow. It's okay to sit for a while at the temple door and wait for my return!)

But I have to go in, because in this place I align myself to the possibility of a serendipitous encounter with meaning and mystery. I wave goodbye to my cynicism and I'm leaning towards infinity as soon as I walk in the temple doors, making the chance encounter with meaning and mystery even more likely. I'm willing this encounter to happen almost, because I don't want to leave this sacred space without a feeling of being blessed—without a gift. And it is this gift that I hope to pass on, to create that thing I described as union earlier on. This is the place where mystery also has to remain mysterious. Which is why it is often articulated as coming from elsewhere—from other—from muse.

There is a deep gratitude when your ideas come from elsewhere—from unknowns. The poet Lewis Hyde wrote that "if, when we work, we can look once a day upon the face of mystery, then our labour satisfies. We are lightened when our gifts rise from pools we cannot fathom" (Hyde, 1999). This willingness of inspiration to come from elsewhere has led creators to a sense of connectedness not just with their heroes or personal stories for inspiration, but to mystery and the divine. Thomas Keneally describes an inspired state as follows: "you do have the sense that you're at play in the fields of the Lord, and that you're dancing with angels (Grenville & Woolfe, 1993)." Stephen Nachmanovitch writes: "when I first found myself improvising, I felt with great excitement that I was onto something, a kind of spiritual connectedness that went far beyond the scope of music making" (Nachmanovitch, 1990). As Ralph Waldo Emerson wrote: "all writing is by the grace of God" (Emerson, 2003).

Many thinkers have described creativity as a state of 'waiting' for ideas/illumination. Csikszentmihalyi claims that "what happens in the *dark* spaces [during this phase] defies ordinary analysis and evokes the original mystery shrouding the work of genius. One feels almost the need to turn to mysticism, to invoke the voice of the Muse as an explanation" (Csikszentmihalyi, 1996).

Hardly surprising, then, that we created the divine muses as our conspirators—and hardly surprising that we incant and cajole them to appear before us.

The temple says, 'believe me,' just as an apple says 'eat me' or a park bench says 'sit on me.'

Believe what?

In a voice that echoes against the stone it says: "Believe that it is here that the most serendipitous, blissful, creative, rewarding encounter will happen." The promise is written into the very architecture, not to mention, into your intentions that led you up the aisle and into the sacred space that you imagined in the first place. It is here that you will encounter the soul of the muse and through a state of communion perhaps even notice that it is no different from your own. Hence the bliss. This is the place from which your gift, and all other gifts arise.

This is the place where humans have gone to from the beginning of time to summon their muses. The Greeks claimed a team of them, with Calliope presiding over all of them, the muse of epic poetry, with a voice so utterly ecstatic it could deglove you from your body, helping you experience the transcendent quality of your creative practice (Kirk, 1985). Then there was Lorca's muse, a goblin named Duende, who only visited with the most poignant, ecstatic, disturbing kinds of truth which involved one's mortality (García Lorca et al., 1998). Duende only entered a work when there was some sort of sacrifice, when the creator's blood and skin were in the piece.

I rely on a muse I will try to name now. Let's call her Paripūrna after the Sanskrit word for 'accomplished' and 'whole.' She's the muse of stories, but also of music. I first encountered her in a 24-track recording studio when I heard a musician asking: "Did we get it?" This muse arrives when you try and capture more than just a sound on one track, but a gestalt of many tracks and feelings—a sum greater than its parts—a connectedness with the whole.

This muse always leaves you with the unexpected gift of transcendence—quite beyond the suffering of Duende: the gift of connectedness with your audience. For me, Paripūrna harnesses the yearning for transcendence and allows the creator to pass this gift on. For creative practitioners who do not have any inclination towards transcendence, pick another muse. But one thing that all creative practitioners tend to

transcend, is time—often losing awareness of it in the creative process (Csikszentmihalyi, 1996).

Finally. The Library.

The Library (Sense-Making)

The Library is the quiet place of logic that I visit last to verify all of these encounters, reflect on what actually happened and try to validate my notion of serendipity through self-analysis and the research of others. And the analytic phase (or tight construing) is necessarily different from the generative process of loosely construing a narrative (i.e. the stream of consciousness phase; Csikszentmihalyi, 1996).

The Library is a place for wearing my academic gown in all its resplendent, validating glory.

I have divided the insights I gained from analysing this piece of writing into several themes that might help others understand the type of serendipity that took place. The themes I land on here are: connectedness, choice, bias, trust, heroes, personification and mystery. These themes were demonstrated through an inner 'landscape' of things that prompted serendipity. A process also described elsewhere as "creative thinging"—that is—recognising that thinking involves things. And acknowledging that these things "actively participate in human cognitive life" (Malafouris, 2019).

Connectedness offers the pathways that lead everywhere—and a belief that 'everything is connected to everything' allows a creative thinker to travel down serendipitous alleyways, often leading to dead ends, and yet enables them to reverse back and recalibrate into new, more rewarding directions in search of the most inspiring ideas. Whilst the notion of connectedness requires us to know a lot about the world around us (Louis Pasteur famously commented that "chance favours the prepared mind"; (Pasteur, 1854), a mind that is open to the connectedness of all things allows me to bump into the various different knowledges that need to combine and connect in new ways that are characteristic of discovery and creative endeavour (see also Glăveanu, this volume). A sense of connectedness to my environment, past, people

etc., and an openness to the possibility of these connections, leaves me open to an 'encounter' with my muse—and it must be an encounter on some level, as serendipity by definition cannot be sought, it can only be cajoled. It's as if we can decide on directions to walk in, without knowing fully what we will encounter on that walk.

Choice is the mechanism that enables creative agency through this way-finding of a creative writing process. The author must make a new decision with every word that is written onto a page, and with each choice a dozen other choices will spring forth. When faced with the possibillionism of directions at my signpost, I chose to arrive at a park bench. This might be described as 'intentional serendipity,' because I still didn't know what would happen when I left the park bench to continue the narrative. Yet I cannot deny my agency in guiding my feet there. Not all our ideas are the children of happy accidents, and even if they were, we still have to play a role in raising them to adulthood (and no matter how much planning you might put into raising a child, luck or fortune will shape them, too; see also Sneddon, this volume).

Bias. (Closely related to choice.) Every writer is drawn to serendipitous encounters through their own bias. Which writers and genres called me? In my example of the park bench, I also knew that I was subject to *recency bias*, having just read about Kafka's park bench in a Linkedin post a few days earlier. And the fish with eyes that flicked between the inner and outer worlds (the Anableps) came from a metaphor used by a colleague recently to teach leadership—again recency bias.

Trust is the ingredient that allows a writer to know whether the glow they are following will lead them in a worthwhile direction. One novelist and teacher writes: "There is, for me at least, an almost visceral sensation that the voice will lead me through the story, that the voice already knows the story though I don't" (Woolfe, 2007). Indeed, radical trust in serendipity is sometimes used as a creative method for writers. (Don't even pick up your pen until you've cleared your head of any idea of what you want to write.) Whilst so much literature is about encountering **information** serendipitously, this could just as easily be achieved by a machine algorithm programmed to search in a serendipitous way. Encountering a muse, however, puts the mortal face back into the very human process of generative thinking. Also, it gives the creator the sense

that they are being guided, rather than doing the guiding of their own thought, insight and inspiration. A lack of control is an important aspect of the divergent process of creative thinking (whilst control is definitely an important part of the convergent process). A well-known piece of advice, often attributed in the literary world to Ernest Hemingway, is that we should "write drunk and edit sober."

Heroes are another factor acknowledged in this personal narrative that helps shape the type of serendipity that emerges. If my literary hero is Kafka or Gabriel Garcia Marquez, then I might be drawn to try my luck in a more spectacular, magical direction, whilst other heroes might inspire a more gritty, realistic engagement with the muse. In acknowledging the impact of heroes, writers are not only recognising that they 'stand on the shoulders of giants' to use a term purportedly coined by Isaac Newton, but they are also demonstrating the validity of Csikszentmihalyi's Systems Model of creativity, which recognises that a creative thinker will make a choice in dipping into their culture (the domain) for inspiration, as well as interrogating themselves (or person) and paying respects to invisible gatekeepers and criteria, often exemplified through their heroes (the field) (Csikszentmihalyi, 1996).

Personification is what happens when there is a sense that words or ideas appear to be coming from 'elsewhere' as described by Sue Woolfe, above—where a writer loses that sense of control, and therefore attributes serendipitous discovery to a force outside of themselves. Creativity is a mysterious process, so it's hardly surprising that there's a sense of alterity that accompanies inspiration: that it's often projected and externalised, given ethereal form as the muse, the divine messenger who connects heaven and earth by helping the human artist aspire and transcend beyond the material and the known.

Moreover, many writers have described themselves as being at the service of the muse—not in control of their own words, as if they are 'secretaries of their imagination,' according to one colleague, Stephen Sewell. Blake writes about his ideas as follows:

> And tho' I call them mine, I know that they are not mine, being of the same opinion with Milton when he says that the Muse visits his slumbers

and awakes and governs his song when morn purples the East. (Blake & Keynes, 1968)

In theorising the muse and her history, it's important to understand that until recently, artistry as a human endeavour existed only in the sacred domain. All Western art until the Renaissance, for example, was developed on the bedrock of religion, as was all learning. In the words of religious historian, Mircea Eliade in *The Sacred and the Profane*, today's "nonreligious man descends from homo religious" (Eliade, 1959).

Hardly surprising that writers still attribute their individual agency and encounter with serendipity as if this illumination is coming from 'outside' them or 'beyond' them, as this illumination was seen to come from elsewhere. Yet in this world that privileges the profane over the sacred, what is the extra 'something' that is being sought when laying down a track in a recording studio? This brings me to the final theme unearthed through this writing.

Mystery Writers have spoken to this theme throughout history. Certainly, part of the adventure and joy in writing a story is the uncovering of what that story might be and being a conduit in the telling of the tale (Le Hunte, 2020b). I write above that "mystery must remain mysterious."

Lorca wrote about his goblin muse—Duende—describing it as "a mysterious power which everyone senses and no philosopher explains." And part of this mystery comes from a sense of connectedness with humankind, in that this is "the same Duende that scorched the heart of Nietzsche, who searched in vain for its external forms on the Rialto Bridge and in the music of Bizet, without knowing that the Duende he was pursuing had leaped straight from the Greek mysteries to the dancers of Cádiz or the beheaded, Dionysian scream of Silverio's siguiriya" (García Lorca et al., 1998).

Lorca distinguishes his Duende from the alterity of an angel or muse, which he says come from 'outside us.' His Duende came from "the remotest mansions of the blood." It came on "a wind that smells of baby's spittle, crushed grass, and jellyfish veil, announcing the constant baptism of newly created things" (García Lorca et al., 1998). Here he describes the essential difference:

> Years ago, an eighty-year-old woman won first prize at a dance contest in Jerez de la Frontera. She was competing against beautiful women and young girls with waists supple as water, but all she did was raise her arms, throw back her head, and stamp her foot on the floor. In that gathering of muses and angels – beautiful forms and beautiful smiles – who could have won but her moribund Duende, sweeping the ground with its wings of rusty knives. (García Lorca et al., 1998)

There will always be mystery involved in any encounter with serendipity—which begs a question—is there a danger that we might know too much about its origins? Some writers have even expressed a fear of over-interrogating their muse (which is why I wrote earlier that I have to ask my muse my questions tangentially). Blake describes having to abandon the process of reasoning, saying that he cannot "describe in words what I mean to design, for fear I should evaporate the spirit of my invention" (Blake & Keynes, 1968). Even in using this method of intro-spective auto-ethnographic, highly speculative narrative non-fiction—we call it 'Dreaming'—I have chosen to use words that are beyond ordinary usage. I have mentioned the external influences of the muse, but I do not want to 'disappear' her through systematic, academic investigation that privileges Newtonian systems of rigour. The muse requires a more oblique approach, as I mentioned above.

Lewis Hyde tells us of an old English fairytale that explores the importance of mystery remaining mysterious. In this tale, a man from Devon is given a barrel of ale that is inexhaustible by his fairies (think muses). This runs freely for years until the man's maid removes the cork to find the secret, discovering only cobwebs. Thereafter, the ale ceases to flow. Hyde writes:

> The moral is this: the gift is lost in self-consciousness. To count, measure, reckon value, or seek the cause of a thing is to step outside the circle, to ease being "all of a piece" with the flow of gifts and become, instead, one part of the whole reflecting upon another part. We participate in the esemplastic power of a gift by way for a particular kind of unconsciousness, then: unanalytic, undialectical consciousness. (Hyde, 1999)

Have I revealed too much through my analysis? Should I return the cork to the ale, lest I see cobwebs in a dry cask? Perhaps it is time to rise now—to back out of the library—to remove my academic gown and walk back into the tall blonde grass of innocent discovery.

References

Augustyn, A. (2014). Stream of consciousness. In *Encyclopaedia Britannica*. Encyclopaedia Britannica Inc.

Blackwell, E. (2017). *The Kindness of Kafka*. https://begininwondersite.wordpress.com/2017/05/26/the-kindness-of-kafka/

Blake, W., & Keynes, G. (1968). *The letters of William Blake* (2nd ed.). Hart-Davis.

Calvino, I. (1981). *If on a winter's night a traveler* (Harvest pbk, Ed.). Harcourt Brace & Company.

Carroll, L., & Tenniel, J. (1866). *Alice's adventures in wonderland*. D. Appleton and co.

Cipolletta, S. (2013). Construing in action: Experiencing embodiment. *Journal of Constructivist Psychology, 26*(4), 293–305. https://doi.org/10.1080/10720537.2013.812770

Csikszentmihalyi, M. (1996). *Creativity: Flow and the psychology of discovery and invention* (1st ed.). HarperCollins Publishers.

Davies, C. A. (2008). *Reflexive ethnography: A guide to researching selves and others*. Routledge.

Eliade, M. (1959). *The sacred and the profane: The nature of religion* (1st American ed.). Harcourt Brace Jovanovich.

Emerson, R. W. (2003). *Selected writings of Ralph Waldo Emerson*. Signet Classic.

García Lorca, F., Maurer, C., & Di Giovanni, N. T. (1998). *In search of Duende*. New Directions.

Gibson, J. J. (2014). *The ecological approach to visual perception: Classic Edition*. Psychology Press.

Golembiewski, J. (2013). A determinism and desire: Some neurological processes in perceiving the design object. *The International Journal of Design*

in Society, 6(3), 23–36. https://doi.org/10.18848/2325-1328/CGP/v06i03/38504

Golembiewski, J. (2015). The designed environment and how it affects brain morphology and mental health. *HERD: Health Environments Research & Design Journal, 9*(2), 161–171. https://doi.org/10.1177/1937586715609562

Golembiewski, J. (2021). Anableps.

Grenville, K., & Woolfe, S. (1993). *Making stories: How ten Australian novels were written.* Allen & Unwin.

Hyde, L. (1999). *The gift: Imagination and the erotic life of property.* Vintage.

Kaufman, C. (1999). Being John Malkovitch. In.

Kirk, G. S. (1985). *The Illiad: A commentary.* Cambridge University Press.

Le Hunte, B. (2000). *The seduction of silence.* HarperCollins Publishers.

Le Hunte, B. (2020a). *Elephants with headlights.* Transit Lounge.

Le Hunte, B. (2020b). *Why do we protect ourselves from unknown unknowns?* https://i2insights.org/2020/02/11/unknown-unknowns-and-creativity/

Lewis, C. S., & Baynes, P. (1950). *The Lion, the Witch and the Wardrobe: A story for children.* Macmillan.

Malafouris, L. (2019). Thinking as "THINGING": Psychology with things. *Current Directions in Psychological Science, 29*(1), 3–8. https://doi.org/10.1177/0963721419873349

Martel, Y. (2009). *Life of Pi.* Canongate Books.

Nachmanovitch, S. (1990). *Free play.* Penguin Putnam.

Pasteur, L. (1854). *Formal inaugural address of the faculty of sciences.* University of Lille.

Rowland, L. (2020). First person accounts. *Schizophrenia Bulletin.* https://academic.oup.com/schizophreniabulletin/pages/first_person_accounts

Saussure, F. d., Bally, C., Sechehaye, A., & Riedlinger, A. (1966). *Course in general linguistics.* McGraw-Hill.

Woolf, V. (1931). *A room of one's own.* Hogarth Press.

Woolfe, S. (2007). *The Mystery of the cleaning lady: A writer looks at creativity and Neuroscience.* University of Western Australia Press.

Yunkaporta, T. (2019). *Sand talk, how indigenous thinking can save the world.* Text.

The Pleasure of Not Knowing and the Importance of Serendipity in Contemporary Art Practice

Andrew Sneddon

The work in this chapter will examine the unsettling nature of not knowing and its importance to artistic practice. I am not the first to comment on this; Fortnum and Fisher (2013, p. 128) write,

> Not knowing can be paralysing, prohibitive. It can usher in the feeling of anxiety and embarrassment, the debilitating sense of being at a loss or lost, unable to see a way out or forward.

However, this feeling of not knowing and 'unforeseeing' runs through contemporary art as clearly stated by Ginsborg (2004),

A. Sneddon (✉)
University of Edinburgh, Edinburgh, Scotland, UK
e-mail: a.sneddon@ed.ac.uk; a.g.sneddon@shu.ac.uk

Sheffield Hallam University, Sheffield, UK

W. Ross and S. Copeland (eds.), *The Art of Serendipity*,
Palgrave Studies in Creativity and Culture,
https://doi.org/10.1007/978-3-030-84478-3_10

> How unforeseen is an unforeseen event? Where does the boundary of possibility come? Having a technique to facilitate unforeseen events is a classic technique of modernist art. The facilitation of unforeseen discoveries is what ran through the whole of the art of the last century, not all artists of course, but unstable techniques, the absurd and the illogical are all about the unforeseen.

This chapter situates these ideas in my own practice and that of other contemporary artists to draw out the relationship between not-knowing and serendipity. I first experienced and became aware of the importance of serendipity and sagacity within contemporary art practice during an artist-in-residence that I was awarded at Yorkshire Sculpture Park (YSP). The residency was funded by The *Esmée* Fairbairn Foundation, The Hepworth Wakefield and Arts Council England and organised by The ArtHouse. The residency followed a familiar pattern of inviting the selected artist to respond to a particular site, location or context and to generate new work that is often referred to as site-specific or site-responsive. The residency differed from most in that there was no requirement by the organisers or host institution to finalise a work for exhibition.

This open-ended approach was developed and popularised from 1966 onwards by the Artist Placement Group (APG) and became their mantra, stating that 'context is half the work' (John Albert Walker, 2002, p. 54). This meant that the location, site and immediate environment that an artwork is exhibited within is of equal importance as the actual work itself (see also Turner & Kasperczyk, this volume). The residency at YSP involved research and experiments through a series of trials and errors. Much of the research borrowed methods not unfamiliar to geography, anthropology or cultural studies by way of fieldwork and interviews. On reflection, this methodology of borrowing from other disciplines in a pseudo-scientific fashion is a common practice adopted by artists and accepted by host organisations involved in supporting artist in residence programmes.

During the eight-week residency, I had set out to make work that responded to the immediate landscape as I had recently completed a publication that explored the relation between Japanese stroll gardens

and their European equivalent pleasure gardens and my residency was also scheduled to coincide with a large exhibition at YSP by the Japanese/American designer and artist Isamu Noguchi (1904–1988). I had struggled to generate any meaningful response; no ideas were forthcoming and I became acutely aware that time was ticking (see March & Vallée-Tourangeau, this volume). The opportunity of time and space to think about and to make work in response to such a rich context was a huge attraction as ideas came and went, nothing was working and mild panic was beginning to set in. As the artist, writer and educator Rebecca Fortnum (Fortnum et al., 2008, p. 4) articulated for the accompanying residency catalogue;

> An artist subjects his or her practice to a certain amount of self-scrutiny, re-evaluation takes place and something new emerges. In order to produce this new thing, we might need to dismantle trusted processes, treasured forms, familiar ways of thinking. This theory speculates that it is important that artists do this from time to time in order to reinvigorate their practice, to prevent them from 'going stale' and to avoid the fate of endless and uncritical repetition. It works on the premise that artists seek, as well as need, such testing.

In desperation, I joined a regular group tour of the Bretton Hall Estate which quietly nestles in what are now the grounds of Yorkshire Sculpture Park. The tour was led by an in-house archivist and halfway through the tour we entered Bretton Hall where we were ushered into a large reception room on the ground floor and directed to study a marble fire surround. Our guide proudly and confidently informed the group that this was the very room where the iconic naked wrestling scene from *Women in Love* (1969), directed by Ken Russell was filmed. The scene in question depicts two of the characters played by Oliver Reed and Alan Bates wrestling in front of the roaring fire. I don't consider myself to be a film expert but for some unexplained reason my vague recollection of the film didn't correspond to what we were looking at despite being confidently informed by our guide that this was the room where the filming took place (Figs. 1 and 2).

Fig. 1 Bretton Hall fireplace (YSP), photo by the author

Fig. 2 Still from *Women in Love* (1968) Elvaston Castle, Derbyshire, England

After watching the film and studying the infamous scene at length it was clear that the Breton Hall fireplace design did not match the fireplace from the film. Unfortunately, the location of the filming was wrongly attributed. It would appear that the story told by the tour guide at YSP

was wrongly attributed and the incorrect story had been told and retold for over forty years. The scene's surrounding rich gold-leaf detail and architecture is in the Victorian Gothic Revival style while in comparison the architectural details of Bretton Hall are clearly more subdued and restrained. The reception of the scene's new provenance was met at first by YSP staff and stakeholders with disbelief and then with much disappointment followed by annoyance and frustration. The strong reaction to this news prompted me to question why this scene should be so important, highly valued and protected. This unanticipated and unsought information provided me with enough knowledge and intrigue to begin a work for the residency (see Glăveanu on the importance of curiosity, this volume). This unintended discovery of information allowed me to make 'A Period Drama'. As a result of the residency, I made a re-edited version of the wrestling scene that reduced the variety of camera angles to only one and kept this monocular view accompanied with accompanying dialogue from the original film on a loop where both actors discuss the merits of ancient Japanese wrestling before they begin to wrestle.

On reflection of how this work came about, I realised that the occurrence of serendipity was a significant factor in the creative process alongside sagacity. In this case, I see serendipity as deciding to join a random tour group where I encountered information that was incorrect and discovering new information that I was not looking for. I also see sagacity as the ability to recognise and make an informed judgement with regard to a serendipitous discovery. From this point on I began to recognise recurring patterns of serendipity with other artist's practices that favour a 'post studio' approach or who prefer to develop their practice away from the confines of a traditional studio where the unpredictable, the unforeseen and active audience engagement is encouraged and becomes an essential component in the realisation of their practice.

During a fact-checking inquiry for this chapter with the artist Adam Chodzko (b. Britain, 1966), I was directed towards 'Expulsion from the Garden of Eden' (2015). Chodzko alerted me to the serendipitous nature of his work where he felt he needed to hold back or play down the serendipitous nature of how the work came about. He felt this aspect was too strong a narrative and might be a distraction to the viewer. Whilst on a residency in Beppo, Japan the artist was searching online for an

old tourist guide booklet for Beppo but instead, stumbled across two old postcards of the Beppo shopping market from two different sellers both on sale at the same time. Chodzko bought one postcard from Henrico, Virgina, USA and the other from Tampa, Florida. The artist arranged for a re-enactment of the picture by a group of local participants from Kannawa, Beppo who were also invited to ruminate and speculate on the interior psychology and possible narratives portrayed in each of the photographs. The unanticipated discovery of these two postcards that Chodzko was not looking for provided the basis of his video and sound work.

I was attracted to Chodzko's easy acceptance of serendipity into his decision-making process relating to unintentional finds that eventually become the instigation of many of his artworks. Very similar to my own acceptance of serendipity, Chodzko also recognises that before a serendipitous discovery takes place a failure of some sort often happens which has the effect of making alternative and often unsought information seem more significant and more interesting. The artist refers me to *Reunion; Salò* (1998) where he attempted but failed to create a reunion of a group of young actors involved in Pier Paolo Pasolini's 1975 film '*Salo or 120 days of Sodom*'. The failure to track down all but one of the original cast members forced Chodzko to rethink his original idea of creating a reunion for the original cast some 23 years later and instead developed an alternative scenario where he used contemporary lookalike actors to stand in instead of the original cast (Fig. 3).

Although these incidents of 'serendipitous coincidence' described here might at first, seem small or even insignificant within the broader confines of a project, they are nevertheless highly relevant and important (see Ross, this volume). As Chodzko suggests,

> the creative process is a lot about managing various levels of discomfort (regarding risk, feeling lost, out of one's depth etc.) with some level of faith that this will somehow all lead to some kind of delayed enjoyment. So, in line with many other traditional forms of labour in terms of that relationship between discomfort and pleasure. (Email exchange with the artist, 30 April, 2021)

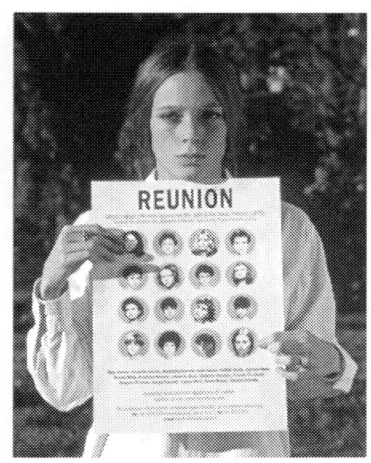

Fig. 3 Adam Chodzko, *Reunion; Salò* (1998) Video with sound; 8 minutes 10 secs, 12 framed c-type photographs, and posters

The concern and hesitation expressed by Chodzko of acknowledging the presence of serendipity in the creative process also reminds me of shared concerns in other disciplines expressed by Merton and Barber who claimed that,

> In science, business, and politics, accidental discoveries raised problems of merit and justification: Some might think that accidental discoveries were useful and justifiable while others rejected them as harmful or discreditable, but all pass some judgement on the implications of accidental discoveries. (Merton and Barber, 2004, p. 223)

Advanced contemporary art practices appear to have always had a close and supporting role with that of serendipity. In 1968, Cybernetic Serendipity was curated by Jasia Reichardt at the Institute of Contemporary Art (ICA) in London which would go on to tour to the United States in Washington DC and San Francisco attracting high audience figures and enthusiastic press coverage from a diverse range of art journals, science and technology journals and daily news correspondents. The Cybernetic Serendipity exhibition represented 130 contributors, of whom 43 were composers, artists and poets, and 87 were engineers,

doctors, computer scientists and philosophers. The exhibition consisted of objects, diagrams, films, sounds, all contributing to the overall theme of the exhibition of information. A number of the artists involved were experimenting in the space between computer technologies and traditional or recognisable art practices. Artists such as Bruce Lacey, Roger Dainton, Tsai Wen Ying and Naim June Paik who is widely credited for introducing the term, 'information superhighway' in 1974 all contributed to the importance of the exhibition. Avantgarde musicians such as John Cage, Iannis Xenakis and Peter Zinovieff along with films from Kenneth Knowlton and Michael Noll exhibited alongside each other to create a seminal exhibition that introduced examples and incidents of serendipity to a wider public.

If we initiate an internet search today using the words serendipity with art or creativity, the search engine will inevitably take us to the exhibition and catalogue associated with Cybernetic Serendipity. Reichardt's curation of the project had many achievements, mainly the bringing together of participants from the realms of science and technology with the arts, avant-garde music and visual arts. However, the area surrounding serendipity remained relatively unexplored with the potential cybernetic possibilities becoming the main focus of the exhibition. As Catherine Mason recorded for Studio International on the fiftieth anniversary of the exhibition by suggesting that;

> The burgeoning subject of computer arts or cyberart was thus introduced to a younger generation of artists in a positive social and political climate. This generation subsequently laid the foundation for decades of advancement in the arenas of digital image-making, animation, interactivity, intermedia and cross-disciplinary collaboration in the arts, which is a feature of much contemporary art today. (Mason, 2018)

Mason is referring to a period in Britain which is often described as the 'white heat of technology' set up by Prime Minister, Harold Wilson's government to promote industrial efficiency and the use of new technologies in industry. In Labour's 1963 party conference, Wilson laid out a plan that positioned pioneering technologies at the forefront of the country's progress and promised Britain a bright and new future "forged

in the white heat of this revolution with no place for restrictive practices of or outdated methods".[1] *Cybernetic Serendipity* can be seen to be riding on this new wave of enthusiasm and promise. Despite the interest in promoting the unification of science and technology with the arts, an important and guiding principal was the uncharacteristic 'open ended' nature of many of the exhibits. Audiences were given no indication as to whether an exhibit was created by an engineer, scientist or artist. The democratising of the exhibition seems to capture much of the atmosphere of the late 1960s. Although the exhibition was well attended in both Britain and America it struggled to attract significant funding which was much needed to host a show of this nature. Also, many of the exhibits experienced severe damage in transportation which led to a much-reduced touring schedule across America and wiped out potential and much-needed revenue from the exhibition.

The primary emphasis for the exhibition was clearly to establish a dialogue between the sciences and the arts and to blur the permeability of disciplinary boundaries. This fertile ground created by inter-disciplinary research combining concepts, theoretical frameworks and potential methodological tools creates the ideal conditions for serendipity to manifest. The judicious borrowings, transfers, and hybridisation build bridges between disciplines (Darbellay et al., 2014). A secondary emphasis was the incorporation of ideas surrounding serendipity. In the 1968 press release from the ICA exhibition in London, Reichardt (1968) noted that;

> Walpole used the term serendipity to describe the faculty of making happy chance discoveries. Through the use of cybernetic devices to make graphics, film and poems, as well as other randomising machines which interact with the spectator, many happy discoveries were made. Hence the title of this show.[2]

[1] http://nottspolitics.org/wp-content/uploads/2013/06/Labours-Plan-for-science.pdf, p. 7 (Last Accessed 9 November 2020).

[2] Reichardt, J. (1968). http://www.medienkunstnetz.de/exhibitions/serendipity/ (Last Accessed 9 November 2020).

In 2005, Reichardt would go on to change or refine her statement by exchanging serendipity for chance.

> The principal idea was to examine the role of cybernetics in contemporary arts. The exhibition included robots, poetry, music and painting machines, as well as all sorts of works where chance was an important ingredient. It was an intellectual exercise that became a spectacular exhibition in the summer of 1968.[3]

Although not a hugely significant alteration combined with an acceptance of the economies of speech and language where chance and serendipity are often conflated to mean one and the same (see Copeland, this volume), Reichardt's use of serendipity to simply mean 'happy chance discoveries' is worthy of a little closer inspection. I would argue that Reichardt's curation sought to exhibit works that simply had an unspecified aim or result. This becomes clearer, if we consider one of the exhibits in particular: Edward Ihnatoxicz's interactive sculpture Sound Activated Mobile (SAM), 1968. This was an interactive electrohydraulic sculpture consisting of a four-petalled, flower-shaped fibreglass 'head' mounted on a custom made, flexible aluminium skeleton. This kinetic sculpture would respond to sounds emitted from the audience via a microphone mounted on each of the petals which activated hydraulic pistons, causing the body of the mobile to lean in the direction of where the sound came from.

Many of the exhibits depended upon similar bodily activity and movement from the willing participants. Although the precise outcome was not known for many of the exhibits there was a certain amount of certainty within limited parameters. No unanticipated or surprising outcomes could be said to have been reached. To set up a project where the outcome is serendipitous, discovery cannot be serendipitous as the outcome is known or can be imagined. True serendipity is the discovery of knowledge that was not or could not have been anticipated. We are reminded of Walpole's full letter to Mann where he states that "you must

observe that *no* discovery of a thing you are looking for comes under this description" (emphasis in the original; Merton & Barber, 2004, p. 234).

The introduction of the word serendipity into the English Language is a relatively recent entry. The English novelist and politician, Horace Walpole is credited with its coinage in 1754 in a letter to the British diplomat, Horace Mann. Inspired by reading a silly fairy tale, called *The Three Princes of Serendip*, Walpole was intrigued by the prince's ability to make fortuitous discoveries by accident and sagacity of things that they were not initially looking for.

> This discovery indeed is almost of that kind which I call serendipity, a very expressive word, which as I have nothing better to tell you, I shall endeavour to explain to you: you will understand it better by the derivation than by the definition. ...One of the most remarkable instances of this accidental sagacity (for you must observe that no discovery of a thing you are looking for comes under this description). (Merton & Barber, 2004, p. 2)

Although Walpole is credited with the word's coinage the sociologist Robert Merton must be credited with making the 'serendipity pattern' familiar and its distribution and acceptance across a range of disciplines commonplace, from the Sciences to the Humanities.

> The serendipity pattern refers to the fairly common experience of observing an unanticipated, anomalous and strategic datum which becomes the occasion for developing a new theory or for extending an existing theory... The datum is, first of all, unanticipated. A research directed toward the test of one hypothesis yields a fortuitous by-product, an unexpected observation which bears upon theories not in question when the research was begun. Secondly, the observation is anomalous, surprising, either because it seems inconsistent with prevailing theory or with other established facts. In either case, the seeming inconsistency provokes curiosity... And thirdly, in noting that the unexpected fact must be strategic, i.e., that it must permit of implications which bear upon generalized theory, we are, of course, referring rather to what the observer brings to the datum than to the datum itself. For it obviously requires a

theoretically sensitized observer to detect the universal in the particular. (Merton, 1968, pp. 157–162)

Our contemporary understanding of serendipity as we have seen might be summed up as 'accidental discovery'. Certainly, in Walpole's terms when considering the Three Princes of Serendip, he recalls that "they were always making discoveries, by accident and sagacity, of things they were not in quest of" (Merton & Barber, 2004, p. 108). Merton suggests that Walpole realises that this type of discovery is simply an example of abductive abilities. Discoveries through serendipity are associated with the type of reasoning that Charles Sanders Peirce (1839–1914) called abduction, which compliments deduction and induction. Abduction, involves a more intuitive and exploratory way of reasoning which allows one to provide the best explanation possible of a surprising and unexpected fact (Darbellay et al., 2014, p. 5).

In 1957, *The Art of Scientific Investigation* was published by William Ian Beardmore (WIB) Beveridge an Australian animal pathologist and director of the Institute of Animal Pathology at the University of Cambridge considering scientific breakthroughs and the significant presence of chance coupled with sagacity and suggests that:

> they are the more remarkable when one thinks of the failures and frustrations usually met in research. Probably the majority of discoveries in biology and medicine have been, come upon unexpectedly, or at least had an element of chance in them, especially the most important and revolutionary ones. (Beveridge, 1957, p. 31)

The importance and significance of serendipity and sagacity seem well recorded in the sciences and there now seems to be a new interest in how these connections might be harnessed from information seeking and retrieval disciplines such as library research or internet developers. Google's executive chairman, Eric Schmit in a lecture titled '*The Digital Future*' proudly proclaimed that;

> We're never out of ideas. We can suggest things that are interesting to you, based on your passions, things that you care about, where you're going, that sort of thing. Our suggestions will be pretty good. We have

figured out a way to generate serendipity. We actually understand now how we can surface things that are surprising to you, but based on things that you care about and what other people care about. (Schmidt, 2011)

Daniel Liestman describes the ability to discover connections that are not always apparent but favour the prepared mind as 'intuitive sagacity', that comes from "a random juxtaposition of ideas in which loose pieces of information frequently undergo a period of incubation in the mind and are brought together by the demands of some external event, such as a reference query, which serves as a catalyst" (Liestman, 1992, p. 530; see also Gilhooly, this volume). The notion of incubation of an idea seems to fit well with how an idea might somehow percolate in the mind of an artist for a period only to be activated and brought into being in the world by an external event such as in a response to a particular context or as we will see in the pioneering work of the Artist Placement Group.

In 1966, two years before *Cybernetic Serendipity* was exhibited at the ICA, a new organisation was being formed by John Latahm (1921–2006) and Barbara Stiveni (1928–2020) called The Artist Placement Group or APG. The importance of this artist-led initiative is key to understanding the comfort and familiarity contemporary artists have today with occupying a position of not knowing and working in an environment where the unanticipated or the unforeseen are happily accepted into the artists' practice. The work of both Stiveni and Latham is also important in understanding the rationale and value of contemporary art's desire to be operating within the public realm and outside the conventional museum or gallery system and traditional studio environment.

The legacy of APG within this debate centres upon their three registers that defined their practice and contribution to today's contemporary artists. 'Context is half the work', the 'Incidental Person' and the 'Open Brief' are all familiar and widely accepted positions within contemporary art practices. These are also important registers for understanding why and how today's artists that operate outside of the institutional systems of museums and galleries are comfortable with not knowing the outcome of every aspect of a project and their willingness to accept and incorporate the unanticipated.

APG created placements and residencies with industries and companies such as the BBC, British Rail, The National Coal Board, British Steel Corporation and Scottish Television, DHSS (High Security Hospitals Broadmoor and Rampton) where artists were placed at the heart of these organisations. Companies were advised not to anticipate a work of art to be produced but to see the insertion of a creative outsider into the midst of the organisation (an 'Incidental Person', to use APG terminology). Framing the artist in this way broke the traditional view of an artist as simply either a sculptor or painter and provided the artist with agency to respond in a variety of manners that incorporated new approaches to what an artist might produce.

In *Artificial Hells: Participatory Art and the Politics of Spectatorship*, Claire Bishops (2012, p. 2) suggests:

> the (APG) artist is conceived less as an individual producer of discrete objects than as a collaborator and producer of situations; the work of art as a finite, portable, commodifiable product is reconceived as an ongoing or long-term project with an unclear beginning and end; while the audience, previously conceived as a 'viewer' or 'beholder', is now repositioned as a co-producer or participant.

Alongside the Incidental Person was the idea of the 'Open Brief' where the host organisation would accept at the outset that no pre-planned or pre-conceived outcome would be expected and that both parties would accept whatever might be an outcome of the residency. Working with no recognised or agreed brief between both parties must have been both frightening and exciting. This aspect alone demanded a great deal of faith in the chosen artists from the host organisation and a huge responsibility placed on the artist to respond to the situation and context that they encountered. I would argue that this combination of registers created by APG would have invested each artist with a strong desire and sense of being in a heightened mind-state of preparedness as well as being on the lookout for the unanticipated or unfamiliar, armed with the freedom to respond to the unpredictable in creative and untested ways.

APG broke the traditional and long-established relationship of patronage. They sought to create a position where the artist was a valued

member of the workforce involved in the day-to-day work of the organisation but also separate enough in order to create a critical distance to see activities in new light. The work of Ian Breakwell (1943–2005) at Broadmoor Special Hospital is worthy of note and is often recognised as being one of the best-known projects. Breakwell kept a diary of his placement at Rampton hospital in 1976 where he would work alongside a group of specialists to initiate minor reforms within the healthcare system. Breakwell's diary which included patients' views, was used in a report which angered management and was eventually restricted under the Official Secrets Acts (Breakwell, 2004, 2005). It seems very doubtful that Breakwell could have foreseen how he would respond to the situation he found himself in at the hospital or how his response would have gathered momentum. His diary also contained images of the squalid conditions at Rampton which was also used in a documentary by Yorkshire Television (*The Secret Hospital*, 1979) which in turn contributed to media coverage, public outcry and eventually led to a government enquiry. Ian Breakwell viewed his first APG placement at the DHSS as a success but is on record as saying that he felt the second placement at Broadmoor and referring particularly to 'the end result was "failure"'. Within the context of art, deciding what is a failure or not is a difficult task. What might appear as a failure at one point can easily become a success at a later date. As the curator and writer Lisa Le Feuvre suggests,

> The inevitable gap between the intention and realization of an artwork makes failure impossible to avoid. This very condition of art-making makes failure central to the complexities of artistic practice and its resonance with the surrounding world. Through failure one has the potential to stumble on the unexpected – a strategy also, of course, used to different ends in the practice of scientists or business entrepreneurs. (Le Feuvre, 2010, p. 12)

The Parisian Salon des Refusés of 1863 was an exhibition of failures. The Salon was the ultimate authority that validated artists of the modernist period. The Academicians rejected around 3,000 works that year that they felt were failures, including works by Whistler and Manet. An

alternative exhibition was hastily set up to run alongside the official exhibition to include the failures. The alternative exhibition became a huge success attracting bigger audiences and many of the successful artists were desperate to be part of the exhibition of failures as the failed art was deemed more exciting and current.

Failing and failure alongside error and mistakes are outcomes most would want to avoid, instead favouring success and achievement as desired outcomes (see Lock & Sikk, March & Vallée-Tourangeau, this volume). In a gallery talk at The Common Guild in Glasgow, critic and curator Caoimhin Mac Giolla Leith introduced a relatively recent concept, that of 'Disappointment Avoidance Cultures' for the consideration of many contemporary art practices' chosen approach to thinking about practice. Developed by the psycholoanalyst, Ian Craib in his 1994 book '*The Importance of Disappointment*', this appears to be inspired by Disappointment Theory, developed by the economists David E. Bell (Bell, 1982, pp. 961–981).

Bell suggests that the feeling of dissatisfaction following failure of expectations is an important factor in decision making. The feeling of disappointment is similar to the feeling of regret and is often considered the same emotion but in fact is quite different. Someone feeling regret focuses on their poor choice that contributed to the unwanted outcome whereas someone feeling disappointed at their failure focuses on the outcome itself. "Disappointment is created by comparing the actual outcome with prior expectations. It is related to the sense of loss or gain incurred by resolution of a chosen alternative" (Bell, 1985, p. 117).

According to Wilco W. van Dijk and Marcel Zeelenberg, regret and disappointment following failure are the two emotions that are most closely linked to decision making (Dijk & Zeelenberg, 2002). Avoiding failure is often at the heart of many major decisions as there is usually an element of uncertainty and unpredictability present. To fail in business, commerce or industry could be said to have a negative status and undesirable implications. However, within the realm of art and the humanities, failure would appear to have a different register altogether.

The work of APG artists and their legacy of projects and archives has arguably paved the way for subsequent generations to embrace ideas surrounding the open brief that doesn't require a fixed or agreed

outcome but encourages artists to be on the outlook for the unantici-
pated. This pioneering work can also be argued to support the growth
of the expanded field of post-studio practices that captures much of
contemporary art practices today.

I believe there to be intriguing relations and connections between
failing and serendipity discoveries. A failure often makes way and
provides creative space for serendipitous discoveries to emerge and be
recognised without which the unanticipated and the unsought might
not have the space to come into view. In '*The Art of Failure*' a group
exhibition catalogue from 2009 at Kusthaus, Baselland the art critic
Hans-Joachim Müller ruminates on the nature of failure suggesting that:

> 'The Art of Failure' is nothing less than an artistic practice that assumes
> that failure is not merely an error. One could also describe it as a
> cultural technique, a manner of enlightened awareness that rehabilitates
> the aesthetic principal by the very act of freeing it from the duty of having
> to be an absolute principal at the same time. (Spinelli & Schaschi, 2009,
> p. 11)

Whilst referring to contemporary art practice, Müller's phrase 'enlight-
ened awareness' could easily be applied to the need to have a curious and
prepared mind in order to recognise serendipitous discoveries. Another
turn of phrase important to developing a contemporary understanding or
any consideration of serendipity within the realm of creativity would be
that of negative capability. In a letter dated, December 1817 (or possibly
1818, there has been much debate on the actual date) John Keats (1795–
1821), the English Romantic poet coined this phrase to best describe the
working method of great poets, writers and artists such as Shakespeare
that are content and happy to pursue a vision of beauty even when such
an enquiry leads them into intellectual confusion and uncertainty. Keats
compares and contrasts this method against other writers such as Samuel
Taylor Coleridge (1772–1834) who would shun negative capability for
the pursuit of reaching after fact and reason.

> I had not a dispute but a disquisition with Dilke, on various subjects;
> several things dovetailed in my mind, & at once it struck me, what quality

went to form a Man of Achievement especially in Literature & which Shakespeare posessed so enormously – I mean Negative Capability, that is when man is capable of being in uncertainties, Mysteries, doubts, without any irritable reaching after fact & reason – Coleridge, for instance, would let go by a fine isolated verisimilitude caught from the Penetralium of mystery, from being incapable of remaining content with half knowledge. This pursued through Volumes would perhaps take us no further than this, that with a great poet the sense of Beauty overcomes every other consideration, or rather obliterates all consideration. (Keats, 1899, p. 277)

Keats believed in the importance and need for freedom of the imagination to pursue artistic beauty. Li Ou, in her 2009 book, *Keats and Negative Capability* suggests that;

To be negatively capable is to be open to the actual vastness and complexity of experience, and one cannot possess this openness unless one can abandon the comfortable enclosure of doctrinaire knowledge, safely guarding the self's identity, for a more truthful view of the world which is necessarily more disturbing or even agonizing for the self. (Ou, 2009, p. 2)

Alongside Walpole's coinage of the word serendipity, I would argue that Keats has provided us with further insight into the necessary state of mind required to allow serendipity to flourish and be recognised. Keats is not using the word 'negative' in an uncomplimentary manner, but to suggest the potential and capacity, a deficit, of what a person doesn't know, to be of value. He suggests that a lack of knowledge or not knowing can lead to great creativity and should be embraced by the poet even if this leads to doubt, uncertainty or a pursuit of what seems mysterious (see also le Hunte, March & Vallée-Tourangeau, this volume). Must have seemed an anti-intellectual idea at the time of post-Enlightenment which encouraged the pursuit of rational thinking and scientific debate. An understanding of serendipity and negative capability in connection to the pursuit of knowledge is succinctly described by Jacques Rancière (1991, p. 33) in *The Ignorant School Master*:

> Whoever looks always finds. He doesn't necessarily find what he was looking for, and even less what he was supposed to find, but he finds something new to relate to the thing that he already knows. (Rancière, 1991, p. 33)

The acquisition of knowledge is at the heart of the fascination with serendipity from both the sciences and the creative industries. With so many scientific, technological and pharmaceutical breakthroughs that can trace a lineage back to an unanticipated or accidental discovery, one can understand the desire to be able to replicate the circumstances that could lead to the next big breakthrough. The American cultural theorist, landscape designer, architectural historian and co-founder of the Maggie's Cancer Care Centres, Charles Jenks, (1939–2019) declared in his 1972 book, *Adhocism*, that;

> If some cultural psychologist and management are to be believed, an important additional aid to creativity is serendipity: the aptitude for making fortunate discoveries accidentally. Like being accident prone, being serendipity prone seems a state into which it is possible to will oneself unthinkingly. (Jenks & Silver, 1972, p. 131)

However, there has always been a significant distinction lurking in the background that separates the creative industries and the sciences and that is expressed by Merton and Barber (2004, p. 58),

> For scientists, an accidental discovery is only the initial step, stimulating them to seek explanation for the unexpected or anomalous finding. Nothing intrinsic to science is ultimately accepted as accidental, and insofar as serendipity contributed to scientific advance, it came to be seen as an integral mechanism in the process of research. Both the experience of accidental discovery (serendipity) and the fruits of accidental discovery had to be brought within the orbit of rationality.

This is where serendipity and negative capability share commonality in the need to have an open mind, agile enough to change course and become receptive to new and unanticipated data (see Copeland, this volume). It is also at this point of conversion that the role of the artist is

beginning to be acknowledged as artist and academic Rebecca Fortnum along with curator Elizabeth Fisher have articulated in their 2013 book, *Not Knowing How Artists Think*. Forntum suggests that "artists enjoy the challenge of potential, and the pleasure of surprising themselves and so create spaces for not knowing, both physical and intellectual" (Fortnum & Fisher, 2013, p. 77). This position is further supported by the writer of short stories and educationalist, Donald Barthelme in his famous 1987 essay where he makes a case for the importance of not knowing as not knowing provides creative space to be 'serendipity prone', to borrow Jencks's helpful phrase. Barthelme argues that:

> The not-knowing is crucial to art, is what permits art to be made. Without the scanning process engendered by not-knowing, without the possibility of having the mind to move in unanticipated directions, there would be no invention. (Barthelme & Herzinger, 1997, p. 12)

In 1939 the American educationalist Abraham Flexner (1866–1959), the founding director of the Institute for Advanced Study in Princeton and the man that is credited for bringing Albert Einstein to the United States wrote a short essay called, *The Usefulness of Useless Knowledge* which first appeared in Harper magazine. In 2017, the above essay was published with a companion essay by Robert Dijkgraaf the Institute's director at the time. Flexner built the Institute as a 'paradise for scholars' on the principle of no students or administrative duties for its academics allowing them to practise the 'unobstructed pursuit of useless knowledge' (Flexner & Dijkgraaf, 2017, p. 5). Flexner makes the case for research in Higher Education to follow unobstructed curiosity-driven research which is often at odds with the current and prevailing outcome-driven approach to research funding. Flexner argued tirelessly against predictable goal-driven research structures and favoured goals that were increasingly directed towards applied or practical outcomes, with the intent of creating products of immediate value. Robert Dijkgraaf attempts to continue Flexner's philosophy and suggests that,

> It was Flexner's lifelong conviction that human curiosity, with the help of serendipity, was the only force strong enough to break through the mental

walls that block truly transformative ideas and technologies. He believed that only with the benefit of hindsight could the long arcs of knowledge be discerned, often starting with unfettered inquiry and ending in practical applications. (Flexner & Dijkgraaf, 2017, pp. 16–17)

I'd like to bring this chapter towards closure by returning to the art practice of Adam Chodzko and to consider a particular body of work, *The God Look-Alike Contest* (1991–1992) where he placed a number of advertisements in *Loot,* a classified advertisements newspaper, which requested "… artist seeks people who think that they look like God…". Loot functioned as a pre-internet precursor to Ebay where anyone could place ads to sell unwanted items or to search for objects, services and like-minded people. Chodzko would publish advertisments for impossible items that dealt with some aspect of failure or unrealised broken projects such as a "Millenarian heterogenous apparition, 3 m long with a slight defect, unstructured model, reasonable condition, £75 ono". Speaking of his own work Chodzko reveals the thinking behind this work as (Fig. 4);

> Basically, it was describing nothing. The idea was to put art objects out into public spaces as descriptions, or possibilities, to be encountered accidentally in the course of searching for something else – a coffee table, a car, a book, etc. Instead of them being spectacular, they were just small but very odd signals that you would stumble across. (Carson & Silver, 2000, p. 32)

Chodzko's projects and approach to practice highlight the confidence and uncertainty of contemporary artist's ability to balance the known and the unknowns of a project that allows for the unanticipated to occur and they are there waiting and prepared to pounce. The academic and writer Terry Diffey, explains the lack of an available predictive model for artistic endeavour is, "to create, is to engage in undertakings the outcome of which cannot be known or defined or predicted, though there may be some presentiment of the outcome" (Diffey, 2004, Vol 3 No 2:95).

I believe Diffey is getting at the trust, the blind faith contemporary artists have in their ability to recognise the unanticipated, the unsought nugget of gold that serendipitously appears in the most unfamiliar of forms, times or place. Where does this ability come from? Is it taught

Fig. 4 Adam Chodzko, *The God Look-Alike Contest* (1991–1992) Black & white photographs, colour photographs, colour photocopy, ink on paper drawing and page from the *Loot* newspaper; each in artist's frame, in thirteen parts. External dimensions of each: 22.1/2 × 17.1/2in. (57 × 44.5 cm)

through an art school where an open and questioning education system combines curiosity with a place where encouraging 'creative-risk-taking' is nurtured and highly valued. Or is it learnt by studying in depth artists and art movements, their philosophies and manifestos like APG that have preceded us. Or is it simply fortune that favours the prepared mind? This is also an approach recalled by Brian Eno of his days at Ipswich School of Art when Roy Ascott gave a talk at the school. Eno recalls the idea that, "an artist didn't finish a work but started it". You design the beginning of something, and the process of realising the work is the process of planting it in the culture and seeing what happens to it (Eno & Obrist, 2003, pp. 214–219).

I'd like to end this chapter by considering *A Firework for W.G. Sebald (2005–2006)* by visual artist, writer and academic Jeremy Millar (1970–). Millar takes for his starting point the image and story of the Lowestoft lighthouse which features predominantly in W. G. Sebald's 1998 book, *The Rings of Saturn* and in the 1988 film, *Drowning by Numbers* by

Fig. 5 Jeremy Millar, *A Firework for W.G Sebald (2005)* Installation View, four framed colour photographs, 40 × 50cm, silkscreened text upon wall, CCA, Glasgow, March 2011

English film director Peter Greenaway. Millar focuses on the character Smut from Greenaway's film who is fascinated with death and sets off fireworks in a macabre ritual every time he encounters a death—human or animal—in order to celebrate their life. Millar borrows this ritual and applies it to the spot on the A146 in Farmington Pigot where W. G. Sebald was involved in a fatal car crash. Millar sets off four fireworks and takes four photographs of the plume of smoke left behind as a record of both ritual and memorial, which takes the form of a pilgrimage to the place of Sebald's death. Later on, when Millar is studying the photographic evidence he notices that the fourth and final image of the plume of smoke bears a striking resemblance to the distinctive feature of Sebald with his bushy moustache. Millar decides to present the four photographs in sequence with an explanatory text (Fig. 5).

The reason for citing Millar's work is that it illustrates a number of reasons why artists are attracted to the unanticipated, the unplanned and are quick to recognise fortuitous moments as significant and can exercise a degree of sagacity to capture these unscripted events (see Copeland, this volume). It is possible to imagine Millar initially setting off on a pilgrimage to the accident spot on the A146 to pay his respects to

Fig. 6 Jeremy Millar, *A Firework for W.G Sebald (2005)*, Forth and final photograph in series

the writer when he stumbles across—we could say serendiptiously—an image or a result of an action that he could not have planned or anticipated. Millar's assertion of seeing the features of Sebald in the smoke plume is another aspect worth noting. Millar's imagining of the ghostly presence of the spectre of Sebald conjures up the notion of the hauntology of space as posited by Jacques Derrida. 'To haunt does not mean to be present, and it is necessary to introduce haunting into the very construction of a concept' (Derrida, 1994, p. 202). Mark Fisher (2014, pp. 17–18), further expands this idea where he suggests;

> Hauntology was the successor to previous concepts of Derrida's such as the trace and différence; like those earlier terms, it referred to the way in which nothing enjoys a purely positive existence. Everything that exists is possible on the basis of a whole series of absences, which precede and surround it, allowing it to possess such consistency and intelligibility that it does.

I feel that this passage below, by Sebald from his book *Austerlitz* (2001, p. 261), could be seen as an apposite reply to Millar's haunting image taken at the place of Sebald's fatal car crash (Figs. 6 and 7).

Fig. 7 Screen grab, Grant Gee, *Patience (After Sebald)* A walk through the Rings of Saturn (2012)

> ...if time did not exist at all, only various spaces interlocking according to the rules of a higher form of stereometry, between which the living and the dead can move back and forth as they like, and the longer I think about it the more it seems to me that we who are still alive are unreal in the eyes of the dead, that only occasionally, in certain lights and atmospheric conditions, do we appear in their field of vision.

In conclusion, I have explored the contribution and importance that serendipity occupies within contemporary art practice. By thinking through Keats's notion of negative capabilities in relation to creating and protecting a creative space that allows for the unanticipated I have argued that the contemporary artist operating outside of the traditional studio and gallery space are comfortable with unknown unknowns. I have suggested embracing the unforeseen and accidents is closely related to the ability to respond positively to failure of intention and is an important skill artists develop and nurture. By considering the importance of the Artist Placement Group by preparing the ground for a younger generation of artists to adopt and develop the idea of the 'open brief' and who helped to establish a creative environment for what Flexner argued

for, the need to provide a space for curiosity and serendipity to create the ideal incubation space for new knowledge to emerge. I would like to thank both Adam Chodzko and Jeremy Millar for allowing me to cite examples of their practice that I believe embrace serendipity in the very fabric of their work and suggest the pleasure in collaborating with serendipity.

References

Barthelme, D., & Herzinger, K. (1997). *Not-knowing: The essays and interviews of Donald Barthelme*. Random House.

Bell, D. E. (1982). Regret in decision making under uncertainty. *Operations Research, 30*(5), 961–981.

Bell, D. E. (1985). Putting a premium on regret. *Management Science, 31*(1). http://www.jstor.org/stable/2631680. Last Accessed 21 December 2020.

Beveridge, W. I. B. (1957). *The art of scientific investigation*. W. W. Norton.

Bishop, C. (2012). *Artificial hells: Participatory art and the politics of spectatorship*. Verso.

Breakwell. (2004/2005, December/January). *They thought it would be interesting for me to look at the abnormal society, the closed world of Broadmoor, as a diarist. So, there's an obvious connection there. Whereas I don't know what I would possibly have found of interest in British Steel, for instance. This was about illness, mental states, people, and they are central to my works. I'm not interested so much inmaterials* (Breakwell, interviewed by Victoria Worsley, National Sound Archive, British Library, Tape 16910, side A).

Carson, J., & Silver, S. (2000). *Out of the bubble: Approaches to conceptual practices*. The London Institute and Central Saint Martins College of Art and Design.

Darbellay, F. et al. (2014). Interdisciplinary research boosted by serendipit. *Creativity Research Journal, 26*(1), 1–10.

Derrida, J. (1994). *Spectres of Marxs: The state of the debt, the work of mourning and a new international*. Routledge.

Diffey, T. J. (2004). On steering clear of creativity. *Journal of Visual Art Practice, 3*(2), 95.

Dijk, W. W., & Marcel Zeelenberg, M. (2002). Investigating the appraisal patterns of regret and disappointment. *Motivation and Emotion, 26*(4), 321–331.

Eno, B., & Obrist, H. U. (2003). Extract from interview in *Hans Ulrich Obrist, Interviews* (Vol. 1). Foundaxione Pitti Immagine Discovery.

Fisher, M. (2014). *Ghosts of my life: Writing on depression*. Zero Books.

Flexner, A., & Dijkgraaf, R. (2017). *The usefulness of useless knowledge*. Princeton University Press.

Fortnum, R. et al. (2008). *Space For 10, residency catalogue*. The Art House.

Fortnum, R., & Fisher, E. (2013). *On not knowing how artists think*. Blackdog Publishing.

Ginsborg, M. (2004). *London, The Showroom Gallery*. http://www.visualintell igences.com/michael-ginsborg.html. Last Accessed 5 March 2020.

Jenks, C., & Silver, N. (1972). *Adhocism: The case for improvisation*. Secker and Warburg.

Keats, J. (1899). *The complete poetical works and letters of John Keats, Cambridge Edition*. Mifflin and Company.

Le Feuvre, L. (2010). *Failure, documents in contemporary art*. Whitechapel Gallery and The MIT Press.

Liestman, D. (1992). Chance in the midst of design: Approaches to library research serendipity. *RQ 31*(4).

Mason, C. (2018). https://www.studiointernational.com/index.php/cybernetic-serendipity-history-and-lasting-legacy. Last Accessed 9 November 2020.

Merton, R. K. (1968). *The sociology of science*. The University of Chicago Press.

Merton, R. K., & Barber, E. (2004). *The travels and adventures of serendipity: A study in sociological semantics and the sociology of science*. Princeton University Press.

Ou, L. (2009). *Keats and negative capability*. Bloomsbury Publishing.

Ranciere, J. (1991). *The ignorant schoolmaster, five lessons in intellectual emancipation*. Stanford University Press.

Reichardt, J. (1968). http://www.medienkunstnetz.de/exhibitions/serendipity/. Last Accessed 9 November 2020.

Schmit, E. (2011, May 13). In a lecture titled *'The Digital Future'* at the American Academy in Wannsee in Berlin. https://suitesculturelles.wordpr ess.com/2011/05/14/google-building-the-digital-future/. Last Accessed 23 May 2021.

Sebald, W. G. (2001) *Austerlitz*. Penquin Books.

Spinelli, C., & Schaschi, S. (2009) *The art of failure*. KunstHaus Baselleand.

Walker, J. A. (2002). *Left shift: Radical art in 1970's Britain*. I.B.Tauris.

Problem Solving, Incubation and Serendipity

Ken Gilhooly

Serendipity and incubation are events and states that can aid problem solving when straightforward conscious search processes have not worked. In this chapter I will be exploring possible connections between incubation and serendipity. First, I will discuss how we might define and characterise problems and problem solving; then I will consider incubation and serendipity (separately and together). Finally, I will discuss suggested mechanisms by which external and internal serendipitous events may bring incubation periods to successful conclusions.

K. Gilhooly (✉)
University of Hertfordshire, Hatfield, UK
e-mail: k.j.gilhooly@herts.ac.uk

W. Ross and S. Copeland (eds.), *The Art of Serendipity*,
Palgrave Studies in Creativity and Culture,
https://doi.org/10.1007/978-3-030-84478-3_11

267

Problem Solving

Karl Duncker (1945) proposed a widely accepted definition of a *problem* as a situation in which a person has a *goal* but does not know how to reach that goal, and so search becomes necessary to find a solution. All problems have three main elements—a starting state, a goal state and a set of possible actions or means to move from the starting state to the goal state. Within this very general characterisation, problems come in many guises and can be classified in various ways. One classification is into those in which all the elements of the problem, the starting situation or state, the goal state to be reached and the means available for moving from the starting state to the goal are *well-defined* as against problems where some or all elements are *ill-defined* (Lynch et al., 2006; Reitman, 1964; Simon, 1973). A chess problem is a prototypical example of a well-defined problem, in which the starting state is given, the goal is well defined (say, checkmate for white in 3 moves) and the means available are specified by the legal moves in the game. On the other hand, a problem may be very ill-defined, such as that of "improving the quality of life", in which the starting state, the goal state and the means available are not well-defined.

Another way of dividing problems is into those that can be solved by routine search processes without any need to re-interpret the problem statement and those which require re-interpretation or "re-structuring". An example of a problem that could be solved by routine search is an anagram; by searching possible re-arrangements of the letters, "ccpteno", one could find the scrambled word, "concept". Some problems, however, do generally require most participants to engage in re-interpretation or re-structuring. For example, "How could a man marry 30 women in one month and break no laws against bigamy"? Most participants find this puzzling—because the word "marry" must be re-interpreted from its dominant interpretation of "becoming married" to an interpretation as "causing others to become married". Thus, the solution is that the man is authorised to conduct marriages. Another example is "How could someone walk over the surface of a deep mile wide lake without any floatation devices or aids"? This problem requires the solver to move from a default representation (at least in non-arctic regions) of the water

in the lake as being in its liquid state and to represent the water in its solid frozen state. Such problems, which require re-structuring or re-interpretation, are often labelled "*insight*" problems.

Some problems, particularly those generally referred to as "*creative problems*", require the production of new approaches and many possible new solutions, before an acceptable solution is found. "New" solutions and approaches are taken as those novel to the solver and may or may not be historically novel (Boden, 2004; see also Simonton, this volume). Independent thinkers who solve the same problem can all be said to have been personally creative on reaching the solution, although only the first to solve would have been historically creative.

Incubation

In the case of creative and insight problem solving it has frequently been argued that stopping conscious work on such problems for a period of time (known as an "*incubation*" period) can help in the production of novel solutions. Often in real life, incubation follows an *impasse* in which the person cannot generate new ways of searching or re-structuring, *i.e.*, is "stuck" or "stumped" (Bar-Hillel, 2020).

Incubation While Awake

We can divide research efforts on incubation into those concerning *waking incubation* and those concerning possible *sleeping incubation*. The waking case may be further divided into episodes in which the main problem is set aside while other tasks are consciously addressed ("*distraction*") and into episodes in which no particular task is focussed on ("*relaxation*" or "*daydreaming*" or "*mind-wandering*").

There are two broad ways in which incubation may assist in solving. First, solution ideas might come to mind, spontaneously, while not focusing on the problem ("*inspiration*"); or, second, solutions may occur very quickly, when the previously unsolved problem is returned to and attended to again ("*facilitation*").

Early studies drew heavily on personal accounts by outstanding scientists and artists (see Simonton, this volume). The typical situation in personal accounts was one of *Delayed Incubation*, where the target problem was worked on consciously for a period (Preparation) and then set aside (Incubation), often following an *impasse* when no more progress seemed possible. More recently, a number of laboratory studies have explored *Immediate Incubation* in which the target task is set aside immediately after it is introduced and then returned to after a distraction period.

Using personal accounts, by themselves and by others, Henri Poincaré (1910) and Graham Wallas (1926) presented very influential and mutually consistent analyses of creative thinking, in which Incubation was a key stage. It is striking that around 100 years on, their work is still highly cited and closely analysed for insights which may have been overlooked (Amabile, 2019; Corazza & Lubert, 2019; Sadler-Smith, 2015). However, these early analyses were based on retrospective self-reports often given many years after the creative problem-solving events. Doubts about the reliability and validity of such long-delayed subjective reports led many researchers to doubt the reality of incubation effects. This scepticism regarding incubation was reinforced by early failures to demonstrate experimentally the reality of incubation. However, an accumulation of supportive empirical studies has now largely resolved these doubts. From a meta-analysis (Sio & Ormerod, 2009) of over 100 studies, and a narrative review (Dodds et al., 2012), as well as from recent empirical studies (e.g., Gilhooly, Georgiou, et al., 2013; Gilhooly, Georgiou, Garrison, et al., 2012; Gilhooly, Georgiou, Sirota, et al., 2015), there is evidence that incubation periods, whether they are Delayed or Immediate, are indeed helpful, particularly for creative, divergent problems. Over a range of insight and divergent tasks, Sio and Ormerod (2009) found an overall significant average effect size of incubation in the low-medium band ($d = 0.29$). In addition, Dodds et al. (2012) found that 75% of the 36 studies in their narrative review reported significant benefits for incubation. Thus, the question has become, not *whether* incubation effects exist, but *how* such effects come about.

Three main alternatives for how incubation might be beneficial have been proposed. The first, "sceptical" view is that of Intermittent Conscious Work, according to which participants go against their instructions and return consciously to the target task during the incubation period and so gain extra time on the main task relative to controls. The second view is that there is an essentially passive process of forgetting or decay of misleading sets during the incubation period, permitting a Fresh Start when the task is resumed after the break. The third more active view is that of Unconscious Task Related Processing (sometimes labelled "Unconscious Work" e.g., Poincaré (1910), or "Unconscious Thought" e.g., Dijksterhuis and Nordgren (2006)—but here I will use the more neutral term "task related processing" rather than the words "thought" or "work" that carry overtones of deliberate conscious activity). On this view, Unconscious Task Related Processing, such as *spreading activation*, changes the person's representation of the task and possibly generates useful connections and associations. Such processing may then lead to Inspiration interrupting the conscious flow of thought, whether that conscious flow is dealing with a distracting task or is daydreaming; alternatively, unconscious processing during incubation may help on resumption of the task (i.e., lead to Facilitation). The three broad options of Intermittent Conscious Work, Fresh Start or Unconscious Task Related Processing are not actually mutually exclusive and all could occur and contribute to real life episodes of incubation. However, in the laboratory, the aim has usually been to examine the viability each possible explanation as separately as possible.

From the laboratory research (Dijksterhuis & Meurs, 2006; Gilhooly, 2016; Gilhooly, Georgiou, et al., 2012) evidence has been found which supports a role for Unconscious Task Related Processing. This has been shown by the effectiveness of the Immediate Incubation paradigm, in which the target task is set aside immediately for an incubation period, after instructions have been given. In this Immediate Incubation paradigm, sets were unlikely to have been developed and so the Fresh Start hypothesis would not apply. In addition, Gilhooly, Georgiou, et al. (2012) found no support for the Intermittent Work hypothesis, from studies in which suitable control conditions were included. Unconscious

Task Related Processing then remained as the best candidate explanation for the effects of Immediate Incubation periods. In a comparison of Immediate v. Delayed Incubation, Gilhooly, Georgiou, et al. (2012) found that Delayed Incubation was also beneficial but less so than Immediate Incubation in a divergent thinking task (viz., Alternative Uses). It was suggested that in Delayed Incubation, sets could build up during the initial period of conscious work, and were then reduced by forgetting, after which beneficial Unconscious Task Related Processing and Fresh Starts could come into play. In contrast, with Immediate Incubation, there were no sets to be overcome and beneficial Unconscious Task Related Processing could start sooner than in the Delayed paradigm, so leading to better performance than with Delayed incubation. As further support for the Unconscious Task Related Processing view it was noted that "doing something different" during an incubation period was beneficial. This finding (Gilhooly, Georgiou, et al., 2012) is most consistent with the Unconscious Task Related Processing explanation for incubation effects as compared with Fresh Start.

When participants were given opportunity to mind-wander during incubation by use of a low-demand distraction task it seemed that unconscious processes were facilitated, which benefitted the divergent Alternative Uses task on return to that task (Baird et al., 2012). This result supports the idea that incubation in the form of mind-wandering can be beneficial. The content of the mind wandering during incubation was not itself relevant to the target task; it seems that the benefit arose from unconscious activity during the mind-wandering period (see Le Hunte, March & Vallée-Tourangeau, this volume) for a description of this process from a first person perspective).

Incubation While Asleep

Moving now to sleeping incubation, if you are at an impasse in tackling a problem, is it actually helpful to sleep on it? In real life, sleep will intervene in any problem solving that is not completed within the waking day and so it is of interest to know if sleep has a role in tackling difficult problems that cannot be dealt with in one waking day.

Of course, the everyday word "sleep" covers a complex mix of states and stages that may differ in their effects on problem solving. Sleep is bookended by a *hypnagogic* stage of moving from wakefulness to sleep and a *hypnopompic* stage of moving from sleep to wakefulness. The main division of sleep itself is into *rapid eye movement* (REM) sleep and non-REM sleep which occur and recur throughout the whole sleep period. If awakened during REM periods, dreaming is nearly always reported. Dream reports are less frequent and less vivid when people are awoken from non-REM sleep.

There is experimental evidence that sleeping on problems is beneficial. Gilhooly (2019, Ch. 6) reviewed 10 studies of effects of sleep on solving problems begun before sleep onset and returned to on waking. Overall 8 out of the 10 studies found significant benefits for a period of sleep incubation but with small to medium-sized effects (weighted average effect size, $d = + 0.40$).

Why might sleep incubation be beneficial? Possible cognitive processes during sleep, whether conscious, as in dreams (during REM), or at an unconscious level, as in consolidation (during non-REM), seem to offer plausible mechanisms for wide ranging automatic searching through unusual associations in dreams which could link to current goal representations and so signal solution possibilities. Even if solutions are not actually reached during sleep, the automatically derived changes in activation patterns and connections brought about by memory consolidation during sleep could leave a useful residue of new directions to guide conscious search on waking.

As noted earlier, any real life problem that takes more than sixteen hours to solve is likely to involve *both* periods of *waking* and *sleeping* *incubation*. Commonly, sleeping will follow waking periods of conscious work and waking incubation, probably on a number of distinct problems that have arisen during the day. Cognitive processes during sleep, although with conscious aspects, in that we are aware of dreams while they are happening, appear to be more "wild ranging" and generate more unusual associations and re-combinations than those produced by waking incubation. This wider search through the conceptual space of what can be imagined (e.g., in a dream it may rain gold coins that turn out to be edible and give you the powers to fly) may occasionally yield

clues or even answers to daytime problems. Thus, sleep incubation may complement waking incubation by producing more unusual possibilities. However, the highly unusual possibilities presented by dreams do not generally become consolidated into long lasting memories unless the possibilities are still active on wakening and recognised as potentially useful at the hypnopompic stage, as may have happened in Loewi's very useful dream of an experiment to test the chemical hypothesis of neural transmission (Loewi, 1960). In fact, Loewi reported that he had the dream twice. First occasion, he awoke in the night, jotted the idea down and fell asleep; but when he awoke at 6 a.m., he had forgotten the details and could not read his scrawled note. The next night at 3 a.m. the dream returned. This time he reports that he got up immediately and performed the simple experiment on the frog hearts according to "the nocturnal design" as he called it. The design involved placing two surgically removed, but still beating, frog hearts in saline solutions, in separate glass vessels. One heart was stimulated via its vagus nerve to slow its beating and some of the saline solution that had surrounded the stimulated heart was added to the solution around the second heart—which then slowed down, indicating that a chemical was involved in communication between neurons.

Serendipity

In Horace Walpole's original coinage of the term in 1754, "Serendipity" was said to involve discovery of things *that were not being looked for* by "*accidents* and *sagacity*" (Van Andel, 1994). On this view, accident or chance generates events but "sagacity" or "knowledge" is needed to recognise the interest value of the chance event. However, Walpole's stricture that "no discovery of a thing you are looking for" comes under the description "serendipity" is over-restrictive, as argued by Merton and Barber (2004) and Yaqub (2018). Although such "Walpolian" serendipity has been important in the history of science, e.g., Jocelyn Bell stumbling across regular pulsing signals from space leading to the identification of

pulsars, for present purposes my focus will be on "Mertonian" serendipity as proposed by Yaqub (2018). In this view, "Mertonian" serendipity is an important form of serendipity which arises when the serendipitous individual does have a goal being looked for, and solution or discovery is aided by an accidental event (see also Ross, this volume). This "Mertonian" form of serendipity is relevant to incubation as incubation involves a goal (i.e., something sought or looked for) but one that has been set aside; the "Walpolian" form of serendipity does not involve a pre-set goal and so cannot involve incubation which requires a goal and so the topics of "Walpolian" serendipity and incubation have no obvious connection with one another. Henceforth, in this chapter then, I will be focussing on "Mertonian" serendipity, where a targeted search is ended by an accidental discovery. The classic example of this type of serendipity is that of Alexander Fleming and penicillin. In 1928, Fleming noticed that an accidental mould killed staphylococcus bacteria in a Petri dish which had been left unattended during a holiday period in an empty laboratory. This unexpected chance event was relevant to one of his current goals and pointed to a solution to a particular problem which he had been working on for a while (viz., to find a treatment for staphylococcal infections). In another example, after a decade of search in 1837, Goodyear found a way (vulcanisation) to make rubber thermostable when he accidentally allowed a mixture of sulphur and rubber to touch a hot stove (Yaqub, 2018).

In these and other cases of serendipity, the precipitating event did not arise as part of a deliberate search process, but rather was due to uncontrolled chance; however, it was noticed and interpreted as being of interest by a "prepared mind". In the cases described, Goodyear and Fleming were knowledgeable and active investigators in their fields and so noticed and recognised the significance of unusual events that less prepared observers would likely either not have noticed or not seen as being of any interest. As Pasteur (1854) put it "…in the sciences of observation, chance favours only prepared minds" (This translation, from Pasteur's original French manuscript, is by van Andel (1994, p. 635).

Connecting Incubation and Serendipity

How might serendipitous accidental events affect the course of incubation? In these sections I will discuss possible roles of both external (exogenous) events and internal (endogenous) events in bringing incubation periods to a satisfactory conclusion.

Exogenous (External) Events

Before looking at incubation, when a problem is set aside, it is of interest that when someone is working consciously on a problem, chance external events can prompt solutions. For example, in an early study by Maier (1931), participants attempted the two-string problem in which two strings hanging from the ceiling were to be grasped simultaneously but were too far apart for this to be done easily. The solution involved using a pair of pliers as a weight so that one of the strings could be swung as in a pendulum. In one manipulation, the experimenter appeared to accidentally brush past one of the strings and set it swinging. This subtle cue led a substantial proportion of participants to solve compared to controls. Interestingly, many of the successful solvers following the external cue reported that they were unaware of the cue (although see Glăveanu, Ross, this volume). This indicates that a serendipitous event need not be consciously noticed although it must receive some degree of attention, albeit unconscious, in order to affect processing of the problem.

In the case of incubation, how might external events affect processing when a problem is set aside? Seifert et al. (1995) and Yaniv and Meyer (1987) proposed an *Opportunistic-Assimilation* model that could account for effects of accidental events during incubation. According to this model, when a problem is set aside because it has not been solved and an impasse has been reached, a persisting "failure index" is set in long-term memory which describes the type of information needed to solve the problem. If the required type of information is encountered in the environment during the incubation period, the solution may be activated and an illuminating insight experience result, or less dramatically, solution

may be facilitated on returning to the problem, as relevant information has become active in long-term memory.

A real life example of external events influencing incubation is given by the invention of a method for dealing with problems regarding the Hubble space telescope. In this case, a need arose to install an array of small correcting mirrors onto the existing satellite telescope which was already in space. A way was needed to adjust the exact positions of the mirrors so that optimal corrections would result and give the sharpest images possible. At the end of a fruitless day's meeting, held in Europe, to discuss the problem, Jim Crocker, a US engineer, went to shower in his hotel and encountered European shower controls which were different from those of the typical US shower with which he was familiar. The European shower was much more flexible in that the height of the shower head could be adjusted as well as the angle and direction of the shower water flow. This kind of mechanism suggested to Crocker a solution to the problem of installing the small correcting mirrors by fixing them to highly flexible arms and this was the adopted solution (Zimmerman, 2010, pp. 150–151).

This and many other examples of Mertonian serendipity are consistent with the Opportunistic-Assimilation model in that chance events suggested solutions to incubated problems. The model has also received support from laboratory studies. For example, Seifert et al. (1995) reported two relevant studies on opportunistic assimilation both of which had similar designs. Participants first tackled general knowledge problems such as, "What is a nautical instrument used to measure the position of a ship"? (Answer—a sextant). Around 33% of questions could not be answered on the first presentation. In a second stage, participants carried out lexical decision tasks in which some of the words were answers to the questions in the first stage and to later questions presented in a third stage. The third stage was one day later and involved further general knowledge questions of which some were repeats from the first stage and some were new. As mentioned, some of the answers had been given to some of the old and new questions in the second stage. Thus, in the last stage, the independent factors of whether a question was old or new and whether the answer had been shown in stage 2

or not, were completely crossed in a factorial design. A significant inter-action was found, such that exposure to answers in stage 2 benefitted old questions repeated in stage 3 but exposure to answers in stage 2 did not benefit new questions in stage 3. Thus, the external inputs relevant to outstanding unsolved problems aided incubation, as Opportunistic Assimilation would predict, when the relevant "failure indices" had been set. This basic result was strongly replicated in a procedural variation in which the stage 1 and stage 2 trials were interleaved rather than carried out as separate phases.

The persistence of activation of "failure indices" or unachieved goals is also apparent in the phenomenon known as the *Zeigarnik* effect. Zeigarnik (1927) had participants undertake a large number of tasks including arithmetic problems, puzzles, construction tasks and so on. In half the tasks participants were interrupted before they had completed the tasks and were moved on to other tasks. When at the end of the task sequence, participants were asked to free recall all the tasks they had worked on, recall of the unfinished interrupted tasks was considerably higher than that for the completed tasks. For example, in one study, 26 out of 32 (80%) of participants showed this trend ($p = 0.008$). This result is again consistent with the Opportunistic Assimilation approach that posits lasting activation for unmet goals.

Seifert et al. (1995) proposed a key role for persisting subliminal acti-vation, to maintain Unconscious Task Related Processing on the target task during incubation, principally of the unmet goal during incuba-tion periods, following unsuccessful conscious work. During incubation, Seifert et al. suggest that incidental environmental cues related to the solution might activate the goal above threshold causing the solver to realise that an environmental cue indicates a solution.

The general idea of Opportunistic Assimilation has also been adopted in later models. For example, by Simonton (2010) in his *Blind Vari-ation and Selective Retention* (BVSR) approach to creativity; and also in a slightly different form in Gilhooly's (2019) *Goal + Associative Network Interaction* (GANI) model of incubation. The GANI model

(Gilhooly, 2016, 2019) proposes a mechanism for automatic inspiration by positive feedback loops of mutual activation between the initially subliminally activated goal and possible solution representations. The model is most applicable to relatively small scale, although knowledge rich problems, such as Alternative Uses tasks or small-scale insight problems as found in the Remote Associates Task and similar problems. It is consistent with facilitation of solving by external accidental inputs either by sudden insights during incubation or by facilitation on returning to the task following incubation.

Endogenous (Internal) Mental Events

We should note that an event during incubation that precipitates solution to a problem or leads to new research lines is not necessarily external but could be *internal*; that is, it could be an *endogenous* mental event, in the form of an unusual association of ideas, without a direct or obvious link to any external input. Such serendipitous unusual associations could result from unconscious processes of spreading activation, while one is *awake*; or may arise during *sleep*, while dreaming, or *following sleep*, in a hypnopompic stage, as a result of sleep related unconscious processes of memory re-organisation that facilitate new associations on awakening (see also Simonton, this volume).

An example of an important endogenous and serendipitous mental event was reported by Poincaré (1910) who recounts that he *set out* to prove the existence of a certain type of Fuchsian function but reached an *impasse* before the goal could be met, and then set the problem aside while undertaking military service. After a while, he reports, that "One day, going along the street, the solution of the difficulty which had stopped me suddenly appeared to me". In this case, a goal had been set aside and persisted over a long period of incubation, to be finally achieved by an unconscious endogenous mental event with no obvious external cue or stimulus.

How Might Problem Solutions Become Conscious Through Endogenous Mental Events?

Spreading activation accounts are suggested by a number of studies consistent with the notion that spreading activation, below conscious threshold level until the final stages, can lead to implicit effects and theoretically to insight solutions occurring through incubation (Dorfman et al., 1996). For example, participants can tell intuitively at above chance levels which Remote Associate Task (RAT)-like triads of words are solvable or "coherent" in that they have a common associate, without being able to give the actual solution. Thus, the three words "Playing, Credit, Report" are a coherent triad and are all associated with the solution "Card"; but, "Still, Pages, Music" are not a coherent triad as they have no common strong associate. Similarly, Bowers (1984, 1994) presented participants with "Dyads of Triads" (known as the DOT task) and intuitions about which Triads were coherent were accurate even when participants could not solve. Lexical decision tasks also showed priming of solutions to unsolved triads. Similarly, with the Accumulated Cues Task (ACT) in which people are shown 15 words, one at a time, which all have a common associate, when asked to generate guesses of the common associate as each word is shown, guesses become more closely associated with the answer (Bowers et al., 1990). Again, in Durso et al.'s (1994) study of insight problem solving, the participants' ratings of closeness of associations of task elements to solution elements increased over time, before solution was reached. (The problem was to explain the following: "A man walks into a bar and asks for a glass of water. The bartender points a shotgun at the man. The man says "Thank you" and walks out". The solution is that the man had hiccups and the shock of being threatened with a gun cured him!) As Durso et al. (1994, p. 98), put it, rather dramatically–

> Like dynamite, the insightful solution explodes on the solver's cognitive landscape with breathtaking suddenness, but if one looks closely, a long fuse warns of the impending organisation.

Dorfman et al. (1996) also point to work by Yaniv and Meyer (1987) using a Definition task in which participants are given cues to the definition of an uncommon word (e.g. "Large Bright Coloured Handkerchief; Brightly Coloured Square of Silk Material;…?; Solution – Bandana"). On unsolved words, definite priming effects were found for the solutions and the priming effect was maintained over short and long delays suggesting that such priming could be involved in extended incubation periods. Yaniv and Meyer proposed that during incubation problem solving, activation among relevant nodes in semantic memory spreads both (1) autonomously (*i.e.*, endogenously) without external inputs and (2) interactively in response to new external cues (as in the Opportunistic Assimilation approach), until solution relevant material is activated. Similar analyses have been proposed by Mandler (1994, 1995) and Gilhooly (2016, 2019) who have both suggested that during incubation, the solution goal, or demand, is in a continuing high (but subliminal) state of activation and that autonomous or interactive processes of spreading activation occasionally, accidentally and so, serendipitously, produce mental combinations that connect with the goal representation. These accounts are then consistent with the idea of autonomous spreading activation accidentally leading to solution combinations and to their above threshold activation without need for the kind of special sensibility filters proposed by Poincaré (1910) which were specific to mathematical elegance for mathematical problems or for poetic effectiveness in poetry problems and so on for different fields.

Semantic Network Modelling and Spreading Activation

The general idea, that knowledge is represented in associative networks over which activation can flow, has been developed in more detail by a number of researchers (Collins & Loftus, 1975; Gray et al., 2019; Kenett, 2018; Marupaka et al., 2012; Schilling, 2005). These researchers apply graph theory to model semantic memory as networks where concepts are represented by nodes that are interconnected more or less strongly. Schilling (2005) proposed the important idea that long-term

knowledge is represented by a particular form of associative or semantic network, known as a *small-world* network. In small-world networks, ideas or concepts are linked in clusters of tightly related ideas and links between clusters provide shortcut routes whereby apparently unrelated concepts can be reached from one another in a few steps along the network links between clusters. An analogy can be drawn with social networks and the finding that the average number of steps between random individuals in a large society is quite small typically about 6 steps (Dodds et al., 2003; Milgram, 1967; Travers & Milgram, 1969). As an example, in the small-world semantic network below (Fig. 1) it is only 4 steps from "Truck" to "Clouds".

Measures of individuals' associative networks, using word association responses, have found that people with higher network scores on measures of "small-worldness" (that is, having tight clusters and shortcut links between clusters but with relatively sparse connectivity overall) of their associative networks tend to perform better on tests of divergent thinking (Benedek et al., 2017; Kennet & Faust, 2019). This finding is consistent with Mednick's (1962) theory that creative individuals tended to have "flat" as against "steep" associative hierarchies and so would perform better on divergent tasks and on Remote Associates Test (RAT) items. "Flat" hierarchies are present when the alternative associations to most items are about equal in strength; "steep" hierarchies typically involve one very strong association and a few weak associations for each item.

In recent related work, Gray et al. (2019) have looked at sequences of continuous free associations (such as Table -> Chair-> Wood-> Axe-> Chop -> Lamb...) to examine differences between participants, some of whose thought sequences rapidly diverge semantically from the starting stimulus word or "seed" and some who show less divergence. For example, with the seed word "candy", a high diverging participant might give a sequence such as "candy -> store -> warehouse -> forklift -> safety" and a low diverging participant might give a sequence such as "candy -> sugar-> delicious -> yummy -> treat" After just 4 steps one participant is considerably farther semantically from the "candy" seed (with "forklift") than the other (with "yummy"). Gray et al. (2019) measured the degree of what they label forward flow, by how semantically distant associates

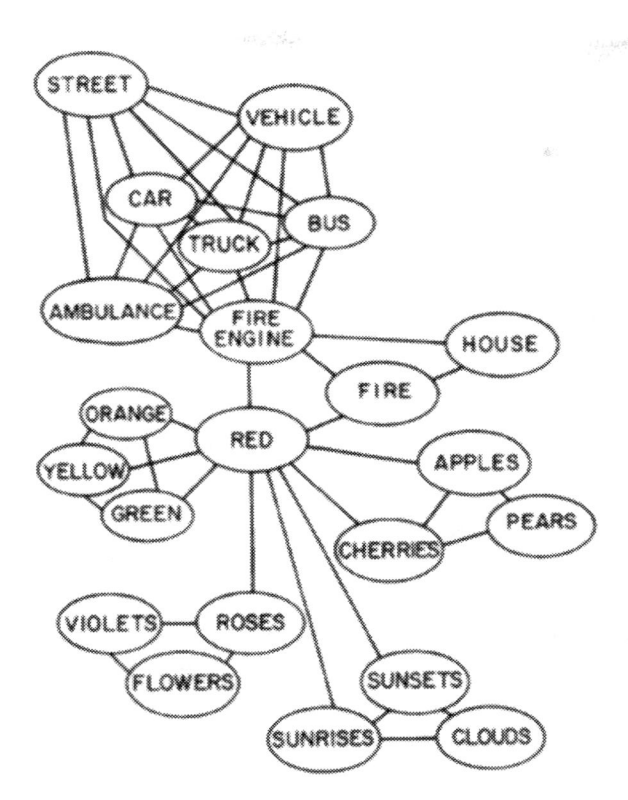

Fig. 1 Example semantic network. From Collins, A. M. & Loftus, E. F. (1975). A spreading activation theory of semantic processing. *Psychological Review, 82,* 407–428 (Reproduced with permission of the American Psychological Association)

in a sequence tend to be from all their predecessors. Using a variety of creativity measures and a large group of participants ($N = 1397$), those who were high in the forward flow measure consistently scored higher on creativity tasks than did low forward flow participants. Although the forward flow measure assesses conscious (continuous) free association, it would seem plausible to suppose that high scorers on forward flow have highly connected semantic networks with small world properties and so may well benefit more from incubation opportunities for unconscious associative chains than low forward flow scorers.

During incubation, spreading activation is usually seen as involving multiple streams (or "chains" or "trains") of associations and these streams would be more likely to depart far from the starting point when the networks are highly connected with small world properties; such network properties should facilitate development of novel connections and so higher creativity during incubation.

Endogenous Events as Chance Events

Overall, I have suggested that incubation can involve a kind of serendipity in which the mental events (such as free associations) precipitating solution are purely internal or endogenous. It may be questioned as to whether solution-precipitating endogenous events are truly *chance* events? (see also Simonton, this volume) The chance characterisation is plausible because semantic networks are highly interconnected, so that activation flows can go along multiple links at any one time with variable degrees of strength and which particular linked node will be most highly activated and so might enter consciousness cannot always be predicted with any certainty. The most activated linked node out of, say tens of possibilities, from any given starting node, will surely vary between individuals at the same time, and between different times for the same individual. The complexity of semantic network systems would seem to guarantee intra-individual variability over time and the emergence of stochastic variability. This seems especially likely as we look at longer and longer chains or trains of associations, where each node in the chain has connections to tens of other nodes; in such systems the number of different possible activation sequences grows exponentially with the number of steps in the sequence and so predictability of the outcome will drop rapidly as the number of steps increases.

At the *neural* level, the brain is ideally suited to implement a semantic network as it is estimated to comprise some 100 billion neurons (Herculano-Houzel, 2009) each of which can have many thousands of synaptic connections; thus, at the "hardware" level there is a highly connected physical network system with astronomically many possible patterns of moment-to-moment active connections and so scope for

considerable variability. Although, like other complex systems such as the weather, the semantic network system may be deterministic at some very low level, in practice, it is best modelled as a probabilistic system.

It is usually assumed that consciousness reflects the most activated nodes in the semantic network and that the sequence of most active nodes is experienced as the stream of consciousness. At the *phenomenological* level, as William James (1880, p. 456) put it, with regard to the stream of consciousness, apparently chance changes in content seem omnipresent (but see March & Vallée-Tourangeau, this volume).

> Instead of thoughts of concrete things patiently following one another in a beaten track of habitual suggestion, we have the most abrupt cross-cuts and transitions from one to another, the most rarified abstractions and discriminations, the most unheard of combination of elements, the subtlest associations of analogy; in a word, we seem suddenly introduced into a seething cauldron of ideas, where everything is fizzling and bobbing about in a state of bewildering activity, where partnerships can be joined or loosened in an instant, treadmill routine is unknown, and the unexpected seems only law.

Interestingly, James points to *unstable brain processes* as a major natural source of novel ideas (1880, p. 456) when he writes-

> ...new conceptions, emotions and active tendencies...are originally produced in the shape of random images, fancies, accidental outbirths of spontaneous variation in the functional activity of the excessively unstable human brain...

James (1880, p. 456) also argues that both useless associations ("grotesque whims") and useful associations ("an intuition of the solution of a long-unsolved problem") can arise by chance. Furthermore, he specifically discusses problem solving by incubation and in so doing anticipates later writers such as Helmholtz (1896), Poincaré (1910), and Wallas (1926) in suggesting stages of Incubation, Inspiration and Verification–

> When walking along the street, thinking of the blue sky or the fine spring weather, I may either smile at some grotesque whim which occurs to me, or I may suddenly catch an intuition of the solution of a long-unsolved problem, which at that moment was far from my thoughts. Both notions are shaken out of the same reservoir, - the reservoir of a brain in which the reproduction of images in the relations of their outward persistence or frequency has long ceased to be the dominant law...The conceit perishes in a moment, and is forgotten. The scientific hypothesis arouses in me a fever of desire for verification...

Also, later, James (1890, p. 552) wrote, again regarding incubation–

> Why do we spend years straining after a certain scientific or practical problem, but all in vain – thoughts refusing to evoke the solution we desire? And why, some day, walking in the street with our attention miles away from that quest, does the answer saunter into our minds as carelessly as if it had never been called for - suggested, possibly, by the flowers on the bonnet of the lady in front of us, or possibly by nothing we can discover?

It may be noted that here James anticipated both the recent notions of opportunistic assimilation, with an external cue ("flowers on the bonnet"), and of internal serendipitous events, with no obvious external cues, as ending incubation with an inspiration.

Concluding Summary

In this chapter, I have outlined the notion of incubation, viz., that it can be beneficial to set a problem aside. Research has supported the benefits of incubation periods and has supported explanations involving Unconscious Task Related Processing. More specifically, models have been developed in terms of subliminal goal maintenance and spreading activation through semantic networks together with Opportunistic Assimilation as leading to successful incubation periods. Opportunistic Assimilation envisages chance, serendipitous, exogenous events as leading to

activation of goal relevant information and solutions. It also proposed that the inherent variability of activation flow in complex semantic networks can lead to serendipitous, chance, endogenous mental events that activate goal relevant information and lead to incubation based solutions without external cues.

Acknowledgements I would like to thank Robert Weisberg, Dean K. Simonton and Wendy Ross for their helpful comments on earlier drafts of this chapter.

References

Amabile, T. M. (2019). The Art of (Creative) Thought: Graham Wallas on the creative process. In V. P. Glaveanu (Ed.), *The creativity reader*. Oxford University Press.

Baird, B., Smallwood, J., Mrazek, M. D., Kam, J. W. Y., Franklin, M. S., & Schooler, J. W. (2012). Inspired by distraction: Mind wandering facilitates creative incubation. *Psychological Science, 23*, 1117–1122.

Bar-Hillel, M. (2020). *An annotated compendium of stumpers*. SSRN. https://doi.org/10.2139/ssrn.3661310

Benedek, M., Kenett, Y. N., Umdasch, K., Anaki, D., Faust, M., & Neubauer, A. C. (2017). How semantic memory structure and intelligence contribute to creative thought: A network science approach. *Thinking and Reasoning, 23*, 158–183.

Boden, M. A. (2004). *The creative mind: Myths and mechanisms* (2nd ed.). Routledge.

Bowers, K. S. (1984). On being unconsciously influenced and informed. In K. S. Bowers & D. Meichenbaum (Eds.), *The unconscious re-considered* (pp. 227–223). Wiley-Interscience.

Bowers, K. S. (1994). Intuition. In R. J. Sternberg (Ed.), *The encyclopedia of intelligence* (pp. 613–617). Macmillan.

Bowers, K. S., Regher, G., Balthazard, C. G., & Parker, K. (1990). Intuition in the context of discovery. *Cognitive Psychology, 22*, 72–110.

Cannon, W. B. (1940). The role of chance in discovery. *The Scientific Monthly, 50*, 204–209.

Collins, A. M., & Loftus, E. F. (1975). A spreading activation theory of semantic processing. *Psychological Review, 82*, 407–428.

Corazza, G. E., & Lubart, T. (2019). Science and method: Henri Poincaré. In V. P. Glaveanu (Ed.), *The creativity reader*. Oxford University Press.

Dijksterhuis, A., & Meurs, T. (2006). Where creativity resides: The generative power of unconscious thought. *Consciousness and Cognition, 15*, 135–146.

Dijksterhuis, A., & Nordgren, L. F. (2006). A theory of unconscious thought. *Perspectives on Psychological Science, 1*, 95–109.

Dodds, P. S., Muhamed, R., & Watts, D. J. (2003). An experimental study of search in global social networks. *Science, 301*, 827–829.

Dodds, R. A., Ward, T. B., & Smith, S. M. (2012). A review of the experimental literature on incubation in problem solving and creativity. In M. A. Runco (Ed.), *Creativity research handbook* (Vol. 3). Hampton Press.

Dorfman, J., Shames, V. A., & Kihlstrom, J. F. (1996). Intuition, incubation, and insight: Implicit cognition in problem solving. In G. Underwood (Ed.), *Implicit cognition* (pp. 257–296). Oxford University Press.

Duncker, K. (1945). On problem solving. *Psychological Monographs, 58*, 1–113.

Durso, F. T., Rea, C. B., & Dayton, T. (1994). Graph-theoretic conformation of restructuring during insight. *Psychological Science, 5*, 94–98.

Gilhooly, K. J. (2016). Incubation and intuition in creative problem solving. *Frontiers in Psychology, 7*, 1076.

Gilhooly, K. J. (2019). *Incubation in problem solving and creativity: Unconscious processes*. Routledge.

Gilhooly, K. J., Georgiou, G. J., & Devery, U. (2013). Incubation and creativity: Do something different. *Thinking & Reasoning, 19*, 137–149.

Gilhooly, K. J., Georgiou, G. J., Garrison, J., Reston, J., & Sirota, M. (2012). Don't wait to incubate: Immediate versus delayed incubation in divergent thinking. *Memory & Cognition, 40*, 966–975.

Gilhooly, K. J., Georgiou, G. J., Sirota, M., & Paphiti-Galeano, A. (2015). Incubation and suppression processes in creative problem solving. *Thinking & Reasoning, 21*, 130–146.

Gray, K., Anderson, S., Chen, E. E., Kelly, J. M., Christian, M. S., Patrick, J., Huang, L., Kenett, Y. N., & Lewis, K. (2019). "Forward flow": A new measure to quantify free thought and predict creativity. *American Psychologist, 74*, 539–554.

Helmholtz, H. v. (1896). *Vortrage und Reden* (Vol. 1). Vieweg.

Herculano-Houzel, S. (2009). The human brain in numbers: A linearly scaled up primate brain. *Frontiers in Human Neuroscience, 3*, 31.

James, W. (1880). Great men and their environment. *Atlantic Monthly, 46*, 441–449.

James, W. (1890). *The principles of psychology* (Vol. 1). Henry Holt & Co.

Kaufman, J. C., & Beghetto, R. A. (2009). Beyond big and little: The four C model of creativity. *Review of General Psychology, 13*, 1–12.

Kenett, Y. N. (2018). Investigating creativity from a semantic network perspective. In Z. Kapoula (Ed.), *Exploring transdisciplinarity in art and sciences*. Springer International Publishing AG.

Kenett, Y. N., & Faust, M. (2019). A semantic network cartography of the creative mind. *Trends in Cognitive Sciences, 23*, 271–274.

Koestler, A. (1969). *The act of creation*. Pan Books.

Kozbelt, A., Beghetto, R. A., & Runco, M. A. (2010). Theories of creativity. In J. C. Kaufman & R. J. Sternberg (Eds.), *Cambridge handbook of creativity* (pp. 20–47). Cambridge University Press.

Loewi, O. (1960). An autobiographic sketch. *Perspectives on Biology and Medicine, 4*, 1–25.

Lynch, C., Ashley, K., Aleven, V., & Pinkwart, N. (2006). Defining ill-defined domains: A literature survey. In V. Aleven, K. Ashley, C. Lynch, & N. Pinkwart (Eds.), *Proceedings of the Workshop on Intelligent Tutoring Systems for Ill-Defined Domains at the 8th International Conference on Intelligent Tutoring Systems* (pp. 1–10). Jhongli (Taiwan), National Central University. http://www.cs.pitt.edu/~collinl/Papers/ITS06_illdefinedworkshop_LynchEtAl.pdf

Maier, N. R. F. (1931). Reasoning in humans II: The solution of a problem and its appearance in consciousness. *Journal of Comparative Psychology, 12*, 181–194.

Mandler, G. A. (1994). Hypermnesia, incubation, and mind-popping: On remembering without really trying. In C. Umilta & M. Moscovitch (Eds.), *Attention and performance XV: Conscious and unconscious information processing* (pp. 3–33). MIT Press.

Mandler, G. A. (1995). Origins and consequences of novelty. In S. M. Smith, T. B. Ward, & R. A. Finke (Eds.), *The creative cognition approach*. MIT Press.

Marupaka, N., Iyer, L., & Minai, A. A. (2012). Connectivity and thought: The influence of semantic network structure in a neurodynamical model of thinking. *Neural Networks, 32*, 147–158.

Mednick, S. A. (1962). The associative basis of the creative process. *Psychological Review, 69*, 220–232.

Merton, R., & Barber, E. (2004). *The travels and adventures of serendipity*. Princeton University Press.

Milgram, S. (1967). The small world problem. *Psychology Today, 2*, 60–67.

Pasteur, L. (1854/1939). Discours. In V.-R. Pasteur (Ed.), *Oeuvres de Pasteur, Tome 7* (pp. 129–146). Masson & Co..

Poincaré, H. (1910). Mathematical creation. *The Monist, 20*, 321–333.

Reitman, W. (1964). Heuristic decision procedures, open constraints, and the structure of ill-defined problems. In M. W. Shelley & G. L. Bryan (Eds.), *Human judgment and optimality*. Wiley.

Runco, M. A., & Jaeger, G. J. (2012). The standard definition of creativity. *Creativity Research Journal, 24*, 92–96.

Sadler-Smith, E. (2015). Wallas' four-stage model of the creative process: More than meets the eye? *Creativity Research Journal, 27*, 342–352.

Schilling, M. A. (2005). A "small world" network model of cognitive insight. *Creativity Research Journal, 17*, 131–154.

Seifert, C. M., Meyer, D. E., Davidson, N., Patalano, A. L., & Yaniv, I. (1995). Demystification of cognitive insight: Opportunistic assimilation and the prepared mind perspective. In R. J. Sternberg & J. E. Davidson (Eds.), *The nature of insight*. (pp. 65–124). MIT Press.

Simon, H. A. (1973). The structure of ill structured problems. *Artificial Intelligence, 4*, 181–201.

Simonton, D. K. (2010). Creative thought as blind-variation and selective-retention: Combinatorial models of exceptional creativity. *Physics of Life Reviews, 7*, 156–179.

Sio, U. N., & Ormerod, T. C. (2009). Does incubation enhance problem solving? A meta-analytic review. *Psychological Bulletin, 135*, 94–120.

Travers, J., & Milgram, S. (1969). An experimental study of the small world problem. *Sociometry, 32*, 425–443.

Van Andel, P. (1994). Anatomy of the unsought finding. Serendipity: Origin, history, domains, traditions, appearances, patterns and programmability. *British Journal of the Philosophy of Science, 45*, 631–648.

Wallas, G. (1926). *The art of thought*. Jonathan Cape.

Yaniv, I., & Meyer, D. E. (1987). Activation and metacognition of inaccessible stored information: Potential bases for incubation effects in problem solving. *Journal of Experimental Psychology: Learning, Memory & Cognition, 13*, 187–205.

Yaqub, O. (2018). Serendipity: Towards a taxonomy and a theory. *Research Policy, 47*, 169–179.

Zeigarnik, B. (1927). Das Behalten von erledigten und unerledigten Handlungen. *Psychologie Forschung, 9*, 1–85.

Zimmerman, R. (2010). *The universe in a mirror: The saga of the Hubble Space Telescope and the visionaries who built it*. Princeton University Press.

Serendipity and Creativity in the Arts and Sciences: A Combinatorial Analysis

Dean Keith Simonton

Creativity can encompass a wide range of distinct phenomena. Certainly, problem solving, discovery, and invention can all count as forms of creativity that need not completely overlap (see also Gilhooly, this volume). Yet one guise of creativity has a special interest in this chapter: serendipity. Most kinds of creativity involve some explicit intentionality on the part of the creative person. This feature is most obvious when the creator sets out to solve a chosen problem. Indeed, the role of intention becomes especially conspicuous in the highest manifestations of problem-solving creativity. For instance, Pablo Picasso worked on *Guernica*, his most famous painting, for 35 days. In that wilful effort, he generated dozens of sketches concerning not just the overall composition but also the specific figures that dominate the composition

D. K. Simonton (✉)
University of California, Davis, Davis, CA, USA
e-mail: dksimonton@ucdavis.edu

W. Ross and S. Copeland (eds.), *The Art of Serendipity*,
Palgrave Studies in Creativity and Culture,
https://doi.org/10.1007/978-3-030-84478-3_12

(Simonton, 2007). Moreover, his painting had a very specific purpose in mind. Besides satisfying a 1937 commission from the Spanish Republican government for the Spanish pavilion at the upcoming Paris World's Fair, the artist endeavoured to convey the horrors of the Nazi German and Fascist Italian aerial bombing of the Basque town of Guernica, thereby creating one of the greatest anti-war statements in the history of world art. Far from a slapdash *pièce d'occasion*, the end result required not just artistic skill but also persistently directed willpower.

This creative episode stands in contrast with serendipitous creativity. A clear example is the invention of what became known as Velcro by George de Mestral. Returning from a walk in the woods in 1941, he wondered why burdock seeds had stuck to his coat and his dog's fur. After microscopic examination determined the underlying mechanism, he conceived the idea of analogous hook and loop fasteners which he finally perfected as a commercially viable product a decade later. By 1999 he had been inducted into the National Inventors Hall of Fame. Yet it's safe to assume that de Mestral never had a long-term intention to invent an attachment system prior to the serendipitous discovery of hooks and loops in nature. Indeed, such an intention seems hardly likely for a Swiss electrical engineer.

It turns out that serendipity has a very unique place among the various forms of creativity. But to comprehend this uniqueness, we first have to spend some time discussing the psychology of creativity in general. Specifically, creativity has to be discussed as a combinatorial process or procedure.

Combinatorial Creativity

The thesis that creativity necessarily entails a combinatorial process or procedure is not new but rather harks back to the first psychological treatments of the subject. For instance, drawing an analogy with the variation process behind biological evolution, William James (1880) argued that mental combinations paralleled molecular combinations (see also Simonton, 2018a). This early hypothesis continued into contemporary research on creativity. For example, Mednick (1962) defined "the creative

thinking process as the forming of associative elements into new combinations which either meet specified requirements or are in some way useful. The more mutually remote the elements of the new combination, the more creative the process or solution" (p. 221). This definition provided the theoretical basis for his frequently-used Remote Associates Test (but see Lee et al., 2014). Finally, this same conception of the phenomenon has informed computer simulations of the creative process (e.g., Thagard & Stewart, 2011). Yet I hasten to emphasise two points.

First, the generation of creative combinations does not stipulate any single process or procedure (Simonton, 2017a). Nor should we expect otherwise, given that creativity researchers have collectively identified dozens of mechanisms or conditions that have contributed to creativity. A partial list includes ordinary cognition, divergent thinking (including fluency, originality, flexibility, and elaboration), remote association, bisociation, cognitive disinhibition (or defocused attention), primary (or primordial) process (including "regression in the service of the ego"), dreams, synesthesia, psychoactive drugs, certain organic brain disorders, overinclusive (allusive) cognition, intuition, mind wandering, analogy, broadening perspective, conceptual reframing (frame shifting), juggling induction and deduction, problem dissection, reversal, systematic and heuristic searches, imagination, tinkering, play, Homospatial, Janusian, and Sep-Con Articulation thinking, Geneplore, and last but not least, pure luck, chance, or serendipity and pseudo-serendipity (cf. Simonton, 2017a). Even if some of those just listed overlap to some undetermined extent, the fact remains that all work some of the time, but none works all of the time (see also Ross, this volume). Therefore, the best option is to commit our discussion to generic combinatorial processes and procedures without specifying which ones (Simonton, 2017a). That specification must most often wait until we have a particular case of creativity in hand.

Second, not all combinations are creative, nor even most (Simonton, 2018b). On the contrary, high levels of combinatorial creativity are extremely rare. The vast majority of time, our thoughts and behaviours are confined to a fairly beaten track, interrupted only occasionally by minor flashes of insight, wit, or ingenuity—like figuring out how to modify a dinner recipe when a crucial ingredient is missing. Truly great

ideas or responses that rise noticeably above that baseline of mediocrity are few and far between. That's true even for a creator at the level of a Picasso. In over a month devoted to a single masterpiece, he produced a large number of prospective images that he himself rejected as untenable. The finished *Guernica* contains only a tiny fraction of every graphic combination generated during that period (Simonton, 2007). Apparently none of the rejected sketches were even deemed suitable for framing to display in the artist's guest bathroom. And needless to say, during those 35 days Picasso was also engaged in much more routine activities that would not even deserve a diary entry—like what food items he had combined for breakfast on 2 May 1937, the day he drew one of his horse head sketches.

This second point requires that I turn to a most critical problem: How to distinguish creative combinations from non-creative combinations.

Defining Creativity

Just as creativity researchers have been very imaginative in coming up with diverse creative processes and procedures, so have they exhibited a comparable imagination in devising definitions of their favourite phenomenon (Plucker et al., 2004). Most researchers subscribe to some version of the definition that Mednick (1962) implicitly gave earlier, resulting in what has been called the "standard definition" (Runco & Jaeger, 2012), namely, "Creativity requires both originality and effectiveness" (p. 92). Naturally, researchers will often create alternate terms for the two criteria, such as substituting novelty or uniqueness for originality and replacing effectiveness with value, utility, adaptiveness, appropriateness, meaningfulness, and the like (Runco & Jaeger, 2012). Despite this supposed standard definition, many researchers reason that a third criterion is necessary for completeness (see also Ross, this volume). For instance, Boden (2004) stipulates that creativity entails novel, valuable, and surprising, whereas the United States Patent Office imposes the requirements of new, useful, and non-obvious (Simonton, 2012b). I have argued that the two-criterion definition is untenable (Simonton, 2018b). That's because a third criterion is logically and psychologically

required to account for a creator's prior knowledge of the combination's utility (see also Tsao et al., 2019, for a mathematically more sophisticated argument). Therefore, the three-criterion definition will be used here. In particular, any given combination can be assigned three parameters (Simonton, 2018b):

First is the combination's *initial probability*, designated by p, which ranges from 0 to 1. Notice that this parameter closely parallels Mednick's (1962) concept of "response strength," where remote associations are characterised by very low response strengths in comparison to common-place associations. The latter are like what is generated when persons are asked to say the first thing that comes to their mind in response to a given cue. In comparison, remote associates have longer response latencies, especially for more difficult associations (Bowden & Jung-Beeman, 2003). Significantly, this parameter enables us to define the first criterion of the three-part definition, namely, *originality* which equals $1 - p$, with the same corresponding range of 0 to 1. A combination's originality is just the inverse of its initial probability.

Second is the combination's *final utility*, u, which also ranges from 0 to 1. Sometimes the utility may only assume a discrete value, either 0 or 1, such as occurs in many laboratory problem-solving experiments (e.g., the classic two-string problem: Maier, 1931). Other times, partial solutions are possible. For instance, the items in the Remote Associates Test require that the participant find one word that associates with three very different words (Mednick, 1962). One of the examples given in the original article was "wheel, electric, high," to which "chair" provides a common remote associate combining the three. That answer would have $u = 1$. But a participant might instead come up with "lock," which only combines the first two words without stretching. So in that case u might be assigned the value of 2/3. Naturally, in real-world creativity, the utility function becomes very complicated. For example, Thomas Edison's quest for a commercially viable incandescent light bulb required his finding a filament that satisfied several diverse criteria, such as low manufacturing cost, electrical conductance but with high resistance, and physical durability in terms of both transportation and oxidation within the imperfect bulb vacuums available at the time (Simonton, 2015b). A given experimental filament might only satisfy a portion of the stipulations, yielding

$0 < u < 1$. Note that u provides the second creativity criterion without any need for the inversion implemented for originality.

Third and last is the *prior knowledge* of a combination's final utility, v, which also can have values between 0 and 1 inclusively. If $v = 0$, then the combination's generator has no idea in advance, but if $v = 1$, the utility is already known perfectly at the moment of generation. Somewhere between those extremes is the "hunch" or "educated guess." For example, when Edison searched for a workable filament, he could often rule out certain possibilities beforehand because of the efforts of predecessors who tried and failed. In addition, the attributes of some potential filaments were often already known, such as the high cost of cobalt. But many aspects of the utility function were most often unknown (see Piñeyro, this volume). For instance, although carbonised fibres can satisfy many requirements, it didn't become apparent until microscopic examination that those fibres had to feature a specific small-scale structure. Hence, it was by no means obvious that carbonised bamboo fibres work better than carbonised thread. In any event, if the prior knowledge value is inverted like was done for the first parameter, then $1 - v$ results, which represents *surprise* (or "nonobviousness"), the third and last criterion in the three-criterion creativity definition.

We can now define *personal creativity* as $c = (1 - p)u(1 - v)$, or, in words, the multiplicative product of originality, utility, and surprise. Because all three factors lay on the same 0–1 scale, the product will as well. Accordingly, $c = 0$ if creativity is totally absent, and $c = 1$ if creativity is maximised. Naturally, the creativity of most combinations falls between, and even somewhat closer to 0 than to 1 (Simonton, 2016). To illustrate, suppose $p = 0.1$ (low initial probability), $u = 0.9$ ("satisficing" rather than maximal utility), and $v = 0.5$ (some hunch predicated on past experience). Then $c = 0.41$, only about two fifths up the hypothetical scale.

Before going to the next section, let me stress that the adjective "personal" is essential to this definition. We are strictly speaking of what creators personally experience when they conceive a particular combination. Later assessments by colleagues, critics, connoisseurs, patrons, audiences, readers, and, of course, members of remote posterity, are irrelevant at this stage. After all, creators have to create first before their

creativity can even receive consensual appraisals. It's absolutely crucial to separate personal and consensual assessments. Many creativity researchers have been led astray by conflating these two judgements. For example, some have questioned the value of the second criterion, utility, because consensual assessments are not only diverse—such as moviegoers liking different films than critics—but also unstable over time (e.g., Weisberg, 2015). Yet those problems vanish for personal creativity because it entails the assessment of one person at one particular time, namely at the moment that the creator's combination ends up in a particular creative product. The creator might change their assessment later, but for the most part, what is done cannot be undone. Even if the creator decides to revise the product, that revision constitutes a new creative act, and thus results in a new final utility estimate. I'll return to this issue at the very end of this chapter.

Defining Non-creative Combinations

According to the foregoing, personal creativity $c \rightarrow 1$ as $p \rightarrow 0$, $u \rightarrow 1$, and $v \rightarrow 0$, where "\rightarrow" signifies "approaches." Those are the three mandatory conditions that maximise the multiplicative integration of originality, utility, and surprise for a particular combination. Any one of the three criteria exerts veto power over the rest, no matter how potent. If p and/or v approach 1 and/or if u approaches 0, then creativity approaches 0. That implies that there are multiple ways that a combination might not be creative—seven in fact.

Two of these are extremely unlikely for any rational human being. That ensues because if the utility is well known beforehand, then the initial probability should strongly correspond to that known utility. Stated in formal terms, as $v \rightarrow 1$, $p \rightarrow u$. Substantial departures from this pattern are irrational. This leads to the following: (a) *irrational suppression* ($u \rightarrow 1$ and $v \rightarrow 1$, yet $p \rightarrow 0$) and (b) *irrational perseveration* ($u \rightarrow 0$ and $v \rightarrow 1$, yet $p \rightarrow 1$). The latter fits the maxim often incorrectly attributed to Albert Einstein: "The definition of insanity is doing the same thing over and over and expecting different results."

In stark contrast, rational combinations tend to be those corresponding to *routine* or *habitual* thoughts and behaviours (viz. as $u \rightarrow 1$ and $v \rightarrow 1$, then $p \rightarrow 1$; Simonton, 2018b). The combination has a high probability because it has a high utility and that utility is already well known. At the mundane level, these combinations concern what we might put together for breakfast each day—our "go-to" meal like bacon, eggs, and toast. Yet at a more professional level, such combinations represent domain-specific expertise. Such expertise is often affirmed in established if–then statements. To illustrate, if the data distribution exhibits a conspicuous positive skew, then subject the data to a logarithmic transformation. That should be the first thing that comes to mind rather than a highly remote association, like multiply by pi ($\pi \approx 3.14159$).

Yet rationality does have another side: As stated earlier, whenever the utility is very low, and that fact is already known, then the probability should also be low (viz. as $u \rightarrow 0$ and $v \rightarrow 1$, then $p \rightarrow 0$). This has been called *rational suppression* (Simonton, 2016). At the everyday level, this goes on when you extinguish any inclination to put your hand in an open flame or pour a cup of salt into the casserole instead of a mere teaspoon. This negative expertise has its own if–then statements. Like if the divisor is zero, then stop right there. The calculation cannot go forward. That rule holds both for ordinary arithmetic and more advanced mathematics like linear algebra: If the determinant is zero, then the matrix cannot be inverted.

The final three types of combinations are of special interest because they bear some resemblance with serendipity, and sometimes can lead to serendipity. One entails a *fortuitous response* or "lucky guess" (Simonton, 2018b). In this case the combination has both a high initial probability and a high final utility, but the individual is largely if not entirely ignorant of that utility (viz. $p \rightarrow 1$, $u \rightarrow 1$, but $v \rightarrow 0$). If some gambler decides to go to the roulette wheel and bet everything on a favourite lucky number, and amazingly wins, it would be impossible to affirm that the winning number was known in advance. That said, sometimes a person can have a lucky guess come to mind based on a semi-informed intuition (i.e., $0 < v \ll 1$).

Another type has been called *problem finding* because it involves a surprising expectation violation (viz. $p \rightarrow 1$, $u \rightarrow 0$, and $v \rightarrow 0$). That is, a high probability combination turns out to have extremely low utility, jolting the person with the knowledge of failure where success is strongly anticipated (Simonton, 2018b). The individual thus encounters a limit to their expertise, often impelling them to ask why. In Kuhn's (1970) theory of scientific events these problem-finding episodes are termed "anomalies," which happen when the predictions of a well-established paradigm are disconfirmed by experimental data. Other times the impetus is conceptual rather than empirical. Einstein often conducted "Gedanken" (thought) experiments that pinpointed contradictions in the theories of his time, such as the incompatibility of Newtonian mechanics and Maxwell's equations for electromagnetism. Einstein even observed

> the formulation of a problem is often more essential than its solution, which may be merely a matter of mathematical or experimental skill. To raise new questions, new problems, to regard old problems from a new angle, requires creative imagination and marks real advances in science. (Einstein & Infeld, 1938, p. 95)

The final type of non-creative combination is seemingly the strangest of all, for in this instance all three parameters approach zero if not actually equal zero (viz. $p \rightarrow 0$, $u \rightarrow 0$, and $v \rightarrow 0$). These are the ideational combinations generated in mind wandering, the sensory combinations in exploration, and the behavioural combinations in tinkering (Simonton, 2016). Ideas and behaviours are produced that have little or no usefulness and with little or no prior knowledge either. Clearly, their initial probability has to exceed zero, or else these combinations would not be generated at all. Yet that probability is so low that such combinations can only emerge in very low states of arousal, such as when someone lapses into daydreaming or starts playing around on the keyboard out of pure boredom. Most of the time these thoughts and behaviours just come and go without consequences. Yet not always, as will be seen later.

Serendipitous Discovery

Because serendipity seems most strongly associated with scientific creativity, I should point out that we have every reason to believe that the latter phenomenon is combinatorial as well. This conclusion is certainly revealed in the introspective reports of great scientists. For example, Einstein affirmed that "combinatory play seems to be the essential feature in productive thought" (Hadamard, 1945, p. 147). And mathematician Henri Poincaré (1921) reported how "ideas rose in crowds; I felt them collide until pairs interlocked, so to speak, making a stable combination" (p. 387). These colliding images were compared to "the hooked atoms of Epicurus" that bounce off each other "like the molecules of gas in the kinematic theory of gases" so "their mutual impacts may produce new combinations" (p. 393). Not surprisingly, this combinatorial activity shows up in the creative products themselves. Thagard (2012) systematically analysed 100 top discoveries and 100 top inventions, showing that everyone, without exception, represented some combination of representations, albeit various modalities may be involved—whether visual, verbal, mathematical, kinesthetic, auditory, tactile, or even thermal.

Significantly, Thagard (2012) estimated that about one-quarter of the scientific discoveries featured a notable accidental aspect. "For example, Galileo was not looking for moons of Jupiter with his telescope, van Leeuwenhoek was not seeking microbes with his microscope, and Roentgen was very surprised to encounter X-rays" (p. 392). Thagard also emphasises that the combinatorial nature of these serendipitous discoveries is often overlooked. For instance, "the serendipitous discovery of penicillin might be erroneously construed as simply a matter of perception, but what made Alexander Fleming's discovery novel, surprising, and important was his more complex recognition that mold was killing bacteria, producing the key conceptual combination bacteria-killing mold" (p. 392). Notice that Thagard uses the criteria "novel, surprising, and important," which can be easily be paraphrased and reordered into the original, useful, and surprising criteria advocated in this chapter. That suggests that serendipitous discoveries can be analysed in terms of the parameters p, u, and v.

Formal Analysis

So let us go back to the basic inference that $c \to 1$ as $p \to 0$, $u \to 1$, and $v \to 0$. Observe the pair of implicit obstacles that get in the way of maximal creativity no matter how useful the combination might be. First, the highest degree of creativity presumes that $p = 0$, that is, the initial generation probability is zero. Second, maximal creativity also assumes that $v = 0$, that is, the prior knowledge of the utility is zero as well. Even so, Fleming's discovery satisfies both of these criteria. Despite all of the expertise he obtained with respect to bacteria, he would never have conceived a laboratory experiment in which he deliberately introduced mould spores into a petri dish containing a staphylococcus culture. That only happened inadvertently because he left some bacteria cultures on the countertop when he took off on a family vacation. So $p = 0$. Furthermore, even if he had done so deliberately, on some whim, he would have no reason whatsoever to suspect that the combination would exhibit any useful properties. Antibacterial secretions were not then on anybody's list of potential mould actions. So $v = 0$ as well. That's what makes the combination "bacteria-killing mold" such an exceptional discovery, one eventually worthy of a Nobel Prize once the practical issues behind implementation could be worked out. At the personal level, Fleming certainly could suspect that the utility of the resulting penicillin might be absolute, saving millions of lives. After all, much earlier he had discovered the much weaker antibacterial action of lysozyme.

I would argue that all genuine serendipitous discoveries in science can be analysed in an analogous manner. In every case, $p = v = 0$ while $u \to 1$. A useful combination simply comes out of the blue, without any likelihood of the scientist deliberately generating that combination nor any prior inkling of what would happen had the combination been generated anyway. The only real question concerns the utility value. Often the personal value of u is not obvious without providing some context regarding what is going inside the head of the scientist at the time. Many potential serendipitous discoveries were actually overlooked by other scientists who didn't take note of what they observed, and so, metaphorically, the contaminated petri dish just gets thrown into the autoclave without a second thought (see Copeland, Ross this volume).

The "mold-ruins-bacteria-cultures" conceptual combination has no value for any bacteriologist who habitually maintains a tidy and clean laboratory, unlike Fleming's unconventional practice. As physicist Ernst Mach (1896) said in his classic treatment of this subject, such chance events "were *seen* numbers of times before they were *noticed*" (p. 169; cf. "positive" versus "negative" serendipity in Barber & Fox, 1958). All told, the creativity researcher has to do a little psychobiographical homework for each case.

Specific Case

As Thagard (2012) suggested, Galileo's serendipitous discoveries in observational astronomy provide excellent examples (cf. Simonton, 2012a). Although the telescope was not Galileo's invention, nor was he the first to point the instrument towards the night sky, he was original in realising that the telescope needed major improvements before it would prove useful in observing the heavens. After making the necessary modifications, Galileo began a systematic search that revolutionised astronomy: The moon had mountains, Jupiter had moons, the sun had spots on its surface, Venus had phases, the Milky Way consisted of stars, etc. These conceptual combinations violated the received traditions from antiquity, especially Aristotelian cosmology and Ptolemaic geocentric astronomy. For that reason, the initial consensual rejection of his discoveries was totally discrepant from his personal evaluation—and for good reason! There was absolutely no a priori basis for believing that any of these observational combinations were even possible. Most of them flatly contradicted the prevalent dogma that the earth was the centre of the universe and that celestial bodies were perfect, unblemished spheres. Some critics even argued that his new-fangled telescope produced optical illusions, like a kaleidoscope might.

So why did Galileo go against the grain? The reasons are multiple and complex. He was always extremely independent, even non-conformist, dropping out of college against his father's wish that he obtain a medical degree. Even before he began his astronomical observations, he had conducted numerous experiments that seriously challenged the ancient

physics inherited from Aristotle (the Tower of Pisa episode only marking the most legendary test). In addition, Galileo certainly possessed a phenomenal level of what psychologists would now call openness to experience, the Big Five personality factor most strongly correlated with creativity (McCrae & Greenberg, 2014). His polymathic interests and even competencies encompassed mathematics, astronomy, physics, engineering, philosophy, literature, and the visual arts. In the latter case he actually taught at an art school and mastered the chiaroscuro techniques that enabled him to discover and illustrate the lunar mountains (Simonton, 2012a). Moreover, his mathematical competence allowed him to appreciate the merits of the heretical Copernican heliocentric astronomy. One final factor is far more idiosyncratic. As an academic outsider, Galileo began his career in a precarious financial position, and wanted to secure a better and more reliable income for the benefit of himself and his family, which included his mistress and their three children. Suffice it to say that his naming Jupiter's moons after the wealthy and powerful Medici family of Florence was an integral part of that strategy. Galileo needed a big hit and got one.

With respect to serendipity, Louis Pasteur is often quoted as saying "Chance favours only the prepared mind" (Beveridge, 1957, p. 46). Galileo shows that this preparation is not always that simple.

Three Questions

After just explicating serendipity in both general and specific terms, I now want to address three more detailed questions: serendipity versus pseudo-serendipity, external versus internal serendipity, and scientific versus artistic serendipity.

Serendipity Versus Pseudo-Serendipity

As noted at the outset, serendipity sets itself apart from creativity in general by omitting intentionality. Yet chance can combine with intention to yield *pseudo-serendipity*, a term coined "to describe accidental

discoveries of ways to achieve an end sought for, in contrast to the meaning of (true) *serendipity*, which describes accidental discoveries of things not sought for" (Roberts, 1989, p. x). The specific example given was George Goodyear's accidental discovery of sulphur vulcanization (cf. Díaz de Chumaceiro, 1995). There was no doubt that this was a solution he had been seeking for several years, and at a great personal sacrifice. Moreover, because of multiple failures, Goodyear knew exactly what he was looking for—the utility function was well established. The resulting rubber product shouldn't get brittle in cold weather nor become sticky in warm weather, and it should be resistant to more common chemical attacks, such as mild acids. Yet otherwise pseudo-serendipity has the same features as true serendipity, namely, $p = v = 0$ and $u \rightarrow 1$. The difference lies in the prior definition of the utility function, which tends to be more ill-defined for serendipitous discoveries. Galileo and Leeuwenhoek had no conception what they might see through their respective optical instruments. They just operated under the hope that their curiosity would yield something interesting and even important—which is what they fortunately got. That's a far cry from a long-term striving to market genuinely usable rubber boots.

That said, it must be admitted that a precise line cannot be drawn between the two serendipities because sometimes the utility criterion falls between precision and vagueness. Certainly Fleming's previous work with lysozyme would prepare his mind for the opportunity that the mould-spoiled petri dish provided him (even though full recognition of what happened apparently required some prodding from one of his old research assistants). Roentgen's discovery of X-rays also provides another ambiguous case (see Gillies, 2015). Although it is true that he wasn't looking for X-rays, it's also true that his experiment was designed to determine whether cathode rays (later called electrons) would pass through the glass walls of the cathode ray tube. But when he switched on the device, he noticed that a screen some distance away in the laboratory glowed in the dark. Because the rays had very different properties, including exceptional powers to penetrate solid objects, he eventually showed that the rays that caused the fluorescence were new, naming them X-rays to acknowledge that these were hitherto unknown. But what was the screen doing there in the first place? He had planned to use it in

a later stage of his experimentation to help see if the cathode rays had gotten beyond the glass. Hence, he was already halfway there.

Given the difficulty of exactly separating the two serendipities, the stigma "pseudo" is perhaps unfortunate. It tends to downgrade the phenomenon as if such events play a minor role in scientific creativity. Yet the testimony of great scientists suggests otherwise. For example, here's a passage from Hermann von Helmholtz's (1898) autobiography:

> I only succeeded in solving such problems after many devious ways, by the gradually increasing generalisation of favourable examples, and by a series of fortunate guesses. I had to compare myself with an Alpine climber, who, not knowing the way, ascends slowly and with toil, and is often compelled to retrace his steps because his progress is stopped; sometimes by reasoning, and sometimes by accident, he hits upon traces of a fresh path, which again leads him a little further; and finally, when he has reached the goal, he finds to his annoyance a royal road on which he might have ridden up if he had been clever enough to find the right starting-point at the outset. In my memoirs I have, of course, not given the reader an account of my wanderings, but I have described the beaten path on which he can now reach the summit without trouble. (p. 282)

The words "guesses" and "accident" are telling. Yet it's also clear that Helmholtz knew where he was heading, with a well-defined set of criteria to tell him when he reached the mountain top. The ultimate criterion is that if you think you've reached the peak, and can see nothing higher after scanning a full 360 degrees, you've got it!

Individual creativity apart, serendipitous discoveries of whatever kind play a major role in the evolution of scientific knowledge (Kantorovich & Ne'eman, 1989). To appreciate why, we can return to the specification that $v = 0$ for both real and pseudo-serendipity. After the discovery is made, the posterior knowledge of the utility can approach unity even at the consensual level. Suddenly a big hunk of ignorance about the world has converted to definite knowledge. Jupiter has moons and the Moon mountains, microbes roam about all over the place, penetrating electromagnetic X-rays exist, moulds can contain antibacterial agents, natural

rubber can be used for everyday wear, and clothing can be closed or tightened without using buttons, laces, or buckles. The discoveries are decidedly path-breaking rather than merely incremental.

External Versus Internal Serendipity

In all of the examples presented so far, serendipity of either type begins with an external stimulus that could not have been anticipated, even less generated (i.e., $p = v = 0$). That observation from the world outside may require a special instrument, whether a telescope, microscope, or cathode ray tube, but in every case the source is external rather than internal. The origin is not inside the scientist's brain. But now let us consider the latter possibility. I start with an illustration drawn from the domain of abstract mathematics for the straightforward reason that it would seem a domain where combinations could not be readily induced by external stimulation. In particular, I'll select some episodes from the mathematical creativity of Poincaré, who was quoted earlier. More specifically, I will focus on what he says about his work on Fuchsian functions, a topic which has the least imaginable connection with everyday life (see Poincaré, 1921, pp. 337–338).

This story has an interesting onset because it provides another quirk in the distinction between true and false forms of serendipity. Poincaré's goal was to prove that Fuchsian functions were impossible. In his own words, "For fifteen days I strove to prove that there could not be any functions like those I have since called Fuchsian functions. I was then very ignorant; every day I seated myself at my work table, stayed an hour or two, tried a great number of combinations and reached no results" (p. 337). Combinatorial activity is thus not guaranteed success (Simonton, 2010). "One evening, contrary to my custom, I drank black coffee and could not sleep" (p. 337). This led to the earlier quotation about ideas arising in clouds, where their collisions and the interlocking of pairs led to the establishment of a certain class of Fuchsian functions. The interesting point here is that Poincaré obtained a result exactly opposite to what he had set out to do! Rather than pseudo-serendipity should this be called perverse-serendipity?

After working out the implications in diverse directions, Poincaré then had to leave mathematics "to go on a geologic excursion under the auspices of the school of mines" (p. 387), where his job was located at that time. Not surprisingly, he observed that "The changes of travel made me forget my mathematical work" (p. 387). After he got to his destination, he had to board a bus to go elsewhere. "At the moment when I put my foot on the step the idea came to me, without anything in my former thoughts seeming to have paved the way for it, that the transformations I had used to define the Fuchsian functions were identical with those of non-Euclidean geometry" (pp. 387–388). After verifying this remarkable result upon returning from the excursion, he switched to some unrelated mathematical problems that again resisted solution. But while vacationing on the seaside, and contemplating other matters, he went walking along a bluff, and suddenly came to another major mathematical revelation relating to the same area. Poincaré reports one more such instance when he went on military service, yet another environment in which external stimuli relevant to abstract mathematics might not be all that abundant.

Boden (2004), whose three-criterion creativity definition was mentioned earlier, made this striking observation: "*The bath, the bed, and the bus*: this trio summarizes what creative people have told us about how they came by their ideas" (p. 25). These three circumstances, have one thing in common, namely, that they are situations in which a person is most likely to engage in mind wandering, the state that I have described as producing combinations in which the parameters p, u, and v all approach zero (Simonton, 2018b): just random thoughts that merely reveal that the brain is idling, or what has been more technically called in the neurosciences the activation of the "default mode network" (Kühn et al., 2014). Yet this mental state has also been linked to creative insights (Gable et al., 2019; see also Gilhooly, this volume). How can that be? After all, although creativity is maximised when both the initial probability and the prior knowledge value near zero, such maximisation also requires that the final utility approach unity. Even so, there's a catch: The thoughts entering consciousness can have any utility value whatsoever because those thoughts cannot be preselected for utility, given that their utilities are unknown in the first place (e.g. rational suppression becomes

impossible as $v \rightarrow 0$). Therefore, nothing prevents a highly creative idea from entering the mind just by chance—by internal serendipity either real or pseudo. To be sure, it's not a good bet that a brilliant inspiration will appear, and so such insights will be few and far between. Plus, many inspirations will prove false, not standing up to subsequent scrutiny. Yet to make up for that low likelihood, creative people spend appreciable time taking baths, lounging in bed, riding buses, going for hikes, and myriad other mundane activities in which the active mind just drifts off into oblivion. So sooner or later, episodes like Poincaré (1921) narrated are going to arise frequently enough. After all, this narration spanned a relatively short period of his life, a period confined to his work on Fuchsian functions.

One might object that the external stimuli are truly fortuitous whereas the internal stimuli may represent some underlying unconscious guidance (Boden, 2004). Poincaré (1921) himself expressed that belief. Even so, it has been argued that under these conditions the mind effectively becomes stochastic in operation (Carruthers, 2018; Simonton, 2003, 2018a). In support of this argument, it must be observed that in line with Mednick's (1962) concept of "flat associative hierarchies" (p. 223), the most remote associations become virtually equiprobable and thus the corresponding "spreading activation" becomes entirely unpredictable, especially given their susceptibility to subliminal priming effects—like flipping a coin in strong gusts. Indeed, even in retrospect creators cannot reconstruct the associative links that led to the serendipitous discovery. Accordingly, the internal stimuli can be just as undirected as the external. Instead of an idea coming out of the blue, it comes unexpectedly out of the darkness.

Scientific Versus Artistic Serendipity

Again, because combinatorial creativity represents a generic phenomenon, it applies to the arts as well as the sciences (Simonton, 2017). Returning to Picasso's *Guernica* that opened this chapter, empirical studies have demonstrated how the main figures making up this composition usually represent combinatorial retakes on images seen in

the creator's earlier art, such as his *Minotauromachy* executed just two years earlier (Damian & Simonton, 2011; Weisberg, 2004). At the same time, artistic domains are clearly distinct from scientific domains. The most obvious contrast is that all domains of creativity contain distinct elements that define the very nature of that domain (Simonton, 2010). Just as mathematicians combine different ideas than do biologists, so do painters combine different ideas than either writers or scientists do.

That said, artistic creators more often than scientific creators include ideas in their combinations that come from experiences that are far from domain specific. Thus, *Guernica* included images of a bull, a horse, a lamp, a crying woman, a dead warrior, a person consumed by fire, etc. Likewise, fiction authors write about events that might occur in everyday life. Even in more abstract arts, such as purely instrumental music, combinations may include bird songs, car horns, firing canons, train whistles, and a host of other sounds available to more ordinary auditory experience (Respighi's *Pines of Rome*, Gershwin's *American in Paris*, Tchaikovsky's *1812 Overture*, etc.). Hence, it seems reasonable to suppose that such occasions might precipitate artistic serendipity. Just as in scientific serendipity, the three parameters of a given artistic combination would have the values $p = v = 0$ and $u \rightarrow 1$. That is, the artistic creator comes up with a useful idea that they themselves could not have spontaneously generated nor could have anticipated in advance that it would work without trying it out (see also Piñeyro, Sneddon, Vallée-Tourangeau & March, this volume).

Picasso's *Guernica* might count as an example, even if it was the Spanish poet Juan Larrea who first suggested that he paint about that war atrocity. Picasso had already spent the last few months working on a painting to satisfy the Spanish government's commission, but it was on a totally different subject, namely the "artist's studio," a theme he had already treated multiple times to predicted success (viz. $u \rightarrow 1$, but $p \gg 0$ and $v \gg 0$, so $c \ll 1$). Moreover, the treatment of the horrors of war was not a subject familiar to him. Even though some images were carried over from *Minotauromachy*, these had to undergo substantial transformations to convert them from a surrealistic nightmare to a horrific even if symbolic reality. For example, the Minotaur was converted into a

bull. No wonder that Picasso had to make so many sketches to get the outcome he wanted. The net result was far more violent and unsettling.

The access to everyday experience is not the only reason why artistic serendipity might be especially commonplace, even more so than scientific serendipity. Research shows that artistic creators are particularly prone to openness to experience (Feist, 1998). That openness is positively associated with cognitive disinhibition, or what might otherwise be called defocused attention (Carson, 2014). What this mental quirk means in simple terms is that the artist is less likely to filter out supposedly extraneous stimuli and associations. In other words, even when supposedly attentive, they remain disposed towards a certain kind of mind wandering. This cognitive disinhibition would then render artistic serendipity all the more probable. Some random perception or thought may give rise to a theme, plot, character, image, form, sound, mood, or other core feature of an incipient artistic product.

Although defocused attention entails a passive process, artistic serendipity can also be deliberately cultivated. An example is the method of frottage developed by the surrealist artist Max Ernst (see also Piñeyro, this volume). For instance, he would obtain inspiration by throwing paper down randomly on well-worn floorboards, making rubbings, and then creating new imagery based on the forms thus created. The sculptor Henry Moore spoke of walking along the beach to explore the varied pebbles and other curious forms shaped by the surf. Perhaps the best analogue of such behaviours in science is exploratory behaviour driven by pure curiosity, such as Charles Darwin's historic activities as a naturalist aboard the *Beagle*. Even after returning to England, Darwin often conducted "fool's experiments" in which he would "test what would seem to most people not at all worth testing" (Darwin, 1892/1958, p. 101). He was thus inviting serendipity.

Discussion

I have argued that serendipitous discovery can be analysed as a combinatorial product in which both originality and surprise are maximised while inadvertently obtaining a combination with maximal

utility (i.e., $p = v = 0$ while $u \rightarrow 1$). As such, it can be viewed as the purest guise of a creative combination insofar as personal creativity becomes maximised (i.e., $c \rightarrow 1$). In this analysis I wish to emphasise the supreme importance of v, the person's prior knowledge of the combination's utility. Because most creativity researchers assume a two-criterion definition (Runco & Jaeger, 2012), this parameter is often overlooked. Yet, as noted earlier, any treatment of creativity that omits this prior knowledge value can be shown to be both logically and psychologically incomplete (Simonton, 2013; Tsao et al., 2019). For instance, the standard definition cannot be easily reconciled when creativity is said to require what is variably labelled trial and error, illumination and verification, generate and test, or blind-variation and selective-retention (BVSR; Campbell, 1960). These all posit that an original combination requires a subsequent utility evaluation because no procedure or process can guarantee utility. Indeed, the parameter v directly gauges the magnitude of blindness for a BVSR "variation" from totally sighted ($v = 1$) to utterly blind ($v = 0$), where serendipitous discoveries fall in the latter group. More generally, for all combinations, as $v \rightarrow 1$, then it necessarily follows that $c \rightarrow 0$.

This third parameter itself has antecedents in the history of epistemology. To provide perhaps the best illustration, the logic bears a relationship with the conception of knowledge as "justified true belief" that dates back to Plato's *Theaetetus*. Without the "justification," as gauged by v, nothing separates genuine expertise from a lucky guess or response bias where knowledge cannot be said to exist. If somebody has a favourite lucky number that they believe will make them a millionaire in the lottery, and they truly win, v still equals 0 even if $p = u = 1$. In contrast, if the person's true belief is justified because they rigged the lottery in some way, then $v = 1$. The winning number doesn't just happen to be guessed right, but rather that number was known in advance to win.

Nor am I even the first to introduce a concept comparable to the prior knowledge value (v) into the analysis of serendipitous discovery. Recently Copeland (2019; see also Copeland, this volume) stressed the role of "epistemic expectations" that concern the sources of scientific knowledge, the surprise inherent in serendipity then coming from the violation of

those expectations, just as we here take $(1 - v)$ as a gauge of surprise (see also Glăveanu, Ross, this volume). The crucial difference is that she places these epistemic expectations in the scientific community, and thus the serendipitous discovery cannot occur without a retrospective consensual evaluation. From a psychologist's point of view, her treatment conflates personal experiences with later social assessments. As someone who was trained as a social psychologist, I certainly respect the significance of the scientific community (Simonton, 2019). Yet it also has to be recognised that the cognitive encounter with serendipity is not held in abeyance until that community confirms retroactively that the event actually happened. In line with the famous anecdote reported by Vitruvius, Archimedes could very well have run naked down the streets of Syracuse screaming "Eureka!" without waiting for any consensual validation if his bathtub a-ha experience immediately revealed how he might solve the "gold crown problem" (*On Architecture*, Book IX, Paragraphs 9–12). The same personal reality applies to other instances as well. Serendipity is necessarily psychological before it becomes sociological.

Admittedly, one might argue that the epistemic expectations are internalised within the individual creators as part of their domain-specific education and training. Hence, former teachers and current colleagues are in a sense always looking over the shoulders of each creative individual. This communal influence would shape not only the creator's assessment of surprise, but also the other two criteria of originality and utility, and perhaps especially the last criterion. In this way personally appraised creativity is moulded by consensually appraised creativity, maybe even to the point of becoming indistinguishable. The distinction advocated here between personal and consensual assessments would then entail nothing more than splitting hairs. The assessments would otherwise be functionally equivalent. Even so, two considerations lead to a rejection of this sociological reductionism (cf. Simonton, 2013).

First, creative domains do not represent homogeneous cultures that can support a consistent set of explicit and specific norms for judging what is original, useful, and surprising (Simonton, 2004, 2015a). This deficiency is betrayed in the conspicuous lack of consensus regarding the relative merits of contributions to the discipline. Indeed, the reality

of this inferior consensus is personally experienced by any scholar going through peer review, whether for submitted manuscripts or grant proposals (Cicchetti, 1991). Not only will the reviewers disagree with the authors of the submission, but also the reviewers will frequently disagree with each other—even on so basic a question as whether a submission is publishable or fundable! To be sure, the magnitude of disciplinary consensus varies across domains, with the agreement higher in the physical sciences and lower in the social sciences, with the biological sciences falling between (Simonton, 2004). Furthermore, disciplinary consensus is lower still in the arts and humanities (Fanelli & Glänzel, 2013; Simonton, 2009). Yet even in the "hard" sciences the consensus can be insufficient to prevent controversies over who should receive the Nobel Prize. Albert Einstein's much delayed honour offers a prime example: Besides the long wait involving multiple failed nominations, he was not even explicitly bestowed the prize for his greatest scientific achievements—the special and general relativity theories (see also Ross, this volume).

Second, individuals who exhibit the highest levels of creativity possess personal characteristics that do not seem to suggest tight compliance with disciplinary norms (Simonton, 2018a). I have already noted the importance of openness to experience, a trait associated with wide interests and even broad competencies that extend well beyond any particular creative specialty (McCrae & Greenberg, 2014). For example, eminence as a scientist is positively associated with an active involvement in the arts (Root-Bernstein et al., 2008). In addition, highly eminent creators, including scientists, are much more prone to exhibit creative versatility if not outright polymathy, where they contribute to two or more domains or subdomains (Cassandro, 1998; Root-Bernstein & Root-Bernstein, 2020; White, 1931). Another reason why such persons are more likely to venture outside disciplinary boundaries is that they are characteristically independent and unconventional in behaviour and thought (Feist, 1998). This disposition is apparently encouraged by diversifying experiences that occur in childhood, adolescence, and early adulthood which "help weaken the constraints imposed by conventional socialization"

(Simonton, 2000, p. 153). These experiences may include "unconventional backgrounds (e.g., cultural or religious minorities, sickly dispositions, early orphanhood, or financial trouble), ... unconventional educational and training experiences (e.g., studies abroad, multiple mentors, voracious reading, and diverse hobbies), and ... more conspicuous leanings toward psychopathology" (Damian & Simonton, 2014, p. 389). The net result is that the most creative depart appreciably from whatever epistemic expectations might be said to guide their less creative colleagues.

The upshot is that the combinatorial analysis presented here justifiably focuses on serendipity as a psychological phenomenon. That focus incorporates surprise as an initial personal experience during the event.

References

Barber, B., & Fox, R. C. (1958). The case of the floppy-eared rabbits: An instance of serendipity gained and serendipity lost. *American Journal of Sociology, 64*, 128–136.

Beveridge, W. I. B. (1957). *The art of scientific investigation* (3rd ed.). Vintage.

Boden, M. A. (2004). *The creative mind: Myths & mechanisms* (2nd ed.). Routledge.

Bowden, E. M., & Jung-Beeman, M. (2003). Normative data for 144 compound remote associates problems. *Behavior Research Methods, Instruments, & Computers, 35*, 634–639.

Campbell, D. T. (1960). Blind variation and selective retention in creative thought as in other knowledge processes. *Psychological Review, 67*, 380–400.

Carruthers, P. (2018). Mechanisms for constrained stochasticity. *Synthesis.* https://doi.org/10.1007/s11229-018-01933-9

Carson, S. H. (2014). Cognitive disinhibition, creativity, and psychopathology. In D. K. Simonton (Ed.), *The Wiley handbook of genius* (pp. 198–221). Wiley.

Cassandro, V. J. (1998). Explaining premature mortality across fields of creative endeavor. *Journal of Personality, 66*, 805–833.

Cicchetti, D. V. (1991). The reliability of peer review for manuscript and grant submissions: A cross-disciplinary investigation. *Behavioral and Brain Sciences, 14*, 119–186.

Copeland, S. (2019). On serendipity in science: Discovery at the intersection of chance and wisdom. *Synthese, 196*, 2385–2406.

Damian, R. I., & Simonton, D. K. (2011). From past to future art: The creative impact of Picasso's 1935 *Minotauromachy* on his 1937 *Guernica. Psychology of Aesthetics, Creativity, and the Arts, 5*, 360–369.

Damian, R. I., & Simonton, D. K. (2014). Diversifying experiences in the development of genius and their impact on creative cognition. In D. K. Simonton (Ed.), *The Wiley handbook of genius* (pp. 375–393). Wiley.

Darwin, F. (Ed.). (1958). *The autobiography of Charles Darwin and selected letters*. Dover. (Original work published 1892)

Díaz de Chumaceiro, C. L. (1995). Serendipity or pseudoserendipity? Unexpected versus desired results. *Journal of Creative Behavior, 29*, 143–147.

Einstein, A., & Infeld, L. (1938). *The evolution of physics: The growth of ideas from early concepts to relativity and quanta*. Simon & Schuster.

Fanelli, D., & Glänzel, W. (2013). Bibliometric evidence for a hierarchy of the sciences. *PLoS ONE, 8*(6), e66938. https://doi.org/10.1371/journal.pone.0066938

Feist, G. J. (1998). A meta-analysis of personality in scientific and artistic creativity. *Personality and Social Psychology Review, 2*, 290–309.

Gable, S. L., Hopper, E. A., & Schooler, J. W. (2019). When the muses strike: Creative ideas of physicists and writers routinely occur during mind wandering. *Psychological Science, 30*, 396–404.

Gillies, D. (2015). Serendipity and chance in scientific discovery: Policy implications for global society. In D. Archibugi & A. Filipetti (Eds.), *The handbook of global science, technology, and innovation* (pp. 525–539). Wiley Blackwell.

Hadamard, J. (1945). *The psychology of invention in the mathematical field*. Princeton University Press.

Helmholtz, H. von (1898). An autobiographical sketch. In *Popular lectures on scientific subjects, second series* (E. Atkinson, Trans., pp. 266–291). Longmans, Green.

James, W. (1880, October). Great men, great thoughts, and the environment. *Atlantic Monthly, 46*, 441–459.

Kantorovich, A., & Ne'eman, Y. (1989). Serendipity as a source of evolutionary progress in science. *Studies in History and Philosophy of Science, 20*, 505–529.

Kühn, S., Ritter, S. M., Müller, B. C. N., van Baaren, R. B., Brass, M., & Dijksterhuis, A. (2014). The importance of the default mode network in creativity—A structural MRI study. *Journal of Creative Behavior, 48*, 152–163.

Kuhn, T. S. (1970). *The structure of scientific revolutions* (2nd ed.). University of Chicago Press.

Lee, C. S., Huggins, A. C., & Therriault, D. J. (2014). A measure of creativity or intelligence? Examining internal and external structure validity evidence of the remote associates test. *Psychology of Aesthetics Creativity and the Arts, 8*, 44–460.

Mach, E. (1896). January). On the part played by accident in invention and discovery. *The Monist, 6*, 161–175.

Maier, N. R. F. (1931). Reasoning in humans: II. The solution of a problem and its appearance in consciousness. *Journal of Comparative and Physiological Psychology, 12*, 181–194.

McCrae, R. R., & Greenberg, D. M. (2014). Openness to experience. In D. K. Simonton (Ed.), *The Wiley handbook of genius* (pp. 222–243). Wiley.

Mednick, S. A. (1962). The associative basis of the creative process. *Psychological Review, 69*, 220–232.

Plucker, J. A., Beghetto, R. A., & Dow, G. T. (2004). Why isn't creativity more important to educational psychologists? Potentials, pitfalls, and future directions in creativity research. *Educational Psychologist, 39*, 83–96.

Poincaré, H. (1921). *The foundations of science: Science and hypothesis, the value of science, science and method* (G. B. Halstead, Trans.). Science Press.

Roberts, R. M. (1989). *Serendipity: Accidental discoveries in science*. Wiley.

Root-Bernstein, R., Allen, L., Beach, L., Bhadula, R., Fast, J., Hosey, C., Kremkow, B., Lapp, J., Lonc, K., Pawelec, K., Podufaly, A., Russ, C., Tennant, L., Vrtis, E., & Weinlander, S. (2008). Arts foster scientific success: Avocations of Nobel, National Academy, Royal Society, and Sigma Xi members. *Journal of the Psychology of Science and Technology, 1*, 51–63.

Root-Bernstein, R., & Root-Bernstein, M. (2020). Statistical study of intra-domain and trans-domain polymathy among Nobel laureates. *Creativity Research Journal, 32*, 93–112.

Runco, M., & Jaeger, G. J. (2012). The standard definition of creativity. *Creativity Research Journal, 21*, 92–96.

Simonton, D. K. (2000). Creativity: Cognitive, developmental, personal, and social aspects. *American Psychologist, 55*, 151–158.

Simonton, D. K. (2003). Scientific creativity as constrained stochastic behavior: The integration of product, process, and person perspectives. *Psychological Bulletin, 129*, 475–494.

Simonton, D. K. (2004). Psychology's status as a scientific discipline: Its empirical placement within an implicit hierarchy of the sciences. *Review of General Psychology, 8*, 59–67.

Simonton, D. K. (2007). The creative process in Picasso's *Guernica* sketches: Monotonic improvements or nonmonotonic variants? *Creativity Research Journal, 19*, 329–344.

Simonton, D. K. (2009). Varieties of (scientific) creativity: A hierarchical model of disposition, development, and achievement. *Perspectives on Psychological Science, 4*, 441–452.

Simonton, D. K. (2010). Creativity as blind-variation and selective-retention: Constrained combinatorial models of exceptional creativity. *Physics of Life Reviews, 7*, 156–179.

Simonton, D. K. (2012a). Foresight, insight, oversight, and hindsight in scientific discovery: How sighted were Galileo's telescopic sightings? *Psychology of Aesthetics, Creativity, and the Arts, 6*, 243–254.

Simonton, D. K. (2012b). Taking the US Patent Office creativity criteria seriously: A quantitative three-criterion definition and its implications. *Creativity Research Journal, 24*, 97–106.

Simonton, D. K. (2013). What is a creative idea? Little-c versus Big-C creativity. In J. Chan & K. Thomas (Eds.), *Handbook of research on creativity* (pp. 69–83). Edward Elgar.

Simonton, D. K. (2015a). Psychology as a science within Comte's hypothesized hierarchy: Empirical investigations and conceptual implications. *Review of General Psychology, 19*, 334–344.

Simonton, D. K. (2015b). Thomas Alva Edison's creative career: The multilayered trajectory of trials, errors, failures, and triumphs. *Psychology of Aesthetics, Creativity, and the Arts, 9*, 2–14.

Simonton, D. K. (2016). Creativity, automaticity, irrationality, fortuity, fantasy, and other contingencies: An eightfold response typology. *Review of General Psychology, 20*, 194–204.

Simonton, D. K. (2017). Domain-general creativity: On producing original, useful, and surprising combinations. In J. C. Kaufman, V. P. Glăveanu, & J. Baer (Eds.), *Cambridge handbook of creativity across different domains* (pp. 41–60). Cambridge University Press.

Simonton, D. K. (2018a). Creative genius as causal agent in history: William James's 1880 theory revisited and revitalized. *Review of General Psychology, 22*, 406–420.

Simonton, D. K. (2018b). Defining creativity: Don't we also need to define what is *not* creative? *Journal of Creative Behavior, 52*, 80–90.

Simonton, D. K. (2019). Scientific community. In T. L. Pittinsky (Ed.), *Science, technology and society: Perspectives and directions* (pp. 176–202). Cambridge University Press.

Thagard, P. (2012). Creative combination of representations: Scientific discovery and technological invention. In R. Proctor & E. J. Capaldi (Eds.), *Psychology of science: Implicit and explicit processes*. New York: Oxford University Press.

Thagard, P., & Stewart, T. C. (2011). The AHA! experience: Creativity through emergent binding in neural networks. *Cognitive Science: A Multidisciplinary Journal, 35*, 1–33.

Tsao, J. Y., Ting, C. L., & Johnson, C. M. (2019). Creative outcome as implausible utility. *Review of General Psychology, 23*, 279–292.

Weisberg, R. W. (2004). On structure in the creative process: A quantitative case-study of the creation of Picasso's *Guernica*. *Empirical Studies of the Arts, 22*, 23–54.

Weisberg, R. W. (2015). On the usefulness of "value" in the definition of creativity. *Creativity Research Journal, 27*, 111–124.

White, R. K. (1931). The versatility of genius. *Journal of Social Psychology, 2*, 460–489.

Index

© The Editor(s) (if applicable) and The Author(s), under exclusive license to Springer Nature Switzerland AG 2022
W. Ross and S. Copeland (eds.), *The Art of Serendipity*, Palgrave Studies in Creativity and Culture, https://doi.org/10.1007/978-3-030-84478-3

Printed in the United States
by Baker & Taylor Publisher Services